The Other Ireland

Changing Times, 1870–1920

The Other Ireland

Changing Times, 1870–1920

Mary Jones

Gill & Macmillan

Gill & Macmillan

Hume Avenue, Park West, Dublin 12

with associated companies throughout the world

www.gillmacmillan.ie

© Mary Jones, ArkHive Productions 2011

978 07171 4832 5

Index compiled by Róisín Nic Cóil

Design and print origination by Outburst Design, Dublin

Printed in Poland

This book is typeset in Amerigo Md BT 9pt on 13pt.

The paper used in this book comes from the wood pulp of managed forests.
For every tree felled, at least one tree is planted, thereby renewing natural resources.

A CIP catalogue record for this book is available from the British Library.

1 3 5 4 2

Contents

Contents

Acknowledgments

Acknowledgments

Of necessity, the production of an authored work from the point of an improvement upon the blank page through to the binding of a book, is a collaborative effort. Writing can be a lonely occupation and I wish to acknowledge the encouragement and the support of those who made it feel less so.

Gill & Macmillan
Fergal Tobin
Deirdre Rennison Kunz
Jen Patton
The Production Team
The Design Team

ArkHive Productions
Siobhan O'Sullivan: Chronological Data, Timeline 1870–1920
Eugene Finn: Photographic Archive of the RCSI

The National Library of Ireland
The Mason Collection
The Lawrence Collection
The Poole Collection
Keith Murphy of the National Library of Ireland
The Staff of the National Photographic Archive

The Royal Society of Antiquaries of Ireland
Curator: Chris Corlett and curatorial staff, RSAI

National Museum of Northern Ireland
The Welch Collection
Curator: Michelle Ashmore

The Irish Examiner Photographic Archive
Cork Examiner
Curator: Anne Kearney

University College Dublin Archives
Royal College of Science of Ireland Collection
Principal Archivist: Seamus Helferty

Architectural Archives of Ireland
Curator: Colum O'Riordan

Introduction
Introduction

Ireland is perceived — and often perceives itself — through the spectacle of the stereotype: its people assumed to be a quaint if tragic mix of the saint, the scholar and the sleeveen. Questions of contemporary political and cultural identity are complex: globally, legions of peoples — in the wake of war, famine, of need or of greed — are now leaving their places of origin, a modern exodus unparalleled in human history. To assert a claim to the purity of an Irish race, at home and beyond, in the face of such collective disruption of place and in the knowledge that we, too, have borne diverse stock, would be deeply problematic. *The Other Ireland*, with a selection of images from the twilight years of the Union of Great Britain and Ireland, attempts to capture, for a diverse people, a moment within the passing of historical and industrial time when Ireland challenged the authority of, and was curtailed by, the era of the British Empire.

In Ireland, twilight is not swift — it is a time of subtle, sometimes dramatic change; of spatial washes of transforming light, a complexity of shade and, from the west, a moment of deep dark, before the Milky Way maps a passage towards the return of light. Time leaves a residue, the geography of imprint: before the English plantations, the Scottish clearances; before the Union and prior to the Normans, the Vikings; emerging from a line of bards, kings, judges, slaves, back to the earliest surviving records of human life on this island. Early Irish society was culturally homogeneous, 'A common, dialect-free Gaelic language, known to scholars as Old Irish, was spoken throughout an Ireland that itself was a unitary whole, though divided into five provinces or "fifths".' A sophisticated elite controlled a slave-based social order, a complex body of Early Irish law protecting, and placing obligations upon, hierarchies of status based on learning and on the accumulation of power. From a land mapped, but neither directly formed nor menaced, by the Roman Empire, Old Irish bequeathed a rich oral tradition and the impulse to record how we have lived, 'initially in the fifth century in the form of ogham inscriptions on stone memorials, but then by the seventh century ... the first vernacular literature in western Europe ...' (Bartlett, 2010).

The Irish stereotype has proved a seductive form, hardly scathed by more exotic scholarly observation of an island people. In Germany, the Turkish Bath is reputed to be called 'the Irish bath', possibly dating from early excavations of Ireland by German archaeologists and ethnographers. The first record of such Irish 'Sweathouses' is from Ballytra, Co. Donegal, published in Latocnaye's account of *A Frenchman's Walk Through Ireland 1796–7*. He noted, on observation of the inhabitants of Ballytra: 'To use the sweating-house they heat it with turf ... when it is pretty hot, four or five men or women, entirely naked, creep in as best they can through the little opening ... Wherever there are four or five cabins near each other there is sure to be a sweating-house' (Weir, 1979). The bulk of the Irish peasant population lived in cabins and engaged in agricultural labour. Of these, the English factory inspector, Hilda Martindale, noted: 'The vocabulary of the Irish peasant was interesting ... unusual words were often on their lips ... and I was hardly surprised to learn that observations had shown that their vocabulary varied from 3,000–6,000 words' (Martindale, 1909).

The ambition, and the limitations, of *The Other Ireland* reside with the author. The sources of the images are drawn from the repository of magic lantern slides and glass plate negatives held in photographic archives throughout Ireland. The curators and staff in these archives have, collectively, been generous with their time as the distinguished custodians of this body of knowledge: the repository of photographic images of Ireland. The selection of so few from such a vast resource is, of necessity, partial. As with all such images, these only rarely 'speak for themselves'. A large portion of this selection — the images from the Mason Collection and some from the Royal Society of Antiquaries of Ireland — are previously unpublished. Others — from the Welch Collection, the Lawrence and Poole Collections, University College Dublin

Introduction

Introduction

Archives, the Architectural Archive of Ireland and the photographic archives of the *Irish Examiner* — are familiar to some and will be new to others.

The images demand a form of narrative — in this instance, the narrative resides in captions to the images and have drawn on sources from predominantly Irish scholarship. As with the stereotype, such scholars continue to labour in most congenial circumstances and in the last few decades their work has ensured that many assumptions about ourselves, and our erstwhile rulers, have been quietly abandoned. Much analysis, and a range of interpretation of the last 50 years of the Union of Great Britain and Ireland, forms the intellectual ballast that will, critically, stamp authority on any exotic cargo we carry into the future of this island. The end of Union was bloody, as was the beginning and, indeed, the middle. Modern Ireland is, however, distinguished by a public laying down of arms, and much has been acknowledged: 'Republican terrorism intensified in late 1920 and early 1921, in a tit-for-tat cycle of reprisals and punishments for which uncontrolled Crown Forces were at least equally culpable' (Fitzgerald, 2011). It is too glib, but will still reward scrutiny, to assume that 'one person's terrorist is the other's freedom fighter'. In this instance, *The Other Ireland: Changing Times, 1870–1920*, endeavours to stretch the canvas, and to present a less familiar perspective on those turbulent times of transition.

1867 — 1879

1867 The 'Fenians', born of the secret Irish Republican Brotherhood (IRB) and a New York-based sister organisation, the Fenian Brotherhood, has committed to 'secure a republic for Ireland by force of arms'. An attempt by Fenians to rescue comrades from a prison van in Manchester leads to the death of Sergeant C. Brett, a policeman on escort duty. Three men are tried, sentenced and publicly executed. The case of these 'Manchester Martyrs' rekindles the nationalist flame throughout Ireland leading to a brief and abortive insurrection.

A recommendation from the patrons of the Orange Society 'bade the members refrain from processions and open illegal acts … because the Tories were in power … and any disturbance on the part of the Orangemen would … give embarrassment to influential friends' (An Ulsterman, 1868).

The opening in St Stephen's Green of the Royal College of Science for Ireland, following 'intensive lobbying' by the scientist Sir Robert Kane, 'one of the greatest Irish minds of the Victorian era', lays the foundation for a different vision of the Union through the education of 'generations of engineers, chemists, surveyors, teachers, and other professionals'.

1868 Isaac Butt, Member of Parliament, Protestant and Conservative, acts as barrister for the defence in a number of Fenian trials and criticises British 'misgovernment of Ireland'.

William Gladstone, leader of the Liberal Party, resists amnesty for imprisoned Fenians, but acknowledges injustices in Ireland that need to be addressed if the Union is to be preserved. The failure of the 1867 Fenian insurrection, and the executions at Manchester, re-focus Fenian attention on parliamentary agitation and a political route to Irish independence.

William Gladstone is elected Prime Minister.

1869 Gladstone's Irish Church Act becomes law, disestablishing the Church of Ireland and ending the concept of an established Church for Ireland.

1870 Gladstone's Landlord and Tenant Act, 1870 signals the beginning of a legislative challenge to the power of landlordism in Ireland. Thirty-eight per cent of landlords are Irish born, holding 15 per cent of land through inheritance, purchase or by award as part of the colonisation policy of the Crown; 62 per cent of landlords are not of Irish origin, but may be Irish born and descendants of refugees, as with the Huguenot; or descendants of Adventurers, as with those who joined the ranks in the Williamite Wars. Many of these have acquired their land through purchase or through enforced confiscation, and subsequent gifting, of such lands in recognition of their service to the British Crown. Many are absentee landlords. Under the new Act, 'Ulster Custom', which enhanced tenant rights in that part of the island, is given force of law; compensation is provided for eviction other than through the failure to pay rent and, under the 'Bright' clauses, provision is made to allow tenants to purchase holdings from landlords. The year is marked by 548 evictions of Irish tenant farmers.

Isaac Butt launches the Home Government Association seeking limited self-government for Ireland within the Union. The Irish Republican Brotherhood agree to 'confine themselves in times of peace to the exercise of moral influence' and Butt forms an Amnesty Association to assist the case of

incarcerated Fenians. The Union, with some reservations and an acknowledgment of the impulse of Irish people towards self-government, 'appeared to be working' (Bartlett 2010).

1871 The Trade Union Act is passed, signalling an era of legislative recognition for trade unions in recognition of their support for Gladstone's Liberal Party in the 1870 election.

Isabella Todd, a Scottish-born Presbyterian active in seeking education for middle-class women, establishes the Northern Irish Society for Women's Suffrage to seek an extension of the franchise to include women.

Thirty-three Fenians are released from prison in England. Isaac Butt is perceived by Fenians to be ineffective as a leader. They scrutinise the parliamentary tactics of obstructionists, including the Protestant Home Ruler and Wicklow landowner, Charles Stewart Parnell, who had defended Fenians, denying that their acts constituted murder, and had endured opprobrium from the Members of the House of Commons for so doing.

1872 The electoral franchise is extended and the Secret Ballot is introduced. Tenant farmers anticipate their political power at the ballot box. There is sectarian rioting in Belfast, the most severe recorded since a Commission of Inquiry into Riots in Belfast in 1857. The tenant rights movement is strong in areas such as Antrim, Down and the Ards peninsula, where the proportion of relatively affluent Presbyterian farmers is notable.

The Dublin Exhibition of Arts, Industries and Manufactures opens at Earlsfort Terrace on a site acquired by one of the Exhibition patrons, Benjamin Guinness. Other patrons include the owners of department stores, the 'monster houses' where 'commodity culture' reflects and serves the growth of a consumer class in Dublin and elsewhere. The Exhibition boasts a range of goods, from Irish handmade lace to the more exotic bounty of the outposts of Empire. Imports of produce and manufacture of the United Kingdom and foreign and colonial merchandise continue to rise.

1873 A Home Rule League is established with Isaac Butt as president, to replace the Home Government Association. This is a first step towards forming a distinct Home Rule Party at Westminster.

1874 Gladstone's government falls. The Irish Home Rule Party — separate from and independent of both Liberals and Conservatives — emerges. It aims to reform the land system, seeks grants for denominational education and Home Rule for Ireland. Fifty-nine 'Home Rulers' supporting self-government within the Union, with an increasingly nationalist identity, are elected to Westminster but no longer hold any balance of power. The Conservative Party under Benjamin Disraeli wins the General Election, and Irish reform is moved off the Order of Business.

1875 Charles Stewart Parnell is elected Member of Parliament for County Meath.

1876 A period of agricultural prosperity prompts banks across all the provinces of Ireland to extend credit to tenant farmers. Shopkeepers and traders offer tenant farmers a similar facility. By the mid-1870s at least some are in debt. The condition of

small farm tenants and agricultural labourers remains poor; in towns, shop assistants and artisans — an increasingly literate population — join expressions of social discontent. Small industrial firms 'show signs of difficulty'. Belfast, with an established industry in shipbuilding and linen, is less affected. The impact of depression in Britain, and an influx of cheap imported agricultural goods from America, is felt across Europe and in Ireland.

1877 All of Ireland, still overwhelmingly rural, is affected by a series of poor harvests: potatoes fail in the west of Ireland and Ulster experiences the greatest decline in crop yields. Prices fall for Irish producers. Lack of land security and fear of famine provoke the rural tenant farmer population — politicised by experience, with an appetite for power whet by Fenian sentiment and with more to lose than in the 1840s — to organise. A period of global decline begins, with falling prices for produce. The question of rents and rights returns, as Mayo man Michael Davitt, imprisoned in England for gun-running and released in 1877, meets with Parnell in London and Dublin and travels 'to the west of Ireland … he came away a convinced agrarian radical … persuaded that the land question held the key to the national question' (Bartlett, 2010).

1878 Parnell meets with Davitt, with an agenda to resolve the land question by securing tenant ownership. Davitt travels to New York to discuss with John Devoy, Fenian leader, the potential for this 'new departure' in Irish politics. The grievances of agricultural labour, the landless rural worker, are subsumed into questions of land ownership. Publication of an extended version of the official 'New Doomsday Book' gives details of the owners of 2,000 acres or more throughout the kingdom, including, for the

first time, the ownership structure of the land of Ireland.

1879 The Land League is established, a 'formidable national network which co-ordinates local tenant associations', and an emerging threat to the assuredness of the established order. Following the death of Isaac Butt, Parnell becomes leader of the Irish Party. At Irishtown, Co. Mayo, a mass demonstration against a local landlord, a Catholic priest, forces a reduction in rents. A third year of devastating weather and falling harvests pushes up the price of scarce produce, notably the potato. A poor British harvest and a slump in America lead to a decline in emigration, and a rise in agrarian disaffection.

The Royal University of Ireland Act permits women to prepare for university degrees on the same terms as men.

At Westminster, Gladstone introduces the Coercion Bill to impede the progress of the Land League; Parnell and others launch a 41-hour session of resistance. Parnell is elected as president of the Land League: the war for the land of Ireland has begun.

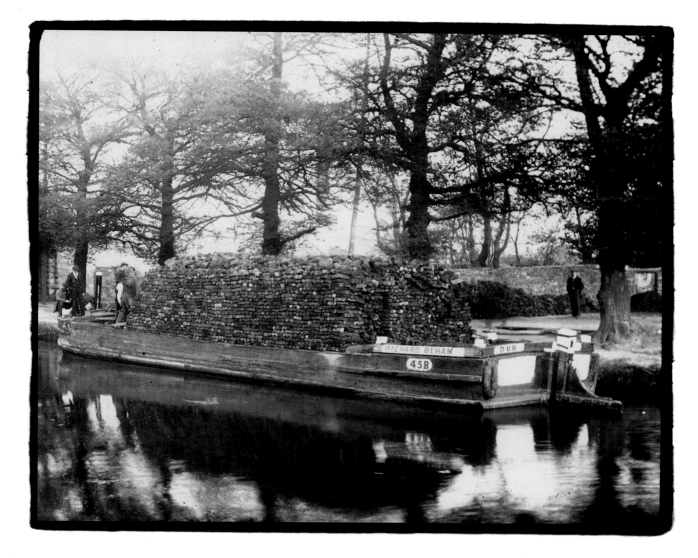

William of Orange had suggested, 'Make canals in Ireland … you will make a second Holland.' Since the second half of the sixteenth century, highly skilled marine engineers, of Dutch and English origin, have settled in Ireland. (Smyth, 2006) In 1715 the Irish Parliament passed an Act 'to encourage the draining and improving of the Bogs, and unprofitable low grounds, and for easing and dispatching the inland carriage, and conveyance of goods, from one part to another within this Kingdom'. Designed by English engineers, in the wake of the Famine of the 1840s, the cutting and digging of the Irish system of canals serves as regular relief work for thousands of Irish men. (Rynne, 2006)

The *Richard Behan, Dublin*. Nineteenth-century transporting by barge. MASON@NLI.

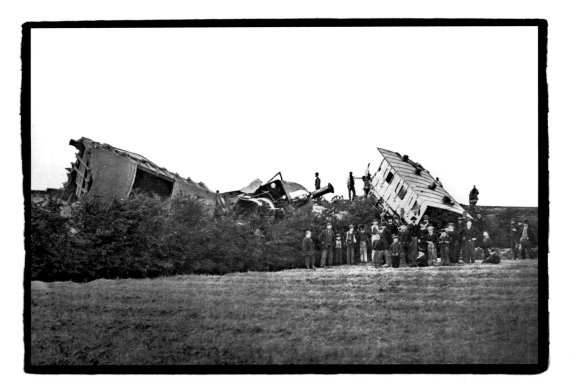

The Dublin–Kingstown railway was opened in 1834, and in 1837 Commissioners were appointed by 'William the Fourth, by the Grace of God, of the United Kingdom of Great Britain and Ireland' to 'Inquire into the Manner in which Railway Communications can be most advantageously promoted in Ireland'. The advance of the line of rail became the hallmark of economic and social development across the British Empire of the nineteenth century.

Belfast and County Down Railway. A train leaves the rails on an embankment near Ballymacarret Junction on 13 May 1871. WELCH©NMNI.

Across Ireland a commitment to provide public libraries was authorised under the terms of the Public Libraries Act (Ireland) 1855, with management and control vested at local level with Boards and Town Commissioners authorised to 'appoint, purchase and provide … Books, Newspapers, Maps and Specimens of Art and Science'. Under the Act, 'The Admission to all Libraries and Museums established under this Act shall be open to the public, free of all Charge.'

The Library at Armagh. LAWRENCE©NLI.

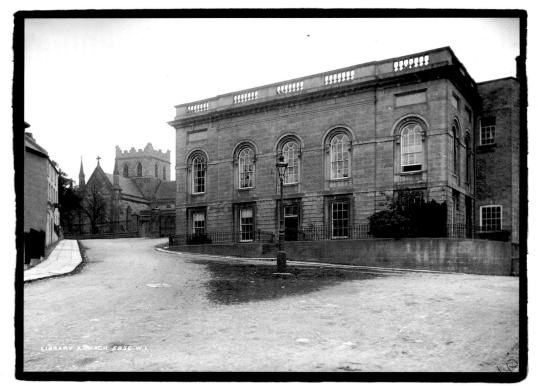

The state of the Union

Colonial patronage fosters the growth of an Irish middle class as 5,800 Irish civil servants administer British rule in Ireland. From street traders to small shopkeepers, Irish Catholics dominate in the main street. A legion of Irish — from engineers to soldiers — expand across the colonies of the British Empire. Ongoing decline in the population of rural Ireland through emigration travels in tandem with migration and growth in the urban centres of Belfast and Dublin. Industrial employment marks the foundation of an urban-based culture — regular employment for many, both men and women, often distinguished by long hours and uneven conditions of employment. The population of urban and moderately prosperous towns and suburbs — Ranelagh and Kingstown — form an aspiring, often native, bourgeoisie; in Drumcondra and Glasnevin, drapers' assistants, clerks and artisans are indicative of the settling of an employed, more confident and aspiring lower middle class.

1,800,000 Irish emigrants are recorded as living in America; 750,000 are living in Britain. By 1871, the Census records that over 5.2 million inhabitants of the country had been born in Ireland, and over 105,000 inhabitants had been born elsewhere.

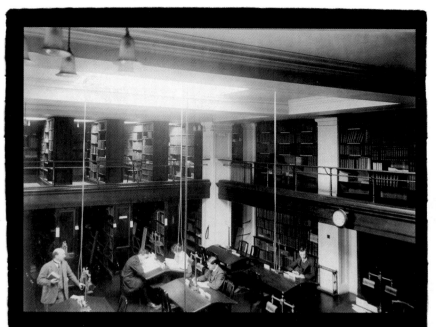

The Royal College of Science of Ireland, founded in 1867, has laid the foundation for an ambitious vision of the Union advancing the education of 'generations of engineers, chemists, surveyors, teachers, and other professionals'. In 1870 The Irish Times *placed on record the aspiration that the RCSI would serve as 'the nucleus of a great University of Technical Education, whose mission it will be to guide and stimulate manufacturing industry, the development of which would go far to solve our agrarian questions, and give peace, and hopefulness, and material ease to the population' (McCorristine, 2009).*

The Library, RCSI, St Stephen's Green, Dublin. RCSI©UCD.

A vision was the guide to developments by the Herdman brothers. In 1835 they had financed the building of a flax-spinning mill at Sion Mills, Co. Tyrone, where a guaranteed and abundant supply of water from the River Mourne was key to turning the wheels of industry. A model village housing a non-sectarian workforce would, they believed, lay the foundation for a prosperous Ireland under the union of sister nations. The vision was not new: the Malcolmson Quaker family in Portlaw, Waterford, had built a school alongside the textile mill they had founded in the 1820s. What was new was the aspiration to educate and train a community of different religious persuasions to learn to live together in a climate of non-sectarianism.

Sion Mills Factory. WELCH©NMNI.

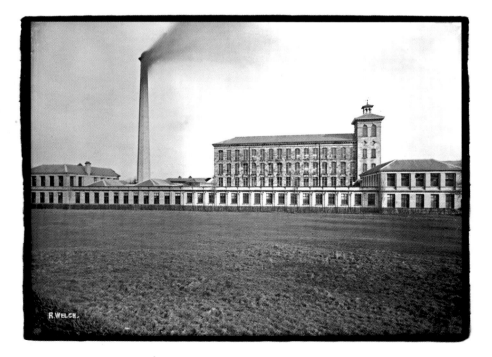

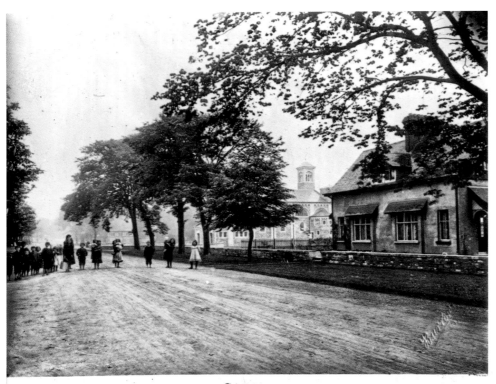

SION
FUTURE WORKERS

A model community of workers for the mill had echoes of the attempt to introduce a non-denominational model school system into Ireland and was testament to the profound differences on the island which presented as, and divided communities on, lines of sectarianism. The legacy, born of the imperative to address such divisions, borrowed from reformers of the early eighteenth century, including Welsh social reformer Robert Owen, whose publications on The Formation of Character *(1813) and* A New View of Society *(1814) were closely linked to his experience in the textile industry and its widespread use of child labour. Unlike Owen, a secular socialist, the Herdman brothers perceived religion both as spiritual sustenance and as a tool for social formation.*

Sion: 'Future Workers'. MASON©NLI.

The factory system had considerable appeal for working people. Payment by truck, and an inability to obtain coin for work done, was widespread in Ireland at this time, and persisted throughout what remained a largely agricultural economy. Although later prohibited by law, 'At No 631, the firm keep a shop ... at which the workpeople are obliged to spend their wages ... and a foreman ... has been obliged to dismiss ... for buying goods at other shops in the village' (Royal Commission, 1893/4). Truck continued to be recorded amongst outworkers in the textile industry in Donegal in the early years of the twentieth century. (Martindale, 1907) Leather buttons were at one stage used at the Portlaw factory, with a company shop provided for exchange of this form of payment for goods. The regular receipt of wages with set hours for workers became a significant attraction of the factory system.

Sion factory workers in front of Sion Mills Shop in the Model Village. MASON©NLI.

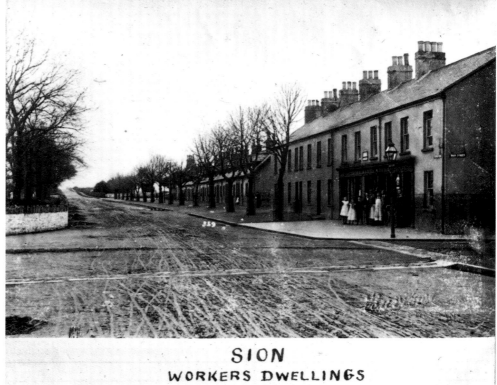

SION
WORKERS DWELLINGS
WINTER

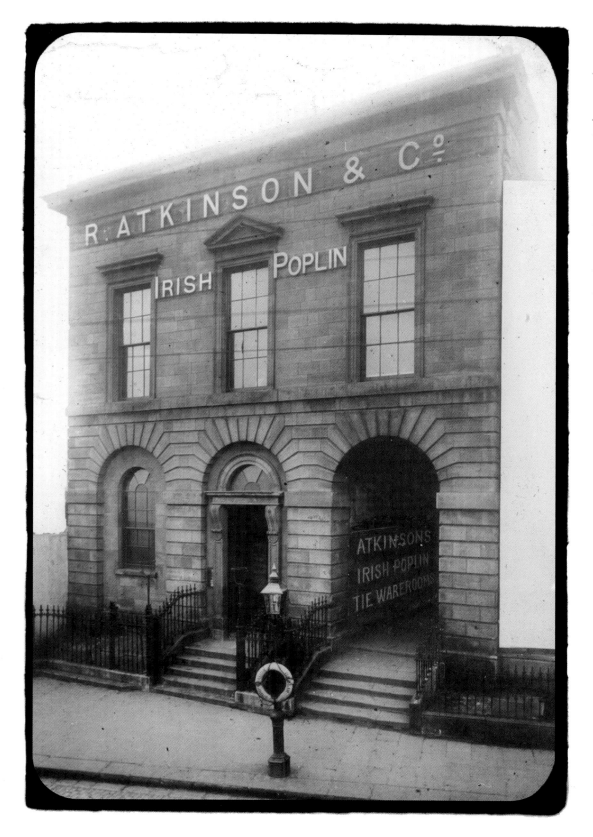

Atkinson's poplin factory was founded in Dublin in 1837. The tradition of nineteenth-century Irish poplin-weaving included factory and outdoor worker production by Atkinson's and other Irish firms including Pym's, Fry's, Mitchell's and Elliot's. Women were paid at the same rate as men. 'In slack times, however, women are not employed as weavers, all the work being given to the men.'

Atkinson's Dublin poplin factory at Merchant's Arch, Dublin, at the Halfpenny Bridge. MASON©NLI.

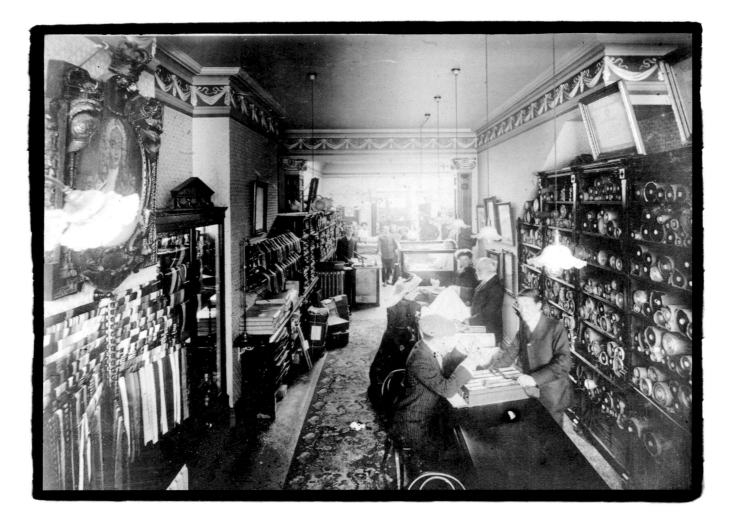

Richard Atkinson, a former Lord Mayor of Dublin, had originally persuaded a group of Huguenot weavers to manufacture Irish poplin exclusively for the company. Atkinson was appointed Queen Victoria's purveyor of the court, this royal connection securing a market under the prestigious label of Royal Irish Poplin. The Atkinson shop in College Green in Dublin becomes a meeting place for fashion, with regimental neckties sporting the seal of approval for an Irish family business.

Atkinson's No. 11: Customer/retail section. MASON©NLI.

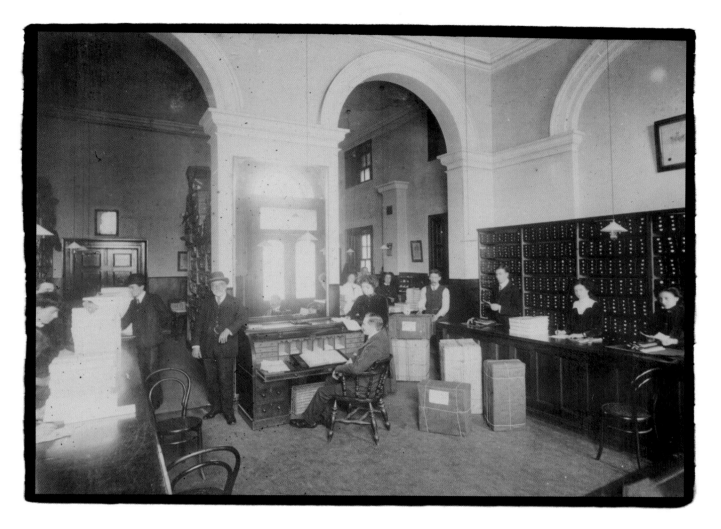

With the establishment of its name as a producer of quality goods, Atkinson's dispatched ties and other items to retail outlets across Ireland by rail and road, and by ship to London and the colonies. The workforce is mixed as the success of manufacture generates clerical and administrative positions. A Royal Commission on Labour recorded the conditions of work within the Dublin poplin factories towards the end of the nineteenth century. On wages in general, they noted that what was earned will 'vary from 9s to £1 a week', with winders averaging 9s, warpers 12s and weavers 16s. The workers within the factories were 'unemployed during four months of the year', and hours were not considered long: in one instance 10 a.m. to 6 p.m. is cited, with half an hour allowed for dinner. Workers in the factory paid 'One shilling a week for the rent of a loom, and in some instances looms are also rented to outdoor weavers'.

Atkinson's No. 10: Office and packaging section.
MASON©NLI.

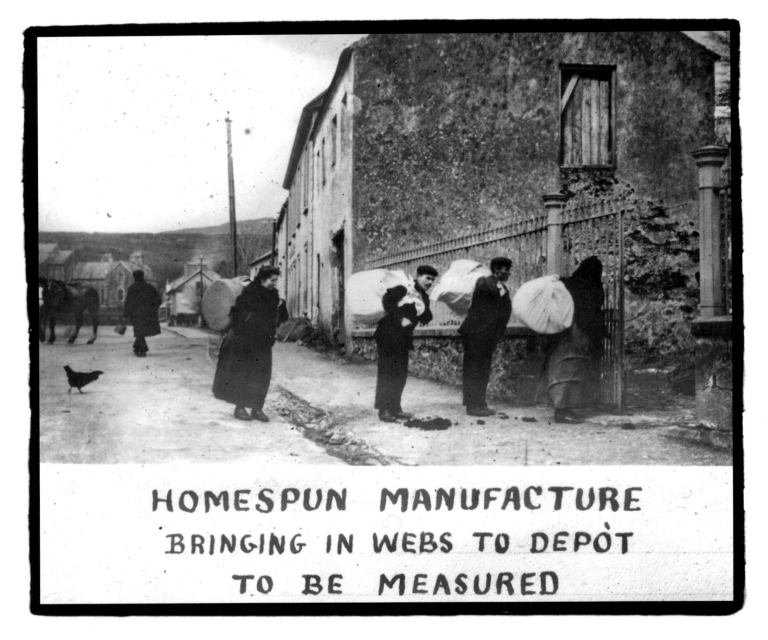

HOMESPUN MANUFACTURE
BRINGING IN WEBS TO DEPÒT
TO BE MEASURED

Many such outdoor weavers lived in rural Ireland. As recorded by the Royal Commission on Labour, a tweed merchant in Donegal acted as agent for various firms. 'He has several hundred names on his books ... the trade has been established since 1842.' Mrs Ernest Hart 'employs a large number of women in the manufacture of homespuns and tweeds ... there are very few in the factory at Bunbeg, the larger number being home workers'. In the weaving of rough tweeds, 'at first all the wool was given out ... and when their task was done they brought it back and were paid'. This worked on a small scale, but 'now they are left to get their own material and must bring in the web finished'.

Bringing the webs into village based depots to be measured. MASON©NLI.

Outdoor weavers were less vulnerable to technological change at this time than were outdoor spinners. The York Street Cotton Mill was destroyed by fire in 1828. On the site, a new Flax Spinning Mill was built, laying, in effect, the foundation for the industrialisation of Belfast. A change in technology had persuaded the owners, the Mulholland brothers, to invest in a significant new invention: the steam engine. The impact throughout the island was profound: handspinners in cottages became redundant, as a single spindle in Mulholland's Mill produced twice the amount of work in one week as did a single handspinner in a cottage. One mill worker would tend to 160 spindles.

York Street Flax Spinning Company Ltd. View of the factory from York Street, looking up Henry Street, Belfast. WELCH©NMNI.

A town or village on market day would bring weavers and others into a central public space where a depot was established, cloth measured and an exchange made. Cloth was also offered for direct sale to the public — perhaps a second level of cloth rejected by the depot due to flaws in the weaving.

Fair and marketplace, including a depot for webs of cloth. LAWRENCE©NLI.

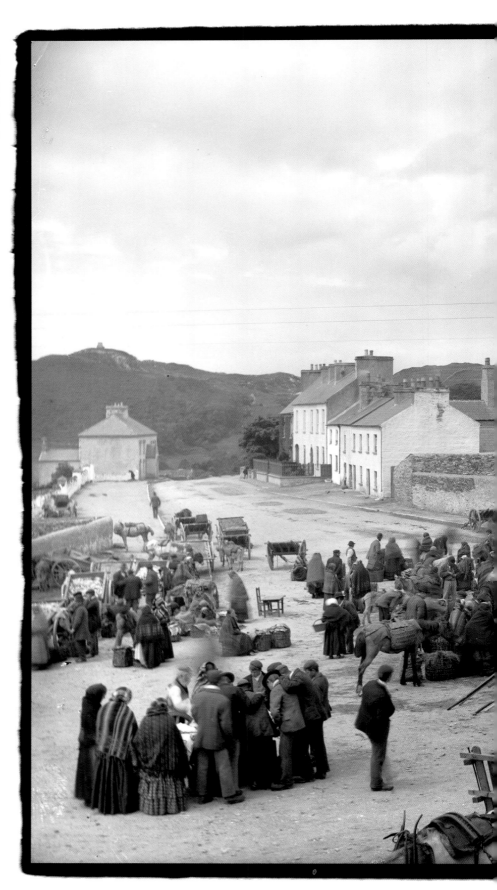

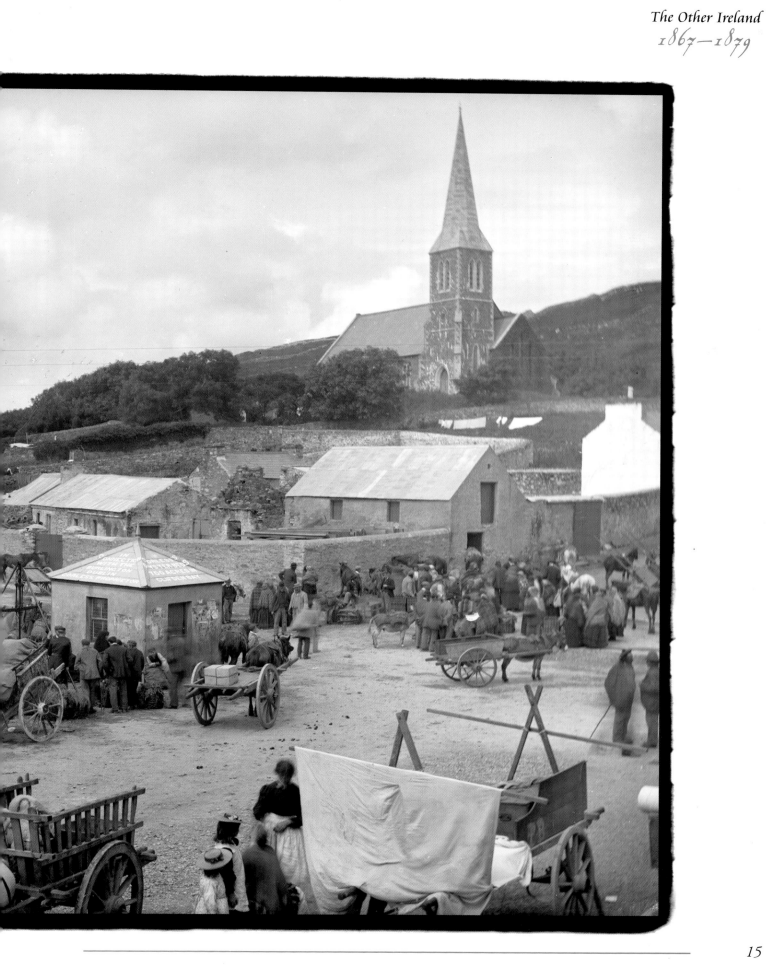

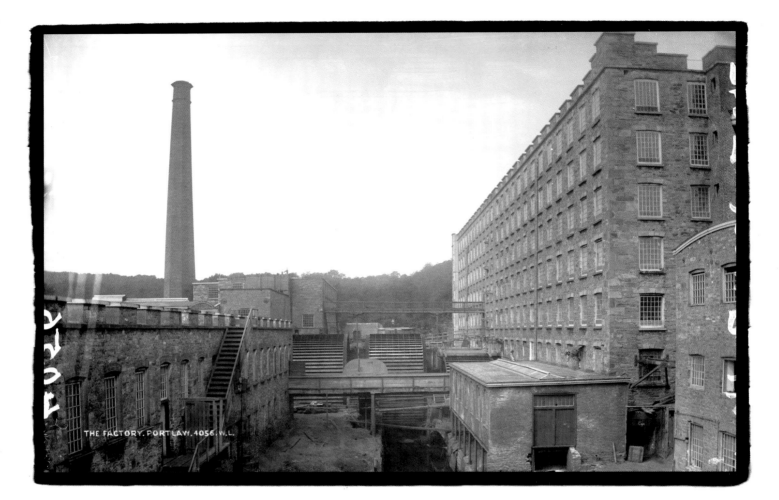

The cotton spinning mill at Portlaw, Co. Waterford, was built in 1826 and developed by the Quaker family of Malcolmson. It was extended in the 1840s and was a major employer throughout the Famine. To the original spinning and weaving process, bleaching, dyeing and printing and some flax spinning were eventually added to this significant and extensive development. Severely affected by the American Civil War in the 1860s, the supply of cheap cotton previously imported from America to Waterford did not resume. Goods had to be transported by canal and by road from Portlaw to the quays at Waterford before export across the globe.

Portlaw, The Factory. LAWRENCE©NLI.

A difficulty, and an exercise in power still vested in landed interests within Ireland, came with the construction of the Limerick to Waterford railway in the late 1840s. Logic suggested it connect with the vast complex at Portlaw. It was, however, required to bypass Portlaw and the textile mill, employing thousands of working people, following objections from the Beresford family. The rail connection at the Hilden Mill in Lisburn, as vast a complex as that at Portlaw, had already been established, and textiles from the Mill in Lisburn were transported by train to the Belfast dock for export.

Railway halt at Hilden Mill: Steam train-car. WELCH©NMNI.

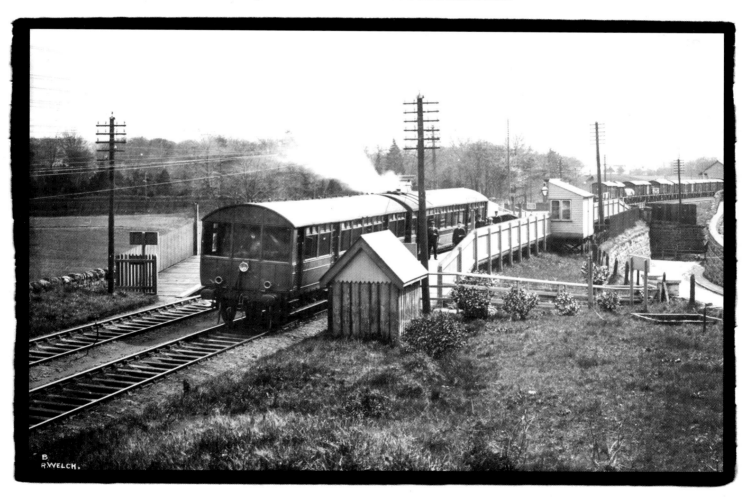

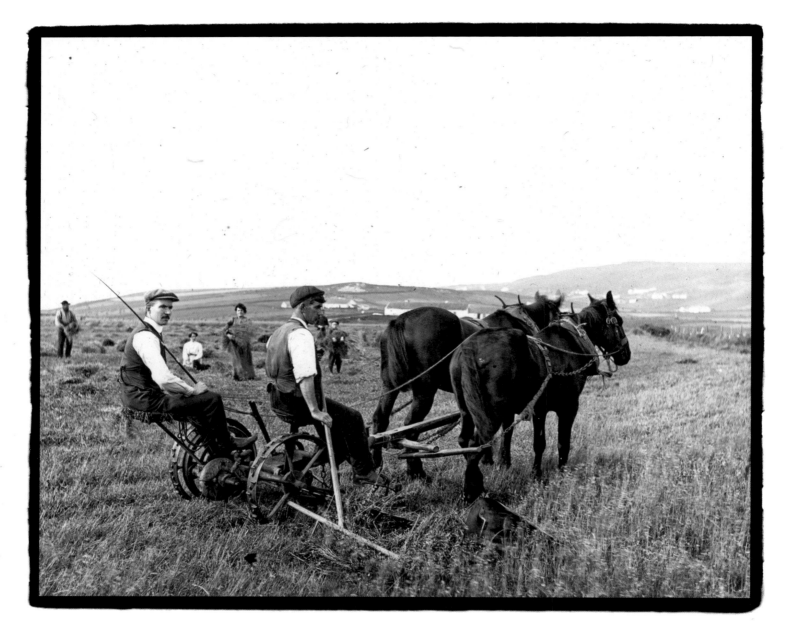

Occupations arising from the development of production in Irish textiles included sowing and generating a flax harvest by agricultural labour; skilled workers in the manufacture of goods, including weavers, spinners and networks of outworkers in both trades; depots for collection and transport workers for distribution. Development also drew on the seasonal and regular semi-skilled and skilled employment generated in the mills. Seasonal labour across Ireland was indicative of the continuing predominance of agriculture and the impact on factory employment of the need to gather the harvest. Agricultural labour is the hiring out by individual workers of their labour to tenant farmers or to major landowners, or the work of women, children and others employed in family-based farming.

Harvest time, Malin Head, Co. Donegal. MASON©NLI.

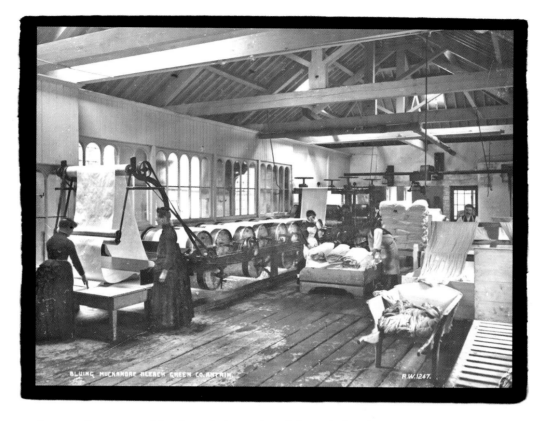

A range of processes arising from the harvesting of the agricultural produce of Ireland generated employment. Many people of working age in Ireland remained single, generally contributing financially to the rural and urban household of their birth. Men, women and many children, across Ireland, England and throughout the Union, were involved in contributing to a family wage, where all members of a family sought paid labour to sustain the life of the household.

Blueing linen at Muckamore, Co. Antrim. WELCH©NMNI.

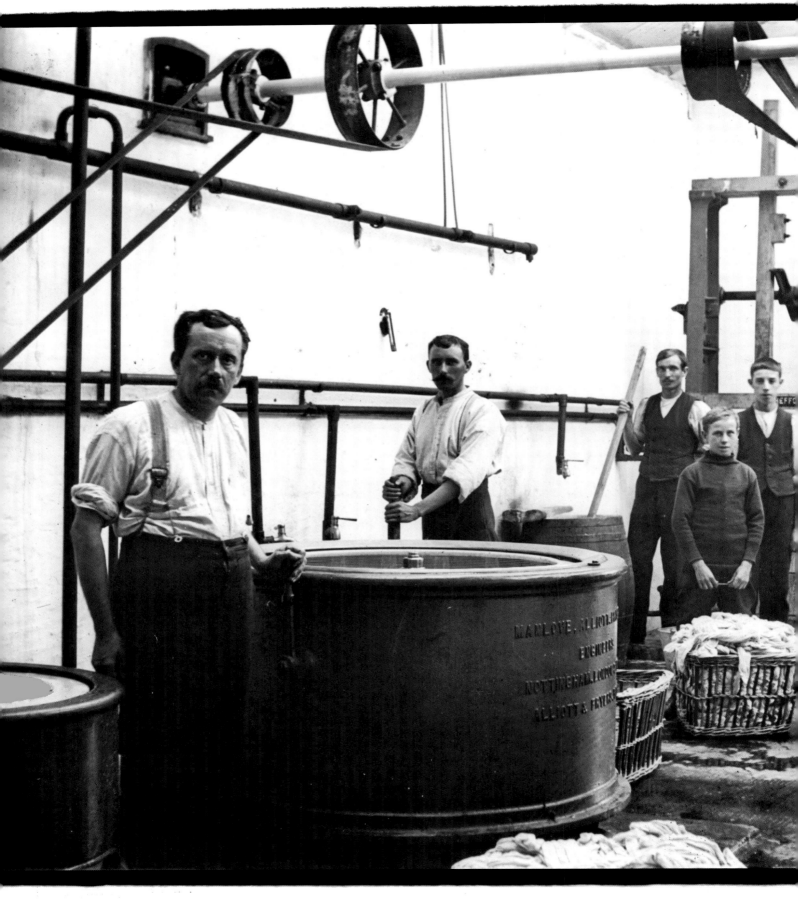

Dyestuffs and dyeing in Ireland is an ancient practice, a cottage industry where 'in the cultivation of the dye-plant men might take a part; but the rest of the process was considered the special work of women' (Joyce, 1908). Alum, a native product, was used in fixing the dye and the harvesting of small shellfish to remove 'the elongated sac containing the purple colouring matter' evokes the same practice of cultivating the quality of the colour purple harvested from the snails of ancient Tyre. The cultivation of flax and the manufacture of clothing increased a consumer appetite for colour, and promoted the industrial development of the process of dyeing.

Dye shed: Vats. Men/boys plus shuttle. MASON©NLI.

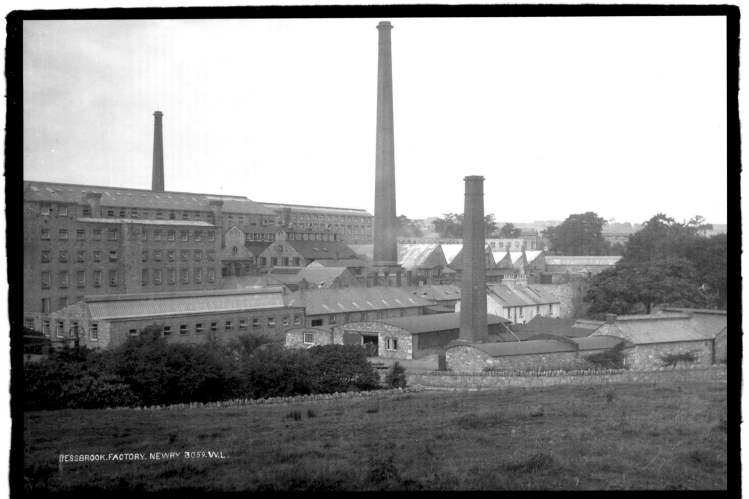

BESSBROOK.FACTORY. NEWRY 3059. W.L.

The owner of the Bessbrook Spinning Company, the Quaker industrialist John Grubb Richardson, established the model village of Bessbrook — with provision for neither public house nor pawnshop. Housing for workers, with 'privies and yards' for many, was a distinctive feature of the development of the model village. (Rynne, 2006) In common with the later development of worker housing at Portlaw Textile Mill in Waterford, owned by the fellow Quaker family of Malcolmson, the plan for the laying out of the streets incorporated the distinctive polyvium, with lines of houses radiating from a central square, and one street leading off towards the factory complex. In the tenor of the age, this represented a thought-out way of achieving a prescribed end.

Bessbrook Spinning Mill. LAWRENCE©NLI.

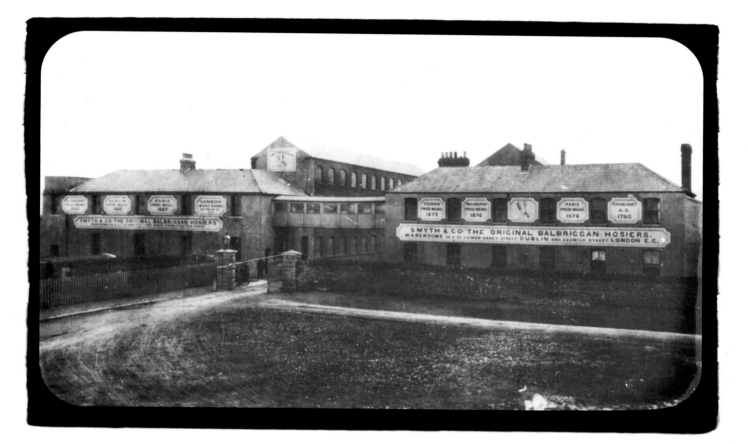

Balbriggan underwear was made by Smyth & Co., Balbriggan, Co. Dublin, Ireland. The company became famous for the production of underwear, to the extent that the name 'Balbriggan' became the noun synonymous with men's underwear in the United States. It is claimed by US historical sources that this arose from the nineteenth-century marketing and sale of the products from the Balbriggan factory through its inclusion in the Sears Catalogue and in the securing of a contract with the US Army.

Smyth & Co., Balbriggan, Hosiers. MASON©NLI.

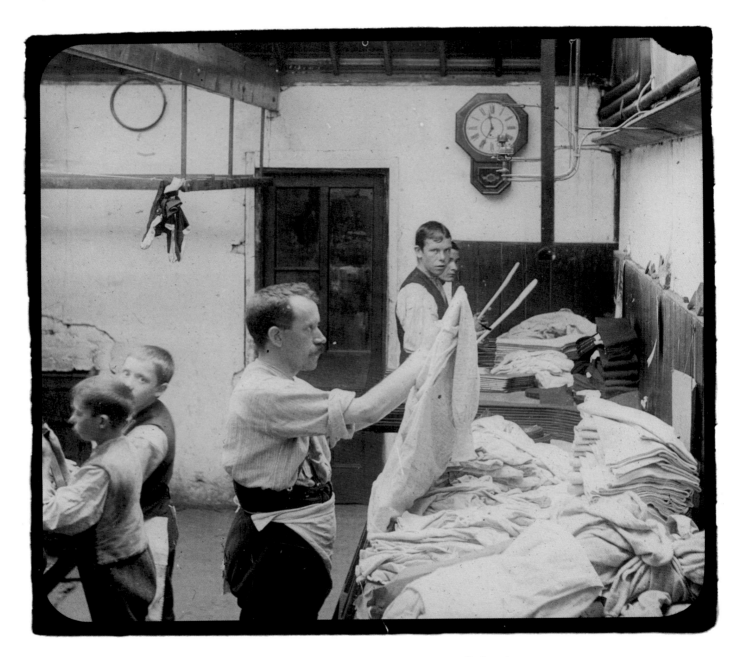

The industry was a training ground for general workers and skilled workers, many of whom began work in the factory at 10 years of age, a practice common throughout the Union.

Men and boys at work, Smyth & Co. trim shop. MASON©NLI.

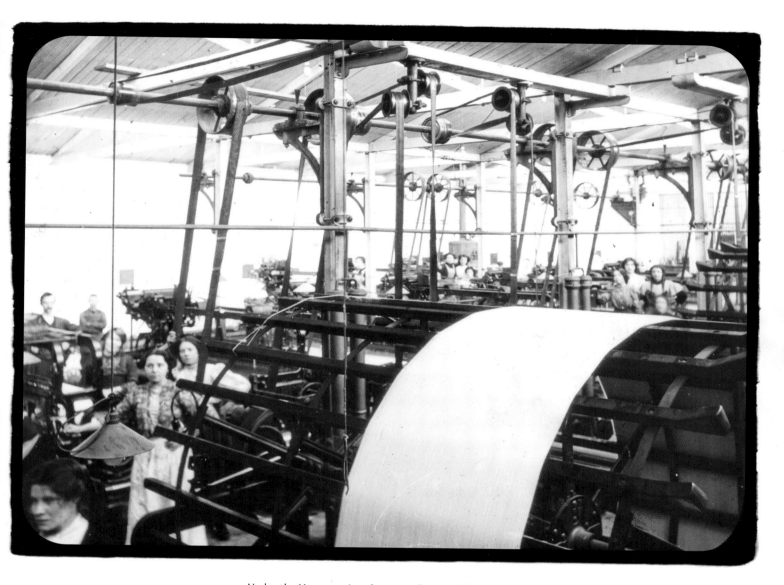

Under the Normans, 'wool came to be one of the country's main exports'. Markets and fairs ensured that trade gravitated out from the town to the countryside, with Ballinasloe and Mullingar 'centres of important wool fairs to which buyers from as far afield as Cork came ... but by the 1770s the trade was already past its peak' (Cullen, 1968). Wool and linen formed the dress of most people, generally produced in the home. Carding, combing and wool-spinning by women and children in cottages was poorly paid and widespread but uncompetitive, despite the price of labour. While the linen industry was rooted in rural Ireland, the woollen industry became town based, with mills in towns such as Enniscorthy and Blarney. By the late nineteenth century there were established industrialised woollen mills in Cork, Galway and Dublin.

City Woollen Mills. MASON©NLI.

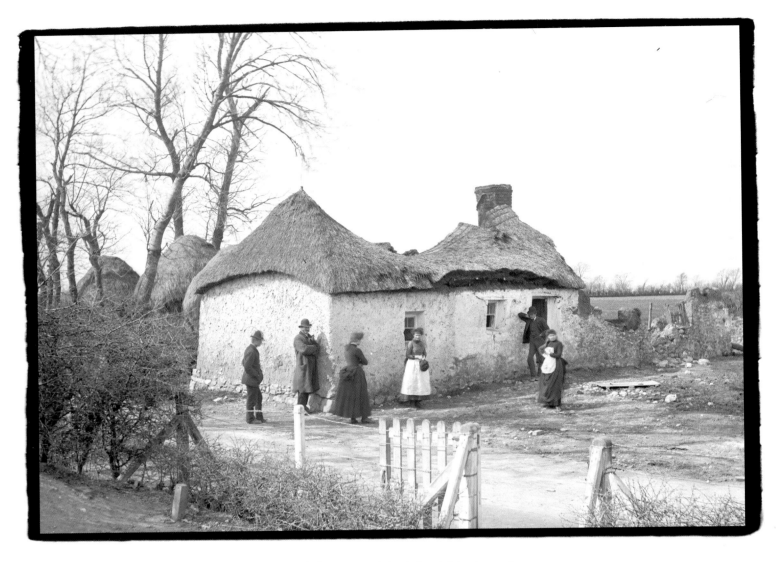

The predominance of textile manufacture, particularly linen, ensured that industrial development remained rooted in a still largely agricultural society, with prosperous landowners, tenant farmers, cottiers and landless agricultural labour a distinctive feature. In the early 1870s over 500 tenant farmers in Ireland — with settled lives and the habit of improving their dwellings and of cultivating the land — were evicted for failure to pay the rent. The evictions fuelled resentment and fostered the climate for a challenge to the dominance of land ownership and related power in Ireland.

Eviction of a household. LAWRENCE©NLI.

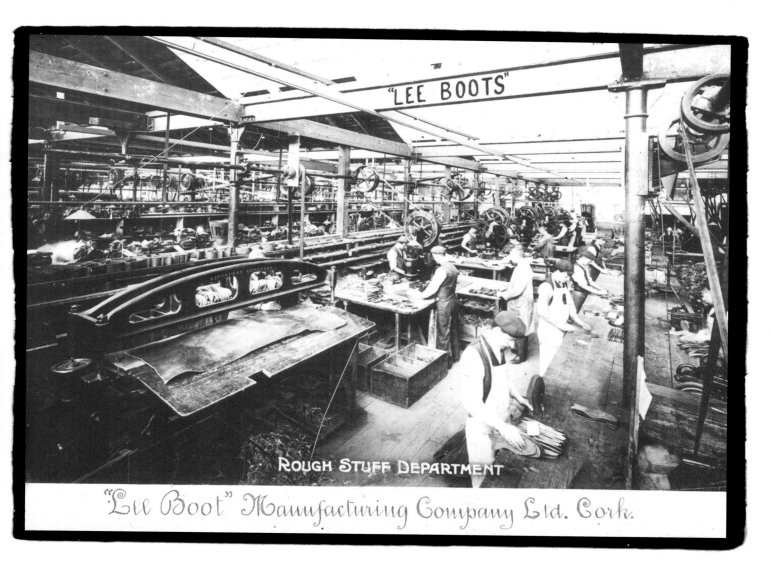

"LEE BOOTS"

ROUGH STUFF DEPARTMENT

"Lee Boot" Manufacturing Company Ltd. Cork.

The Trade Union Act of 1871 signalled an era of legislative support for industrial trade unions. This Act, liberalising legislation sought by trade unions in other parts of the Union, was extended to Ireland. Although few trades in Ireland were organised at this stage, the Act would govern the status of trade unions as they developed.

Lee Boot Rough Stuff Department. MASON©NLI.

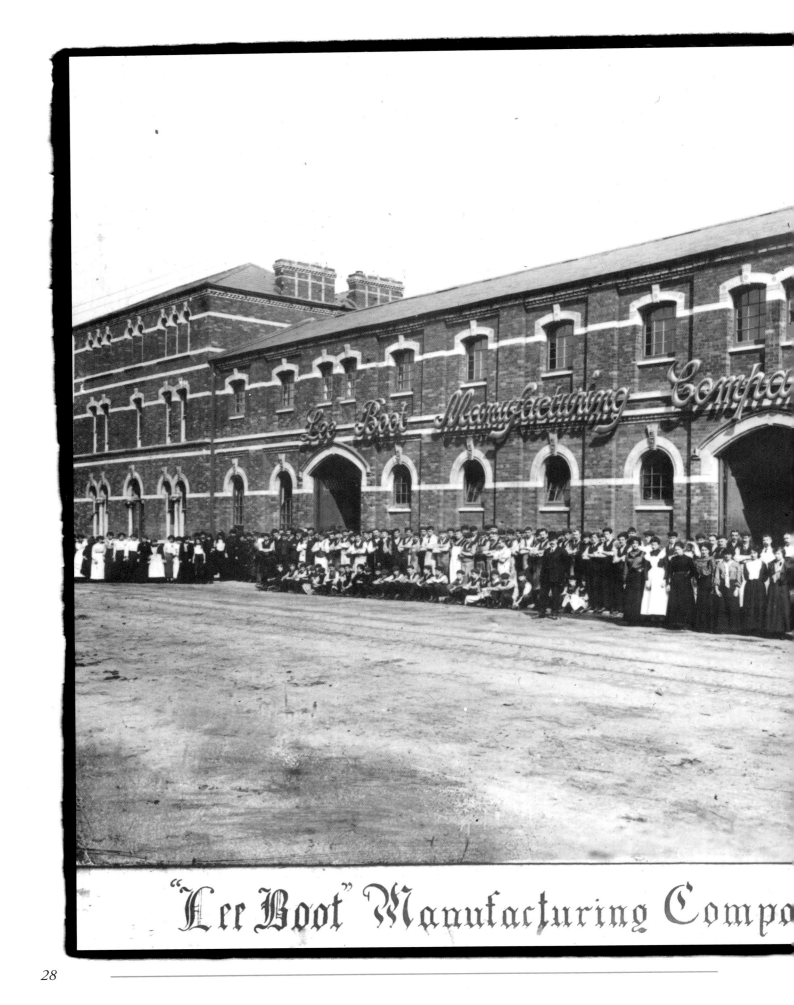

"Lee Boot" Manufacturing Compo

*The scale of production could differ. The Lee factory in Cork
was a major employer of men and women, boys and girls.*

Lee Boot Manufacturing Company Limited, Cork.
MASON©NLI.

Limited. Cork.

The Winstanley shoe factory, bounding Back Lane and Lamb Alley in Dublin's Liberties, was an establishment that provided the boots and shoes for Dublin working people for over a century.

Women and girls at the Winstanley shoe factory, Dublin. MASON©NLI.

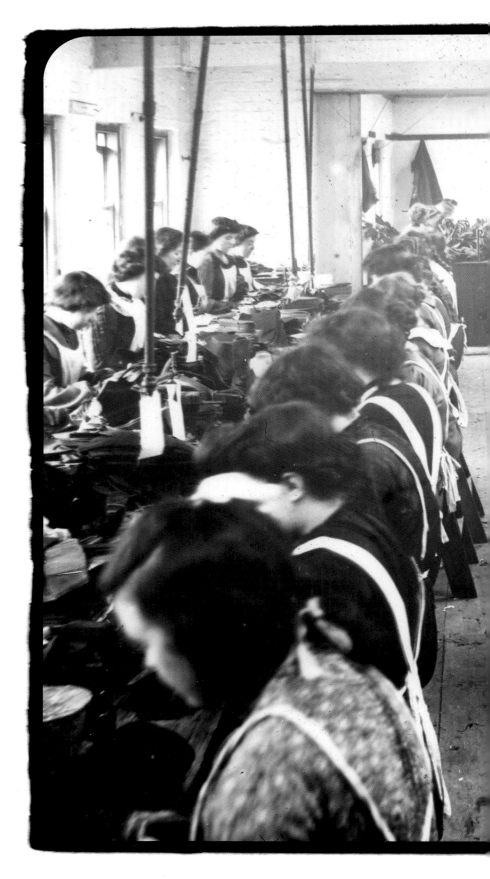

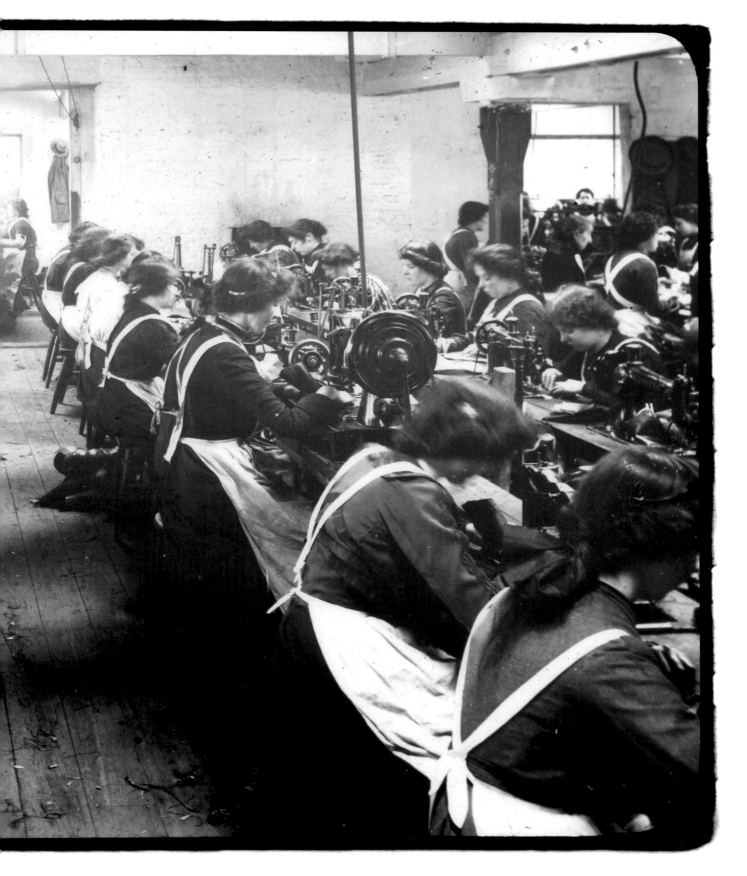

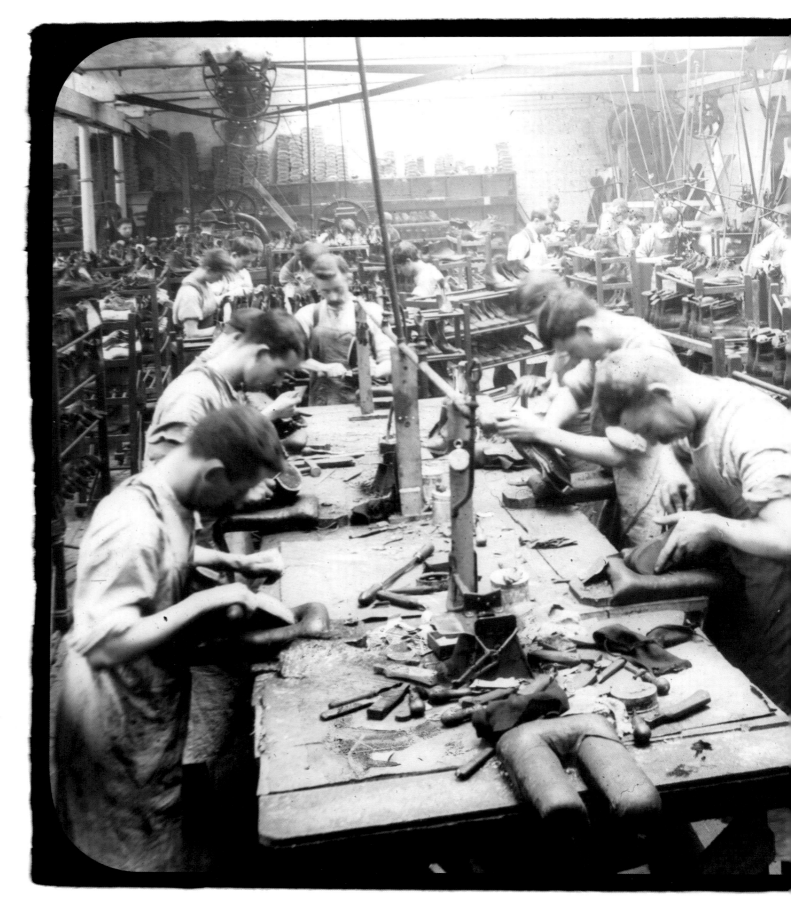

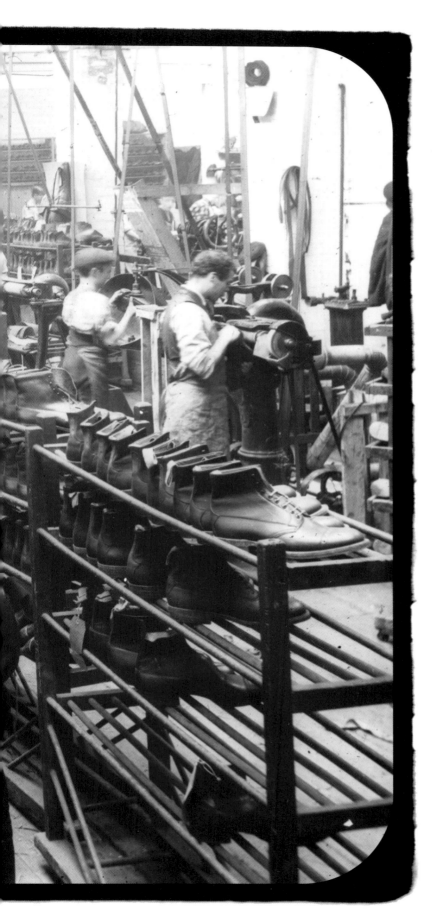

The lives of the entire population of an area were transformed by regular employment in factories.

Men and boys at the Winstanley shoe factory, Dublin.
MASON©NLI.

Boots were big business.

Advertisement for a pair of boots.

The production of items or merchandise for trade generated exports and the growth of the commodity market across the expanding towns and the main cities of the island. The desired — and courted — customers were farmers, agricultural labourers and the industrial working class, the producers, and the consumers, of goods for sale.

Tyler & Sons, Waterford. POOLE©NLI.

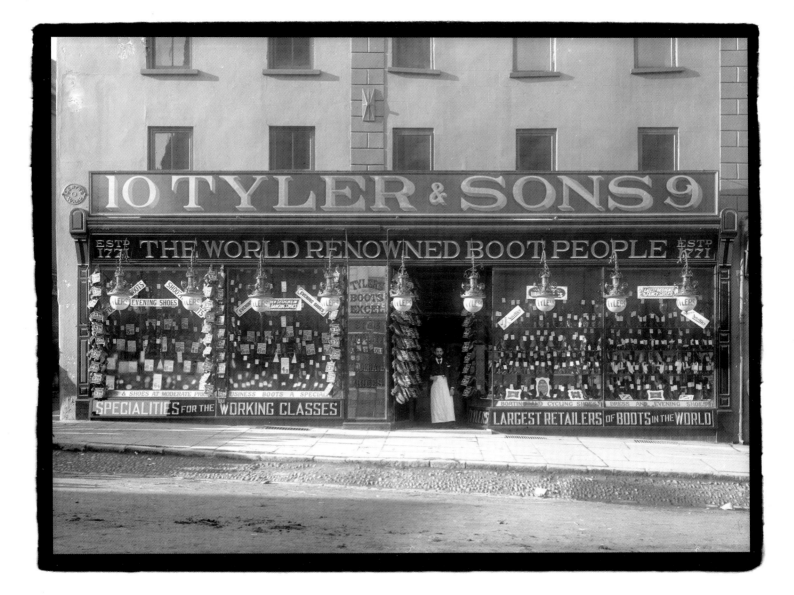

The cording of Irish tobacco was a skill generally acquired by girls and by women. The Goodbody tobacco factory provided significant employment for this stage in the process of production of goods for sale. Tobacco industries in Dublin, Dundalk, Belfast and Tullamore were often small scale, but amalgamations would, by the late nineteenth century, generate employment for thousands of women.

Women at Goodbody's cording tobacco.
MASON©NLI.

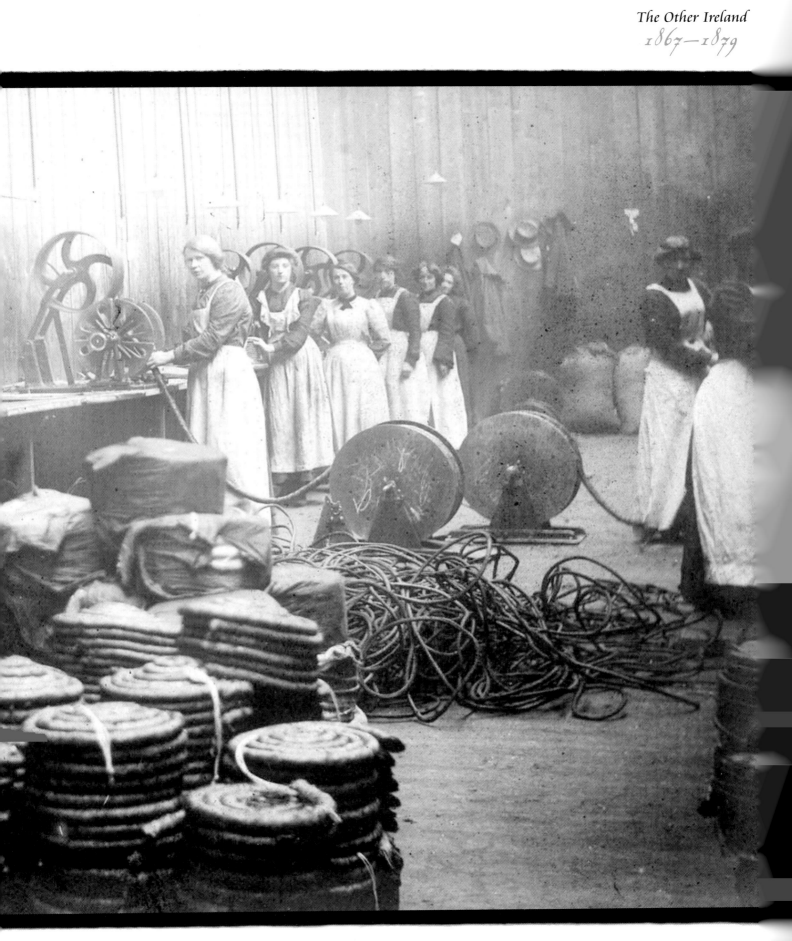

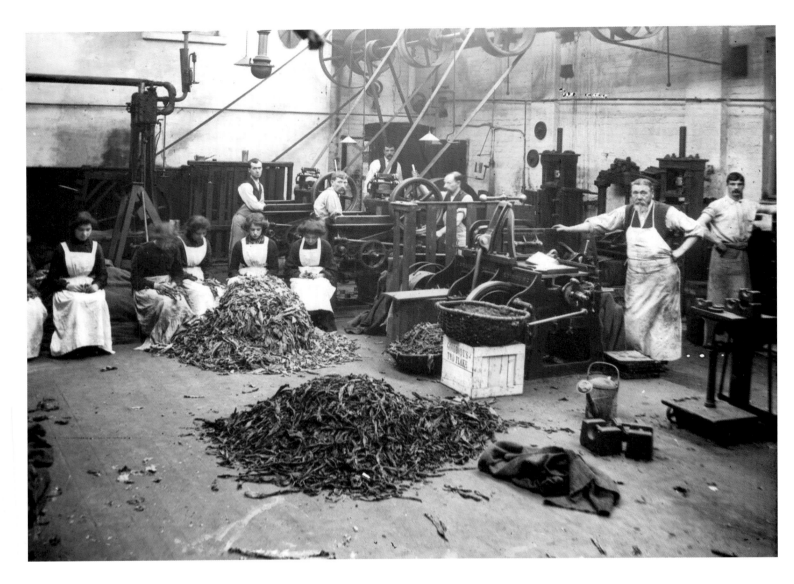

T.P. & R. Goodbody, Quaker brothers, established a tobacco factory in Tullamore in the mid-nineteenth century and employed up to 200 men and young girls. They were producers of a range of marketed blends — tobacco mixtures including 'York River' and 'Golden Shag'.

Men and girls working at Goodbody's of Tullamore. MASON©NLI.

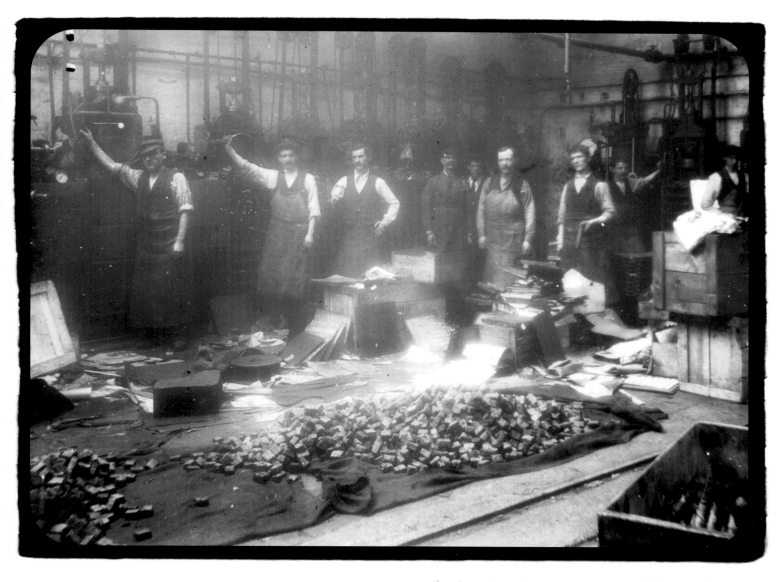

After the cording of tobacco, men would mould the plugs for use in pipes and for rolling into cigarettes. Although in the twentieth century women became the major part of the workforce in companies such as Gallagher's and Imperial Tobacco, men retained their place within this industry.

Men at Goodbody's of Tullamore moulding plugs of tobacco. MASON©NLI.

Friedrich and Heinrich Kapp, from Germany, opened a shop in Dublin in 1855. Ten years later Charles Peterson opened a tobacco outlet in Grafton Street. By 1875 he had designed a pipe and had entered discussions with the Kapp brothers. Together they established Kapp & Peterson, with an agreement secured on the 'Peterson Patented System Smoking Pipe'. By 1890 this pipe, manufactured in Ireland, was an Irish export to England, America and to British colonies across the globe.

Workers at Kapp & Peterson pipe making factory. MASON©NLI.

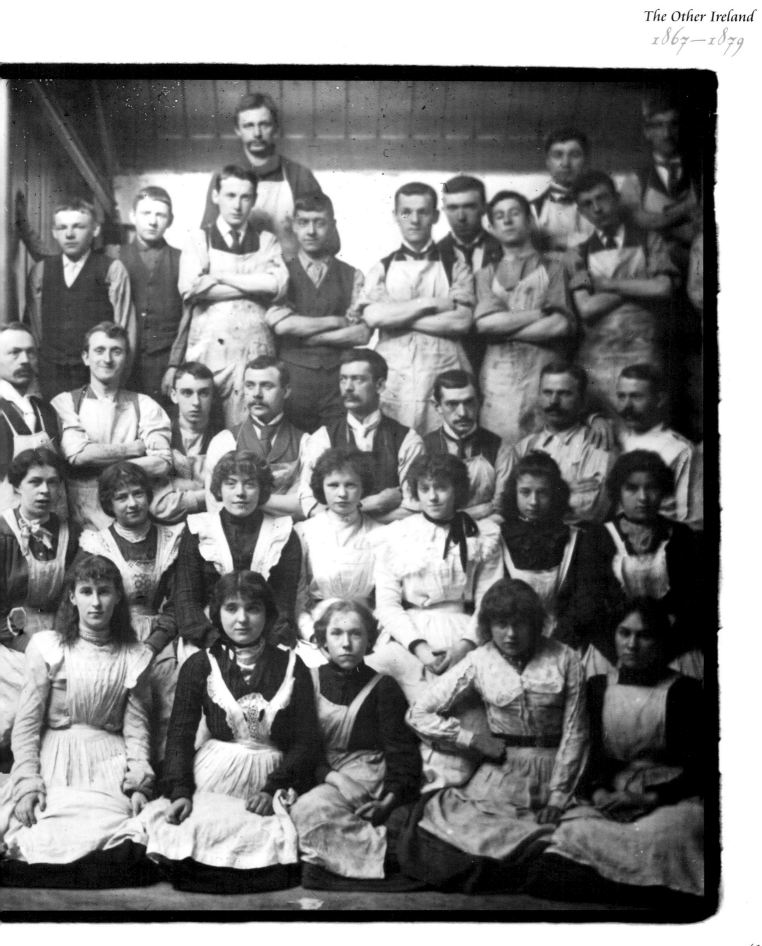

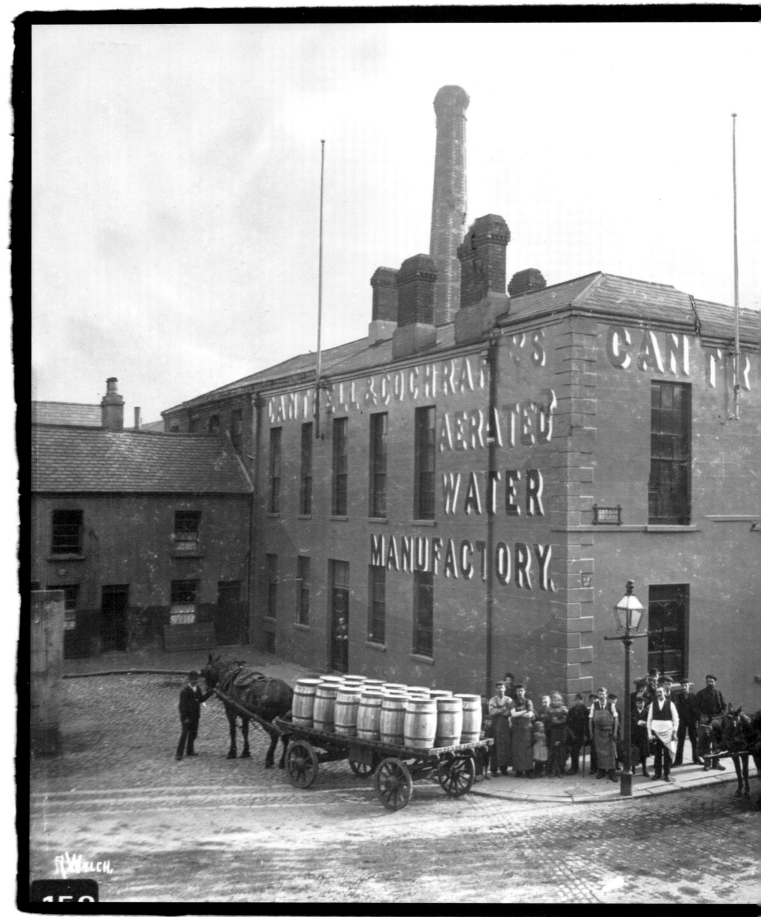

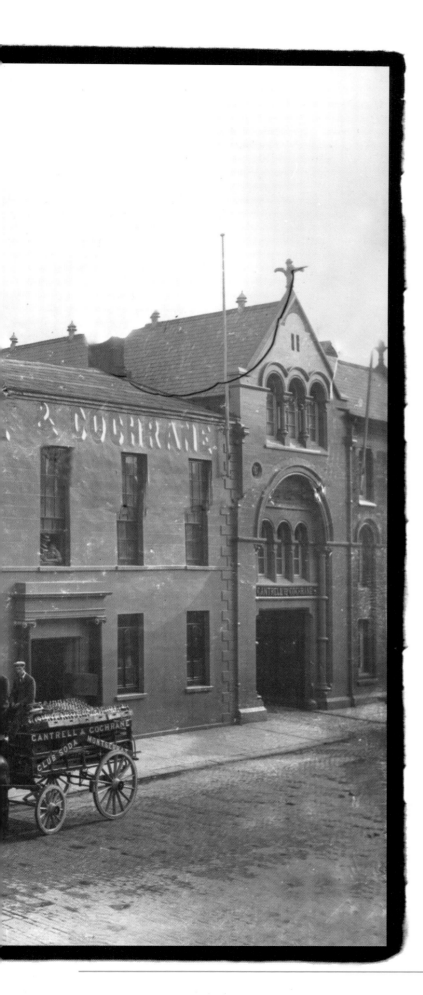

The public engagement with the principles of the Temperance Movement in Ireland, and in England, suggested a ready market for non-alcoholic minerals. Industrial historians date the development of soda water to the 1760s, and to the work of a son of the merchant Augustine Thwaites, who studied medicine at Trinity College, Dublin. Dr Thomas Cantrell opened a shop in Belfast in 1852 and a Dublin factory in 1853 for the manufacture of aerated waters and sweet beverages. In partnership with Alderman Cochrane of Dublin, Cantrell & Cochrane perfected the manufacture of ginger ale and their 'Club' range of products, which was originally commissioned for the Kildare Street Club in Dublin.

Cantrell & Cochrane's Aerated Water Manufactory at Victoria Square, Belfast. WELCH©NMNI.

The production of commodities and the sale of merchandise required the servicing of a retail sector with shop assistants — a feature of small retail outlets in towns across Ireland. The controversial impact of the 'Monster Stores' of the 1850s on the trade and ambitions of the traditional retail trade had, by the 1870s, emerged into the more respectable growth of department stores. Arnott's and Co. on Henry Street, and Switzer, Ferguson & Co. on Grafton Street, amongst others, now cultivated the consumer appetites of the middle-class suburban customer.

Tobin & Sons, Waterford. POOLE©NLI.

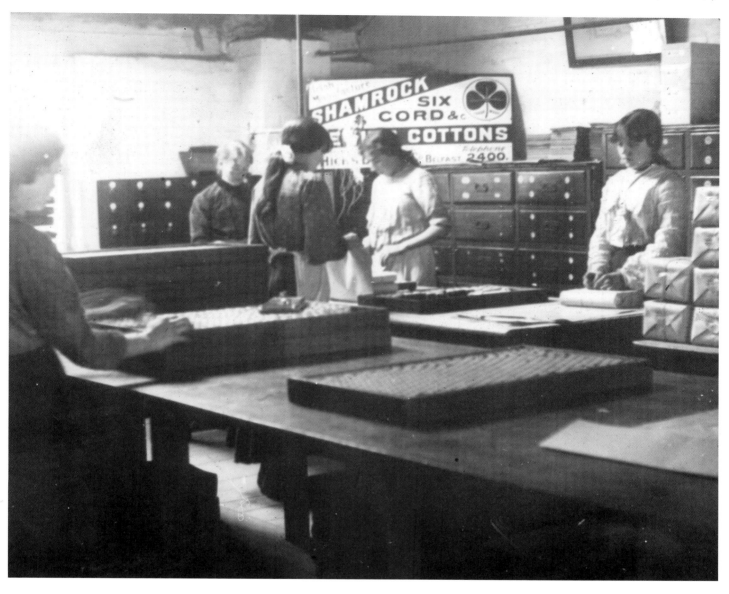

Drapers' assistants, previously an almost exclusively male occupation, were by the early 1870s joined in the department stores by female shop assistants, with the drapers' assistants 'asserting of their rights as a petite bourgeoisie' challenged and changed by public and private ambivalence on concepts of 'masculinity', and on the propriety of male shop assistants encouraging the purchase by women of fine underwear. (Rains, 2010)

Hicks Bullick & Co. of Belfast. Advertisement for Shamrock, Cords and Cottons. MASON©NLI.

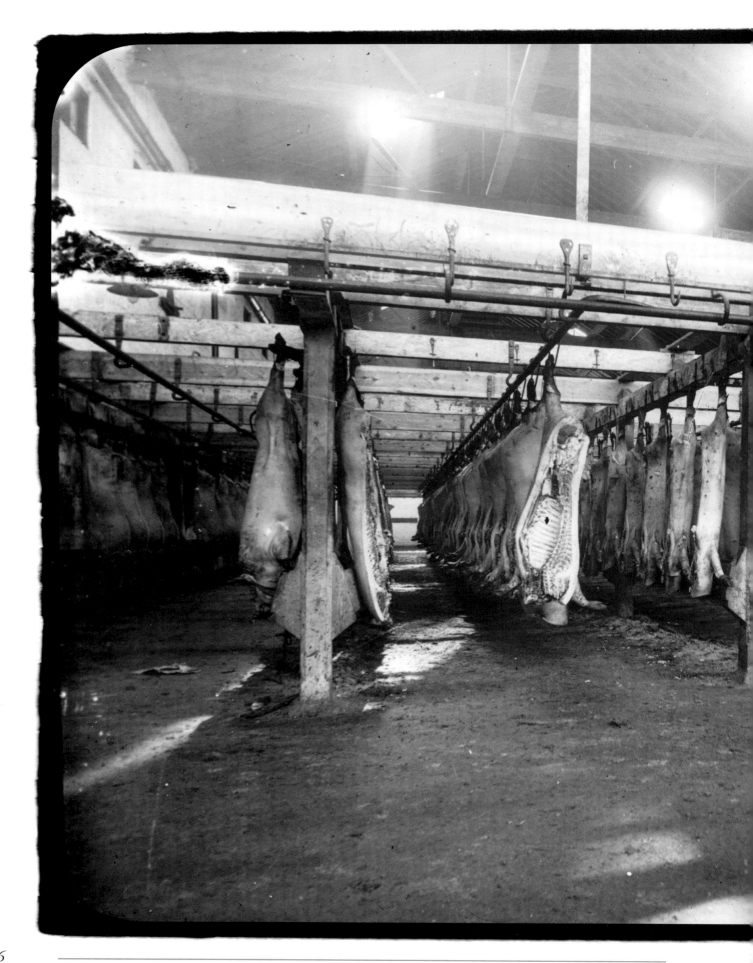

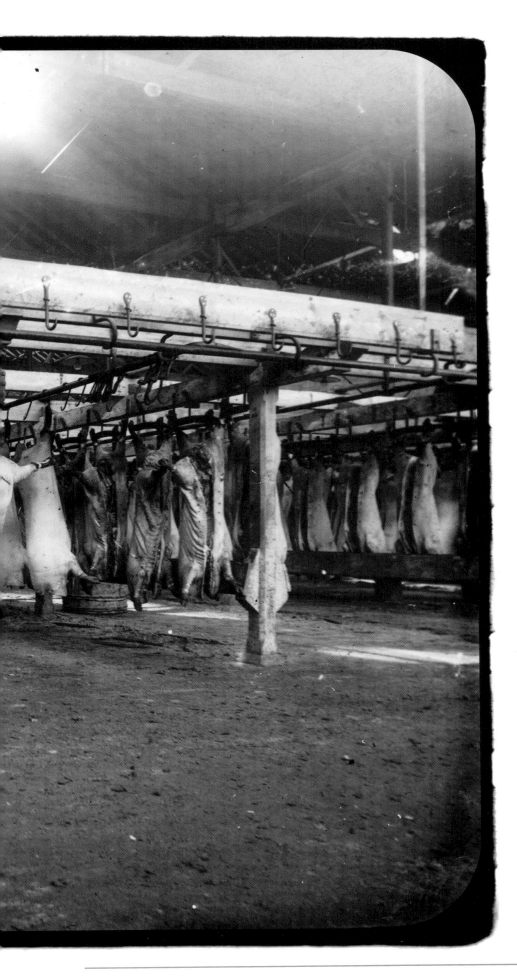

Across Ireland, other industries were generating fortunes, expanding markets, and fuelling the growth of an employed working class. The old race of Irish pigs 'were long snouted, thin-spare, muscular and active'. Giraldus Cambrensis, in the twelfth century, claimed that 'In no part of the world are such vast herds of boars and wild pigs to be found' (Joyce, 1908). In 1871 the number of pigs and female breeding pigs in Ireland peaked at 1,325,000.

Shaw & Sons, Limerick. Pig carcasses hanging in a shed. MASON©NLI.

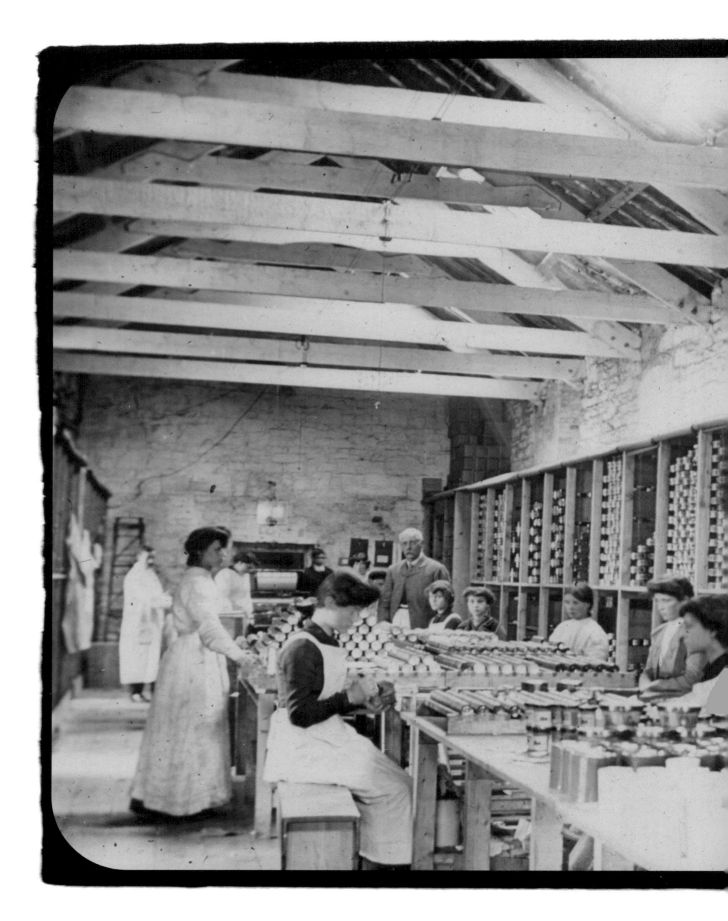

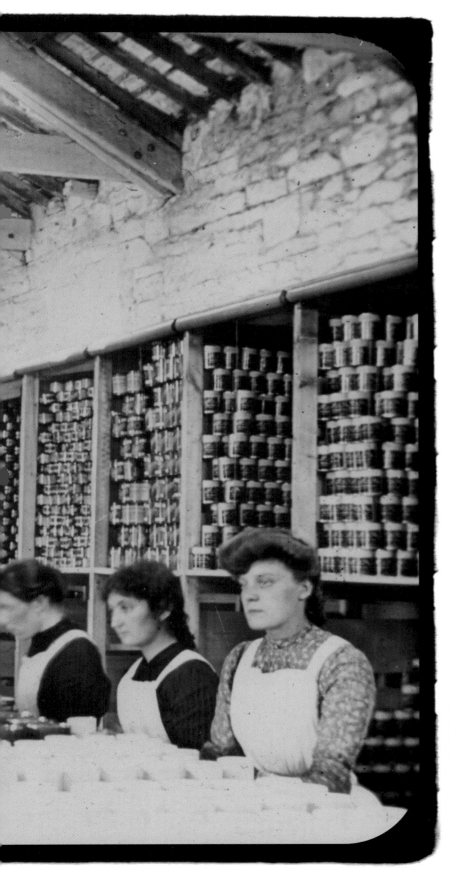

Meat processing was a major employer in Limerick. By the mid-nineteenth century, Limerick's reputation for the provision of bacon and hams 'became the envy of the English speaking world'. Shaw & Sons, owned by the president of the local Home Rule Society, supported autonomy for Ireland, but within the lucrative markets of the British Empire, promoting their offer of a 'Luxury Breakfast ... as supplied to royalty'. Tinned goods travelled well and the labelling of produce served as a critical tool of marketing.

Shaw & Sons, painting and labelling department.
MASON©NLI.

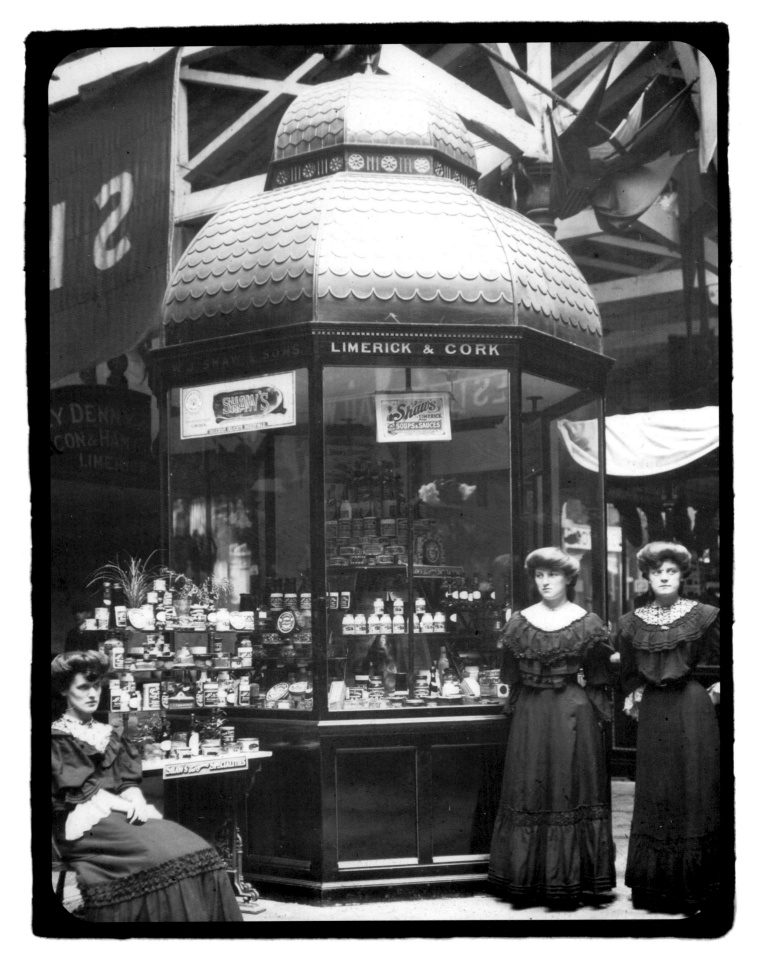

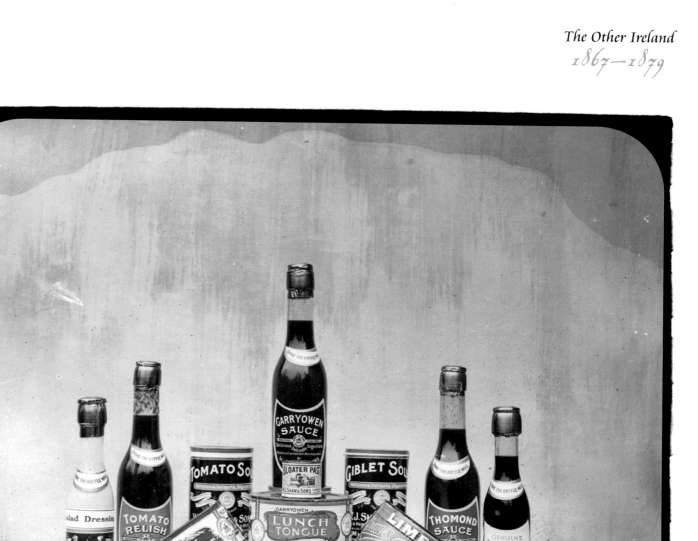

MASON & SONS. Comestibles advertisement.

(left)
The advertising, packaging and marketing of goods for sale and for consumption made Shaw & Sons of Limerick, launched as a family business in 1831, a prime exemplar of the development of Irish produce fit for export across an empire. By the 1880s William Shaw was producing Garryowen Sauce, Limerick Brawn, Giblet Soup and Potted Tongue, canned, bottled and stamped with stylish authority.

Three young women grace the Shaw Kiosk, advertising distribution of Shaw's comestibles. MASON©NLI.

The production of goods and the growth of retail outlets in towns across Ireland generated employment, with a growth in population and demand from the original population and also from substantial military garrisons built in Kilkenny and in towns of a similar scale. The garrison was a dominating feature of most medium-sized towns across the island.

High Street, Kilkenny. LAWRENCE©NLI.

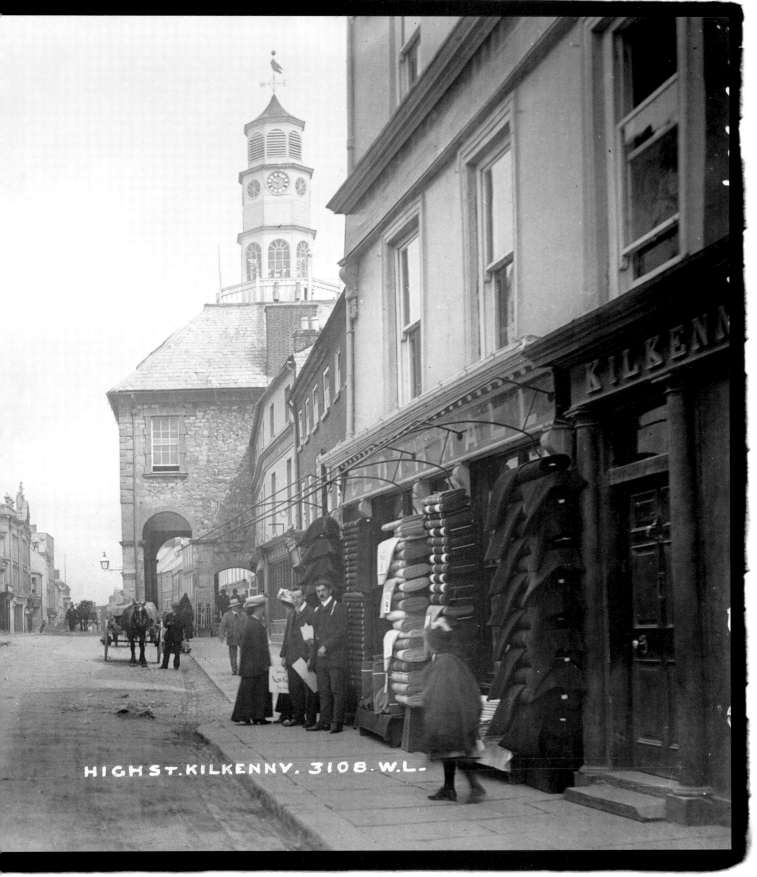

HIGH ST. KILKENNY. 3108. W.L.

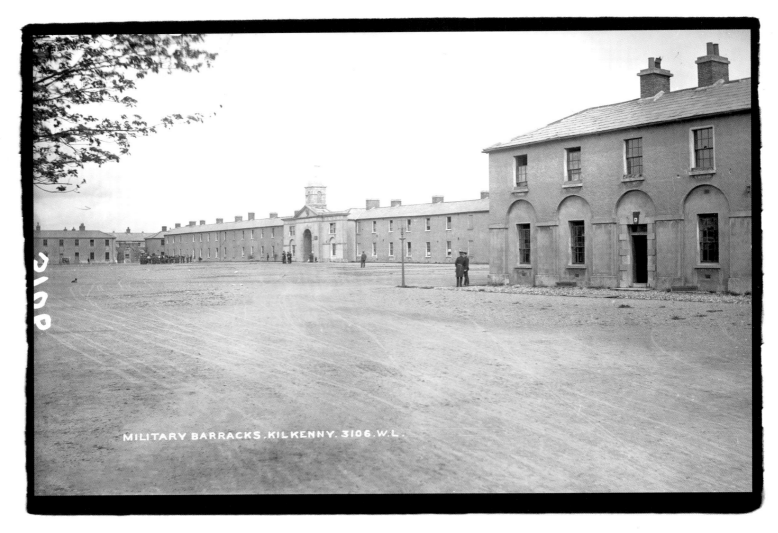

MILITARY BARRACKS.KILKENNY. 3106.W.L.

All army and navy personnel, Irish and English, were incorporated in the Registrar General of Ireland's publication of the 'vital statistics on the population of Ireland' from 1866 onwards. Defined by one of eight social class categories, the Professional and Independent Class including Military Officers; and the General Service Class, including Army and Police. In effect, a garrison town in Ireland had its social complexion transformed by the building and maintaining of a garrison.

Military Barracks, Kilkenny. LAWRENCE©NLI.

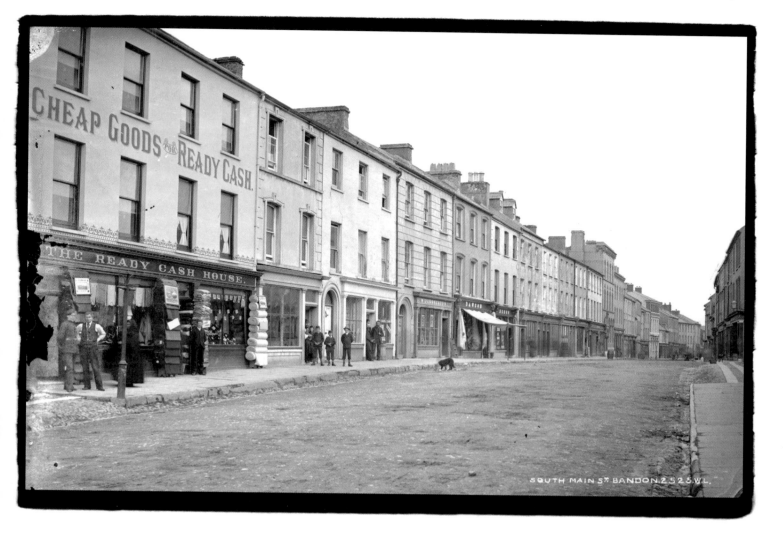

By 1879 agrarian disaffection was widespread and the maintaining of order in Ireland was assisted through Victorian institutions of public control, including the engagement of army garrisons and police barracks. Many tenant farmers, employed industrial workers and the emerging middle class had enjoyed moderate prosperity, but in the late 1870s were severely affected by three years of poor harvests and the threat of global depression. Many were given credit by banks and by small shopkeepers.

South Main Street, Bandon, Co. Cork. 'Ready Cash'.
LAWRENCE©NLI.

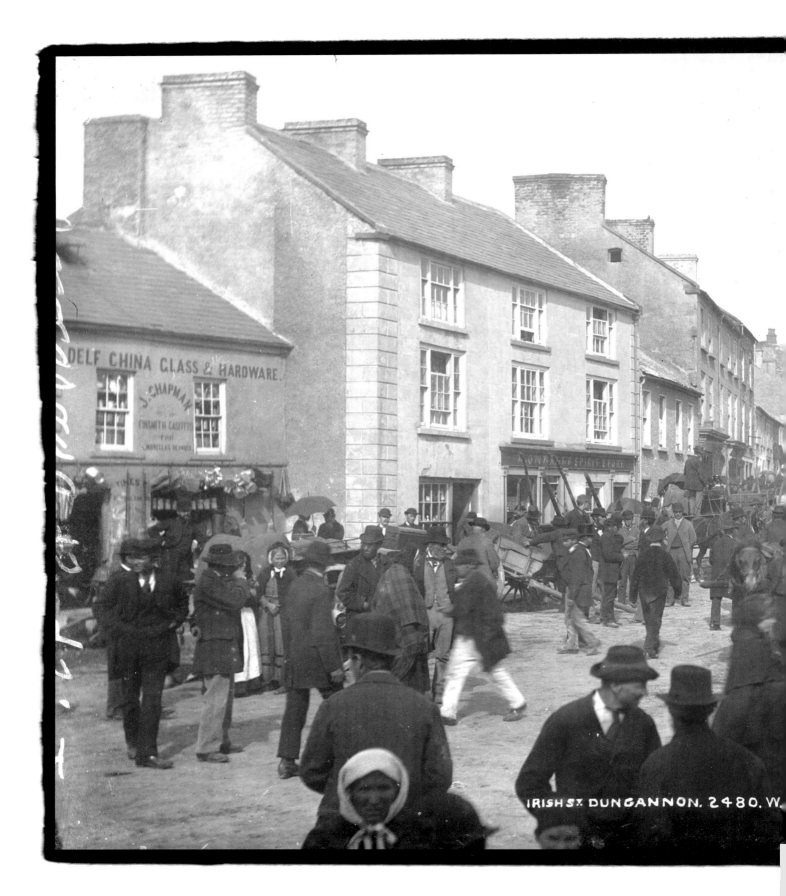

Although the retail outlet was commonplace in towns, most people continued to trade goods for exchange in the public spaces of towns and villages. The tradition of fairs and markets in Ireland is ancient, with the Fair of Carmen a formal gathering involving games, horse and chariot racing long held in Lughnasad, and at Monasteranenagh where there was a fair before there was a monastery. Within the Union, annual and seasonal dates for fairs and markets with smallholders, horse traders, outworkers for cloth depots, farmers and food producers are agreed through the office of local legal authorities.

Irish street, market day, Dungannon, Co. Tyrone. LAWRENCE©NLI.

An 1868 Order of the House of Commons had confirmed Ireland as an intensively policed society. Arising from the Order, information on the extent of policing is apparent: in Leinster, the condition of 161 Police Barracks were 'Satisfactory', and 113 were deemed to be in 'Defective Conditions'; in Connaught, 148 'Satisfactory' and 83 'Defective'; and in Munster, 119 were 'Satisfactory', and 257 'Defective'. With increasing agrarian agitation, associated with evictions and the withholding of rents, the capacity for the exercise of social control through the alerting of an extensive network of police barracks became active. Irish Catholics held over 70 per cent of positions in the Irish police force, but no rank of leadership.

Police Barracks, South Kilkenny. POOLE©NLI.

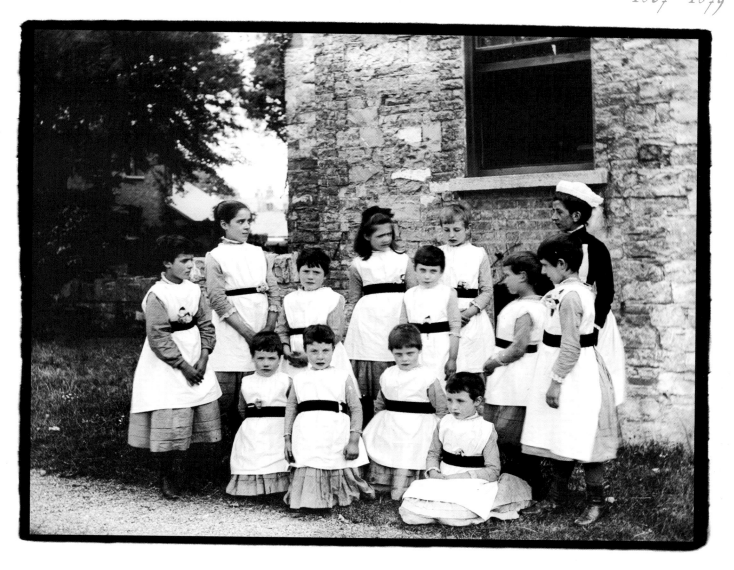

Victorian ideals of institutional reform were reflected in the 1872 Reformatory and Industrial Schools Act (Ireland). This refined a method of reform and instruction of the young, common to both England and Ireland. In 1871 Ireland had 32 such schools, and England/Wales had 91. The combined populations of England/Wales was more than four times the population of Ireland in 1871, and there appears to have been a built-in expectation that reform and instruction across Ireland was planned on an assumption of greater need. Miss Hilda Martindale, in later reflections on her role as an 'English Inspector in Ireland', noted: 'In addition to the genuine trade laundries there were, scattered throughout Ireland, hidden away in some of the most beautiful land, well-equipped laundries carried on in convents and staffed by the inmates many of whom were there for the education, training or reformation' (Martindale, 1905).

Matron and girls at a small denominational institution. ©RSAI.

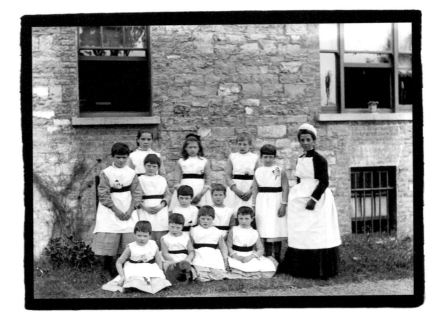

The Report from the Inspector of Industrial Schools (1872) recorded that in Ireland, the schools for Roman Catholics contained 2,105 children, of whom 1,596 were girls and 509 were boys; the schools for Protestants contained 149 children, 53 boys and 96 girls.

Matron and girls at a small denominational institution. ©RSAI.

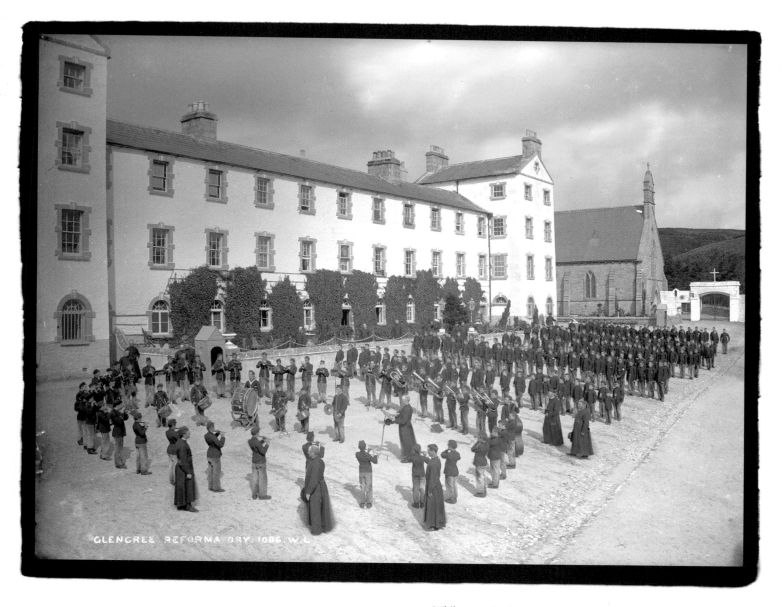

GLENCREE REFORMATORY. 1086. W.L.

While many institutions were organised under the auspices of the main denominations, competition for licences to manage such institutions across the Union, with access to government funding to do so, was significant. The scale of management in the reform and training of those in custody was an enterprise of some magnitude.

The Catholic Reformatory, Glencree, Co. Wicklow.
LAWRENCE©NLI.

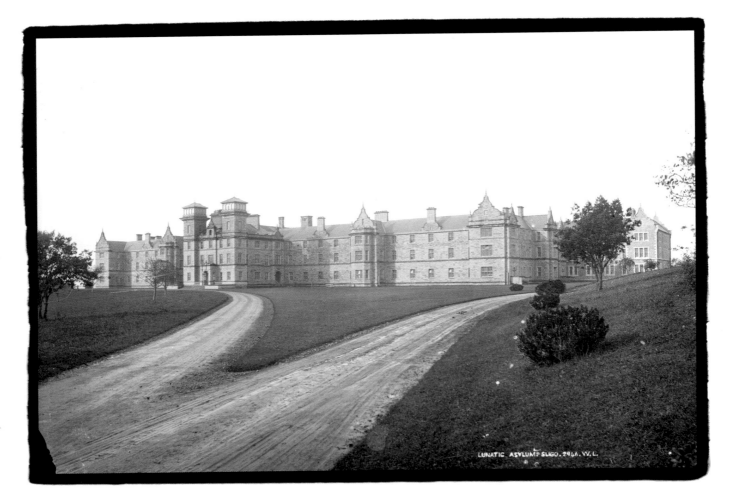

LUNATIC ASYLUM SLIGO. 2946. W. L.

The Asylum was a significant feature of, and provided regular employment in, many towns of Ireland. The Report on the District, Criminal, and Private Lunatic Asylums in Ireland (1870) records a total of 2,692 persons admitted, of whom three were boys under 10 years old. Of both sexes, 224 were between 10–20 years; 818 were between 20–30 years. The oldest of these, aged between 25–30, could have had memories of the Famine and the decimation of all that they had known before.

The Lunatic Asylum, Co. Sligo. LAWRENCE©NLI.

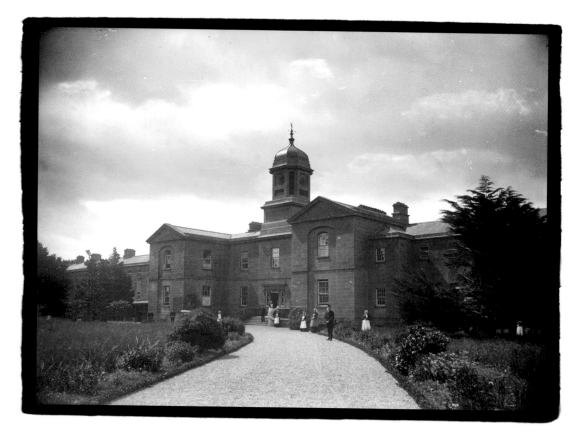

*The remaining 1,647 persons, aged between 30–70 years and older, would
have lived through the Famine years of 1845, 46 and 47. Making modest
assumptions on the impact of such rapid and traumatic social disruption on
a people, some perhaps had sought — and had been given — asylum. Others
are more problematic. Of the direct admission of 2,307 persons to asylums in
1869, 1,180 were defined as 'alleged dangerous lunatics'. Mortality in 1870
'was under 9 per cent, the deaths amounting to 556 on a daily average of
6,258.5 inmates'. Definitions of the categories of 'madness' may be culturally
specific, and to be Irish-speaking, in a context where the authorities were less
likely to be so, could have served to compound the difficulty.*

The entrance to an asylum. POOLE©NLI.

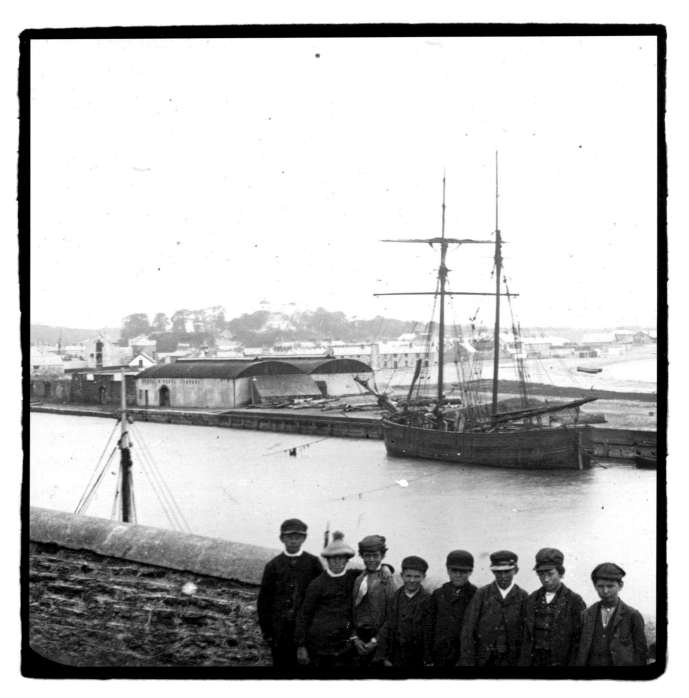

Throughout the nineteenth century, travel between the islands of Britain and Ireland had increased. Sail remained a major form of transport. The Returns of the Emigration Commissioners 1860–1870 recorded that 819,903 Irish people have sailed first from Irish ports, and then onward to the British colonies from ports in the United Kingdom.

Wicklow Quay, ship with sails, and onlookers. MASON©NLI.

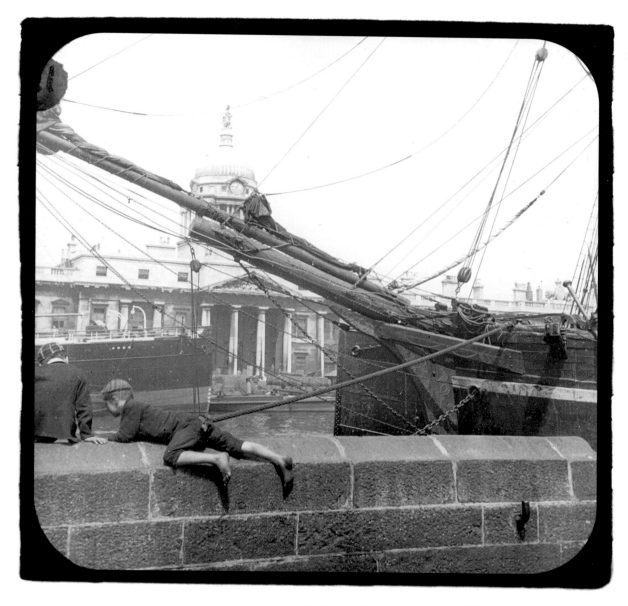

The Custom House, focus in Ireland of the power and prosperity of an empire at the height of its power. The Royal Exchange was housed close by. The architectural edifice of the life of the capital of the sister nation of the Union was impressive. The industrial investment in Ireland reaped dividends during the 1870s, and in many respects would continue to do so. The question of land security became paramount and in 1879 the Land League was established, a 'formidable national network which co-ordinates local tenant associations', and an emerging threat to the assuredness of the established order.

A ship docks at George's Quay, opposite the Custom House, Dublin. Ephraim MacDowell Cosgrave©RSAI.

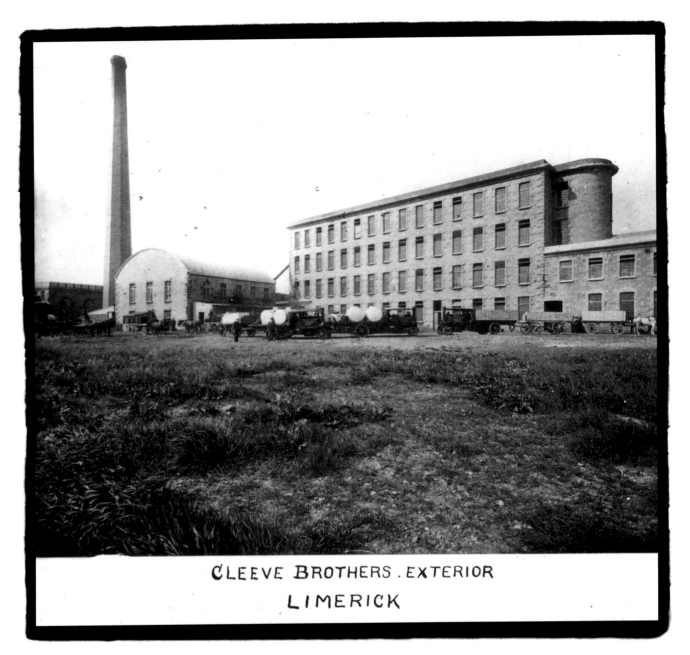

CLEEVE BROTHERS . EXTERIOR
LIMERICK

In 1879 Quebec-born Thomas Cleeve purchased a revolutionary milk separator at the Clonmel Show, thus facilitating competition with industries outside Ireland. Cleeve subsequently established the Condensed Milk Company of Ireland, manufacturing dairy products such as condensed milk, butter, cheese and confectionery. By the close of the century, Cleeve's was the largest business of its type in the Union of Great Britain and Ireland, with 2,000 employees on its payroll and 3,000 Munster farmers supplying its raw material. Exports extended across the British Empire.

Cleeves Brothers, Limerick. Exterior of the factory. MASON©NLI.

1880—1891

1880 The linking of the land question with nationalism delays the spread of the Land League to Ulster, with misgivings voiced by Home Rulers and others on maintaining the security of the Union. By autumn 1880, at a meeting at Saintfield, Co. Down, Michael Davitt addresses tenants, both Protestant and Catholic. Landed estates, the source of wealth and of subsequent power throughout the Union, are served notice that rent, until the question of land ownership is settled, will be 'in arrears'.

The Orange Order is revived. It will oppose the rise of the Land League, resist the call for a Home Rule Parliament based in Dublin and uphold the Protestant Constitution. 2,110 evictions are authorised. Agrarian agitation and membership of the Land League increase.

Gladstone, in opposition, introduces a 'Protection of Persons & Property Bill'. The tactic of Boycotting emerges in Mayo; the Orange Order dispatches 50 labourers from Cavan and Monaghan to save Captain Boycott's harvest. An election is called, and Gladstone is returned as Prime Minister.

1881 The Belfast Trade Council is founded. Industry has transformed the northern landscape, now dominated by textiles, shipbuilding and engineering. Harland and Wolff launch 14,000 tons of shipping, accounting for 20 per cent of all such output of the Union. The linen industry is a bedrock of secure employment and the generating of industrial wealth: a cornerstone in the emergence of an aspiring merchant class. Tensions within the population of Ireland are amplified as sectarianism is reflected in privileged employment practices, and in closed access to craftwork. The Catholic population, accounting for 29 per cent of the population of Belfast, remain occupied primarily as

general labour and in unskilled trades. The 1871 Irish Census has recorded that 815,000 women of Ireland are occupied in paid work and 80 per cent of all occupations have female employees.

Gladstone's second Land Act is passed: a significant reform of land law grants the '3Fs' to tenants: 'free sale', 'a fair rent', 'fixity of tenure'. Many tenants find the Act unsatisfactory. Parnell denounces the Act, frames a No Rent Manifesto and calls for a boycott of the proposed Land Court. He is arrested under the Coercion Act and Gladstone declares the Land League illegal. With Parnell in Kilmainham Jail, his sister Anna forms the Ladies Land League. A Royal Commission on Prisons in Ireland, published in 1884, would note that, 'since the transfer of the local prisons to the General Prisons Board in 1878, Ireland has passed through a period of political and social ferment, which made a rapid and large addition to the prison population of prisoners whose special treatment imposed exceptional labour and responsibility upon all in charge of them'.

1882 Agrarian violence, a theatre of resistance with agrarian insurgent, the mythical 'Captain Moonlight' centre stage, leaves burnings, cattle-maiming and threatening letters in its wake. The level of disorder is 'unprecedented', with '3,433 episodes of agrarian violence recorded'.

Gladstone and Parnell agree a political compromise in the 'Kilmainham Treaty' and Parnell, together with 'suspects' in police custody, will be released. Under the terms of the Arrears Act, 1882, tenants will pay one-third of the rent they owe, the government will pay one-third and landlords will forgo the remaining one-third now due. 100,000 of the poorest tenants feel the benefit, but thousands more are excluded. Parnell, party

to the 'Kilmainham Treaty', advises testing the Act in the courts, and returns to the House of Commons seeking to maintain unity of purpose amongst membership of the League, itself with increasingly diverse aspirations.

On 6 May, in the Phoenix Park, Dublin, Lord Frederick Cavendish, Chief Secretary for Ireland, and his Permanent Under-Secretary, Thomas Burke, are assassinated by the 'Invincibles'. Parnell offers to resign as MP, an offer rejected by Gladstone.

The murders prompt a tactical withdrawal by the Irish Republican Brotherhood from involvement in the Land League and in the Home Rule movement, and a strategic commitment by Parnell to constitutional politics. The Land League is replaced by the Irish National League, with Parnell seeking legislative provision for Home Rule within the Union, for land purchase rights and for an extension of the electoral franchise. A Third Land Act reinforces security of tenure, but 5,201 men, women and children are evicted before the year ends.

1883 Political upheaval and agrarian unrest could, and did, proceed alongside more pedestrian developments in life in Ireland. Amongst the elite, Dublin social life remains dominated by those on the Vice-Regal invitation list, and those who wish to be so. The suburban population of Dublin, serviced since the mid-1850s by rail to the city from Kingstown, Dundrum and Rathfarnham, or by horse-drawn omnibus from Clontarf and Drumcondra, is recorded at 95,450. Of these many, as in other centres including Belfast, Limerick, Waterford and Cork, are in employment. Professional men 'began to converge upon the city centre … arriving at both Westland Row and Harcourt Street stations …' (Rains, 2010); in shops, women had begun to take their place as shop assistants alongside drapers' assistants;

boot-makers, biscuit-makers, printers and breweries provide skilled and semi-skilled manufacture of goods; textile mills are in the Boyne Valley, in Drogheda, on the Quays in Dublin and elsewhere. The industrialisation and development of skills are unlike those of Belfast, but a degree of moderate prosperity is evident in consumer habits and employment extends beyond domestic service and agricultural labour. Transport in Dublin, previously controlled by multiple companies, is consolidated under the ownership of the Dublin United Tramways Company, owned by men who retain a financial interest in drawing custom to their city-based department stores. By 1885, the Dublin United Tramways Company is carrying 18.3 million passengers a year. (Rains, 2010)

1884 The Representation of the People Act enlarges the Irish electorate of 224,000 to more than 738,000. All men within the Union who own or rent property, from a cottage to a single room, are given the vote.

Culturally and socially, there is increasing resistance to a perceived adoption of English manners and mores within the townlands and parishes of nationalist Ireland. The army garrisons at play favour cricket, rugby and soccer, and become the focus for contested visions on and off the playing grounds. In 1884 the newly enfranchised men of Ireland form the Gaelic Athletic Association, championing Gaelic football and hurling.

The field of play is muddied by profound inequality across Ireland. The purchase of land has improved security for those with land, but 9,800 tenement houses fester in Dublin. Similar pockets exist elsewhere, but industrial employment has brought an improvement in housing in Belfast, Waterford and Limerick. Employment in mills and factories and 'monster stores' has

fostered migration from the towns. Decline continues across all four provinces as emigration, economic stagnation and the attraction of an urban wage in Belfast, Dublin, Manchester or Lowell proves irresistible for many. Immigration, from England, Wales, Scotland and 'Abroad' continues to rise steadily.

1885 In the General Election, an enhanced franchise delivers four-fifths of Irish representation to the Irish Parliamentary Party (formerly the Nationalist Party) which has emerged from the suppressed Land League; Gladstone moves to bring in a Home Rule Bill. The Ashbourne Land Act, a land purchase scheme, is passed: in Ulster 25,000 tenant farmers buy their farms.

Home Rule, as envisaged by Parnell and Gladstone, will give autonomous government for Ireland within the Empire. Both favour tenant ownership and a conserving of the status quo in different hands; Michael Davitt, a former Lancashire mill worker, proposes the more radical ambition: the nationalisation of the land of Ireland.

In Ulster, four Home Rule candidates are returned, but Down, Armagh, Derry and Tyrone are divided, with support for the Union in the most populous areas: in effect, 'the division of Ulster divided Ireland' (de Paor, 1970).

Supported by Parnell, Gladstone — whose own party is split on Home Rule — announces a conversion to the Home Rule cause. The Liberal Party splits. Maverick Conservative Lord Randolph Churchill speaks in Belfast in opposition to Home Rule, introducing the phrase, and the act of playing, 'the Orange Card' for the first time. Rising tensions in Belfast lead to a renewal of severe sectarian rioting. A dock labourer, a Catholic, foments dispute with another dock labourer, a Protestant, the former threatening the latter that Home Rule will

deliver no work in Belfast for 'the Orange sort'.

From small sparks, a fire rages. Battle ensues — between shipyard worker and labourer, between Orange crowds and the Catholic rank and file of the RIC. Sectarian riots spread as 'staves, hammers, iron bars, axes and rivets', the tools of a trade, are turned to order as weapons of war.

1886 Gladstone's Home Rule Bill is rejected by the House of Commons. The news is greeted in Ulster by Orange parades — a movement which had been banned from the British Army in 1835, and in decline since, is led into revival by a working class, as matters secular turn savage sectarian. Across the rural landscape, the Plan of Campaign of agrarian agitation is launched to persuade tenants on estates to join forces to suggest landowners reduce rents, and if failing to reach agreement, to withhold payment. Parnell attempts to impede this, and a compromise is reached to curtail it, as the Catholic Church condemns both the Plan of Campaign and Boycotting.

Gladstone resigns and Lord Salisbury becomes Conservative Prime Minister. He appoints a Royal Commission on Sectarian Riots in Belfast, published in 1886, and appoints Lord Castlereagh, 34 years of age and Marquess of Londonderry, to become Lord Lieutenant of Ireland, the first member of an Irish family to hold the office. A major landlord and colliery owner, he agrees to hold the post for three years.

The Catholic Church hierarchy endorses Home Rule, and Parnell backs denominational education. The endorsement of Home Rule by the Catholic Church alienates Protestant support for the concept. The Home Rulers call also for tariffs on goods, an attempt to protect and develop industry in Dublin and elsewhere. Differences within the industrial

development of Belfast and Dublin are pronounced and are linked to discriminatory employment practices, government orders and an increasingly diverse experience of life within the Union.

An 'Irish Loyal and Patriotic Union' pamphlet, published in Dublin, argues that, in the event of Home Rule, the persecution of Protestants would be unlikely, although the property of all churches might be confiscated. The main fear, argues the author Edward Saunderson, is taxation and the proposed protection of Irish industry by the imposition of tariffs. Such measures, rather than hurting England, 'could bring about the ruination of Ireland'. An end to agitation in the country and hard work, Saunderson believes, would be far more beneficial to fledgling Irish industries.

1887 Irish industries, fledgling or otherwise, are subject to the constraints and advantages of a global market established under the flag of the British Empire. Ireland is part of that empire, but as with Scotland, is statistically distinct. In 1831 Ireland's imports from the United Kingdom and foreign and colonial merchandise were valued at £1,549,030. Total exports from Ireland were worth £609,250. By 1864 the official value of imports to Ireland from the United Kingdom and foreign and colonial merchandise, at £5,198,496, have significantly increased. Total exports from Ireland were given an official value of £284,302.

Imports, as with exports, were subject to fluctuations — the depression of the late 1870s and the early 1880s had ended; by 1887 an improvement in rural life was measurable — 'All the evidence points to rural improvement after 1887. Bank deposits ... rose in every year up to 1900. Total deposits and cash balances of the joint stock banks ... had risen ... from £24 million in 1870 to £33 million in 1890 ...' (Cullen, 1968).

Cheaply imported goods increased the wealth of the merchant class and offered the consumer a range of goods from the mundane to the exotic. For those with estates, journeys to the Land Courts and a reduction in rents from their tenants, however, result in a reduction of critical disposable income, although rarely of accumulated wealth. For colonial life, and considerable leisure, on the varied estates of Ireland, 'the twin foundations of landed power — economic control and a deeply deferential society — were being shaken in the north-east as elsewhere in Ireland' (Purdue, 2009).

Arthur Balfour is appointed Chief Secretary for Ireland and introduces the Perpetual Crimes Act, 1887 (or Coercion Act), aimed at the prevention of boycotting, intimidation and unlawful assembly in Ireland, in effect to control the leaders of the Plan of Campaign. Three deaths in riots at Mitchelstown in September earn him the nickname 'Bloody' Balfour.

1888 Horace Plunkett, from one of the oldest Old English families of the Pale and a graduate of Oxford University, publishes an article on Co-operative Stores for Ireland.

1889 A further Home Rule Bill is discussed by Gladstone and Parnell. Other forms of development for rural, and urban, Ireland are under discussion in other less formal quarters. Plunkett starts a co-operative store in Doneraile, Co. Cork.

Many children are attending school and those who are required to work also — if unevenly — experience an improvement in their conditions of labour. The Portlaw textile factory, owned and developed by the Malcolmson Quaker family, has agreed terms whereby children spend a portion of their working week at a school within the extensive grounds of the mill complex, work

for the remainder of the week, and are paid for a full working week.

1889 Balfour legislates for railways and for technical instruction. The first railway in Ireland, the Dublin to Kingstown line, had been open since 1834, and by the 1850s over 840 miles of track have been laid. In the 1890s the Westport Line will be seen as one of the 'Balfour Lines' in acknowledgment of the provision of 'State assistance for the construction of narrow gauge lines to disadvantaged areas'.

As part of an industrial move from habits of paternalism to the new efficiency of professional management, Pierce's of Wexford attempt to bring in unskilled workers to replace fitters and turners. From a skilled, non-organised workforce, this managerial move prompts the foundation of the Wexford Fitters and Turners Society, indicative of the industrial unrest now convulsing the workplaces of Britain and Ireland.

The social and political landscape of Ireland is shaken, utterly, by scandal: Charles Stewart Parnell is named as co-respondent in the case for divorce brought by William O'Shea v. Kitty O'Shea.

1890 At court in 1890, the facts of the Parnell case are not disputed. Gladstone withdraws his support from Parnell and from Home Rule as long as Parnell remains leader of the Irish Parliamentary Party, itself splintered for and against a publicly disgraced and pilloried leader. The movement for Home Rule will survive. Parnell will not.

The building of a National Library of Ireland, opened in 1890, is a repository for books, manuscripts and maps, and a jewel in the crown of an empire. The National Literary Society, founded by Douglas Hyde, W.B. Yeats and others, acknowledges the literature of Ireland. The National Museum for Ireland establishes a place of safety for collections of the ancient artifacts of a complex society, complemented by donations from Irish and other sources, often the intellectual dividend of amateur enthusiasts who combine the leisure of their class with a scholarly passion to list, to label and to organise.

More prosaically, the first Irish-published ladies' magazine, *Lady of the House*, goes on sale, suggesting 'the want has long been felt of a high class Irish Journal solely devoted to Fashion, the Beautifying of the Home and Person, Scientific Cookery, the Toilet … and the hundred-and-one matters which interest educated women …' (Rains, 2010).

1891 Balfour introduces the 1891 Land Act. Land purchase will be the cornerstone of Conservative Party policy in Ireland, with £33 million allocated for the purpose. This economic intervention is seen as pivotal in a Conservative policy to undermine the call for Home Rule, to secure the Union, to conserve the status quo. The Congested Districts Board is established to improve husbandry and fishing, to transfer holdings to tenants and to establish local industries. A Department of Agriculture and Technical Instruction had earlier been given powers to assist industries in specific locations. A Board of Works was empowered 'to lend money for land improvement, for farm buildings, for labourers' cottages and for working-class dwellings in the towns; it arbitrated between railway companies and landowners for the acquisition of land needed for track … constructed piers and harbours all around the coast … becoming in the process an essential part of the fabric of the Irish administration' (Lyons, 1970).

Charles Stewart Parnell dies. His funeral in Dublin is attended by 200,000.

The state of the Union

Since its foundation in 1866, the Office of the Registrar General, Union of Great Britain & Ireland, has defined the population of Ireland by reference to class. This aid to governance — the record of the vital statistics of a population — serves the administration of both Union and Empire. Many aspects of Irish life are 'measured', from density of household, to occupation, to the collection of detailed meteorological records; from reports on the Housing of the Working Class to questions on Water, Disease and Drainage.

On the inhabitants of Ireland, the numbers of 'Irish Born', those born in other countries of the Union and those 'Born Abroad', is also measured. There has been a decline in the population of those born in Ireland since the Census of 1871, and a consistent increase in the population of those born outside the island of Ireland.

The struggle for land rights overlays and obscures class tensions where the majority of the population remain landless or on unproductive holdings. Defined by religious denomination, the concept of the Protestant Nation embraces all Protestant classes, from labour to the lords. Authoritative figures note that the 'income per head [of the Protestant minority between 1851 and 1901] … was generally triple, sometimes quadruple, that of the Catholic majority' (Lyons, 1971). These figures obscure wealth differentials within denominational categories: one peopled by skilled industrial workers, tenant farmers and lords of the realm; the other, by the evicted, by urban slum dwellers, by prosperous merchants and Catholic tradesmen and professionals.

Tensions between classes and across denominations are not new. Sectarianism and riots in Belfast had prompted a Commission of Inquiry in 1857. The significance of denominational difference had been challenged, at least in theory, by the establishment of the Kildare Place Society in 1811, to establish and manage non-denominational schools in Ireland. By 1831 the government had proposed a national school system of elementary education in an attempt to consolidate a disparate and denominational network of schools across Ireland. (Bartlett, 2010)

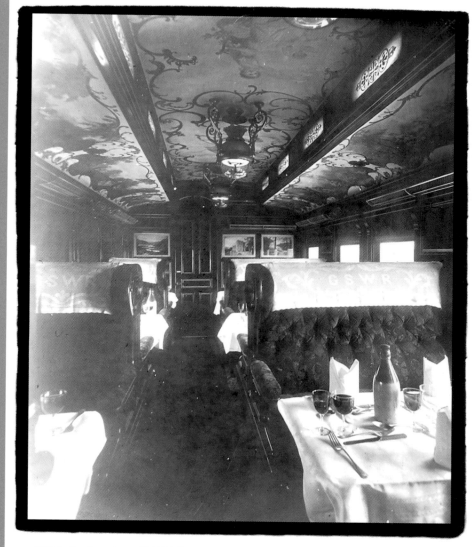

GNR Ireland carriage. MASON©NLI.

The long-established skills of shipwrights and boat-builders were harnessed to the development of modern technologies to address the economics of traditional industries. In fishing, Tyrrell's of Arklow was a family business and the equipping of fishing vessels with motors made more ambitious journeys feasible. The first such vessel with a motor built within the Union was built by Tyrrell's of Arklow.

Tyrrell's of Arklow, with motor fishing boat. MASON©NLI.

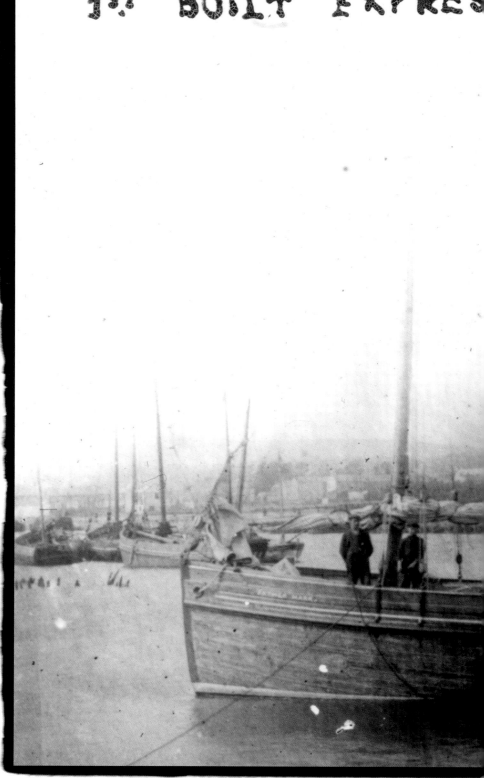

MOTOR FISHING BOA
1ST BUILT EXPRES

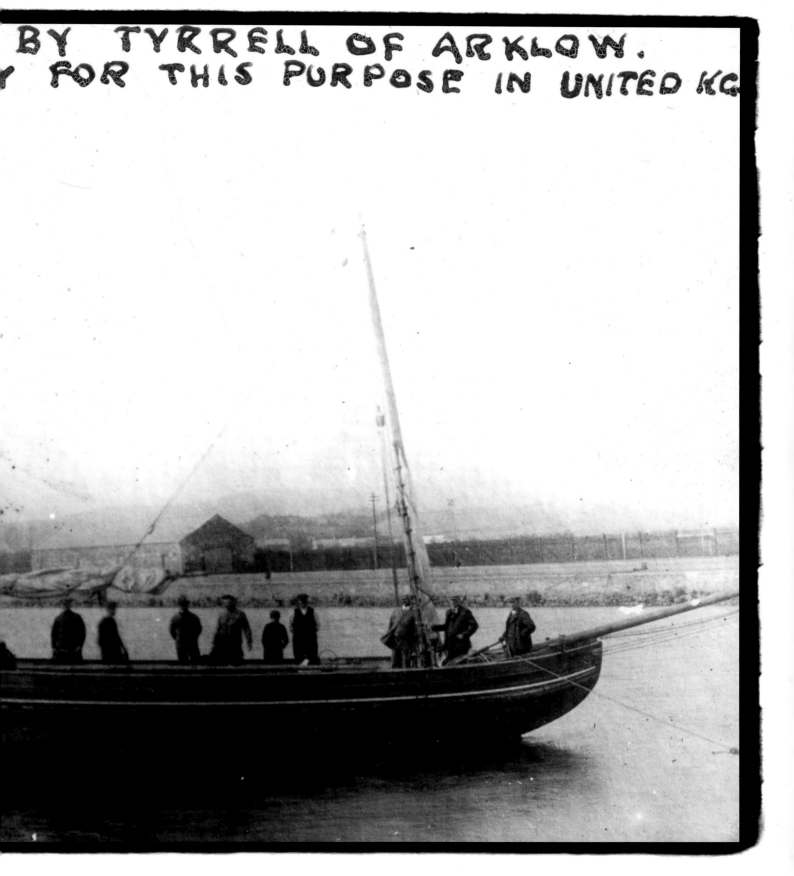

BY TYRRELL OF ARKLOW.
Y FOR THIS PURPOSE IN UNITED KG

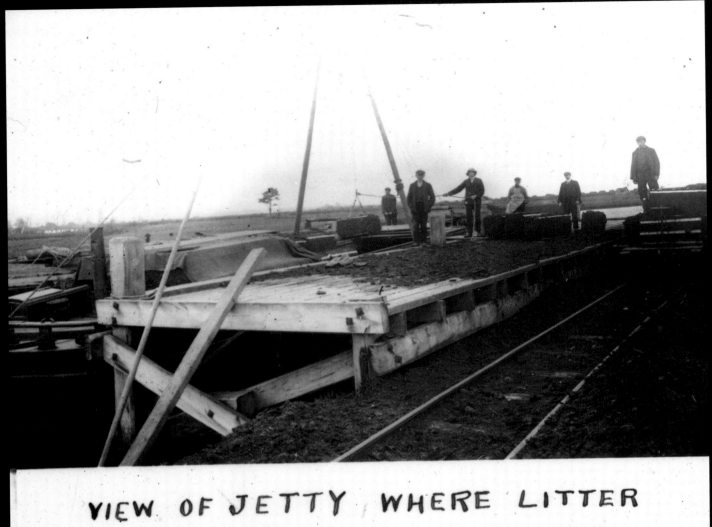

VIEW OF JETTY WHERE LITTER IS LOADED ON LIGHTERS FOR SHIPMENT TO BELFAST, THEN TRANSHIPPED TO LIVERPOOL PRESTON & GLASGOW

The extent of historic trade to and from Ireland is difficult to quantify in this period. From the mid-eighteenth century, prior to the Union, there had been considerable trade between Ireland and the West Indies, but vessels were prohibited from sailing directly into Irish ports and were required to land their cargo in Great Britain. Newry merchants managed, none the less, to establish 'a very lucrative traffic with the most celebrated commercial marts in other countries' (Lewis, 1837). Such restrictions were taken off both large and small-scale commerce of Ireland towards the end of the eighteenth century. In the nineteenth century, shipping, building and ownership of trading vessels was a significant enterprise in Ireland.

Jetty with litter loaded for shipment to Belfast, then trans-shipped to Liverpool, Preston and Glasgow. MASON©NLI.

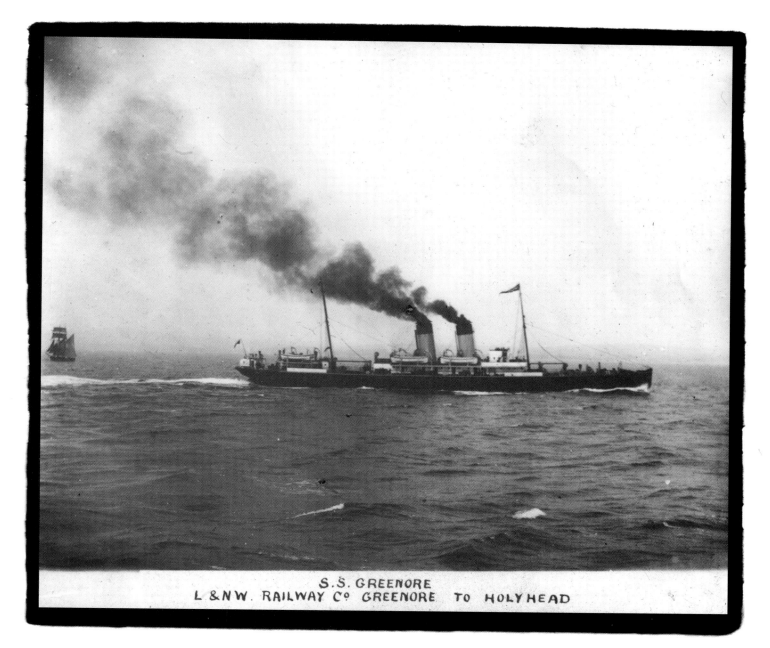

S.S. GREENORE
L & N.W. RAILWAY Cº GREENORE TO HOLYHEAD

By the 1880s steam was an established force in passenger transport such as the S.S. Greencore travelling between Ireland and Wales; and in industrial development, with an LNSW steamship travelling across the Irish Sea with rig-drilling equipment on board. By this time a Cork to Fishguard transit was also well established, involving the City of Cork Steam Packet, and the Laird Line travelling between Dublin and Glasgow.

Indicative of traffic across the Irish Sea as reflected in sail, steam and industrial development. MASON©NLI.

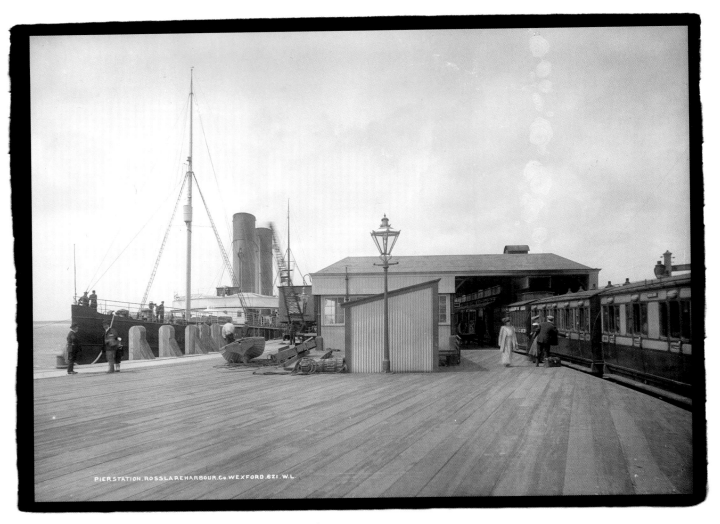

PIER STATION. ROSSLARE HARBOUR. Co. WEXFORD. 621. W.L.

*Images of a still exotic but increasingly familiarised landscape
beckoned the intrepid traveller.*

Pier head, with train, Rosslare, Co. Wexford.
LAWRENCE©NLI.

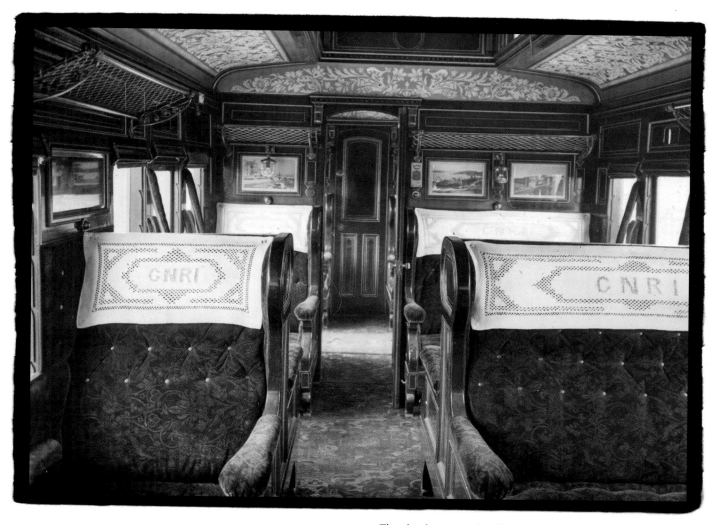

The development of rail, connected to steam shipping on passenger lines, slowly reduced the sense of distance. In 1800 that distance was registered as a three-day journey from Dublin to London; by the 1870s it had been transformed into an overnight trip, with connection from boat to rail to hotel.

GNR Ireland carriage. MASON©NLI.

By the 1880s the landscape such travellers entered continued in many respects to suggest modest prosperity for many. Where the boat train docked, at the pier in Rosslare, the traditional markets of New Ross reflected an Ireland trading in livestock; despite appearances, however, agrarian unrest had become widespread and in 1879, in the wake of threats of eviction for non-payment of rent, the Land League had been formed.

New Ross, Co. Wexford, fair day. LAWRENCE©NLI.

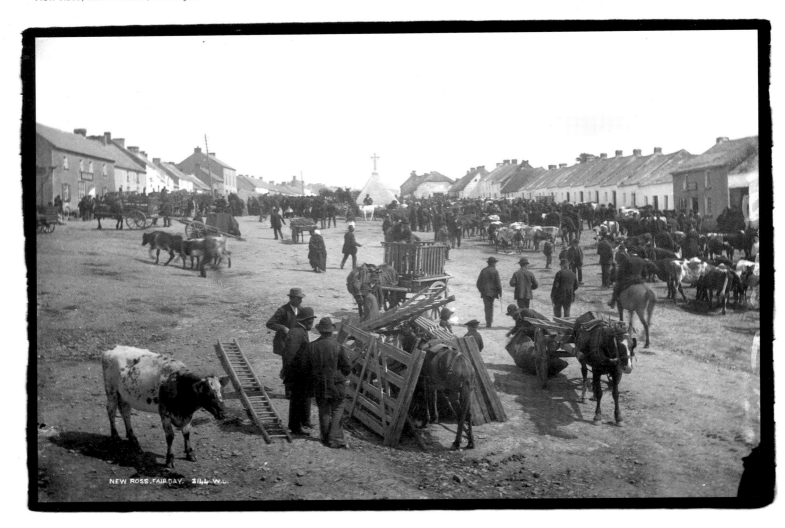

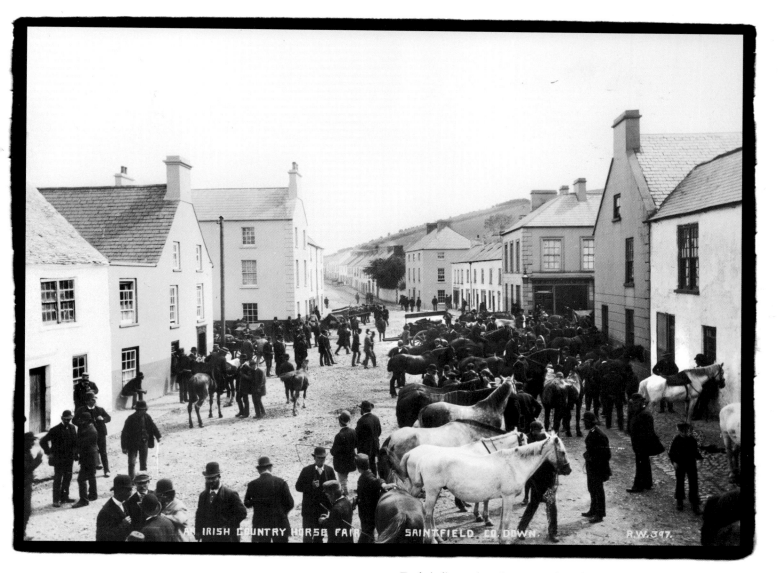

AN IRISH COUNTRY HORSE FAIR SAINTFIELD, CO. DOWN. R.W. 397.

Trade in livestock — horses, cattle and pigs — was extensive across the island. Although Ulster had its own custom in relation to land, by 1880 the rights of tenant farmers and the question of land ownership were being raised at a meeting of the Land League at Saintfield, Co. Down.

Irish country horse fair, Saintfield, Co. Down. WELCH©NMNI.

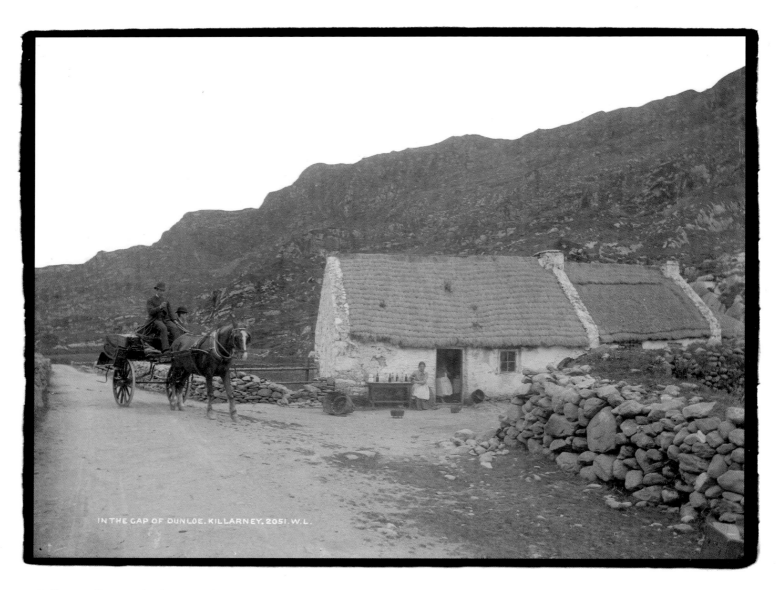

Earlier travellers to Ireland, even to the perceived wild landscape of Kerry, had included Bishop Berkeley and Mrs Mary Delany, artist and writer and spouse of Patrick Delany, Dean of Down, but for most of those venturing in pursuit of Irish Romanticism, 'the extent to which its beauty was far from self-evident is indicated by the fact that ... travellers tended to bypass Kerry ... on their tours of the south' (Gibbons, 1996).

Gap of Dunloe cottage, Co. Kerry. Drinks for travellers. LAWRENCE©NLI.

The Irish landscape from the mid-eighteenth century on now offered a significant, if cultivated, development with the 'opening up', and the cautious taming, of these wilder reaches of the sister nation. The tempering of the landscape, in part, reflected the concern voiced in Arthur Young's Tour of Ireland, *to 'frame his descriptions of wild scenery with the guiding hand of improvement ... to reassure readers ill at ease in such surroundings' (Gibbons, 1996).*

Kate Kearney's Cottage, Gap of Dunloe, Co. Kerry. LAWRENCE©NLI.

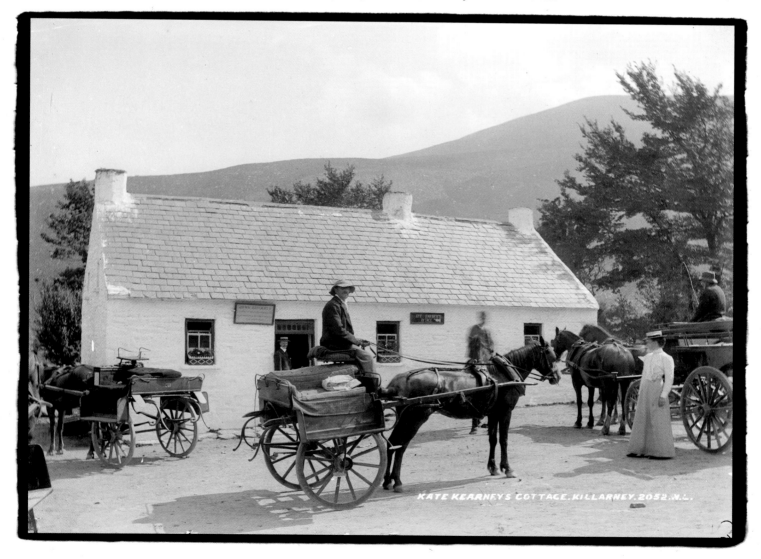

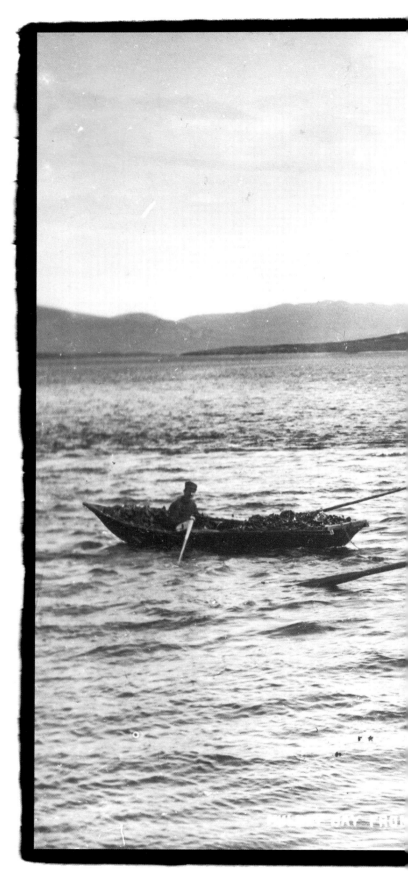

Upon arrival in Ireland, the scene presented the traveller with a glance back in time, where a steamship, a rowing boat and a currach could present within the same visual frame.

Photography had become a pursuit not only of the wealthy but of the paid recorder of an era, presenting to readers within and beyond Ireland the prospect of a tentative venturing of tourism into territory so recently considered difficult.

Mulroy Bay, Co. Donegal, at Rawros ferry, WELCH©NMNI.

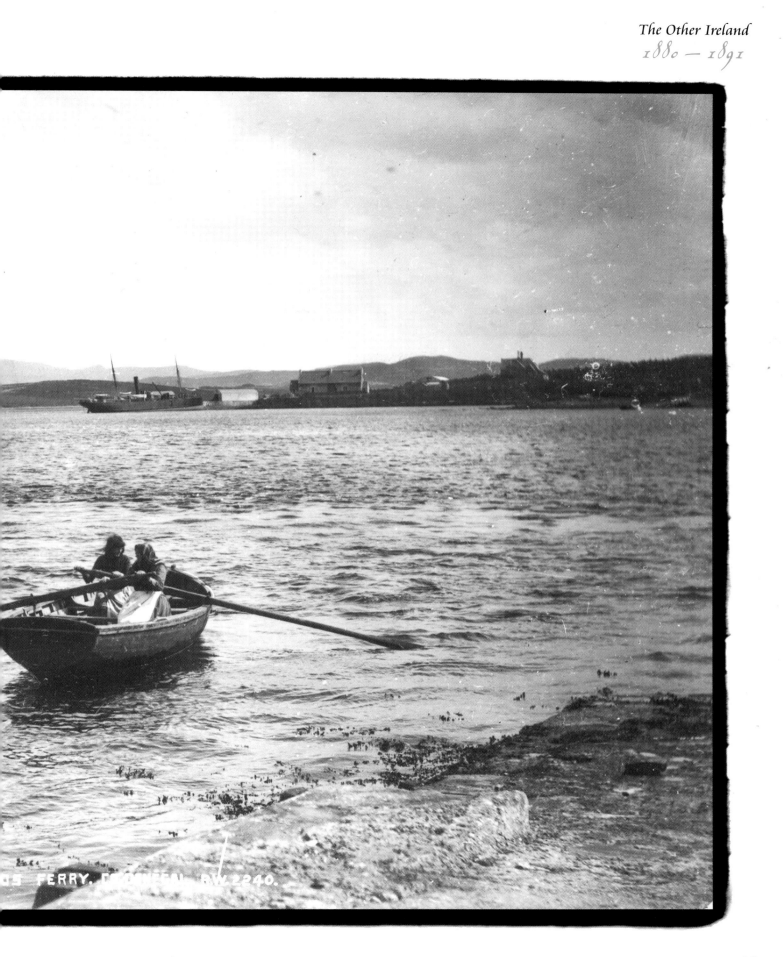

OS FERRY. DONEGAL. R.W. 2240.

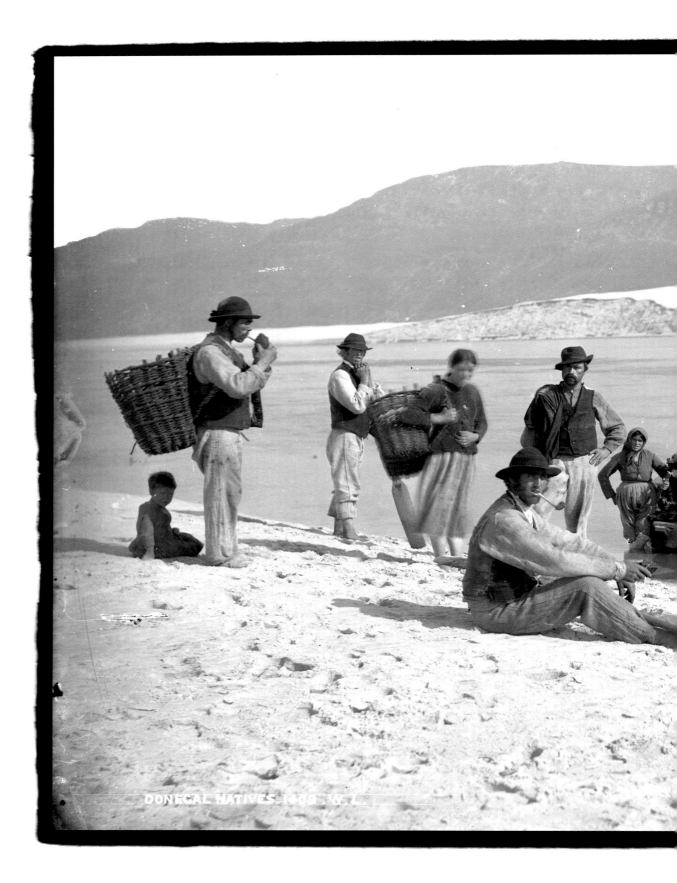

DONEGAL NATIVES 1905 . W . L .

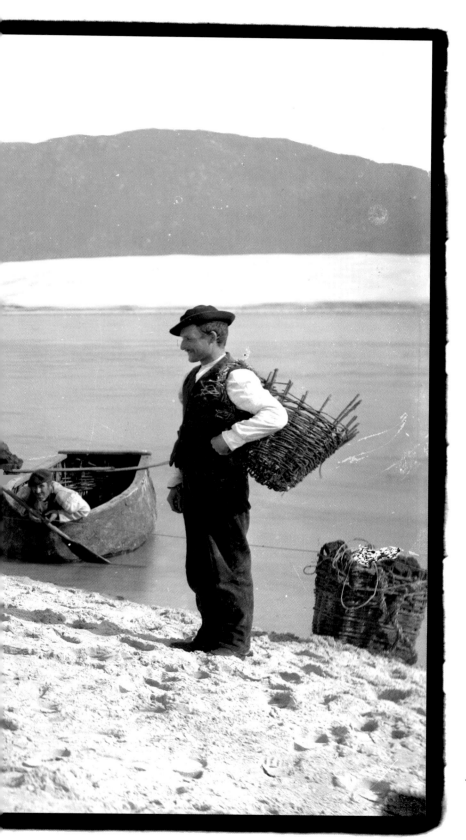

The slightly exotic configuration of the fishing communities of Donegal was aided and abetted by the reality — that fishing in Donegal was undertaken using long-established methods: people dressed for the task, venturing out to sea in currachs, the catch carried in creels to the shore and from there to home, or on to trade in a market.

Donegal 'natives', at seashore with baskets.
LAWRENCE©NLI.

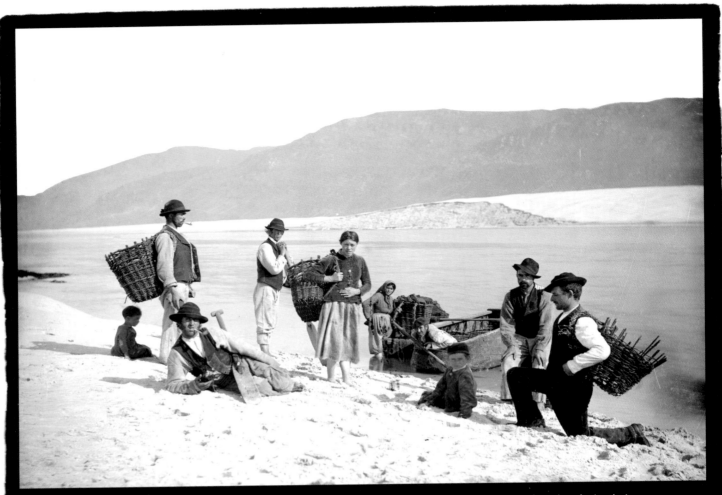

The implied cultural condescension in the adjustment in those latter images, that of the metropolitan eye observing the 'native', is a commonplace of imperial perception.

The catch is gathered at the shore. LAWRENCE©NLI.

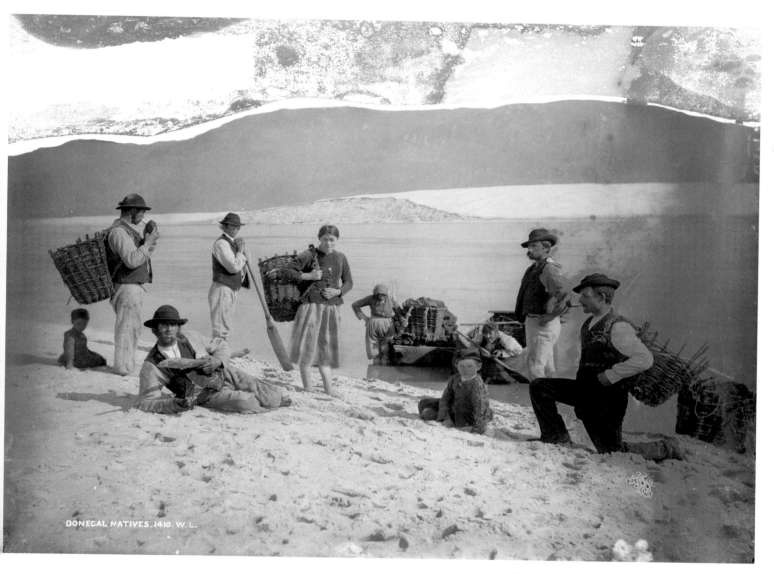

DONEGAL NATIVES. 1410. W.L.

The image of bringing fish to shore is
successfully captured. LAWRENCE©NLI.

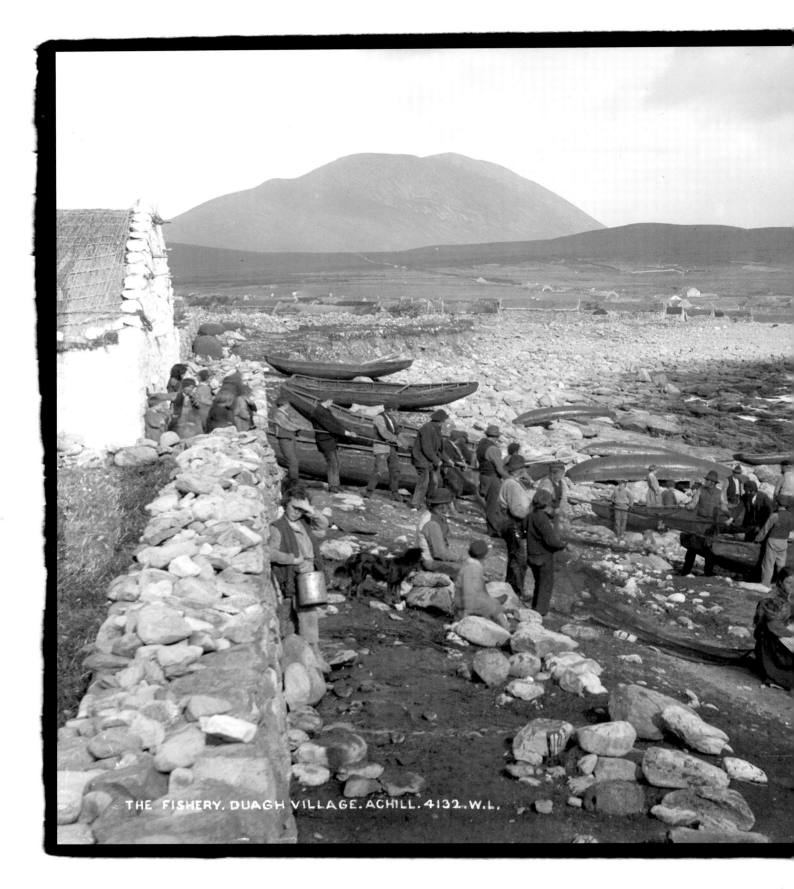

THE FISHERY. DUAGH VILLAGE. ACHILL. 4132. W.L.

The number of Irish-only speakers in Ireland continued to decline, with 1:200 having been identified as such by the 1870 Census. Before the Famine, 'in the 2,500 parts of the country out of 4,000 ... it was still spoken to a measurable extent' (Fitzgerald, RIA). Such communities, often Irish speaking but with some familiarity with English, became the focus of idealisation, both for visitors to Ireland and for many within Ireland, in a revival of a romanticised view of the lives of the peasantry of Ireland.

Duagh village, Achill Island: The Fishery. LAWRENCE©NLI.

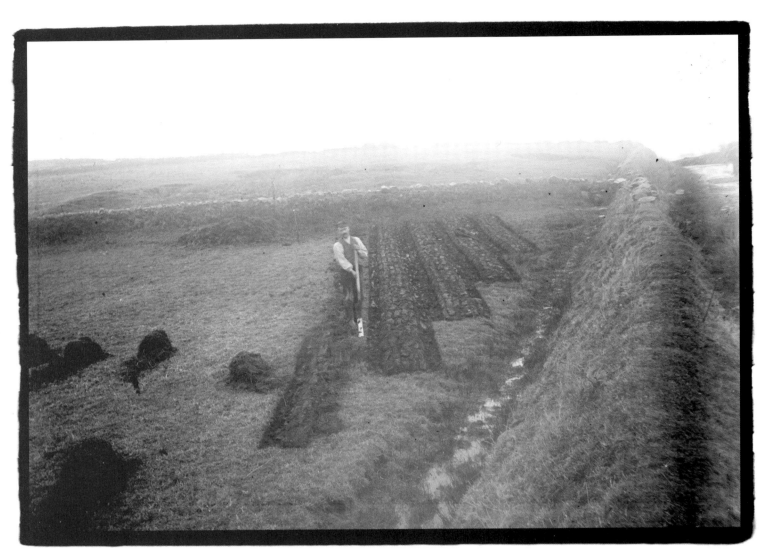

Irish agricultural labour — in effect, the peasantry of Ireland — engaged a mainly seasonal workforce of 943,000 men and 103,000 women — a decline, overall, of almost 800,000 since 1841. (Mitchell, 1975) The Irish landscape is marked by a decline in tillage and in the potato crop and a steady increase in the use of land as pasture. (Ó Gráda, 1988; O'Rourke, 1989) This man is cutting lazy-beds, with heaps of manure beside the beds to feed into the soil.

The process has a provocative name in English, '... cultivation-ridges or lazy-beds. If the modern title is taken to imply lack of energy and enterprise on the part of the farmer who employs this system, it is a complete misnomer. The building up of drier ridges separated by trenches to drain off the surface water gives an efficient method of cultivating soils with poor natural drainage. The Irish name iomaire *emphasises the importance of the ridge' (Mitchell 1986).*

Agricultural labourer, Co. Cavan. Samuel K. Kirker©RSAI.

The Royal Commission on Agricultural Labour (1893/4) defined the labourer as 'a man or woman who does agricultural work for hire at any season of the year, on the land of some other person or persons, and shall include handloom weavers and fishermen doing agricultural work'. This woman is dressed to enter the public space: to take butter and eggs to the Sligo market for sale. The donkey and creels are traditional forms of transport for goods and persons throughout rural Ireland. Creels are wicker baskets used for the transport of goods such as eggs and butter, and also fish.

Pre-famine, spinning and weaving had contributed to family earnings, but machine-based industry has impacted upon cottage-based industry, increasing the vulnerability of agricultural labourers to acute poverty.

Butter and eggs for the Sligo market. WELCH©NMNI.

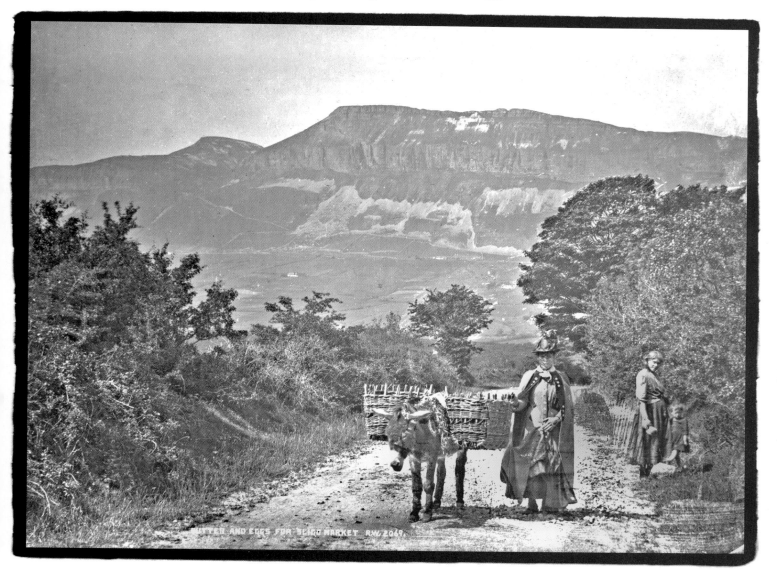

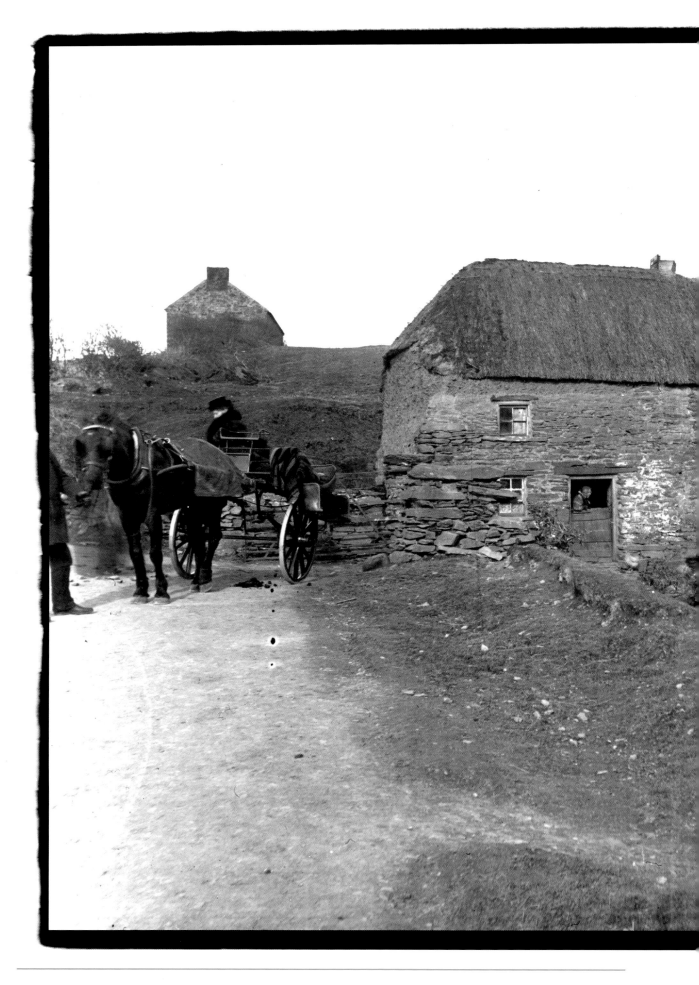

There were a number of classes of labour within the category 'agricultural labour' — 'the cottier, the bound labourer, and the out labourer'. The cottier would get a cabin, the bound labourer had no house provided, and the out labourer had neither regular work nor any provision for housing. The condition of housing for the agricultural labourer differed across the country, with 'Ulster providing better cottagers' cabins'. All were affected by the 'policy of consolidation' by landlords, leading to 'the dispossession of numbers of small holders and converted them into ... agricultural labourers' (Murray, 1903). The early years of the 1880s were defined by agrarian unrest, the emigration of agricultural labourers, and the absence of any provision, through changing land ownership, for the improvement of the status of the landless peasant.

Cavan, cottage with figures and landowner in carriage.
Samuel K. Kirker©RSAI.

'The Colony' at Dugort, Achill, was established as a Protestant proselytising mission. The zeal of the missionaries led to the building of schools, cottages, an orphanage, a small hospital and a hotel. It survived from the 1830s through the years of the Famine and continued to stand while whole communities of agricultural labourers abandoned their dwellings on the mountain, forced by dreadful circumstance to leave the island. The Achill mission began to decline after its founder, the Reverend Edward Nangle, was moved from Achill. In the 1880s the Colony was closed.

The Colony, Achill Island, Co. Mayo. LAWRENCE©NLI.

COLONY.ACHILL.4140.W.L.

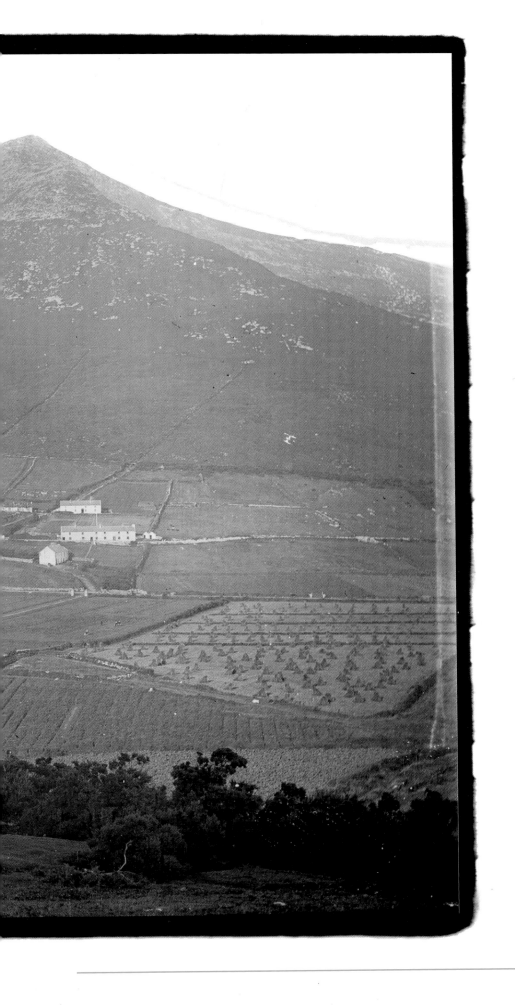

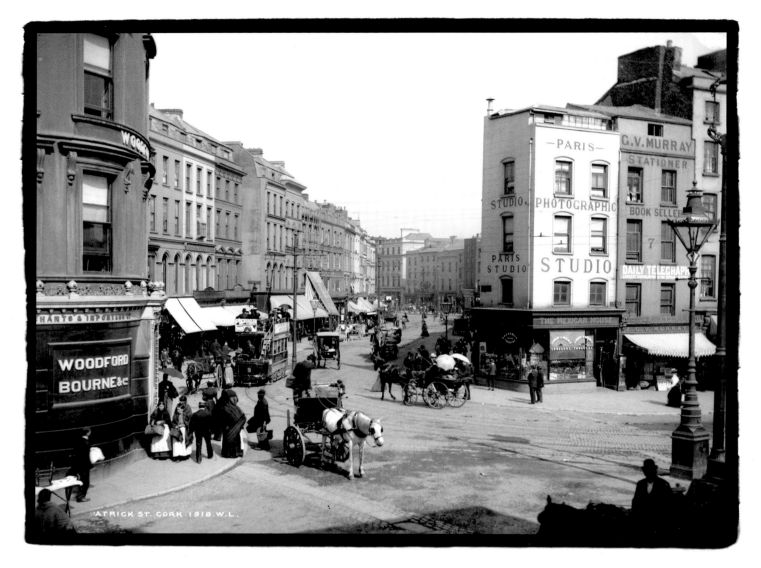

While streets bustled with city life, and photographers earned a living, Ireland's connection with the world outside was nurtured by trade and by significant contributions from those 'Irish born' and those 'born outside' adding to the prosperity of the Union of Great Britain & Ireland.

Patrick Street, Cork City: The photographer's shop.
LAWRENCE©NLI.

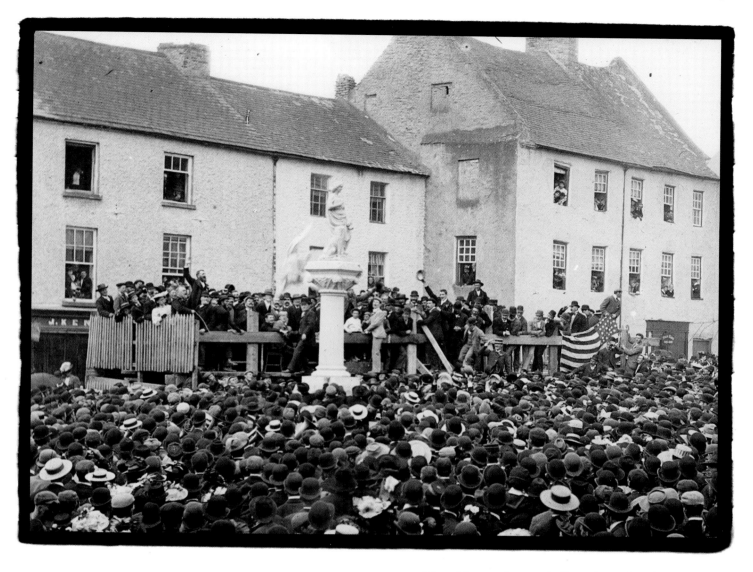

The public space became the focus of a newly enfranchised class, as all men who owned or rented property, from a cottage to a single room, were enfranchised. In the General Election of 1885, the Irish Parliamentary Party emerged triumphant from the roots of the suppressed Land League. Michael Davitt proposed the nationalisation of the land of Ireland while, under the terms of the Ashbourne Land Act, 25,000 Ulster tenant farmers prepared to buy their own.

Town meeting. MASON©NLI.

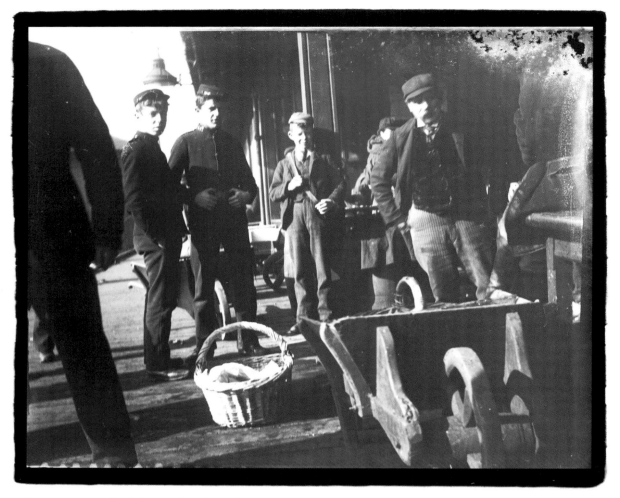

In towns across Ireland, shops and markets reflected improvement in rural life, but also suggested a society becoming accustomed to the pervasive presence of policing and the transformation in social habits associated with a network of garrisons across the island.

Shopkeeper, delivery and purchase of produce; two young recruits look on. ©RSAI.

An improvement in housing, and the extension of the franchise, had developed in tandem with acts of reclamation of Irish cultural traditions. Hurling is an ancient Irish game played with a ball and a wooden hurley, generally made of ash. In 1884 the Gaelic Athletic Association was formed, championing Gaelic football and hurling. The British Army was banned from participation in these games. The part played by the RIC in evictions provoked ongoing difficulties in matters of social life.

Man with hurley, in front of terraced housing, Blarney, Co. Cork.
©RSAI.

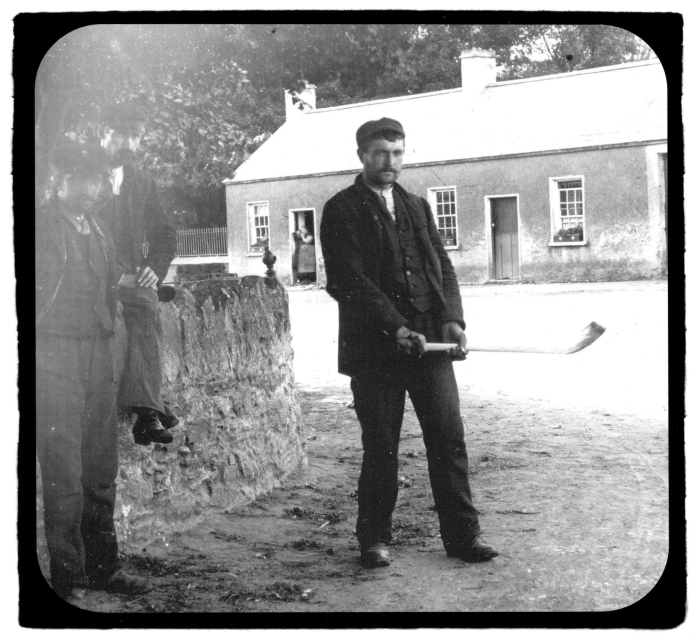

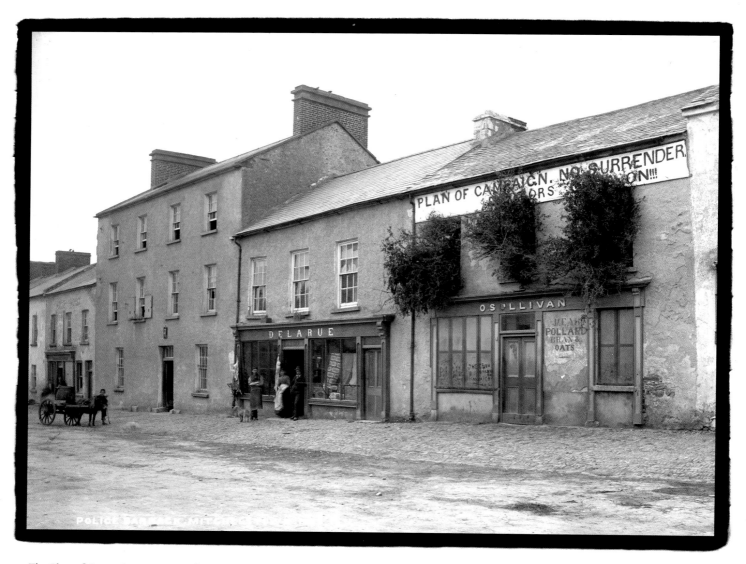

The Plan of Campaign was an anti-rent movement born of the Land League but later distanced from it by Parnell and condemned by the Catholic Church. In 1887, in Mitchelstown, three people were killed in disturbances which earned for Arthur Balfour, Chief Secretary for Ireland, the title 'Bloody Balfour'.

Police Barracks, Mitchelstown, Co. Cork. LAWRENCE ROYAL©NLI.

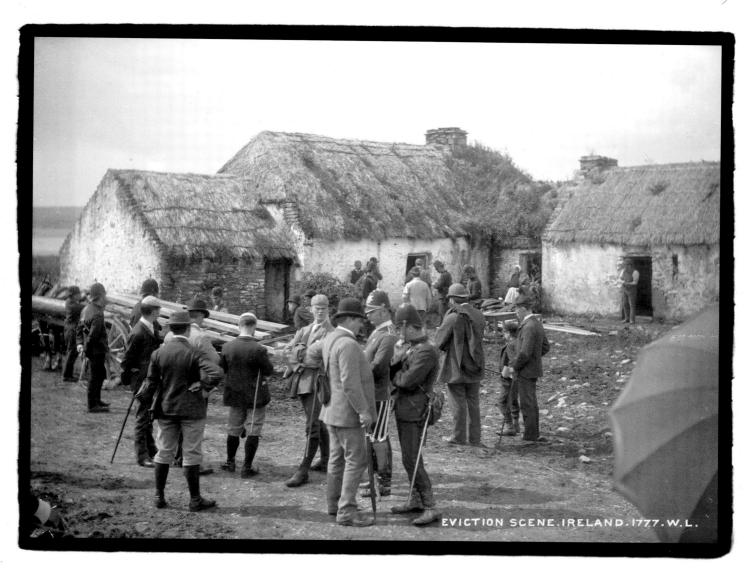

EVICTION SCENE.IRELAND.1777.W.L.

In the early 1880s, more than 5,000 men, women and children were evicted from their dwellings for the failure to pay rent, or to facilitate the consolidation of smallholdings by their landlords. Later in the decade, support for the tactics outlined in the Plan of Campaign persuaded tenants, collectively, to withhold rents on the estates on which they worked. They were promptly evicted.

Eviction scene, with enforcement by RIC and local land interests as onlookers. LAWRENCE ROYAL©NLI.

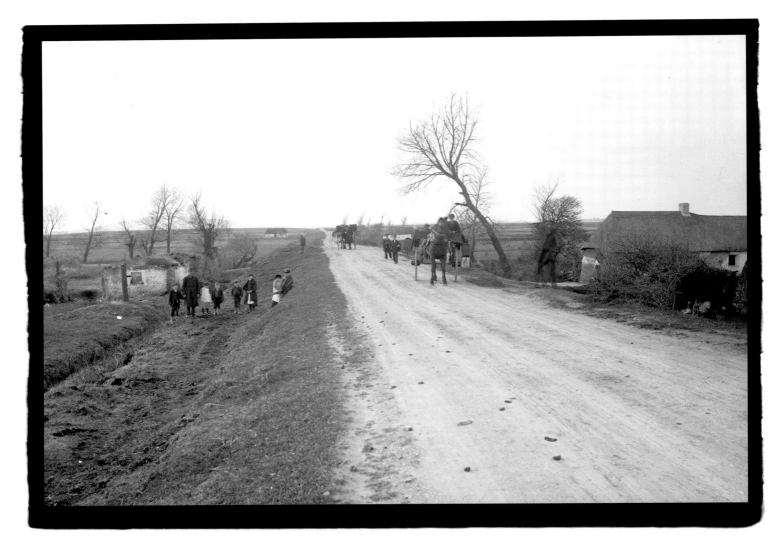

Cottiers who were evicted were reduced to agricultural labour, renting and moving with largely seasonal work. The decline in tillage had reduced the demand for their labour. Clearances and evictions threw many into destitution and towards emigration. Between 1871 and 1891, more than 700,000 people left Ireland, the bulk of whom were agricultural labourers and their children.

Clearances and evictions. LAWRENCE ROYAL©NLI.

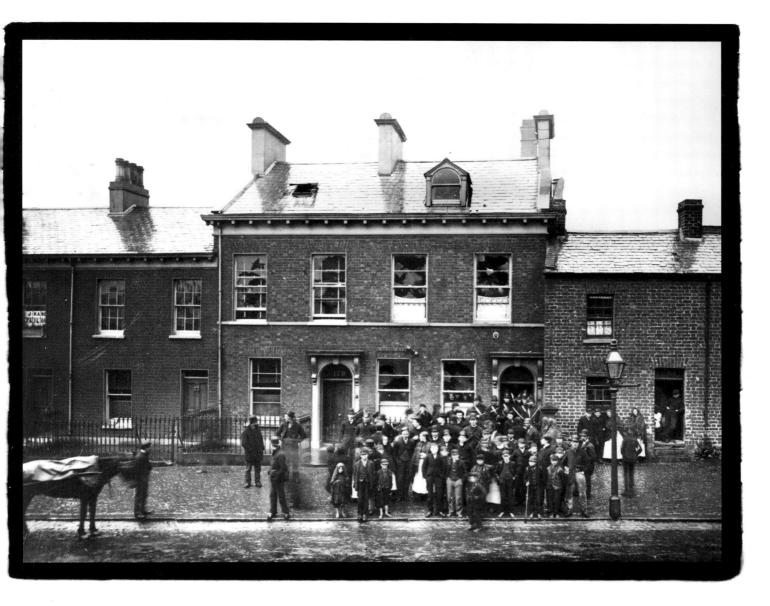

In Belfast tensions were also rising. The Orange Order, with the Ancient Order of Hibernians a less significant counterpart in Catholic organisation, dominated, as Ulster became inflamed. On the Protestant side of the sectarian divide, the promise of Home Rule was translated into a fear of Rome Rule. Sectarian riots broke out in the docks and spread across the city. Police at the Shankill Road Barracks fired on rioters and eight people were killed. A Royal Commission was convened.

June 1896, Shankill Road Barracks, Belfast. WELCH©NMNI.

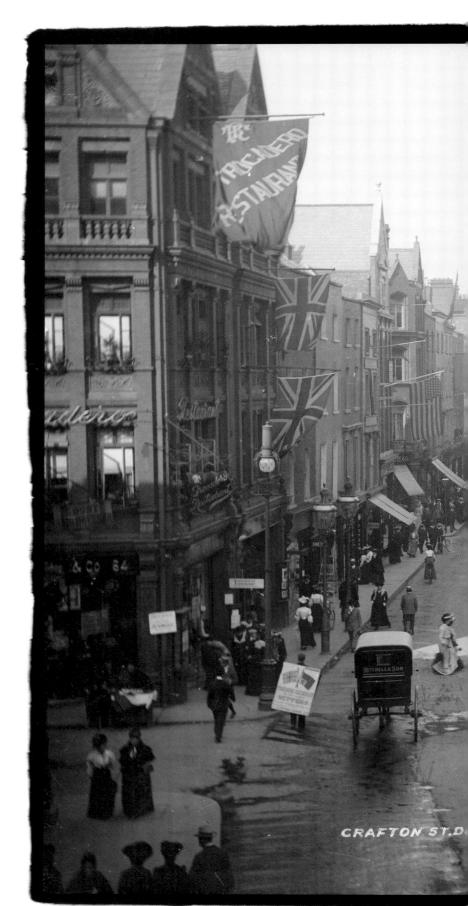

Such tensions remained but were not pervasive: an employed working class in factories and shops across the island enjoyed a degree of prosperity. Between 1874 and 1889 'the number of power looms in the country increased from 307 to 925,776 ...' (Murray 1903). In the early 1880s the South City Markets were opened in Dublin, 'designed to provide affordable retail space for small traders ... the furniture department of Pim Brothers & Co., Whyte & Sons china and glass shop ... the entire structure was extremely large', and erected with a view to cultivating the consumer appetite of the working classes. By the late 1880s, Brown, Thomas & Co. on Grafton Street were 'apparently engaged in a creative method of promoting Irish fabrics and workmanship whilst attempting to retain the status associated with selling Parisian designs' (Rains, 2010).

Grafton Street, Dublin, Union Jacks flying.
LAWRENCE©NLI.

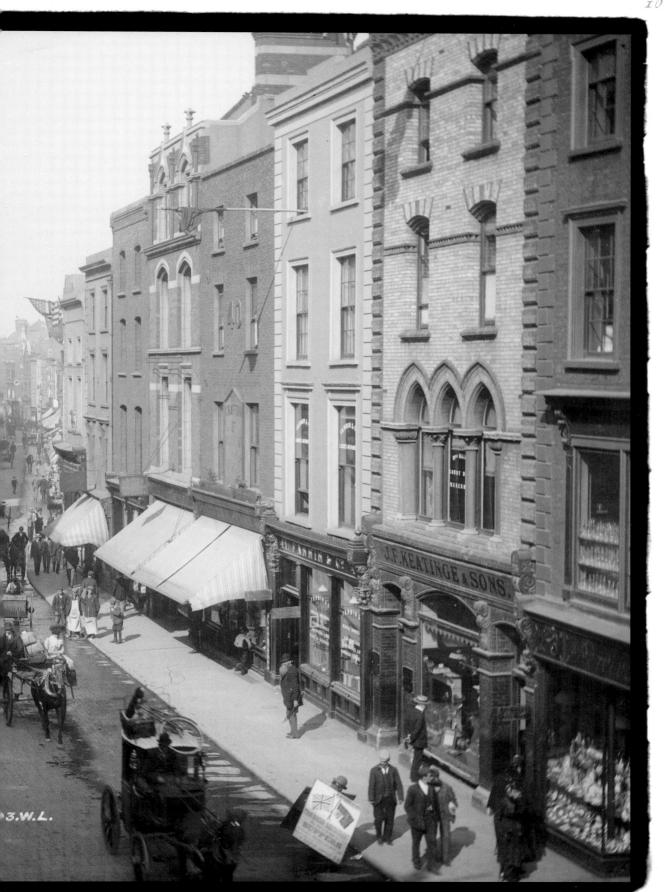

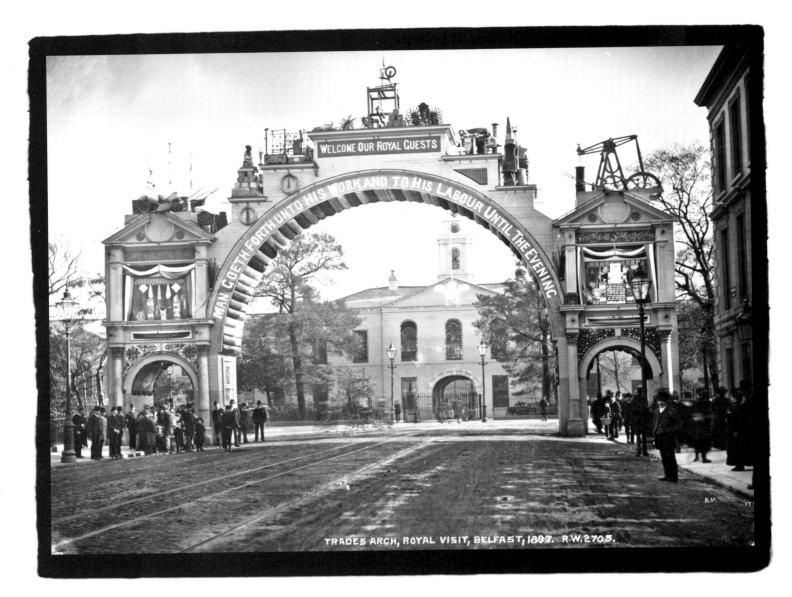

In Belfast a royal visit is anticipated. This vision of Empire reassured 'Our Royal Guests' that the seeds of an industrious future have been sown in Ireland, the Trades Arch celebrating all craft and the employment of a great variety of labour that has reaped the dividend of prosperity. The building in the background is the old Linen Hall, standing on the site now occupied by Belfast City Hall.

Trades Arch, Royal Visit, Belfast 1887. WELCH©NMNI.

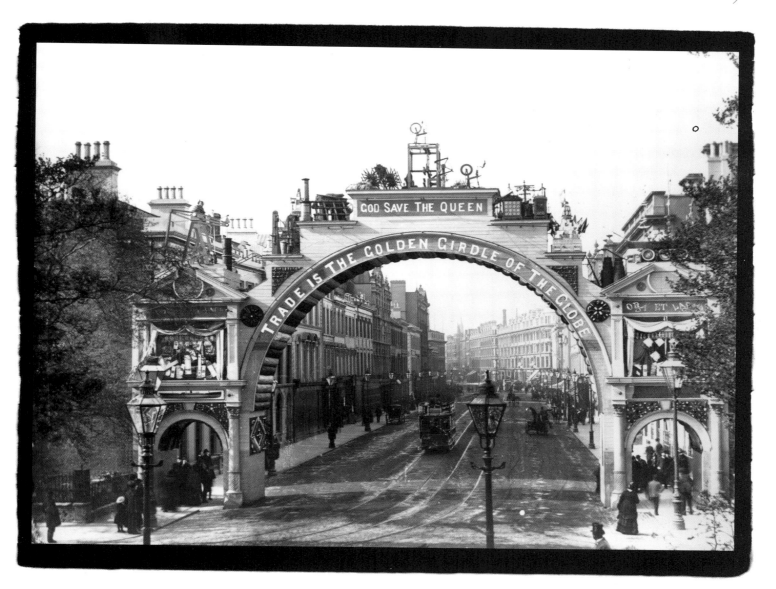

Utterly befitting the era of Queen Victoria, the view of the Arch from one side proclaims that 'Man goeth forth unto his work', and from the other side, extols the claim that 'Trade is the Golden Girdle of the Globe.'

Trades Arch, Royal Visit, Belfast, 1887. WELCH©NMNI.

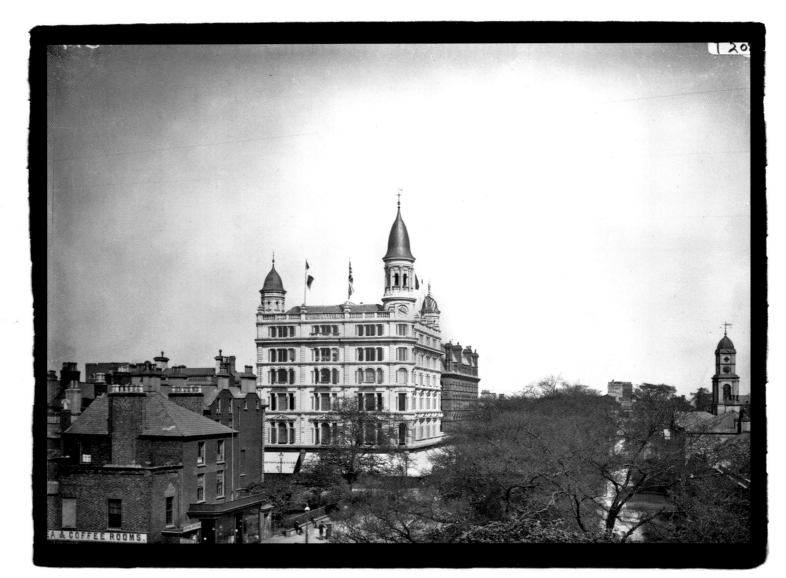

By the 1890s, evidence that the combination of industry and trade has borne fruit towers over the city of Belfast: Robinson & Cleaver's Royal Irish Linen Warehouse. Fortunes have been made for the mercantile class of this key city of the British Empire, and, for many, knighthoods and the purchase of suitable acres to acknowledge their primacy would follow.

Robinson & Cleaver's Royal Irish Linen Warehouse, Belfast.
WELCH©NMNI.

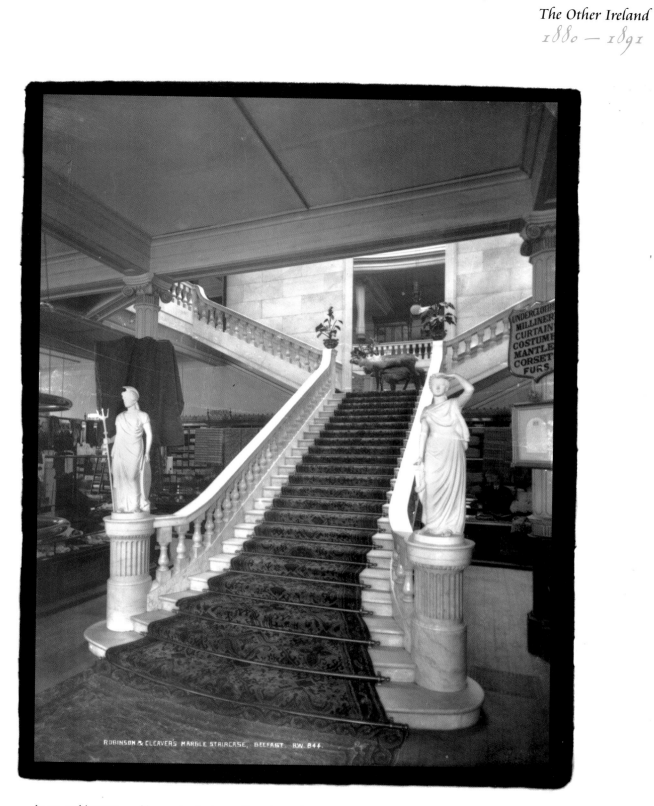

ROBINSON & CLEAVER'S MARBLE STAIRCASE. BELFAST. R.W. 844.

In an architecture evoking a classical era of empire and conquest, the marble staircase of Robinson & Cleaver's emporium invited the consumer to taste the exotic and to purchase the mundane, from home manufactory to the pelts of the previously wild, gathered from the far-flung corners of the Empire.

Robinson & Cleaver's marble staircase at Donegall Place, Belfast.
WELCH©NMNI.

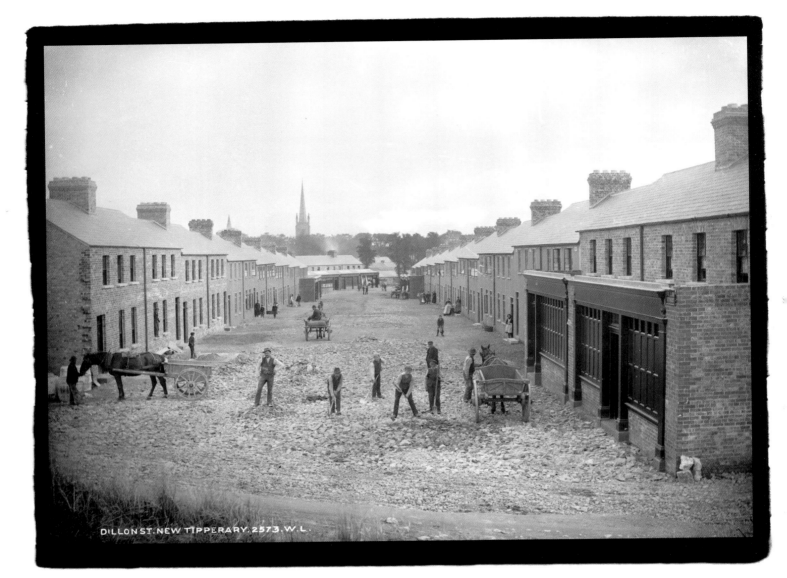

DILLON ST. NEW TIPPERARY. 2573. W.L.

Other visions for the economic and social development of Ireland are in evidence, and the public, churches and charities are not indifferent to such claims. In 1889, during the Plan of Campaign, the population of Tipperary town had taken a decision to withhold rents from their landlord. Supported by £50,000 from public subscription, they lay the foundations for, and build, a New Tipperary. An unintended consequence of the Parnell split in 1890, however, is the loss of interest by the public in continuing such support for the Campaign. The project was abandoned, and, of necessity, a new settlement was made with the landlord. As a reminder of the power equation in such matters of local resistance, the landlord levels New Tipperary.

New Tipperary. LAWRENCE ROYAL©NLI.

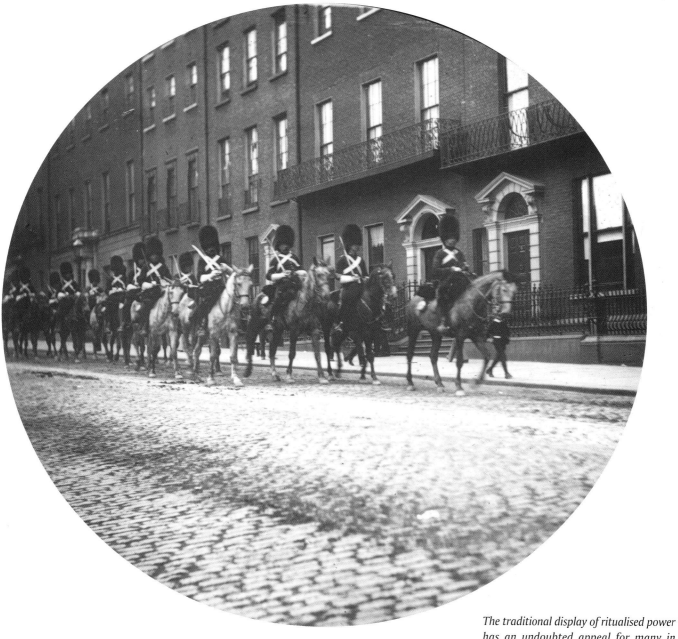

The traditional display of ritualised power has an undoubted appeal for many in terms of pageantry.

Parade, Rutland Square, Dublin, 1890.
©RSAI.

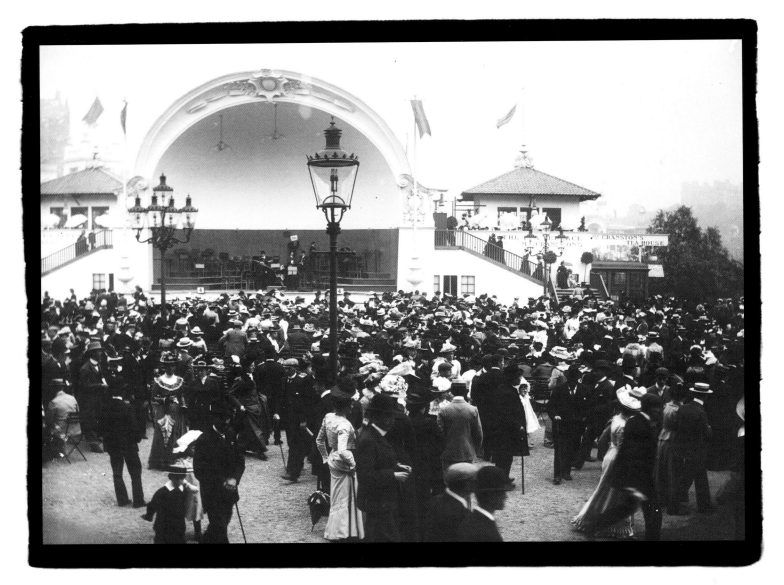

Ireland has a long tradition of music, but by the 1890s this late Victorian image could be either of England or of Ireland.

Amphitheatre, after a concert. ©RSAI.

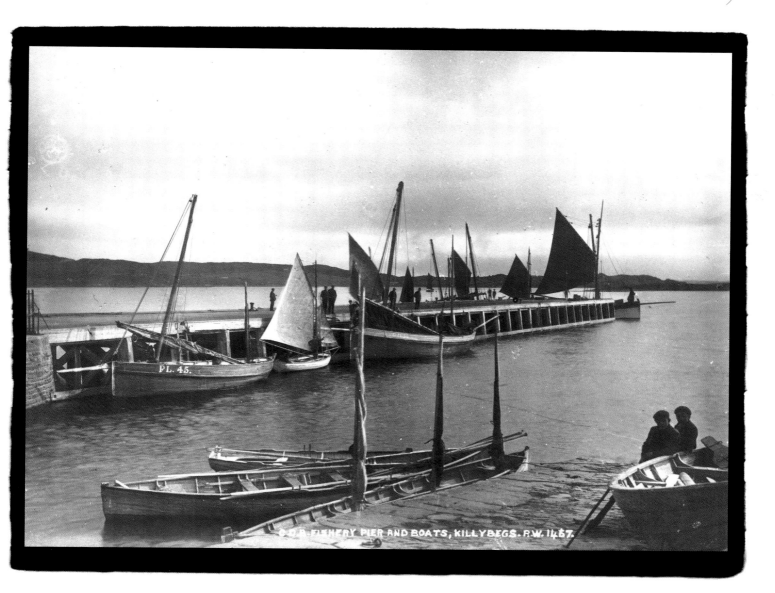

C.D.B. FISHERY PIER AND BOATS, KILLYBEGS. R.W. 1457.

Much of the west of Ireland remains distinctive — geographically, socially and culturally outside the 'Pale'. By the early 1890s significant intervention by the state into what 'Bloody Balfour' identified as disadvantaged areas in Ireland had brought development, and a tangible qualitative change in the lives of those who lived in them, from Donegal to Kerry. The Congested Districts Board was established to improve husbandry and fishing, to transfer holdings to tenants and to establish local industries. A Board of Works was empowered 'to lend money for land improvement, for farm buildings, for labourers' cottages and for working-class dwellings in the towns; it arbitrated between railway companies and landowners for the acquisition of land needed for track ... constructed piers and harbours all round the coast ... becoming in the process an essential part of the fabric of the Irish administration' (Lyons, 1970).

Congested Districts Board fishery pier and boats, Killybegs, Co. Donegal. WELCH©NLI.

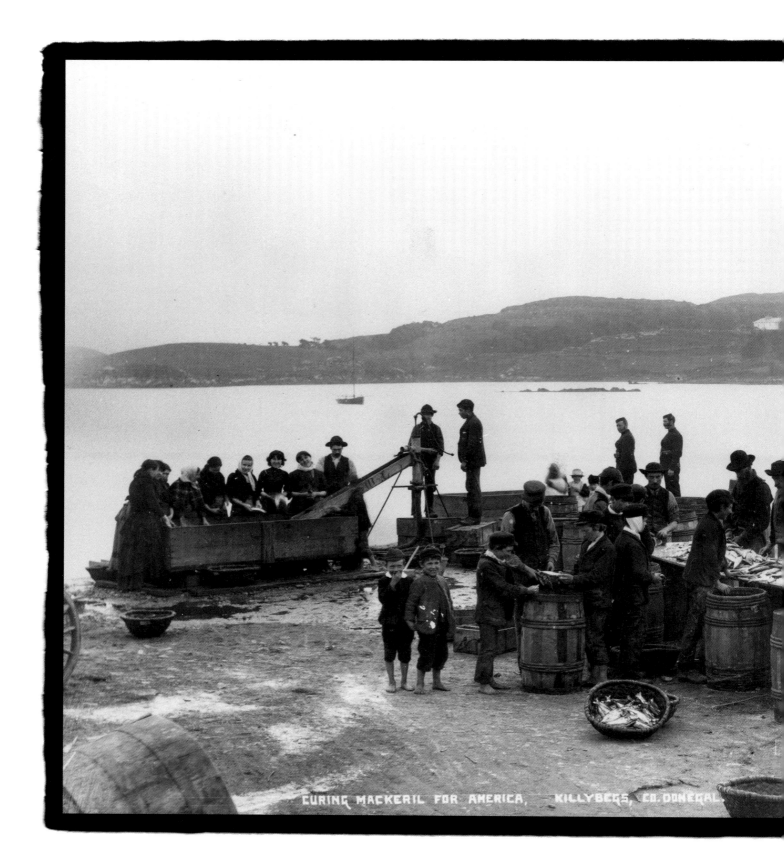

CURING MACKERIL FOR AMERICA, KILLYBEGS, CO. DONEGAL

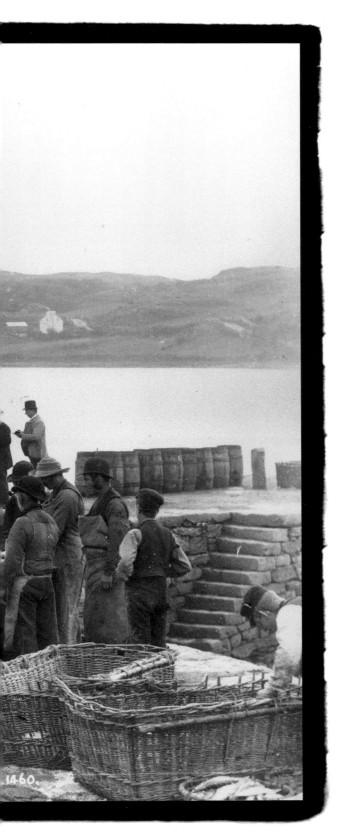

The intent of the development of such areas was to relieve 'congestion', not always a reference to population, although often so. The intention was to improve access to the west through the advance of the railway and to generate industries to provide employment. Overall, the population of Ireland had declined dramatically — from 8,175,124 in 1841 to 4,704,750 in 1891. The populations of all other parts of the Union — England, Wales and Scotland — had increased consistently over the same period; none the less, the Congested Districts Board was required also to facilitate assisted migration. Under the terms of the Balfour initiative, unremitting rural disadvantage had to be addressed, not least as 'acute poverty was held to hamper business initiative' (Bartlett, 2010).

Curing mackerel for America at the old pier, Killybegs, Co. Donegal, 1890. WELCH©NMNI.

YACHTING. 2887. W.L.

The power vested in land had been tempered, but has been neither changed nor fundamentally challenged by transfers of land ownership in Ireland. Some title to ownership had been transferred through tenant rights under the Ashbourne Land Act; the power of brokerage has, to some extent, moved from a landowning class carrying much inherited baggage from the occupation and confiscation of the land of Ireland to those who have purchased that land to complement their rising status as, in effect, merchant princes. In many areas of more privileged life, the old Ascendancy capital of Dublin has much in common with London.

Yachting at Kingstown, Co. Dublin.
LAWRENCE©NLI.

1892—1900

1892 Arthur Balfour's period as Chief Secretary for Ireland ends. Horace Plunkett is elected as a Unionist MP and establishes the 'Recess Committee' to suggest a platform of reform measures for Ireland.

The General Election returns Gladstone, now 81 years of age, as Prime Minister. Plans are announced, in the wake of the death of Parnell, to introduce a Second Home Rule Bill. The Bill passes through the House of Commons but flounders in the House of Lords. In 1893 the Bill is defeated.

1893 The Gaelic League is established with the aim of promoting cultural nationalism. In 1892 Douglas Hyde had delivered a speech on 'The necessity of de-anglicising Ireland', advancing the claim that 'Ireland should follow her own traditions in language, literature and even in dress.' He is elected president of the League.

1894 Horace Plunkett forms the Irish Agricultural Organisation Society to co-ordinate the work of the co-operative movement. Rural Ireland is in a period of transition and the Co-operative Wholesale Society has established the first Irish co-operative creamery at Drumcollogher, Co. Limerick.

The journal, *Shan Van Vocht*, previously the *National Patriot*, is launched in Belfast. It represents a different form of nationalism, drawing on the tradition of Wolfe Tone. All articles from Dublin's Celtic Literary Society's journal founded by Arthur Griffith are included, and the journal unites literary societies in Dublin, Cork and Belfast.

1895 The industrial profiles of Dublin and Belfast remain radically different. Industrial output from Ireland is in decline overall. Dublin boasts 'some significant state-of-the art technical industries, such as the Guinness Brewery and Sir Howard Grubb's works at Rathmines' (McCorristine, 2009). They also have Jacob's biscuit factory, and both it and Guinness have worker welfare policies. Guinness, with 3,000 employees, is the largest brewery in the world. Howard Grubb, owner of the Optical and Mechanical Works, Rathmines, remains so until the 1900s when he becomes involved in the development of military optics. In Wexford, which had industrialised early, two foundries — Pierce's, owned by the Pierce family, and Selskar, owned by the Doyle family, are the centre of a thriving foundry industry which employs several hundred men. The commercial success of the foundries, largely producing agricultural machinery, depends on an export trade to Britain and to the outposts of Empire. Pierce's has established a depot in Buenos Aires, and has also developed independent trade links with France.

A General Election returns the Conservatives to power and Gladstone retires, his vision of a system of peasant proprietorship in Ireland unfulfilled.

1896 James Connolly, the son of Irish migrants, and others, prepare a manifesto of the Irish Socialist Republican Party, stating that the 'national ideal can never be realised until Ireland stands forth before the world a nation free and independent'.

The Conciliation Act recognises collective bargaining and the principle of negotiation in workplaces across the Union.

1897 The first Oireachtas and Feis Ceoil, respectively literary and musical festivals, are milestones of the revival of cultural nationalism.

On the 50th anniversary of her coronation, Queen Victoria visits Belfast. In Dublin, the

anniversary is celebrated, but the aftermath is marked by riots and damage to the Orange Lodge in Rutland Square.

1898 The United Irish League is formed by William O'Brien. Initially a radical agrarian movement, the League is increasingly devoted to politics and to fundraising for Home Rule for Ireland. Marches to commemorate the 1798 Rising are indicative of the persistence of Fenian sentiment.

The passing of the Local Government Act establishes County and City Councils, Rural and Urban District Councils and Boards of Guardians throughout Ireland. The Act undermines the power of landlords and extends the franchise to 100,000 women who are given the right to vote for local councils and to sit on District Councils. Anna Haslam, a Quaker and owner of a small retail outlet in Rathmines, establishes the Irish Women's Suffrage & Local Government Association, launching a movement that will draw on the energies of a predominantly Protestant middle and upper-class membership, advancing the claim for equality through legislation within the Union.

1899 Thirty-three women win seats on District Councils. To increase the productivity of Irish farmers, the government establishes a Department of Agriculture under the authority of Horace Plunkett. Arthur Griffith, a printer and journalist, works with the *Irish Daily Independent* and *The Nation*. He becomes editor of a new weekly paper, the *United Irishman*. His editorials urge the Irish people to work for self-government.

Robert Lloyd Praeger, in a table published under the proceedings of the Royal Irish Academy, gives an indication of the lay of the land at the turn into the twentieth century.

The present condition of the surface of the country is shown by the following figures (1899):

Crops	22.8%
Grass	52.10%
Woods	1.50%
Turf Bog	5.90%
Marsh	1.90%
Mountain	11.10%
Water, roads, fences	4.70%

1900 Griffith is founder of Cumann na nGaedheal, a cultural and education association aimed, on common ground with Douglas Hyde, at the reversal of the Anglicisation of Ireland.

Inghinidhe na hEireann, a revolutionary women's organisation, is formed by Maud Gonne, Countess Markievicz and Francis Sheehy Skeffington.

Queen Victoria visits Dublin: disruptive tactics by the Inghinidhe ensure the Loyal Address is not given.

Edward Carson joins the Unionist government as Solicitor-General and receives a knighthood. For the next few years he represents the Crown in many cases and speaks on Irish affairs in Parliament.

George Wyndham is appointed Chief Secretary of Ireland. Wyndham, a man of letters and former secretary to Arthur Balfour, seeks to preserve the Union of Great Britain & Ireland. What the Union will now move towards is a system whereby tenants could, with State intervention, purchase the land they worked and become as much conservers of the Union as the former owners had been. In effect, the case against Home Rule and for the Union rested upon the assumption, argued by Gerald Balfour, that 'The Irish Question in its most essential aspect is a Farmers' Question', with

difficulties rooted 'in an unsatisfactory system of land tenure, excessive sub-division of holdings, and antiquated methods of agricultural economy'.

Belfast and Dublin are major cities, each with populations of over 300,000, both with urban employment and a thriving consumer culture. If the 'Irish Question' is to reduce to a 'Farmers' Question', the position of 70,000 people working in the Ulster linen industry is clearly less of a political imperative. Of these, 68 per cent are women and 26 per cent are children. In Dublin, the Irish Drapers' Assistants' Benefit and Protective Association is in the process of rising from the ashes of the recent fire at the Drapers' Club.

The bulk of Irish railways were 'designed and built by Irish-born engineers who had garnered experience in England'. Labour was cheap, land negotiable and thousands of men were employed in cutting from rock the extensive line of rail, with 'Dublin ... one of the first European capitals to have a suburban railway'. Irish railway stock paid attractive dividends to investors, and between 1834 and 1900, 'no fewer than 75 separate railway companies ... operated in Ireland ... of which the three largest ... controlled around 75 per cent of goods and passenger traffic' (Rynne, 2006).

Workmen building the railway to Clifden, Connemara, 1893. WELCH©NMNI.

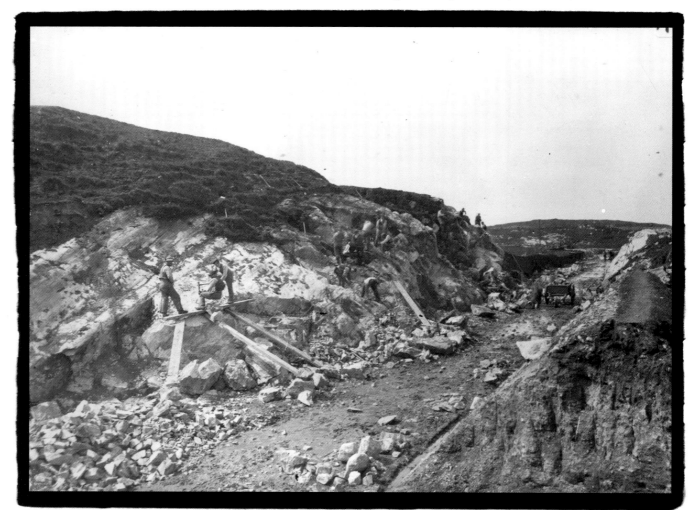

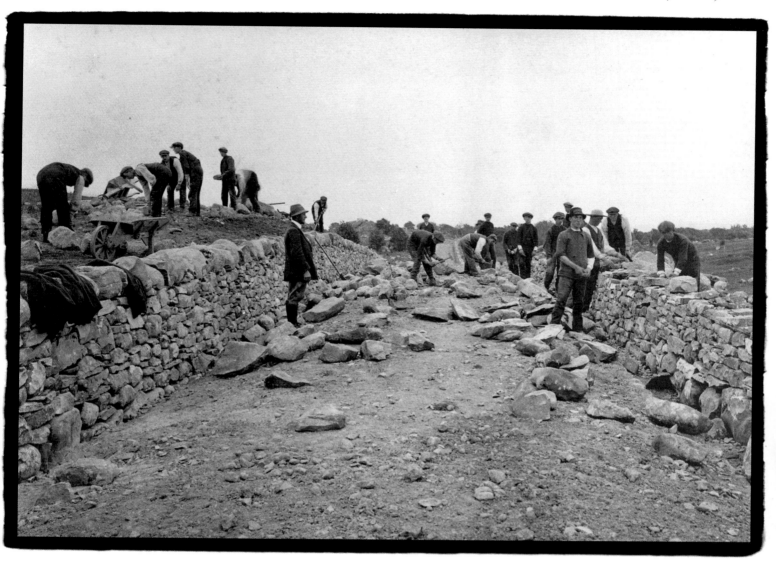

Although over 1.5 million men had left Ireland in the 50 years between 1841 and 1891, many of those who stayed were gainfully employed clearing fields and building walls from the stone of Ireland. The roads of Ireland, in common with the inland waterways and the line of rail, were 'hardly justified by its underdeveloped economy'. Costs per mile were, however, 'three times lower than contemporary Britain' (Rynne, 2006).

Men building walls. WELCH©NMNI.

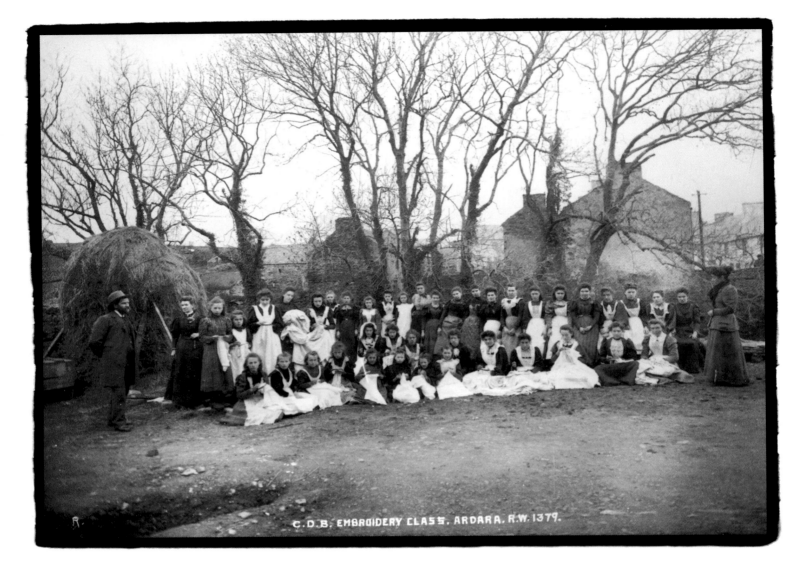

C.D.B. EMBROIDERY CLASS, ARDARA. R.W. 1379.

The fostering of industries under the Congested Districts Board included lace-making and embroidery classes. A tweed merchant in Ardara 'employs about 500 girls in knitting and embroidery ... average earnings are not more than 2s to 3s a week'. The national schools were used for classes to teach lace-making, and 'the girls received 8s or 9s a week'. The embroiderers and lace-makers of Ardara were not untypical in their seasonal attendance at lace-making and other CDB industries. As recorded by the Royal Commission in 1893, 'the women and girls go away from home in the summer, hiring themselves out at fairs as farm labourers and servants. They begin at 12 years of age ... the custom makes school attendance very irregular from March till September.'

Congested Districts Board embroidery class,
Ardara, Co. Donegal. WELCH©NMNI.

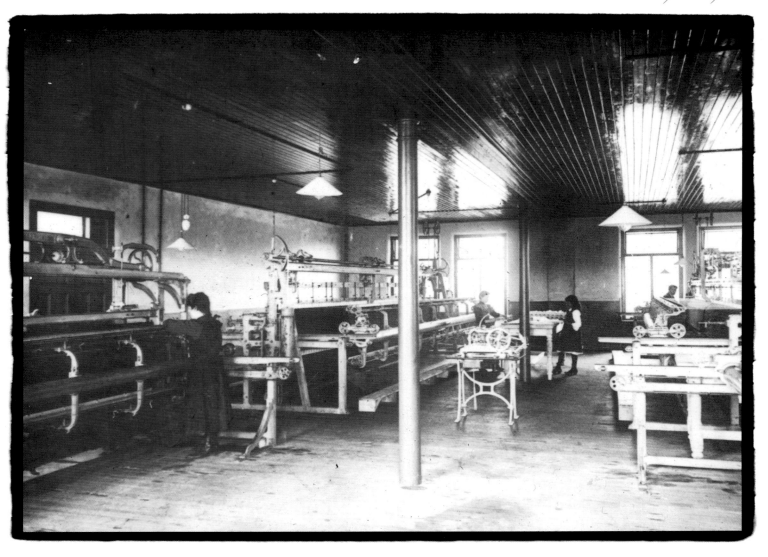

By the early 1890s the potential for productive and well-paid work in this aspect of the textile industry had been undermined by industrialisation. While the art of lace-making and embroidery had long been established in Ireland, mass production of machine-based embroidery was economically viable, and elevated Irish lace-making and handworked embroidery to the status of exclusive and profitable commodities, a value that was not reflected in the payment to those under instruction at the Ardara Embroidery Class.

Textiles, general view, embroidery machine.
MASON©NLI.

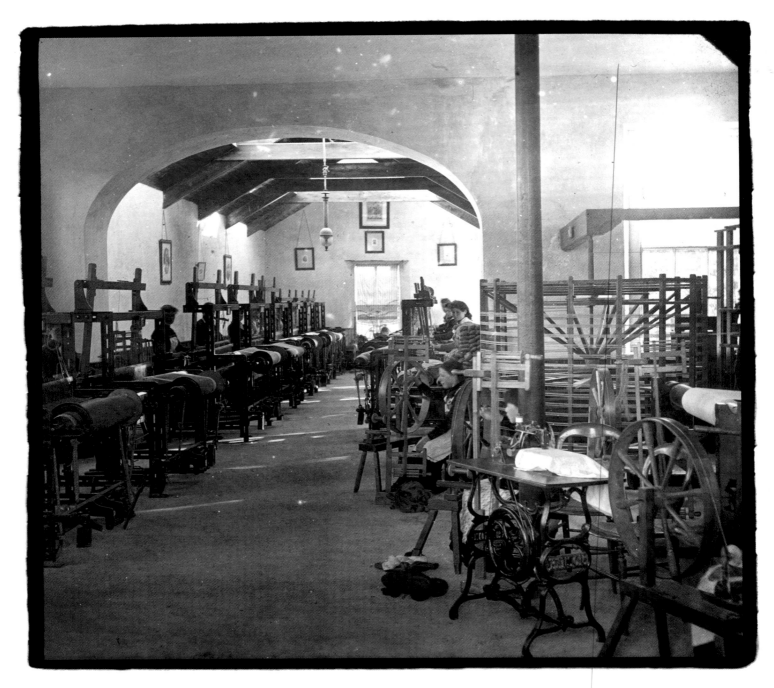

The CDB gave grants to promote convent-based industries in Ireland. The Foxford Mill combined the grant with the dowry of the Mother Superior to launch the Foxford Mills in Co. Mayo, a major employer in the town. In other areas a different vision prevailed: the social formation of young girls. In Skibbereen, Co. Cork, an experiment with handlooms — long redundant in any market competitive sense — began in 1889. 'At present there are 23 looms; they are all worked in one large, airy and pleasant hall … Five convents have now taken up the work and in all there are about 60 looms …' The girls taught 'are of the class which supply domestic servants to small shopkeepers … expected to continue until they marry … In cases of emigration girls have taken looms to the colonies, with the intention of weaving linen for family use' (Royal Commission on Labour, 1893).

Weaving, convent school, Skibbereen, Co. Cork. MASON©NLI.

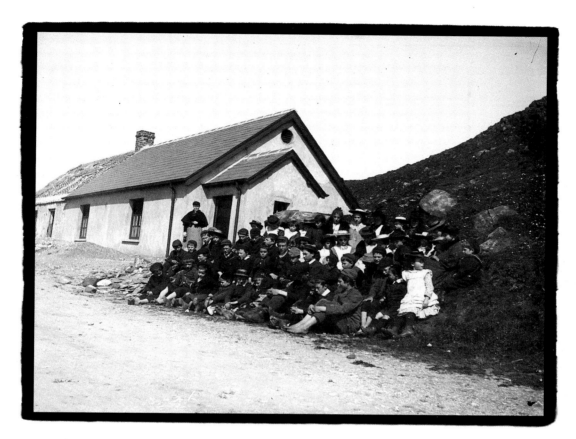

The Balfour initiatives included the building of schools. Many children were attending school on a regular basis, and national literacy was rising significantly — to 46.5 per cent of the population in the early part of the decade. Distinct and denominational schooling was now widespread, the 1830 commitment to a basically secular 'Model School' network for Irish education under the Union having been rejected by all religious denominations. The Whig administration had established a National Board of Education, which 'subsidised teachers' salaries and set up "model schools" teaching a utilitarian diet of values that might be seen as a rather crude attempt at social control, but were at least secular ...' The attempt failed. 'The Church of Ireland founded its own Church Education Society; the Presbyterians used the Scheme to fund its own denominational schools; the Catholic hierarchy eventually withdrew support ...' (Foster, 1988).

Children with teacher, possibly on Rathlin Island, Co. Antrim. ©RSAI.

The state of the Union

A cultural nationalism has been awakened and Ulster perceives itself increasingly as a place apart. The landscapes of Belfast and Dublin differ profoundly. Dublin, the former ascendancy capital, boasts elegant streetscapes and cultural institutions of learning; the once gracious homes of eighteenth-century wealth have, over time, been transformed into hovels for late nineteenth-century poor where one-third of the population of Dublin now live. In Belfast, an industrial city has emerged, with housing for working people registering marginally greater ambition for their welfare; it is a place where sectarianism festers.

During the last 10 or 15 years large numbers of agricultural labourers have left the country, 'the cause being the great diminution that has taken place in the extent of tillage farming, and the consequent loss of a market for their labour'. Four Assistant Commissioners are directed to look at the conditions of women's work in Ireland. From shop assistants to dressmakers, milliners and mantlemakers; from poplin-weaving to the manufacture of wool; from bacon-curing to matchmaking — all are listed and detailed in Appendices under 12 categories of work done by women and girls throughout the island.

The Irish Trade Unions Congress is formed, an all-island body acknowledged as a significant milestone in the organisation of working people, most specifically those working people with a negotiable skill. Neither agricultural labourers nor women workers are included in the ranks. The home rulers' desire for protection to promote nascent industries outside Ulster opens a further gap between them and imperial free-trade Belfast.

Towns across Ireland continued to trade in food, clothing and general business. Puck Fair in Killorglin in Co. Kerry is one of the oldest fairs in Ireland. It was given legal status by James I of England & Ireland (James VI of Scotland) in 1603 but pre-dates Christianity, and the annual crowning of the goat may, or may not, celebrate the pagan god, Pan. It is also reputed to celebrate a good harvest, the Celtic god Lugh and August, or Lughnasa, the time of high summer in Ireland.

Puck Fair, Killorglin, Co. Kerry, 1891. ©RSAI.

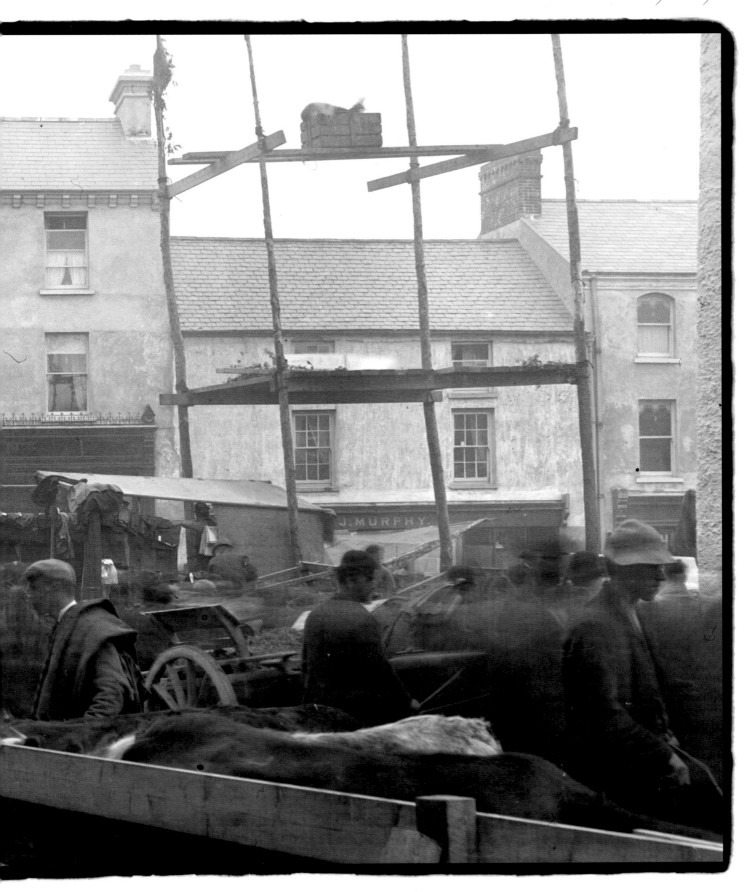

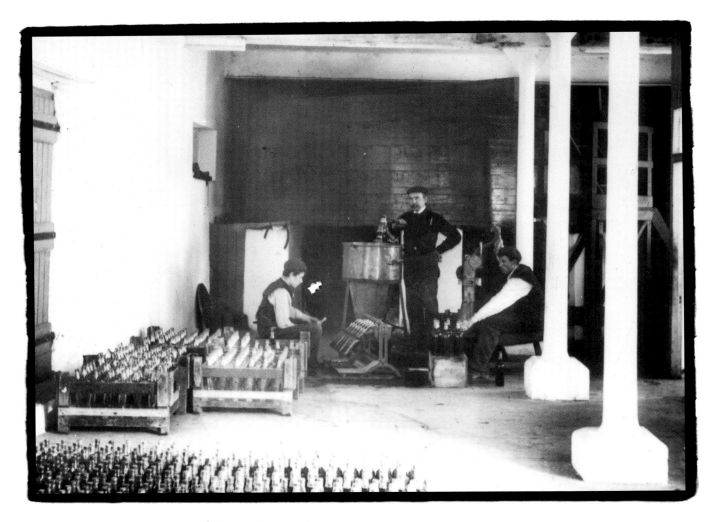

Industries at the level of towns, villages and even cities gave employment to working people, some of whom remain agricultural labourers engaged in seasonal work for tenant farmers or on smallholdings of their own. Levels of technology remained basic and markets local. Few such industries had contact with trade unions.

Presse & Co., Galway. Bottling store: three men at work.
MASON©NLI.

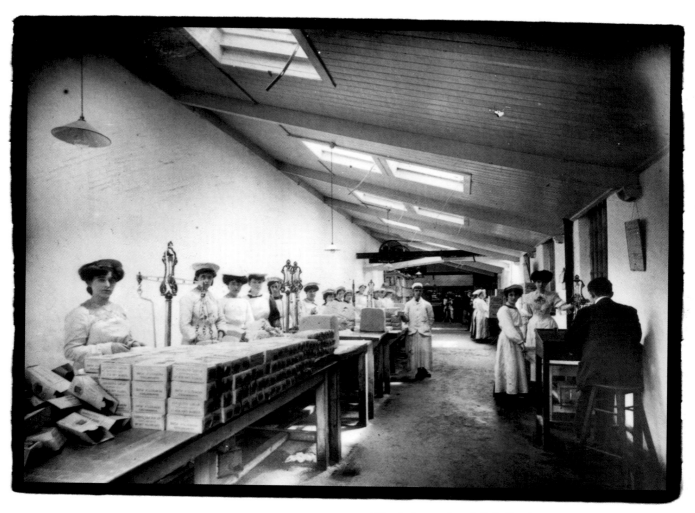

Other industry, directly linked to farming and dairy production outside the factories, now employed girls and young women inside the factories as packaging and the servicing of retail outlets and the export of food products expanded.

Cleeve Brothers, Limerick. Butter packing room.
MASON©NLI.

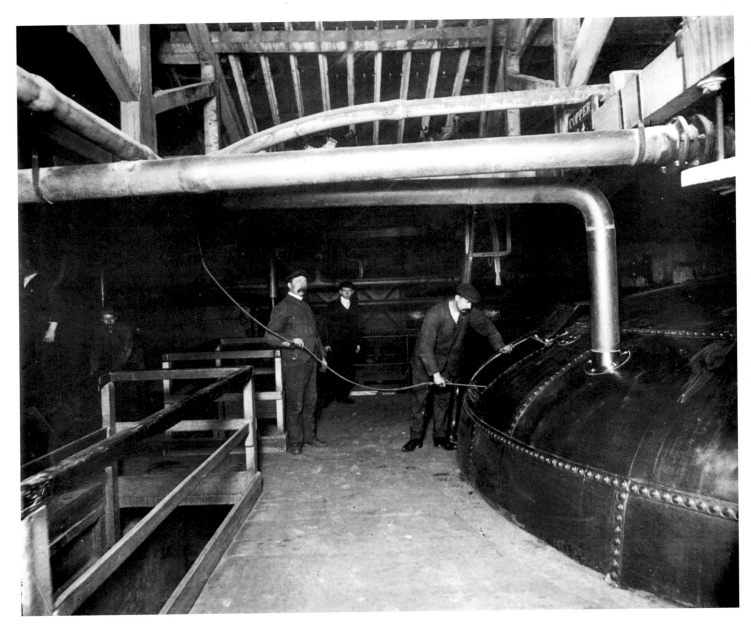

It was envisaged that manufacturing and the railway would transform life in Ireland. The union of Ardee, Co. Louth, with a population of 2,067, comprised a number of towns. 'Of these Castlebellingham has the only manufacture ... a brewery, which employs about 150 men, or almost all the male population.' The 1893 Royal Commission records the necessary elements of life in the last decade of the nineteenth century. The population of Ardee has declined by 15 per cent since the Census of 1881. Development is needed, the commissioners note, to ensure prosperity: '... towns having good ports and lying on the railway line, and Ardee having no railway accommodation, the trade is consequently drawn towards the ports to the disadvantage of Ardee ...'

Stills/brewers. MASON©NLI.

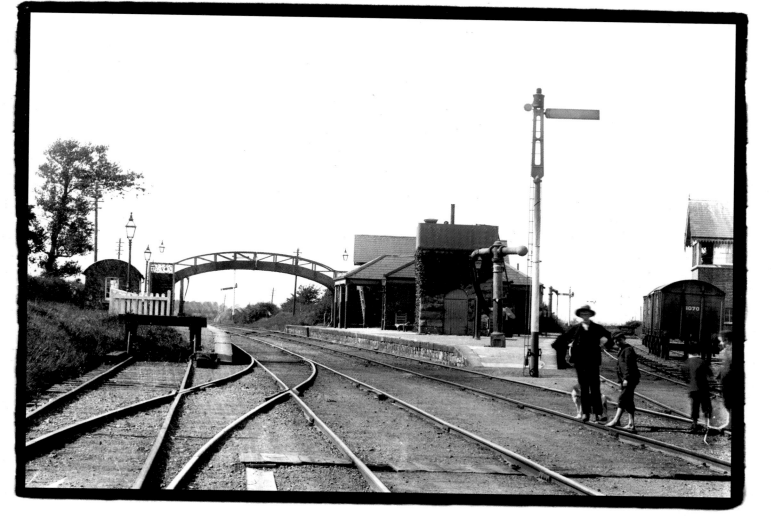

Would development follow the line of rail, or lead it? This was a perennial question for administrators taxed with the challenge of extending an empire. Across Ireland, Africa, India, Australia and New Zealand, the British Empire was advancing by line of rail — often into underpopulated areas, to service peoples who have no resources. None the less, in Ireland the railway is extending travel by the people, and resorts and seaside towns are reaping the benefits.

Boys at line of rail, with dog. ©RSAI.

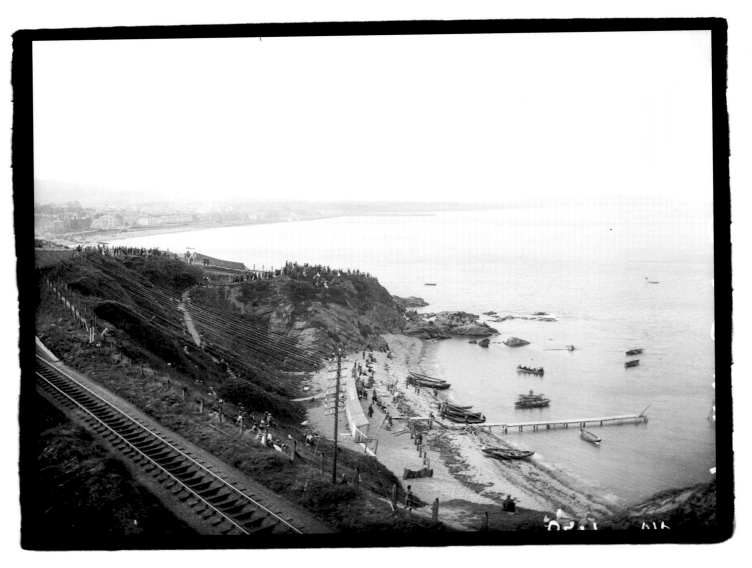

Dublin factory and shop workers, families with resources and leisure, take the train for the holidays to Rosslare, calling at Bray, Greystones, Rathdrum, Wicklow, Gorey and Wexford town.

From the train leaving the tunnel, to see the bathing at Bray Head, Co. Wicklow. LAWRENCE ROYAL©NLI.

Heading south-east to Tramore Strand, Co. Waterford.

Tramore, Co. Waterford. LAWRENCE ROYAL©NLI.

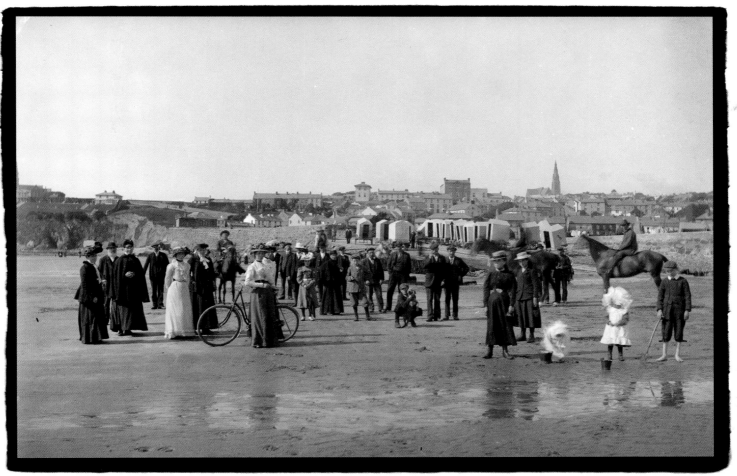

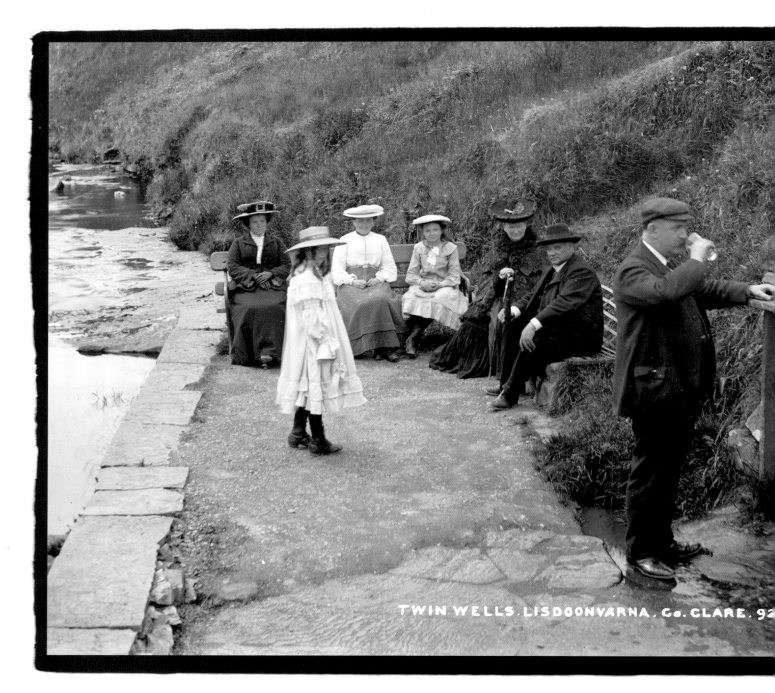

TWIN WELLS, LISDOONVARNA, Co. CLARE. 92

Later known for Matchmaking Festivals after the harvest, the popularity of Lisdoonvarna as an early resort lies in the composition of the mineral waters, 'rich in iron, sulphur, magnesium and calcium and ... said to provide relief for certain diseases'. Lisdoonvarna in September was a popular holiday destination for farmers, in part because it 'ties in with the farming cycle' (Daly, 2006).

Taking the waters at Twin Wells, Lisdoonvarna, Co. Clare.
LAWRENCE ROYAL©NLI.

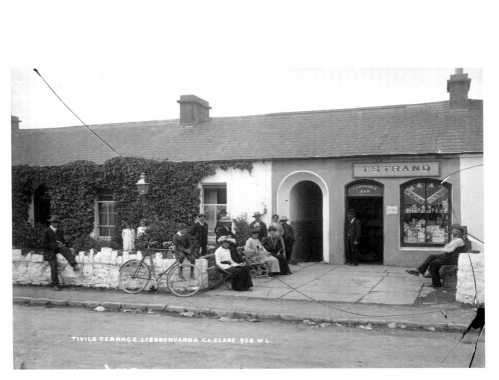

Tivoli Terrace, Lisdoonvarna, Co. Clare. LAWRENCE©NLI.

Ireland has become a land awash with hotels, both grand and more modest hostelries. Taking the waters, fishing for salmon in the rivers, and the increasing interest of scholars from the intellectually curious leisured class of Ireland, England and Germany present unanticipated opportunities for cultural surprise in the ruins of the ancient landscape of Ireland.

Imperial Hotel, Lisdoonvarna, Co. Clare.
LAWRENCE©NLI.

IMPERIAL HOTEL. LISDOONVARNA. Co. CLARE. 925. W.L.

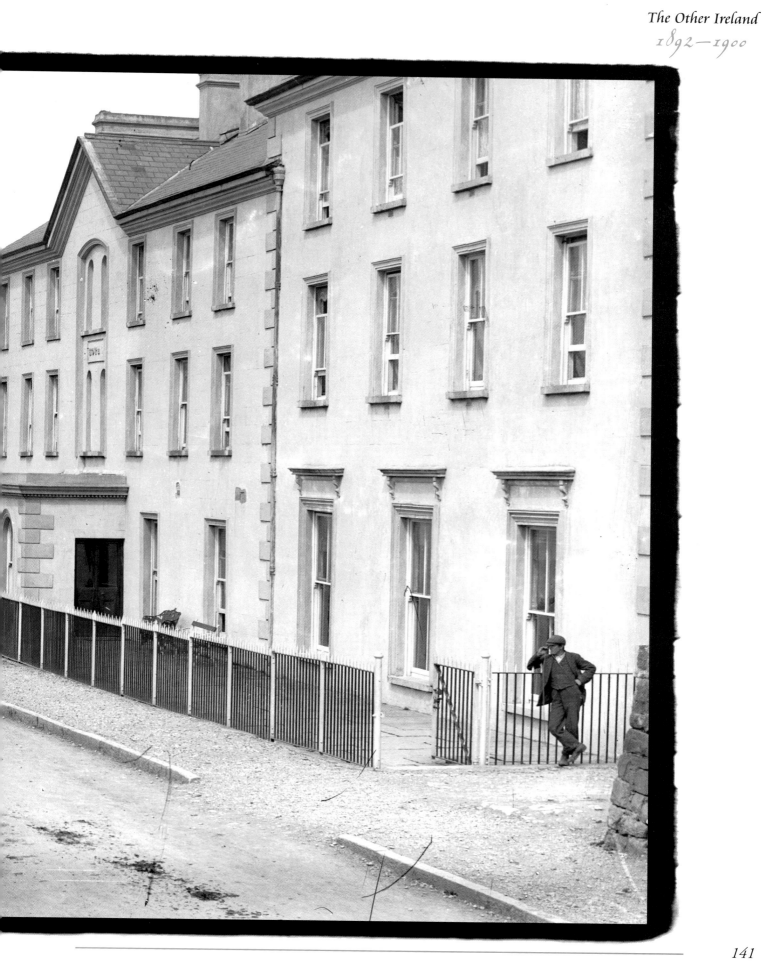

The children of Tory Island, mainly Irish speaking: observers of the curiosity of exotic others in relation to the ruins on which they play. Tory Island lies off Donegal on the north-west coast of Ireland and has two main villages in a land mass of 1,200 acres. In West town stand the ruins of a Norman round tower and ecclesiastical ruins which date from St Columba, who is reputed to have introduced Christianity into Tory Island and to have built a monastery, the ruins of which now form part of the historic landscape. The harvesting of iodine-rich kelp is a key element in human survival.

A trip to Tory Island, Co. Donegal, by members of the Royal Society of Antiquaries of Ireland, July 1895. ©RSAI.

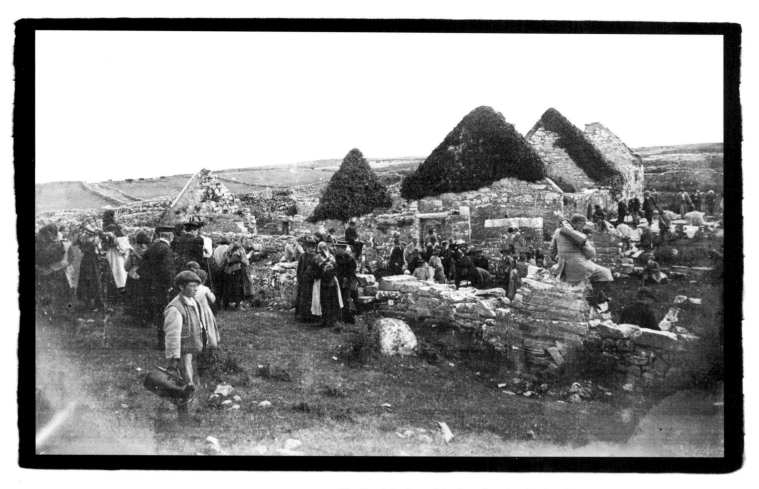

The Royal Society of Antiquaries of Ireland undertakes many journeys to ancient sites on the Aran Islands. The ruins are of Na Seacht dTeampaill (The Seven Churches) on Inis Mór. This is an ancient monastic site with two churches and several outbuildings. The members of the Society visited Inis Mór in 1895, 1897, 1901 and 1904.

A trip by the Royal Society of Antiquaries of Ireland to the Aran Islands. ©RSAI.

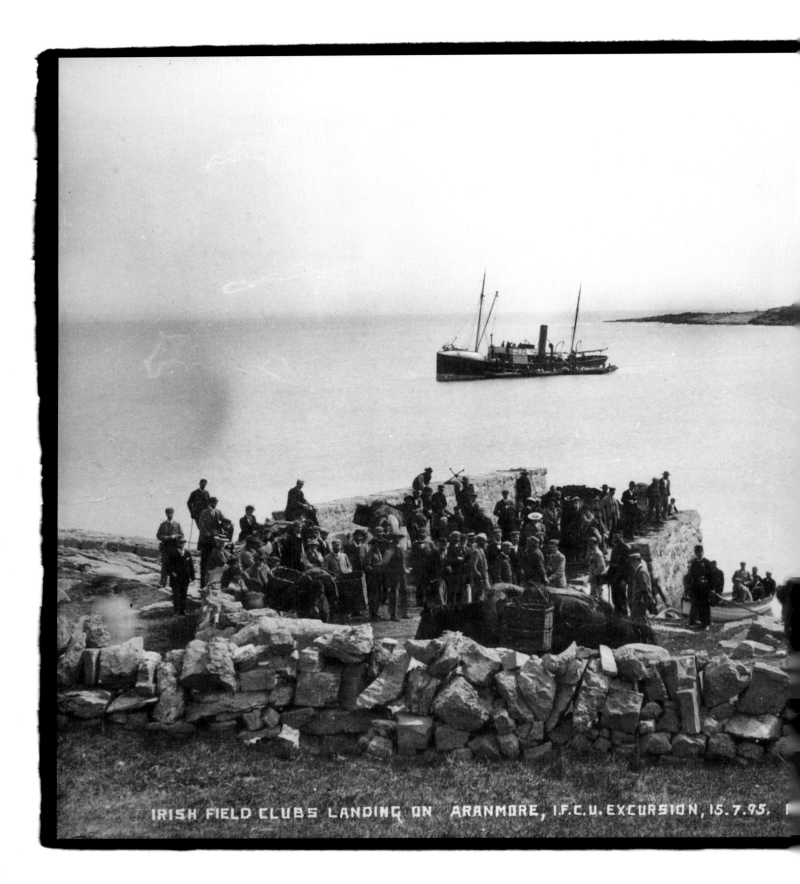

IRISH FIELD CLUBS LANDING ON ARANMORE, I.F.C.U. EXCURSION, 15.7.95.

Árainn Mhór, off the coast of Donegal. The stretch of water between the island and the coast is particularly dangerous, and there has been a lighthouse on the island since 1798.

The Irish Field Clubs landing at the pier on Árainn Mhór,
15 July 1895. WELCH©NMNI.

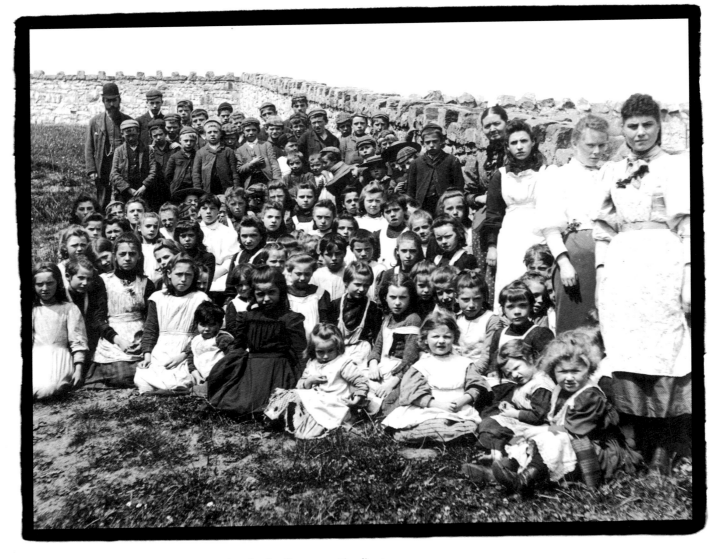

The photographer is greeted with various levels of response: the direct challenge of eye to lens; the more abashed, suspicious of what is essentially a new medium. The image is taken outside, as light will be an advantage in capturing an accurate image. The image could be from any part of Ireland — from the islands off Donegal, Galway or Mayo; from Ulster or from a rural school where attendance by local children has become the norm. Even accounting for dressing for the special occasion of a visit from a photographer, and a ready supply of fish, a basic level of physical well-being is evident in a land where, 50 years earlier, over one million people died in a series of devastating famines.

Group of children with teacher, and pupil-teachers, in a field. ©RSAI.

Physical well-being is dependent upon some form of employment. Domestic service remains a major source of employment for men and for women. In Waterford, as in many such large towns, the established professional house, and the Big House associated with English landowners and large farmers, relies upon the work of indoor and outdoor servants.

Mr Austin's servants, Waterford. POOLE©NLI.

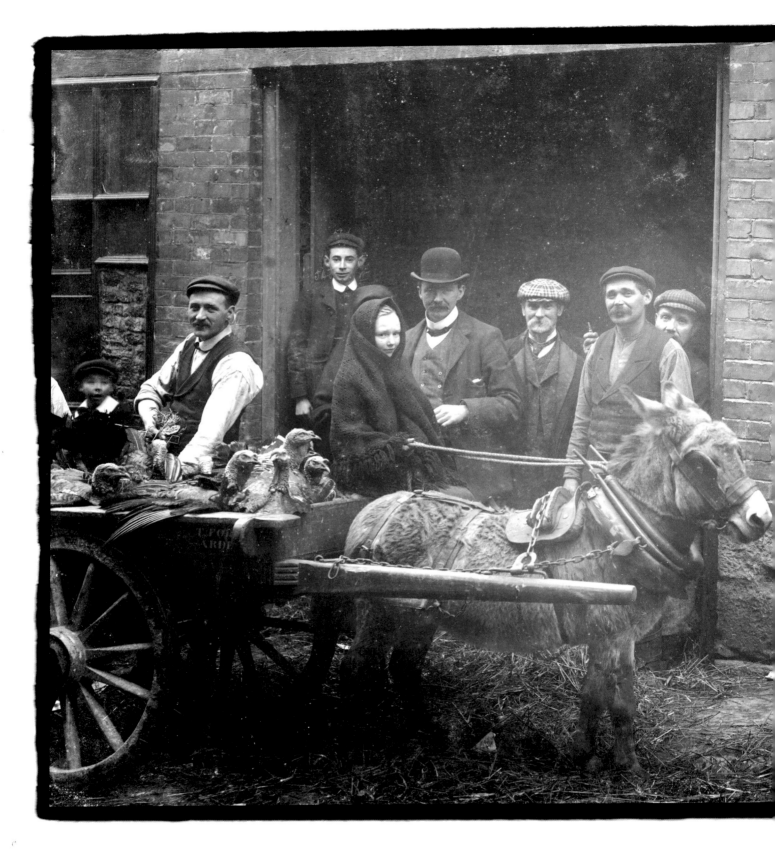

The role of an agricultural worker could be transformed by ownership of a donkey, the means of transporting goods and stock to markets or to shops in the town. The donkey was a key aspect of transportation of goods, and thousands of these animals were sent by sea and by rail across the island.

Flynn & Young's. The turkey seller, Waterford. POOLE©NLI.

The daily bread in many towns is now often purchased rather than baked at home, with regular employment extending the possibilities for women and girls to develop skills long nurtured in training schools of domestic economy, often overseen by nuns.

Mr Adair's bakehouse, Waterford. POOLE©NLI.

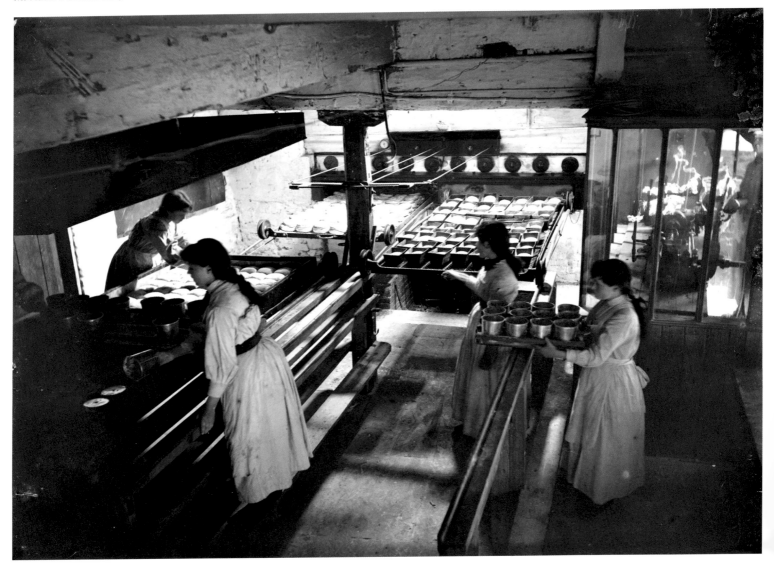

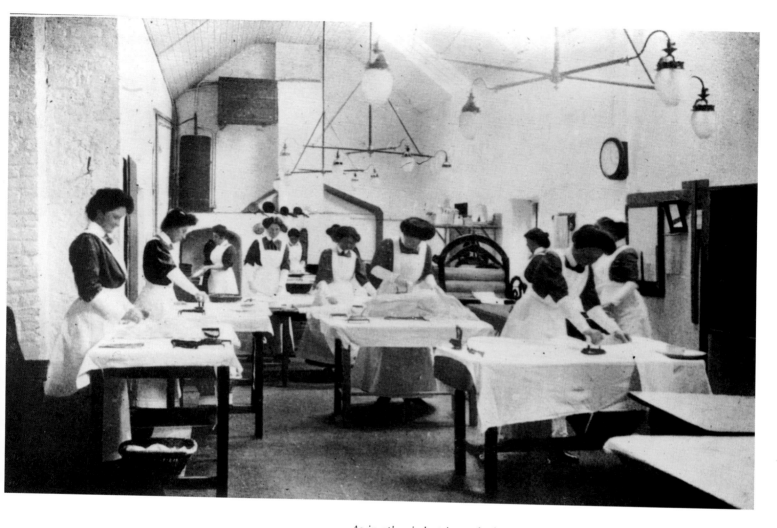

As in other industries and educational establishments, those training in domestic economy had emerged from penitential institutions and from within the confines of early industry. The two were uneasy bedfellows, with convent industries often charged with undercutting commercial enterprise. The laundries serviced the need for domestic and other establishments to either keep servants in-house, or to send laundry out. They were also attached to shirt and collar handwork, preceding the introduction of sewing machines for shirt and collar manufacture on a mass scale. By the late nineteenth century, Schools of Domestic Economy were designed to teach young women how to run a domestic establishment. Many had complained that Irish girls lacked a natural inclination towards domestication, as so many had worked in factories or as hired labour and so few had actually had a permanent domestic space. The basics of laundry work were first addressed.

Preparing to manage domestic and institutional establishments. MASON©NLI.

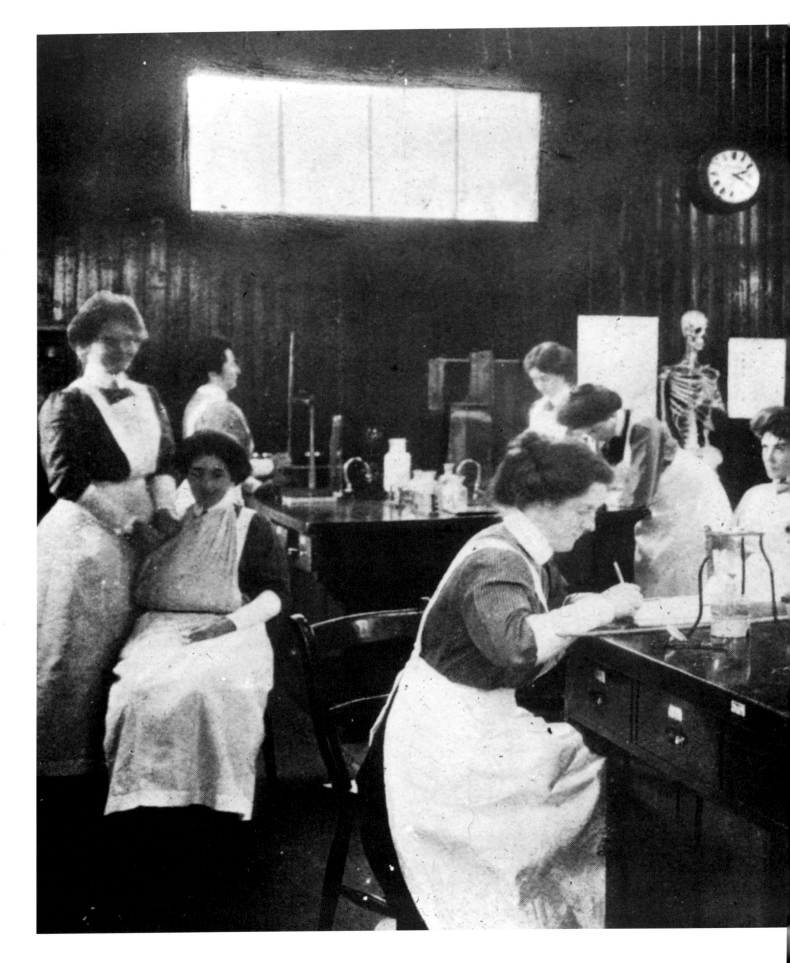

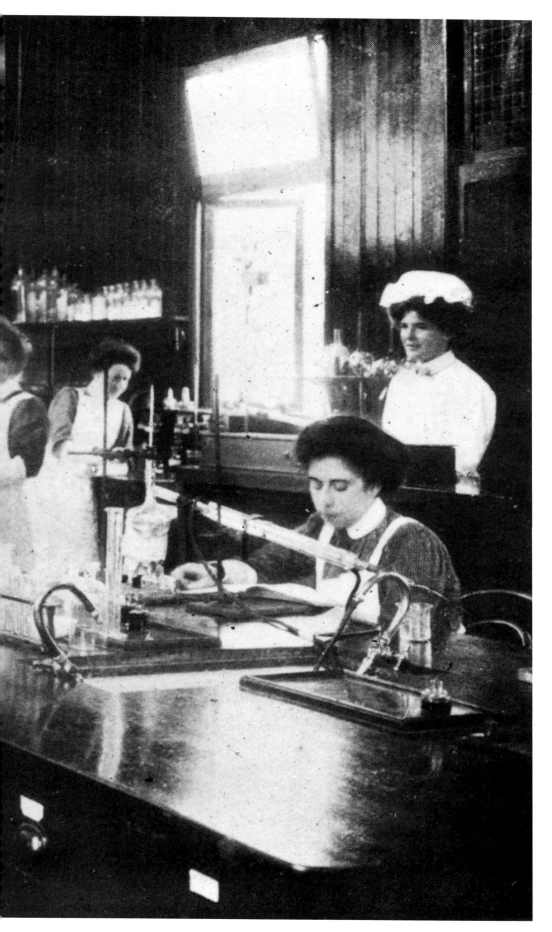

In time, the focus of Training Schools of Domestic Economy extended, with a scientific appreciation of nutrition and basic first aid on the curriculum, a training that expanded the possibilities for paid employment beyond the domestic economy.

Science/first aid in the training schools of domestic economy.
MASON©NLI.

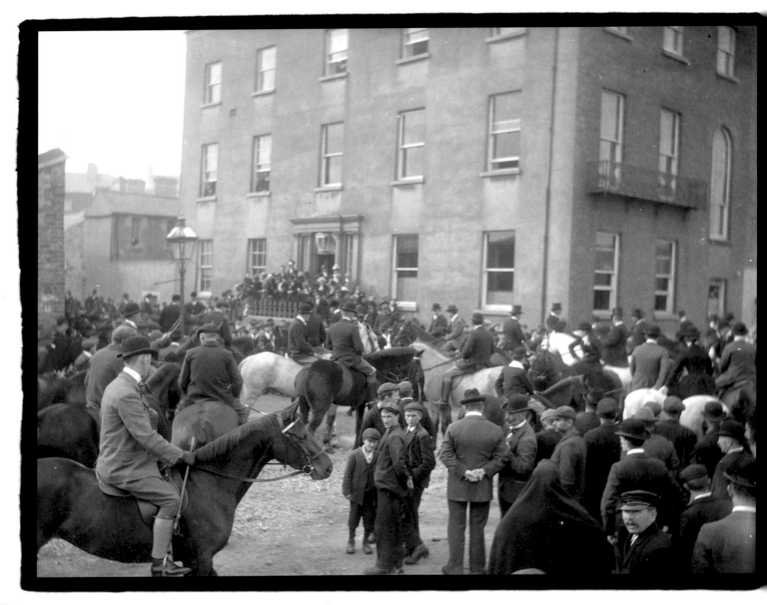

Life in the public space is indicative of shared interests across class lines. The Hunt, both a traditional rural practice and an aristocratic leisure pursuit, brings sport to a public space and, in its wake, servants prepare for the return of the Master and his companions for hospitality at table and accommodation within the stable and throughout the county.

Opening Meet of the Hunt, Co. Waterford. POOLE©NLI.

The history of horse racing in Ireland has little to do with the sport of kings. Sources from the seventh century indicate that in Ireland, as distinct from England, 'kings cannot be considered as of equal importance, and nor were they more important than the resident poet or scholar or bishop … This … marked social organisation in Ireland off from that of England where, by the year 800, there was already a steady advance towards a single unitary monarchy' (Bartlett, 2010). In Ireland, by contrast, power and authority were dispersed not just among kings but among other high status professions — clergy, poets, scholars, lawyers.

The races at Carrolls Cross, Co. Waterford. POOLE©NLI.

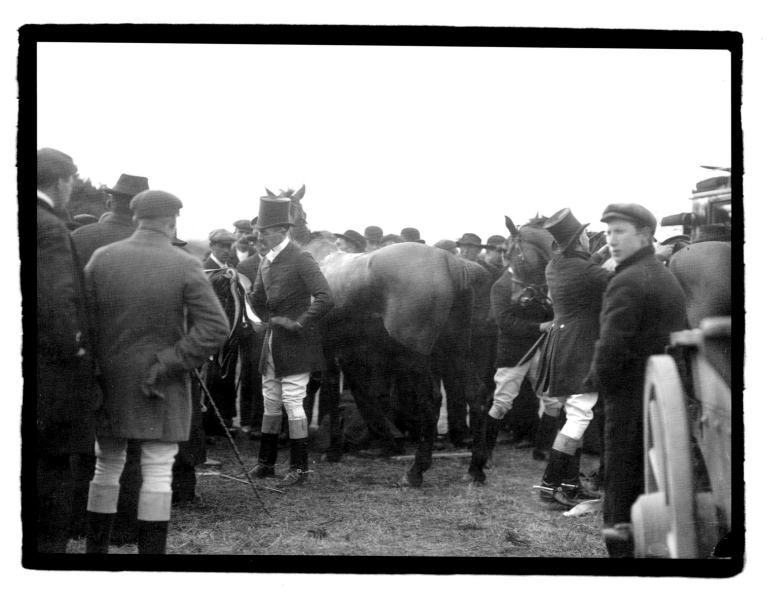

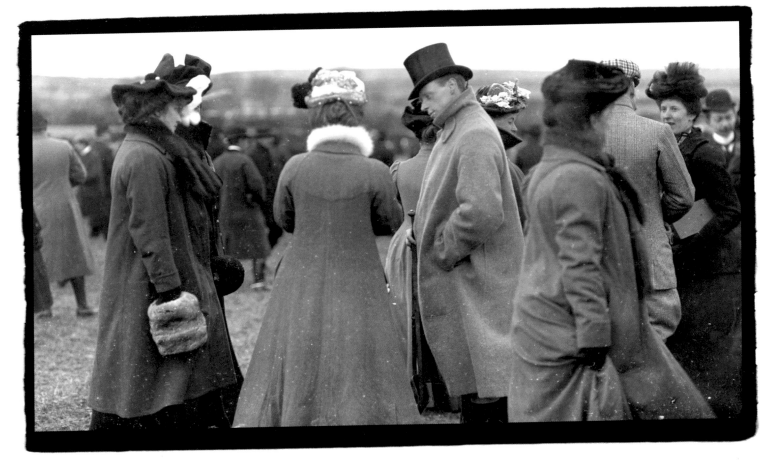

Although a 'limited' position, a king had officers with responsibility for séds, or personal treasures. 'There was a master of the horse who had charge of the king's stables and horses, under whom were one or more grooms' (Joyce, 1908). The saga of Cuchulain, preserved in the oral tradition, describes chariot horses, reputed to be antecedents of the Irish Draughthorse, the workhorse of Irish agriculture. The Anglo-Normans introduced a war horse in the twelfth century, and trade with Spain added to the bloodlines. The Irish draught has served in armies in Europe since the sixteenth century. The passion for horses in Ireland is, as with sailing, a sport with skills shared across class lines and with only passing regard for religious disposition.

The races at Carrolls Cross, Co. Waterford. POOLE©NLI.

Dungannon was the stronghold of The O'Neill, historically the foremost settlement of Gaelic Ireland. Hugh O'Neill, 2nd Earl of Tyrone, put the castle he occupied to the torch as the English forces advanced. In 1607 the Earls of Tyrone and Tyrconnell and their followers sailed from Co. Donegal, in the Flight of the Earls, their decision to leave Ireland for the European continent marking the historical end of Gaelic Ireland as a distinct political system. The Plantation of Ulster, the systematic colonisation of Ulster by the British Crown, followed, with the town and the castle at Dungannon granted to Sir Arthur Chichester, architect of the Plantation. Across Ireland, a day at the races is perhaps one of the most significant public spaces where the descendants of all who inherited the complex tapestry that has emerged from the history of this island, meet.

Ladies' Stand at the races in Dungannon, Co. Tyrone.
POOLE©NLI.

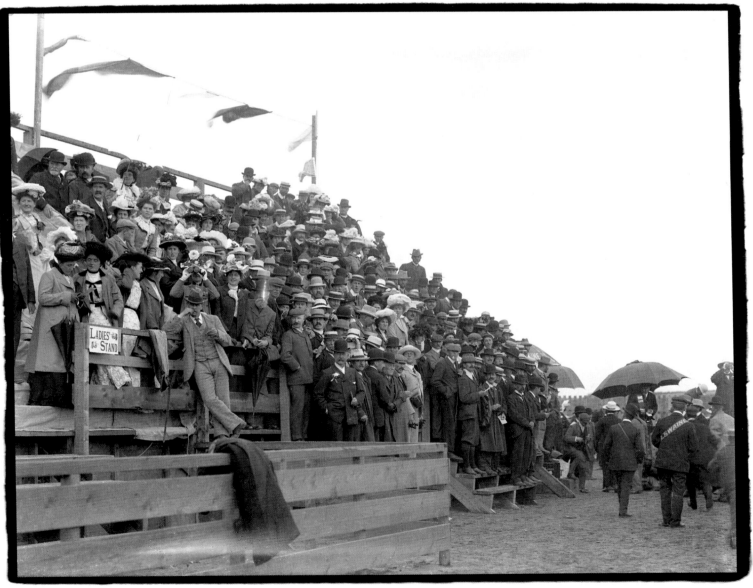

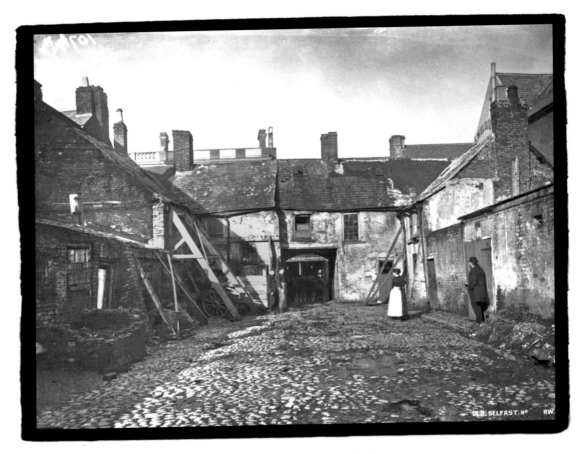

In other parts of Ireland ruins from an earlier legacy are listed for demolition. The Artillery Barracks were erected in the latter part of the 1700s to replace the old barracks situated in Ann Street. The Infantry Barrack was erected in 1792 to replace the military quarters in Barrack Street, and this became the main Belfast garrison. By 1894, the courtyard of the old barracks at Ann Street has become a site of miscellaneous trades, conducted in the courtyard leading from the barracks entrance.

Courtyard of the old barracks, Ann Street, Belfast. WELCH©NMNI.

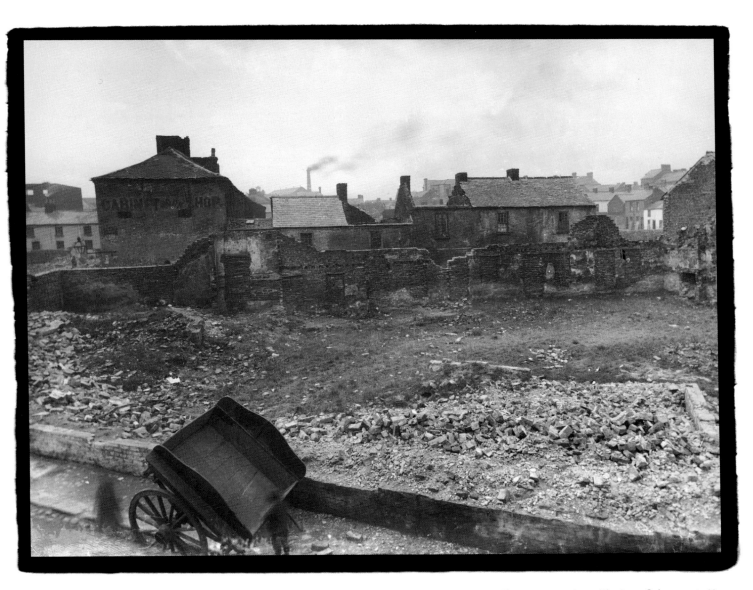

In Belfast, demolition in Little Donegall Street served a widening of the street. New housing would follow. The image is taken from the Turkish Baths. What may sound exotic for the middle of Belfast in the 1890s has a history: the earliest record of 'Sweathouses' in Ireland is from Ballytra, Co. Donegal. (Latocnaye, 1796) In Germany the Turkish Bath is reputed to be called 'the Irish bath', which may date from early excavations of Ireland by German archaeologists and ethnographers. The Return from Inspectors of Lunatic Asylums in 1870 reported that the construction of Turkish baths in the district asylums of Cork and Limerick 'as a remedial measure … appears particularly efficacious'.

Charles Street, view from Little Donegall Street (Turkish Baths) during demolition, February 1894. WELCH©NMNI.

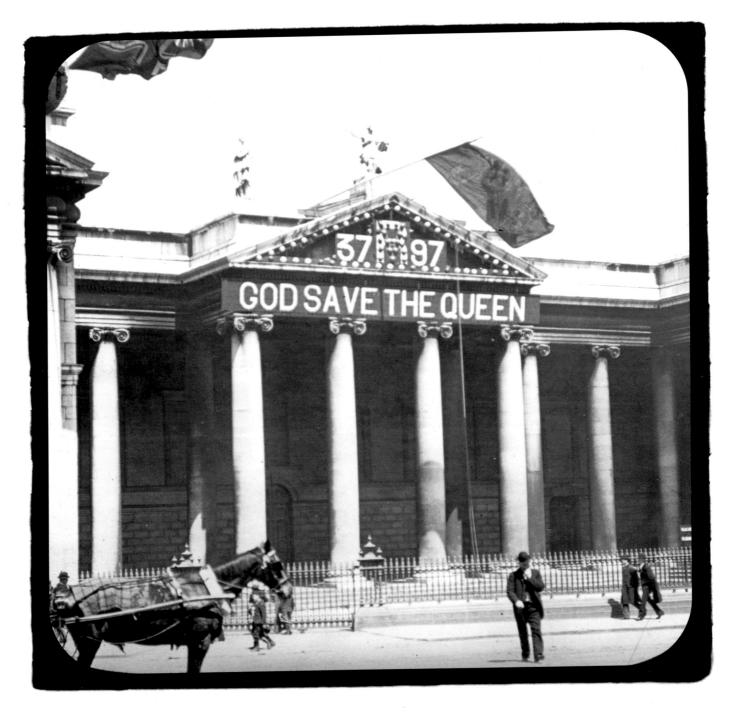

Work was also in progress in Dublin in preparation for celebrations to mark the 50th year of the reign of Queen Victoria, Empress of India and Queen of the United Kingdom of England and Ireland. College Green, the site of Grattan's parliament for the two decades before its abolition with the passing of the Act of Union in 1801, is the main focus for events to mark Victoria's jubilee, 1837–1897.

College Green, Dublin, the Jubilee commemoration. Ephraim MacDowell Cosgrave©RSAI.

The stand for dignitaries to gather for the official Jubilee commemoration was built in June 1897. Prominent amongst the guests would be the social circle surrounding the Lord Lieutenant, Dublin Castle. Support for the bond of Empire remained strong — administration of that empire by Irish men and women had secured the loyalty, authentic and nominal, of many; in the British armed forces, 'Irish soldiers continued to be over-represented' (Bartlett, 2010) and in the Royal Irish Constabulary the lower ranks were predominantly Irish and Catholic. Of the population resident in Ireland on the night of the 1891 Census, 4.58 million were Irish born; 123,176 were from Great Britain or were 'born abroad'.

Flags and bunting decorate the stand erected to mark official celebration of the Jubilee. ©RSAI.

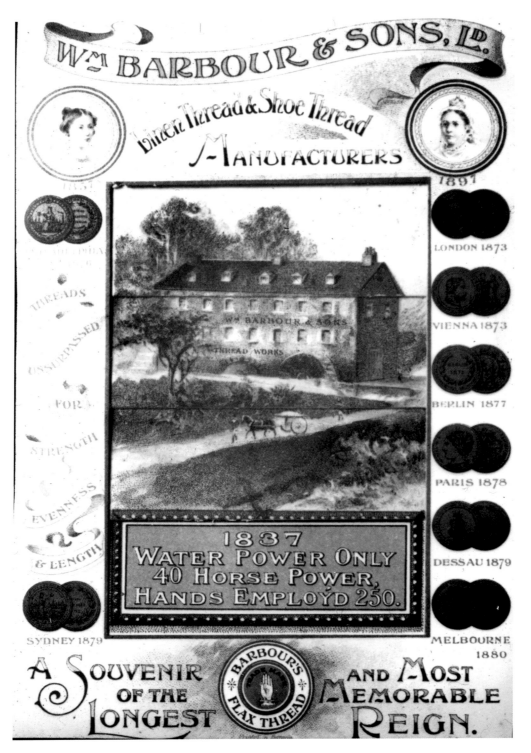

The celebration of Queen Victoria's reign became a focus for championing the long life of the Queen and the splendid trades that had been developed across her kingdom. The Hilden Mill at Lisburn was home to William Barbour & Sons Ltd, producing linen thread and shoe thread; from 1837 it went on to become 'the largest thread mill in the world', employing thousands of workers. The complex included a model village with 350 houses, two schools, 'a common playground' and a village sports ground.

Wm Barbour & Sons Ltd. Souvenir of the Longest and Most Memorable Reign. MASON©NLI.

The Grand Orange Hall of Ireland in Rutland Square hosted meetings of County Dublin Grand Orange Lodge and others. LOL No. 1682 (John R. Fowler Lodge) met at the Orange Hall in York Road, Kingstown, and LOL No. 1505 met at the Protestant Hall, Upper Rathmines Road. The lodges, and the political aspirations associated with the Orange Order, were central to the religious and cultural identity of its members. On 23 June 1897, a day of celebration to mark the Jubilee year, 'lantern slides of recent evictions are shown to a growingly agitated crowd'. These slides were marketed and used to illustrate less pleasing aspects of life under the Union. However provocative the context, rural evictions of Irish families were widespread and ongoing. As reported in the papers the following day, disorder began in Dame Street, initiated by the 'corner boy class', and later spilled out onto the north side of the Liffey. Riots ensued, and by morning the Grand Orange Hall in Rutland Square bore evidence of a street skirmish.

Grand Orange Hall of Ireland in Rutland Square, Dublin. Ephraim MacDowell Cosgrave©RSAI.

Commemoration in the public space had become a focus for registering dissent and for the representation of iconic events to mark the politics of a different vision, that of the United Irishmen. The 1798 Rebellion had been marked by a campaign of terror, 'Reports of half-hangings, floggings, pitch-cappings and house-burnings conducted principally by the North Cork militia, under the direction of loyalist magistrates ...' and 'the summary execution of some thirty four suspected United Irishmen ... In terror, the peasantry — United Irishmen or not — prepared to resist.' The 1898 centenary of the 1798 Rebellion was marked in Mayo, Wexford, Belfast and Antrim-Down. (Bartlett, 2010)

The 1798 commemoration parade on Bridge Street Lower, Belfast, 15 August 1898. Ephraim MacDowell Cosgrave©RSAI.

Challenge, and action taken to address less political and more industrial grievances, also occupied the public space, attracting crowds — and the attention of the Royal Irish Constabulary. The 'Pig Strike' in Waterford in 1897 arose from an old grievance: the bacon factory owners had, since the early 1880s, moved to deal directly with farmers, seeking to exclude the services of middlemen — the professional pig buyers. The pig buyers took action to reassert their position in the trade.

The 'Pig Strike', Waterford, 1897. POOLE©NLI.

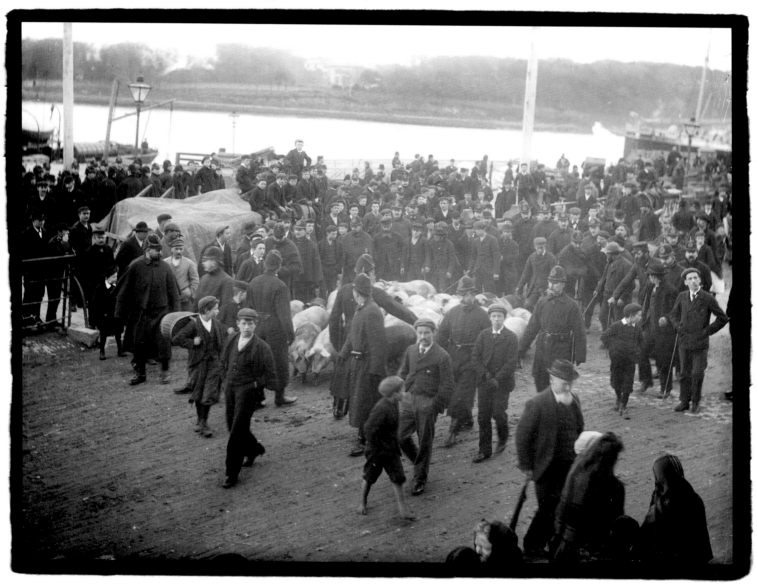

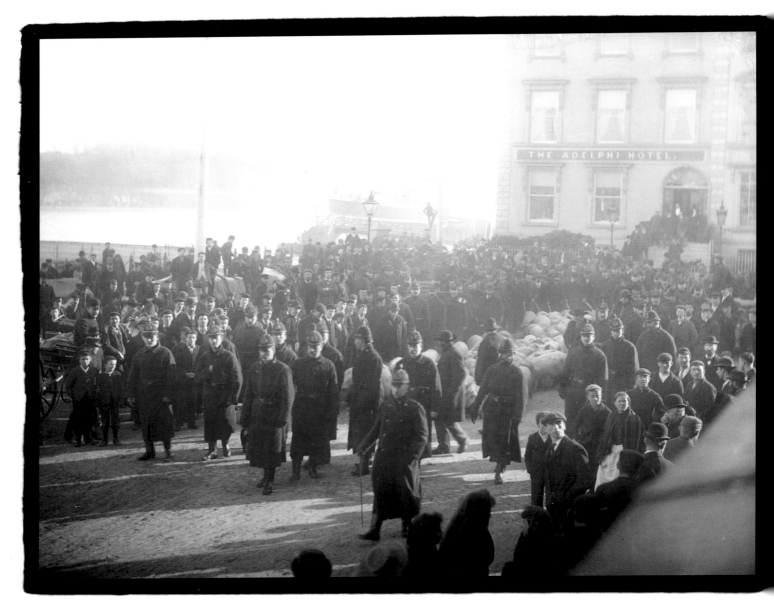

As part of their strategy, the pig buyers sought to purchase all pigs as they were herded across the bridge towards the Adelphi Hotel. The RIC moved to protect farmers from being forced to sell. The pig buyers were charged and tried for a number of crimes arising from the dispute.

The 'Pig Strike', Waterford, 1897. POOLE©NLI.

Outside the cities, a sense of order prevailed, despite changes in land ownership and control. In Ardara, Co. Donegal, where the Congested Districts Board had invested in the development of lace-making schools, an Embroidery Depot was established. Organisations in England, including the Donegal Industrial Fund and the Irish Industries Association, were connected to the agents in Ireland, who delivered and collected goods from such depots and sought a market for the cottage industry of handmade lace and embroidered goods.

Ardara, Co. Donegal. A Congested Districts Board embroidery depot. WELCH©NMNI.

A more leisured class, with the resources to pursue esoteric interests, added significantly to the knowledge of molluscs and related fields of scholarship in remote parts of Ireland. Specimens from enthusiastic and learned amateurs often became absorbed into local and national collections open to the public.

The snail hunters, Murlough Bay, Co. Antrim, May 1897. WELCH©NMNI.

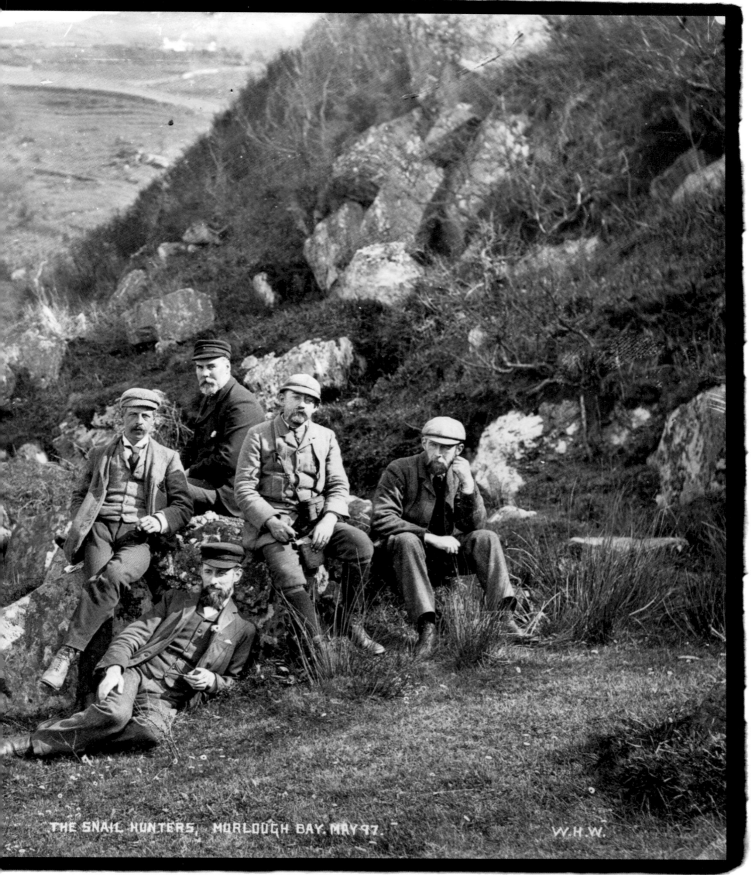

THE SNAIL HUNTERS, MURLOUGH BAY. MAY 97. W.H.W.

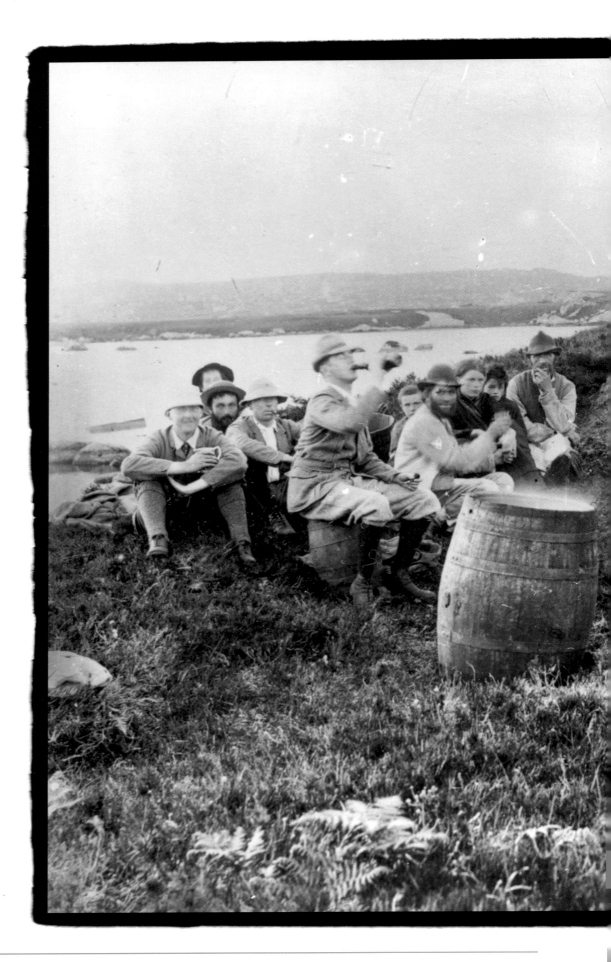

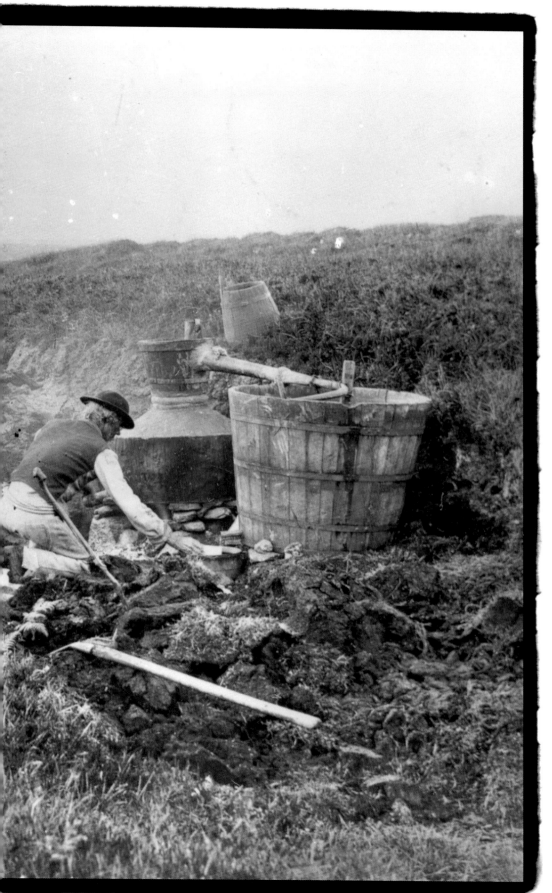

*Other forms of knowledge, addressing the
hidden depths of distillations from illicit
stills, were often pursued at the close of
the working day. Acquiring a taste for the
cultural inclinations of some of the Irish
was generally clandestine.*

Group at poteen still. WELCH©NMNI.

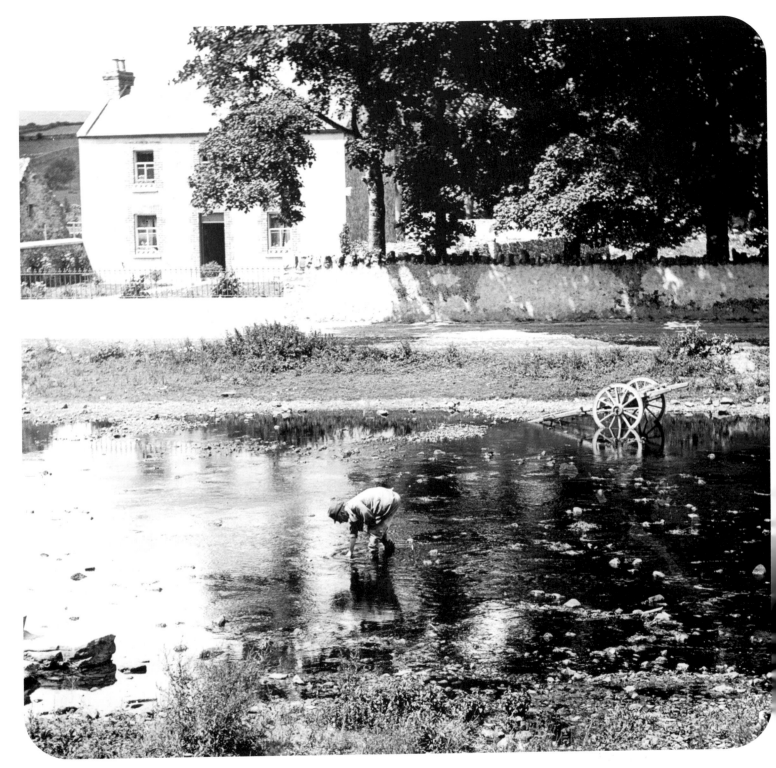

The highly skilled labour of lace-making and embroidery was not reflected in the level of payment received by young girls and women. Handmade goods graced the tables of royalty, served as grace-notes on fine underwear, and became an element in the designation of 'cottage' and 'peasant' industries, such as pearl dredging, in respect to the generating of rural employment in Ireland.

Co. Tyrone: 'peasant' fishing for pearls in river. MASON©NLI.

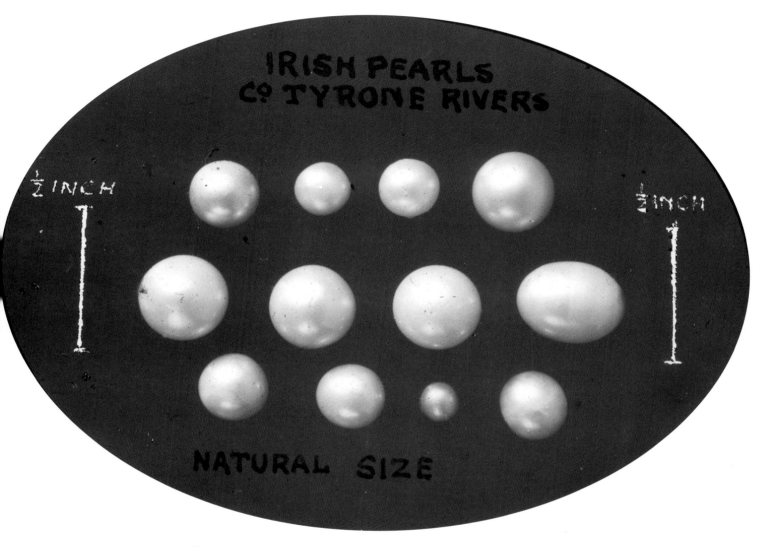

How extensive such 'peasant industry' was in Tyrone or elsewhere is difficult to judge. That there was a market, and an appetite for Irish industry and resources to be developed, is evident from the commercial argument advanced to favour such enterprise.

The science in favour. MASON©NLI.

An industry capable of development. MASON©NLI.

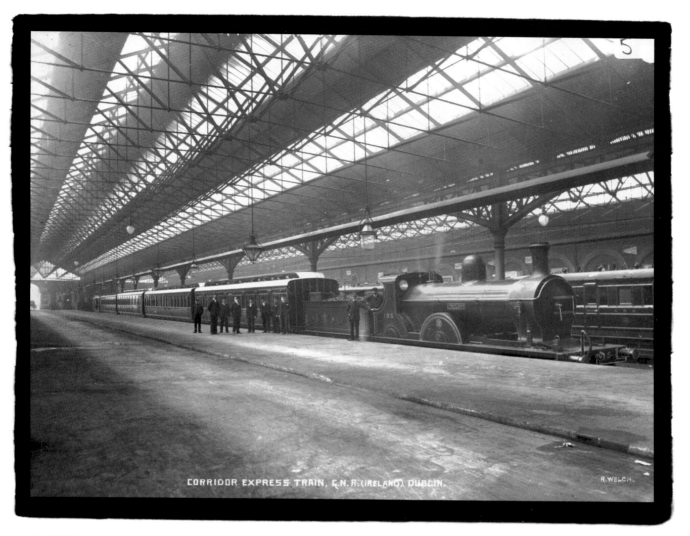

CORRIDOR EXPRESS TRAIN, G.N.R. (IRELAND), DUBLIN.

R.WELCH.

By 1900 businessmen and traders, administrators and professionals and others of the prosperous classes were taking the corridor express train hauled by the Great Northern Railway (GNR) Q Class 4-4-0 locomotive 135 'Cyclops' from Amiens Street Station in the centre of Dublin and heading north to Belfast. A number would change at Dunleer for the line to Ardee.

'Cyclops' at Amiens Street Station, Dublin, 1900. WELCH©NMNI.

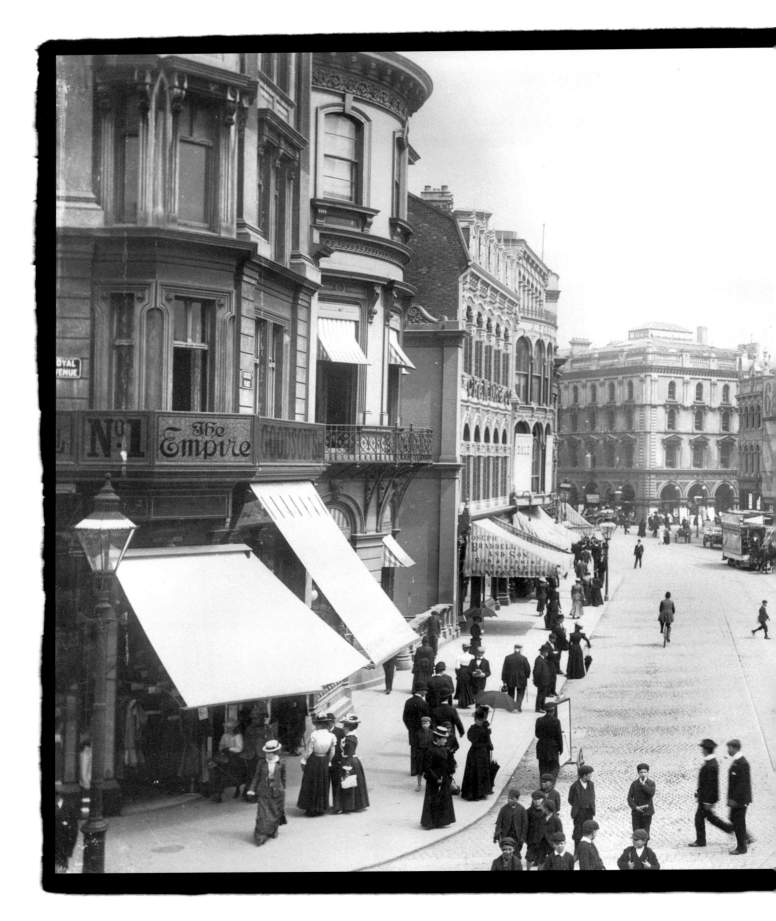

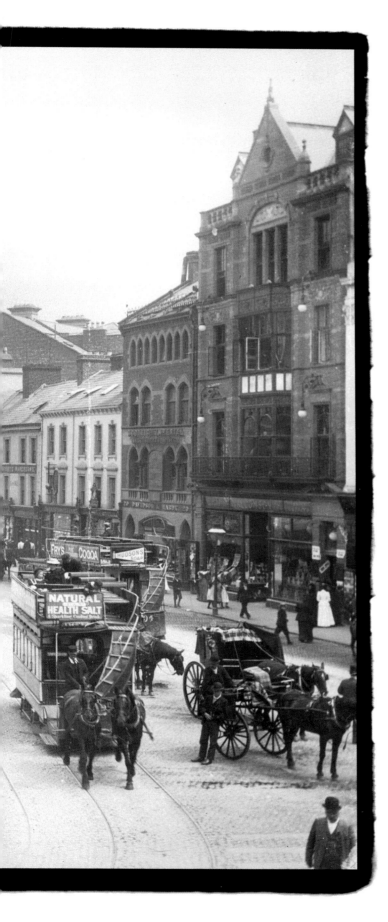

The stamp of Empire on Ireland governed the cultural architecture of much of the streetscape, both urban and rural. In Belfast, as in Dublin, trams and jarveys share wide streets and the formal frontages of a bustling consumer-oriented society. As the Victorian era drew to a close in Belfast, with the fortunes of textiles tangible in the massive scale of mills and factories, change was imminent: by the beginning of the twentieth century, flax was being imported from Russia, Holland and Belgium, and wool from the British colonies of New Zealand and Australia.

View from Royal Avenue corner, Belfast, looking towards High Street, 1897–1902. WELCH©NMNI.

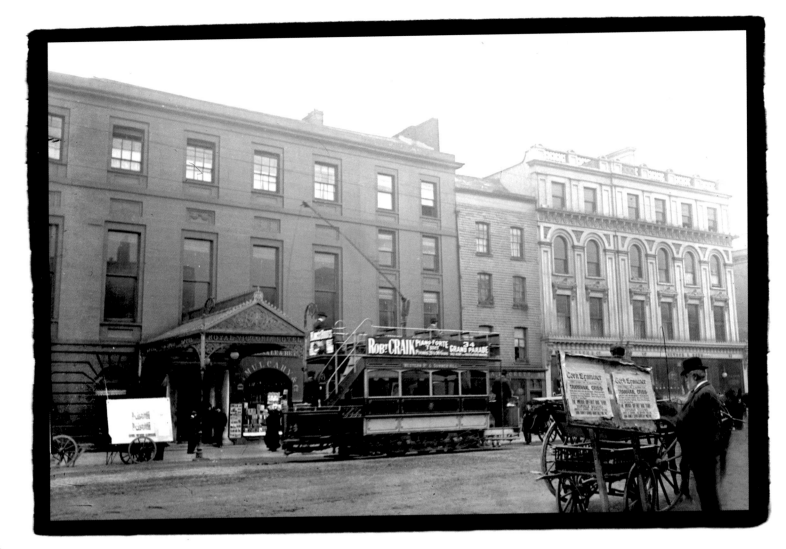

The ties to Empire were implicit in the network of Ireland's railways, in many senses disproportionate to the immediacy of demand on the island. The sophistication of engineering represented within a largely agricultural economy was a connecting line to the ambitions, and access to the wealth, of an empire. Those ambitions and the connections began to appear less easy to assume with the news from Africa on the Second Boer War. In many parts of Ireland, nationalist support for the Boer republics, and against the imperial war, was significant; in Ulster, support for the Union extended to support for imperial ambitions in Africa.

Tram stop outside the Victoria Hotel, Cork. A gentleman peruses the Cork Examiner in 1900 for updates on the Boer War. ©EXAMINER.

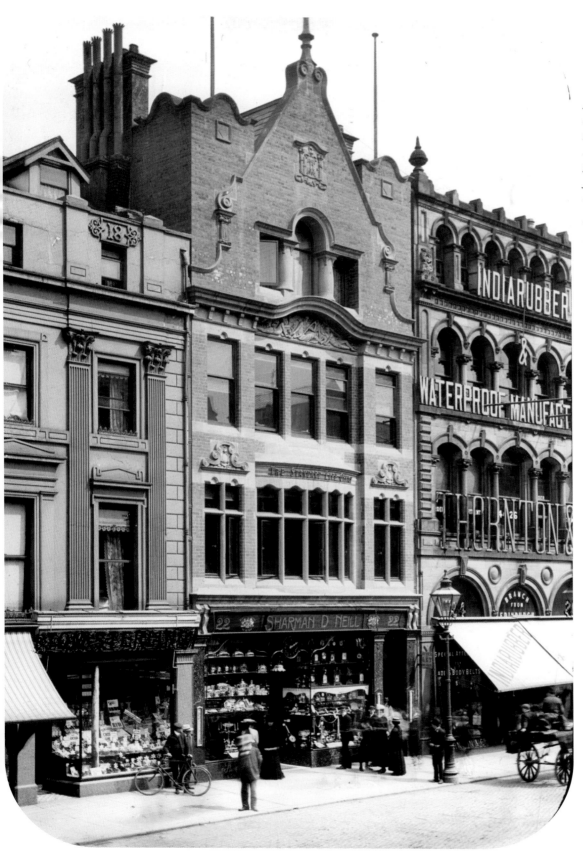

An increasingly divided economy and society was reflected in the shopfronts of Belfast and Dublin. Sharmon D. Neill supplied 'brush gold ornaments and Antique jewels', including diamonds and Irish pearls.

The exterior, Sharman D. Neill, Merchants, Belfast. MASON©NLI.

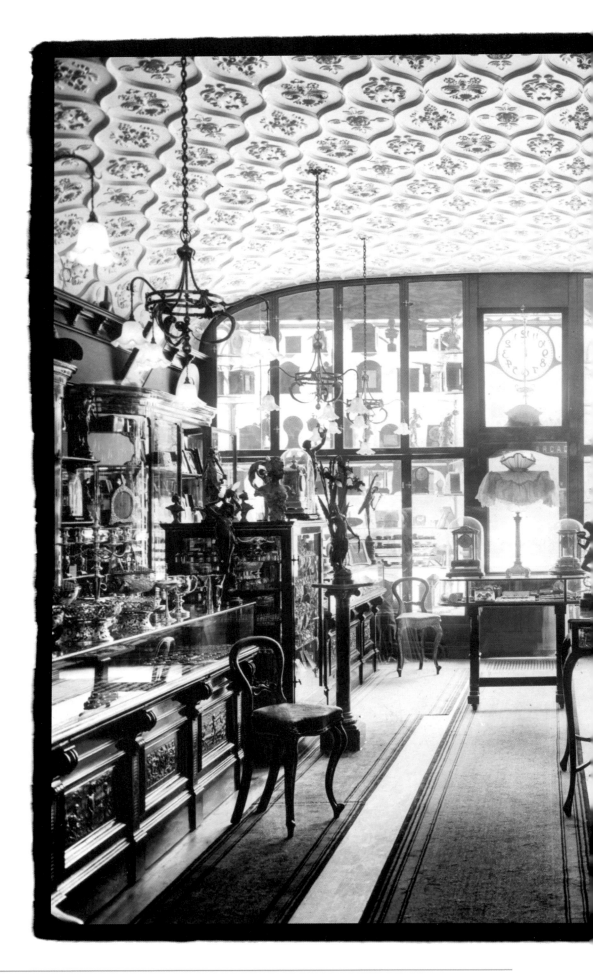

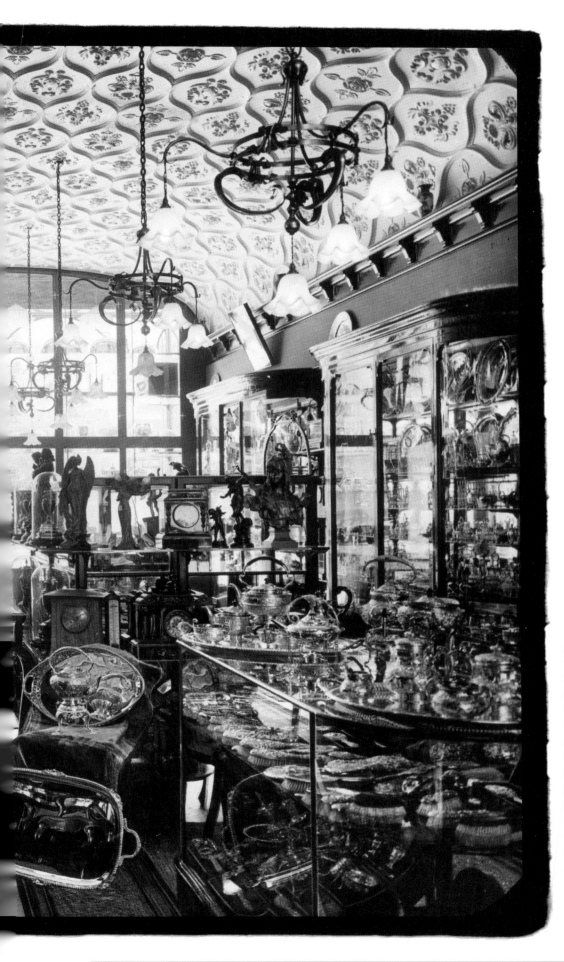

Ireland had the capacity for generating vast wealth — through landownership and mining and the scale and prosperity of its industries, from textiles to shipbuilding. There was a settled landed class, often maintaining houses in Ireland and in England; there was also an aspiring merchant class, seeking titles as they extended their estates; and an established professional class, many of whom had acquired a refined, often cosmopolitan, taste and style. The demand for the exotic and the most mundane of commodities was as well met on the streets of Belfast and Dublin, as it was in London and Paris.

The interior, Sharman D. Neill, Belfast.
MASON©NLI.

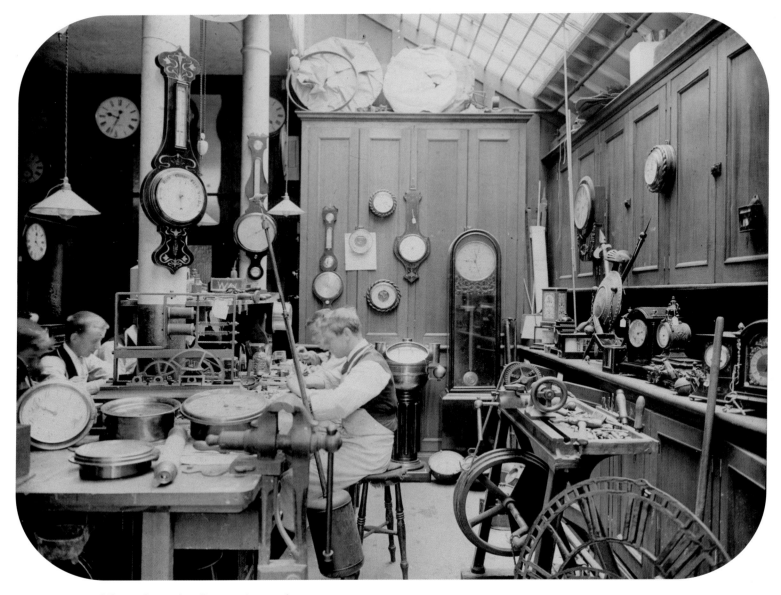

While much merchandise was imported, a body of highly skilled craftworkers, employed in instrument-making and silver and gold and diamond ornamentation, was, authentically, 'Made in Ireland'.

Workshops: craft / instrument makers.
MASON©NLI.

1901—1911

1901 Excessive subdivision of holdings has ensured that beyond securing a future, however constrained, for the first-born son of a dwelling, movement away from the land, and perhaps from Ireland, is inevitable.

Queen Victoria is dead. The Victorian era has left in its wake the trademark of an empire, with goods produced in the Orient traded in the bazaars and emporia of Delhi, Belfast, Dublin, London and beyond.

The British Independent Labour Party is established. Keir Hardie, the founder, is in Belfast to establish a branch. The United Irish League, with more than 100,000 members, demands Land Purchase.

1903 King Edward visits Ireland. The Wyndham Land Purchase Act passes into law. For some it is 'a disaster though it provided a short-term solution to their financial problems'; for others, 'the Wyndham Act sealed the fate of many landed gentry'. A later scholarly study of the sale of estates demonstrated, however, '… that the sale of landed estates in the north of Ireland acted to place many northern landlords in an economically stronger position than they had previously been' (Purdue, 2009). The Act introduced, courtesy of the coffers of the Union of Great Britain and Ireland, a system of 'peasant proprietorship', a deft accounting of the benefit of Union, and a foundation of great and sustained conservatism across an island where the prospect of radical, agrarian reformation had, for a brief moment, threatened an empire.

1904 Southern unionists, including businessmen and bankers, draw up plans for the devolution of power from London to Dublin. The move provokes a tactical response from Ulster: the Ulster Unionist Council is formed.

Cultural nationalism thrives in Dublin, and a star appears in the literary firmament: the Abbey Theatre, offspring of the twin pleasures, and pain, of Anglo and Irish civility.

1905 The first issue of the *Irish Independent* is published, the first halfpenny popular paper in Ireland. The owner, William Murphy, is a director of the Dublin Central Tram Company, later the Dublin United Tramways Company, and supplied part of the capital to establish Clery & Co. with a commitment to the 'Ready Money System' of no credit, all cash.

Sir Edward Carson is involved in the establishing of the Ulster Unionist Party, a move in response to the threat to the Union posed by the Home Rule crisis in Ireland. The decisive Conservative and Unionist defeat in January 1906 removes many of his ministerial rivals, leaving him free to emerge as one of the most prominent politicians in the United Kingdom.

Arthur Griffith, editor of the *United Irishman*, founds Sinn Féin, 'we ourselves', to serve as an umbrella organisation incorporating 'all brands of nationalism with the exception of Home Rule'. He had condemned the visit of King Edward VII to Dublin in 1903, but in a pamphlet published in 1904 articulated 'his ideas on Irish independence under a dual monarchy, like that of Austria-Hungary', and in 1905 elaborated a concept of national self-reliance.

1906 The Liberal Party wins the General Election with a huge majority, diminishing the need to offer Home Rule to the Irish Party.

1907 James Larkin, son of Irish emigrants to Lancashire, arrives in Belfast as temporary organiser for the National Union of Dock Labourers. His landmark achievement is to

bring Protestant and Catholic workers to share in a common struggle for worker rights.

The Vatican issues the *Ne Temere* decree, a declaration of Catholic matrimonial law requiring the children of mixed marriages to be raised as Catholics. The differing theological views of Catholic and Protestant provoke hostility amongst Protestants in Ireland and elsewhere.

The Playboy of the Western World, written by John Millington Synge, opens at the Abbey Theatre, Dublin, on 26 January. It is set a little too close to home, in Michael James Flaherty's public house in County Mayo in the early 1900s. Riots follow the opening performance of the play: a case of patricide, infected by what is deemed the improper use on a public stage of the term 'shift'.

1908 The Irish Women's Franchise League is established by Hanna Sheehy Skeffington with Margaret Cousins as treasurer. Unlike many other suffrage groups, it is associated with Irish nationalism and the cultural revival.

The Universities Act (Catholic Universities of Ireland) establishes university colleges in Belfast, Cork, Dublin and Galway. Since 1793 Catholics have been permitted to take degrees in Trinity and in 1873 all Trinity's religious tests, except those connected with the Divinity School, are abolished.

The *Ne Temere* decree comes into effect at Easter 1908. Although neither Protestant nor Roman Catholic Churches favour mixed marriages, the decree defined marriages by non-Roman clergy as legal, but not valid. It is, however, the requirement to raise the children of mixed marriages as Catholic that provokes contention.

The British Old Age Pension Act is introduced by Prime Minister Herbert Asquith, the prelude to a budget to be introduced by Lloyd George which will represent the first serious political challenge to propertied and inherited wealth within the Union. A pension of five shillings a week will be paid to all subjects of the Union aged 70 years or over.

1909 The Irish Transport and General Workers Union is formed by Jim Larkin, recently living in Dublin following his dismissal by the Dock Labourers Union, and by James Connolly, founder member of the Irish Socialist Republican Party. The establishing of Trade Boards is to address hours of work and conditions of labour in sweated industries.

An Irish branch of the Conservative and Unionist Women's Suffrage Association is established in Dublin, and the Irish Women's Suffrage Society is formed in Belfast.

Bulmer Hobson, the Irish Republican Brotherhood, and Countess Markievicz establish the Fianna, a nationalist boy scout movement and recruiting ground of the Irish Republican Brotherhood.

Under the Liberal government at Westminster, Lloyd George, Chancellor, introduces his 'People's Budget' threatening social reform through taxation, including taxation on land. The budget passes through the Commons but is defeated by the Conservative majority in the House of Lords.

1910 Asquith calls an election to curtail the power of veto by the House of Lords. The Liberal government is re-elected, with the Irish Party holding the balance of power. The 'People's Budget' is passed. The interests of the landowning elite in Ireland are tempered by the legislative curtailing of

their rights, and by the increasing power of merchants, professionals and, to an extent, the organised working class of Belfast.

1911 Carson accepts James Craig's invitation to lead the Ulster Unionists. Craig, Unionist MP for East Down, is of Presbyterian background and a founder member of the Belfast Stock Exchange, who served in the Royal Irish Rifles during the Second Boer War. He is central to the Ulster Unionist Council and the Orange Order. The UUC threatens to establish autonomous government in Ulster if the Home Rule Bill is passed. Arthur Balfour resigns as leader of the Conservative Party.

James Connolly, Ulster District Organiser of the Irish Transport and General Workers Union, arrives in Belfast to begin the organisation of dockers and mill workers. In Dublin, *The Irish Worker* calls for the formal recruitment of women workers into a trade union. The era is driven by electricity: turbines fuel the wheels of industry and the generating of power.

The National Insurance Act permits workers who subscribe to claim unemployment benefit at statutory exchanges.

Carson becomes leader of the Irish Unionist MPs at Westminster but refuses to contest the leadership of the Conservative Party when Arthur Balfour resigns on 8 November 1911. Carson's primary loyalty is to the Union, and he is recognised as 'an Irish patriot but not a nationalist'.

A new building for the Royal College of Science of Ireland and the Department of Agriculture and Technical Instruction at Upper Merrion Street is opened in 1911 by King George V. It is 'the last major public works investment of the British government in Ireland'.

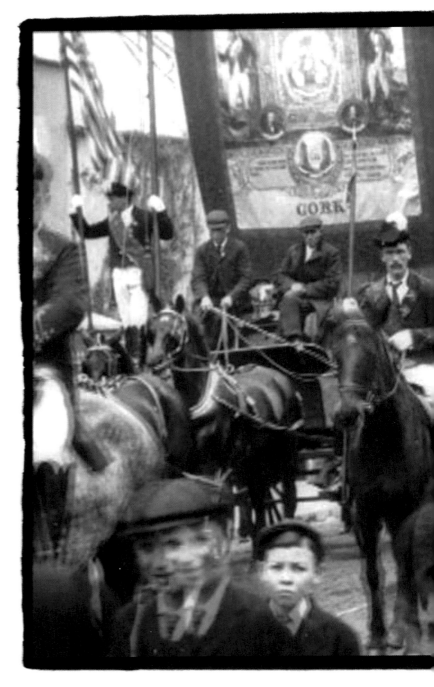

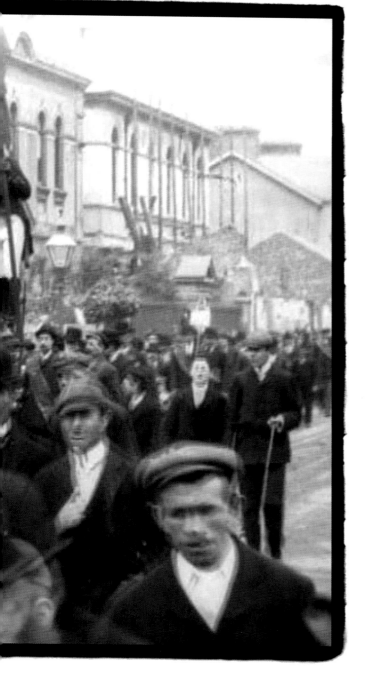

The opening of the Cork Exhibition in 1902 was indicative of a sense of confidence that industry, manufacturing and harnessing the resources of agriculture augured well for the future of Ireland. Exhibition halls housed industrial, agricultural and artistic displays. The opening of the first store of the Co-operative Movement in Doneraile, Co. Cork, had been prelude to the spread of an enormously successful economic movement across Ireland including creameries and credit societies, and by the early twentieth century had a membership of almost 50,000. After the Cork Exhibition officially closed in November 1902, another exhibition in 1903 on the same site included, amongst its many visitors, King Edward VII and Queen Alexandra.

Procession for the opening of the Cork Exhibition, 1902. ©EXAMINER.

When King Edward VII and Queen Alexandra visited the Cork Exhibition they may not have been made aware that confidence in the Union of Great Britain and Ireland was being undermined by continuing evictions. Density of population in already poor housing may have made this community prime candidates for 'improvement', but the role of agricultural labourers on an island where tillage had been replaced by pasture, where the success of the co-operative movement had verified an appetite for labour, and where the land war had revealed a hunger for security of tenure on land worked, evictions were a short-term benefit in a most costly squandering of goodwill.

Evictions at North Cork, 1903. ©EXAMINER.

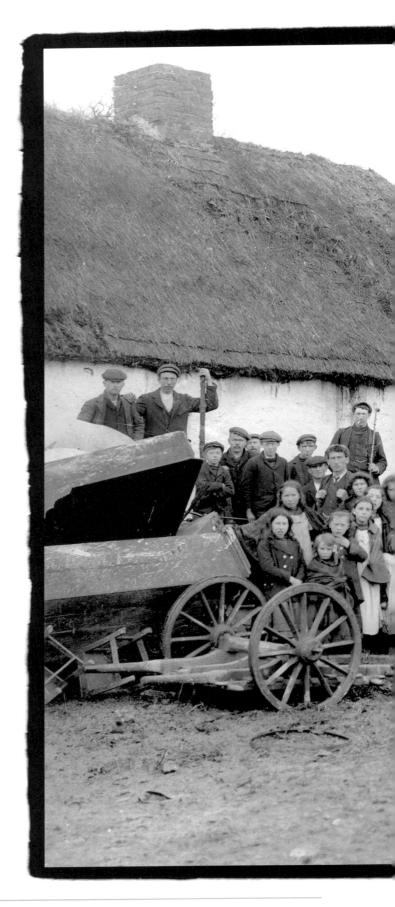

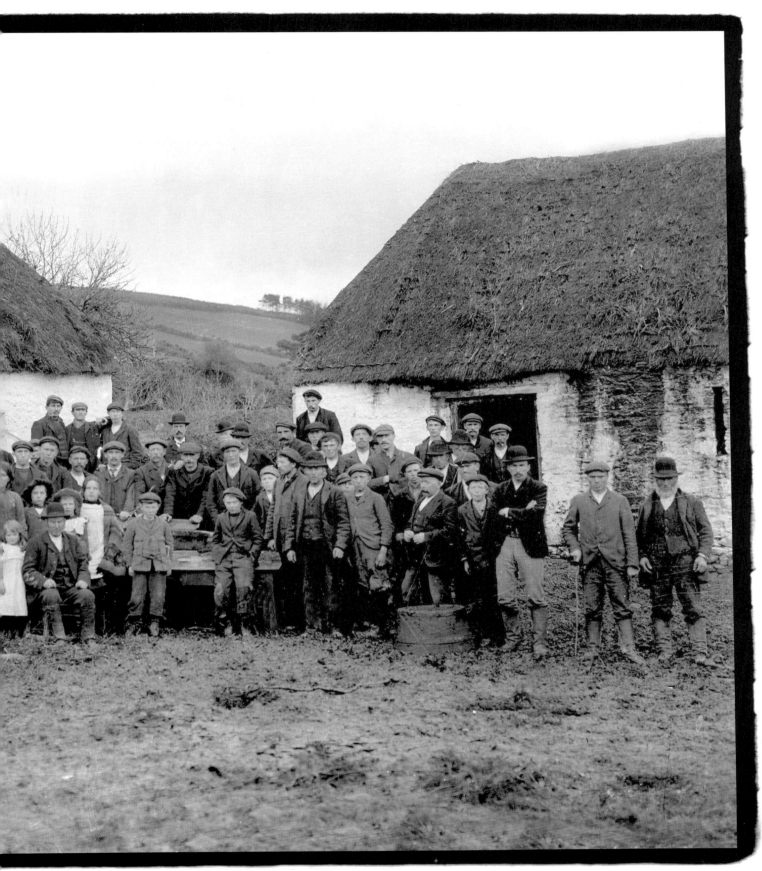

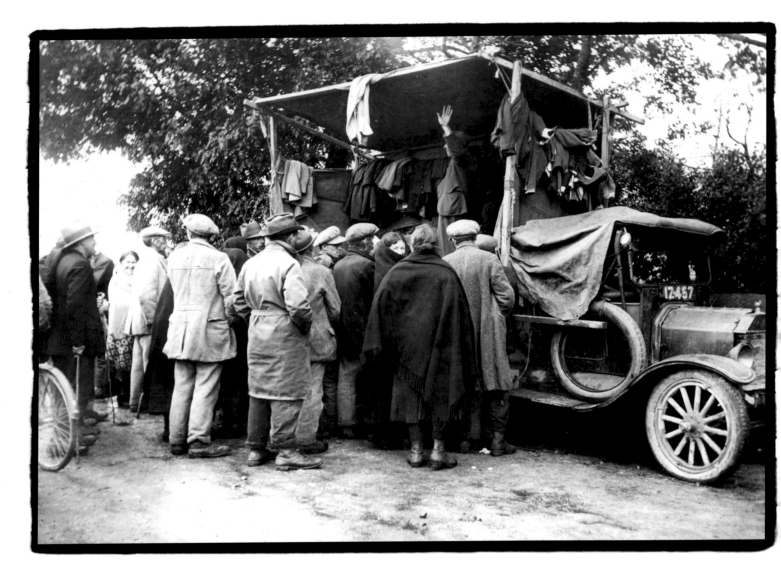

For many, evictions led directly to a life on the road, evidenced in the dress of 'consumers' at this roadside trader's truck; a safari jacket, panama hat and raincoat may have graced earlier, more prosperous backs on the landed estates across the island.

Roadside clothes trader. MASON©NLI.

EVICTION SCENE AT GLENBEIGH.

In Glenbeigh, Co. Kerry, the evictions harnessed the combined forces of landowners, the Royal Irish Constabulary and 'onlookers'. In Early Irish Law, based on the Old Irish law-texts originating in the seventh to eighth centuries AD, what was called cin súlo *(crime of the eye), commonly referred to 'looking on', with legal commentary upon this crime being 'among the four things which debase a lord and his family', on the grounds that 'everyone who looks on at an offence consents to it':* aititnech gach aircsinach. *(Kelly, 1995) This has often been translated into the concept of 'culpable onlooker'.*

Magic lantern: eviction scenes at Glenbeigh, Co. Kerry. MASON©NLI.

The state of the Union

Late marriage in Ireland has become 'traditional', and in 1901 over half of all women between 25 and 34 are celibate: in the decade that follows, of over 14,000 women who leave Ireland, the majority are young, single and will bear a future generation of Irish children in places other than in Ireland.

In Dublin, many continue to live in tenements: 37 per cent of Dublin families live in one-room accommodation. In London only 15 per cent do so, and in Belfast one per cent. In Dublin, many also live in artisans' dwellings in townships and suburbs; others in red brick villas and terraces of Victorian, and in faded Georgian, splendour. Sackville Street and Nelson's Pillar are at the hub of a city life organised around long working hours, the cultivated consumer habits of a leisured class and an efficient and expanding system of public transport. In Belfast, housing stock has increased with the expansion of the industrial landscape, the migration of working people from within the island and from within the Union, and now includes 'streets of terraced "kitchen-and-parlour" houses … built to accommodate the workers from the mills, factories and shipyards' of a prime industrial city of the Union.

The Sister Nation of Ireland has reaped many dividends as blueprint for a system of National Education, with measurable improvements in literacy and in 'The well-known Irish aptitude for mathematics … one important reason why the study of physics prospered in Ireland during the Victorian period' (McCorristine, 2009). The 1900 Census shows 3,000 male university students in Ireland. There are 91 female students out of a total population of 4.5 million. More than 8,000 female religious constitute almost a quarter of professional adult working women.

Union initiatives are to be undertaken in increased provision of public health and of medical services; landlords and tenants across the domain of Ireland are to be offered an accommodation on land that they will not refuse.

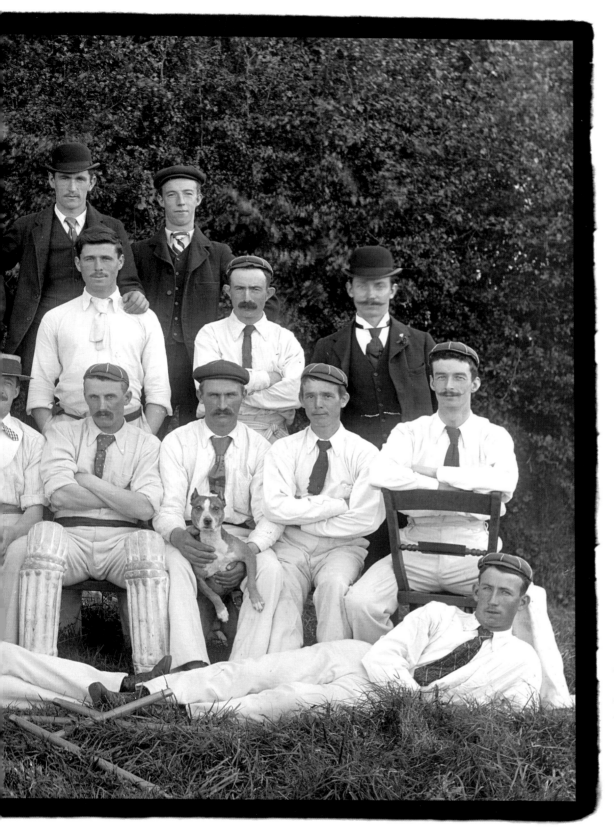

Cultural games more associated with the English at play, and in Ireland with the men of the British Army garrisons, enjoyed some popularity but were indicative of outward signs of the perceived Anglicisation of the historic culture of Ireland.

Ballybickle Cricket Club, 1900s. POOLE©NLI.

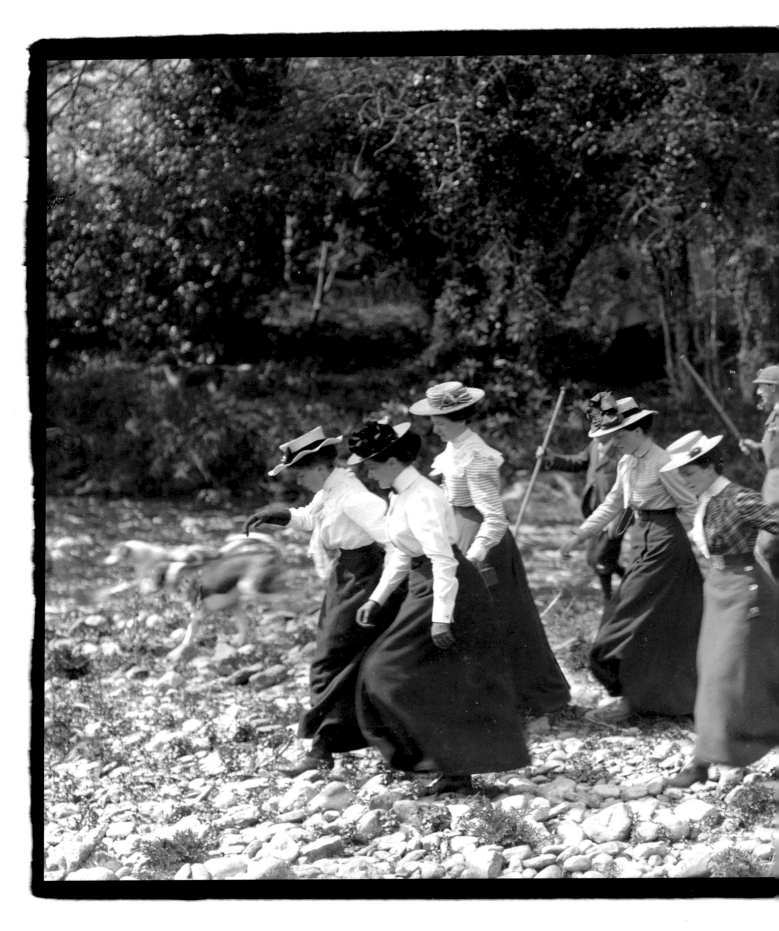

The interplay between cultures is not always adequately caught by concepts of domination of one by the other. In early Ireland the chase of the wild animals was primarily for food and clothing but also often for sport. Dependent upon the size of wild animal, hounds were used by the hunters of deer, wild pigs, badgers, otters and wolves. Wolfhounds and larger dogs were used in the hunt for wild boar, wolves and deer. From the perspective of the camera, it is difficult to distinguish if this Waterford Otter Hunt party is Catholic, Protestant or Dissenter.

Otter hunt at Carragmore, Co. Waterford, 1901.
POOLE©NLI.

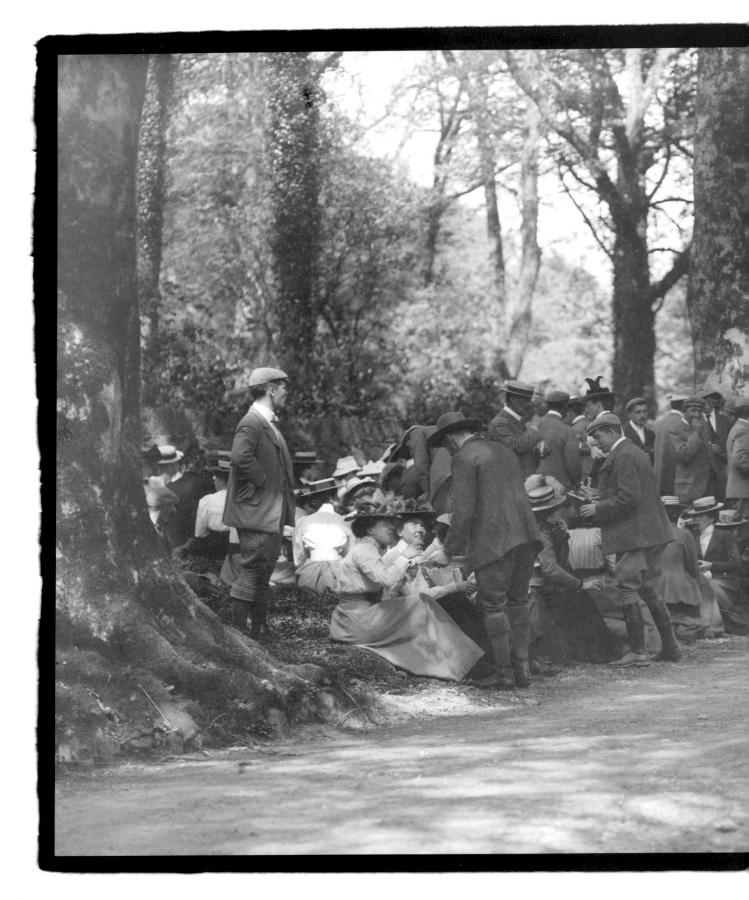

After the hunt: not a woman left standing.

Otter hunt at Carragmore, Co. Waterford, 1901. POOLE©NLI.

MADE BY WEXFORD HAT COY. LTD.

loċ Ʒcarmaın

Sloƚaın na nƷaoḋal

"ḃánn-na maıḋne ċuƷat"
("Top of the morning to ye")

In matters of dress, while religious denomination might be assumed at a glance, the hat could no longer be deemed anything other than a more nuanced trademark. The straw boater was as commonplace amongst the working class of Ireland as it was amongst the leisured class at play, either in Waterford at the otter hunt or gracing heads at Ladies' Day in Dungannon. 'Irishness' becomes capable of translation into coyness as advertising wares for the post-Victorian market become a cultural landmark in Irish life.

The Wexford Hat Company Ltd, advertisement. MASON©NLI.

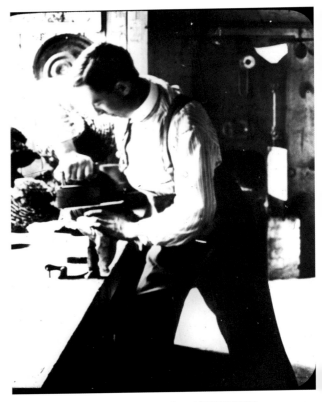

Wexford Hat Co. Man hand-pressing. MASON©NLI.

Wexford Hat Co. Two women with mould for hats. MASON©NLI.

A royal connection is marketed as a key point of attraction. Two hats and a plait are advanced as most carefully labelled marketable commodities: 1. 'Shape as supplied to H.M. Queen Alexandra', the Danish-born wife of the new king; and 2. 'Specially made for H.M. King Edward.'

Wexford Hat Co. MASON©NLI.

Shape As Supplied To Her Majesty Queen Alexandra

Specially Made For His Majesty King Edward

Across industries, the securing of the home market matched the development of production for export. Advertising on billboards and in newspapers was indicative of a market for items for daily consumption. At Masterson's, the pig was acknowledged as the source of all supply.

Pig caricature. MASON©NLI.

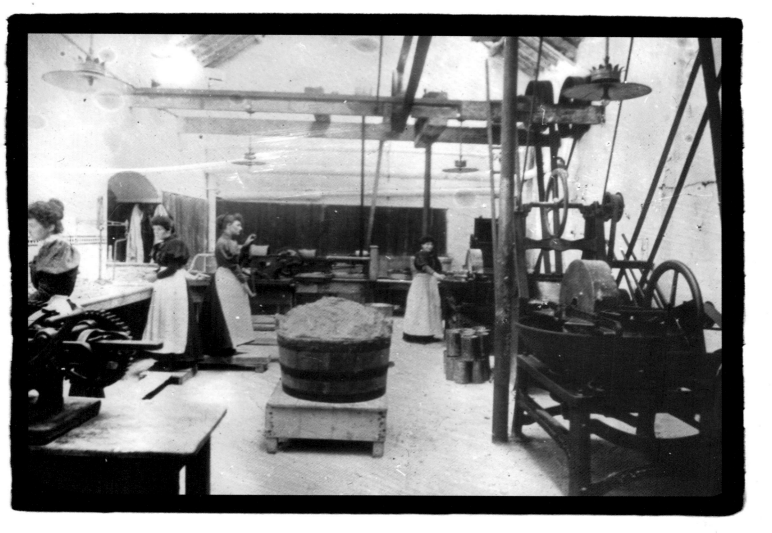

Masterson's No. 62: Women in the sausage department. MASON©NLI.

The state of the Union

The agitation for land reform, from the 1870s on, has been fuelled by the claims and the ambitions of 'strong farmers', acknowledged by the Land Acts and calls for Home Rule as the dominant social and political class in Ireland. The strong farmers were now aligned — and linked by rail — to trade, to travel and to commerce. The prosperity of a merchant class has enhanced the coffers of Empire.

The Irish Women Workers Union is launched in Dublin. There is significant industrial unrest throughout Ireland and England. Many working people remain outside any formal employment status. Others are in craft organisations, many in Irish branches of British amalgamated unions; unskilled workers are members of general unions and join forces each year under the increasingly politicised banner of the national ITUC, by 1914, under the leadership of James Larkin. Others remain hostile to the idea of a trade union. By 1911, Pierce's of Wexford employs 400 men but has a history of disputes and a resistance to trade unionism. The men at Pierce's are locked out on foot of a number of men joining the ITGWU, the general union which has absorbed the members of the Wexford Fitters and Turners Society.

While landed interests are not redundant, in the north-east they are in the process of being perceived as emblematic in a context where the merchant class, enriched by industrialisation, is in the ascendant. In time, this class —from owners of factories, mills, emporiums and breweries — will acquire titles, and purchase lands once owned by an elite that can no longer finance homes in London and acres in Ireland and whose authority can no longer be assumed as a birthright. Amongst the Protestant working class, loyalty to the Crown extends to loyalty to the aristocracy, with workers and their lords the bastions of the Orange Order.

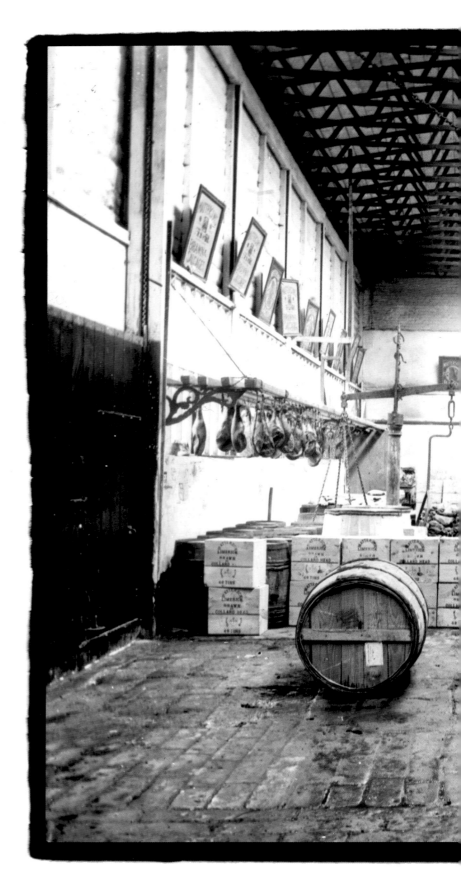

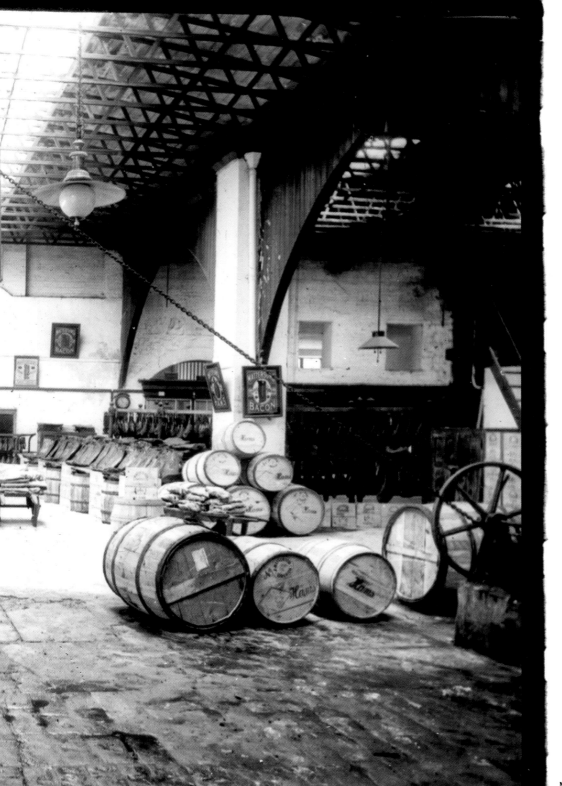

Masterson's No. 65: General
packing with ham.
MASON©NLI.

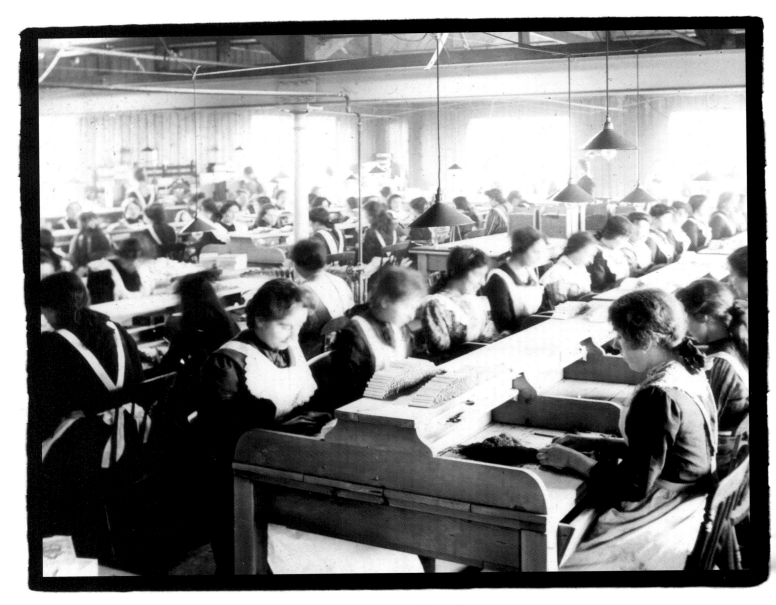

In 1886 Goodbody's had relocated to Harold's Cross in Dublin following a fire at the factory in Tullamore. A special train served as transport for the migration and urban resettlement of the entire workforce and their families from Tullamore to Dublin. From the 1900s Goodbody's came under commercial pressure from the Imperial Tobacco Company, comprising the largest producers of Great Britain. The tobacco industry across Ireland was a significant employer and included Gallagher's of Belfast, employing thousands of workers, and many smaller firms such as Goodbody's. Goodbody's was eventually taken over by the Dundalk firm of P.J. Carroll.

The Cigarette Department, Goodbody's. MASON©NLI.

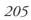

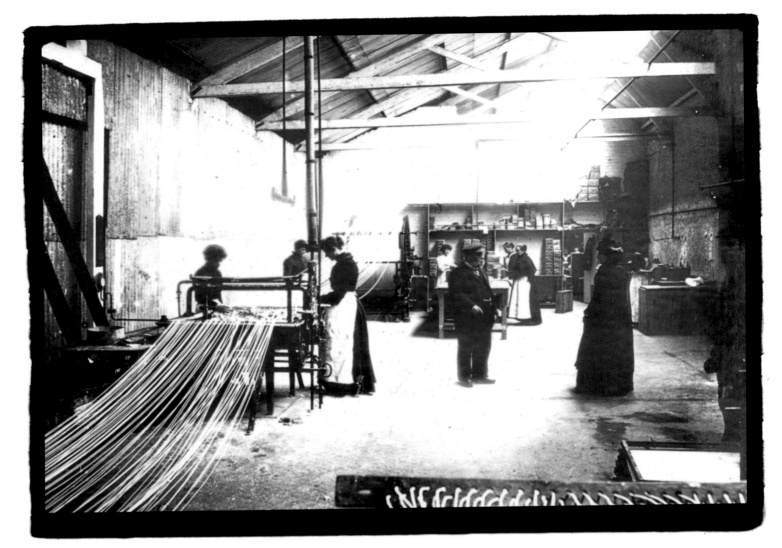

*For every smoker, a match ... The production of matches by Paterson's
was serviced by a mixed workforce in a factory setting, with the root of
the textile industry evident in the manufacture of matches by the 'rope'.*

Paterson's match production. MASON©NLI.

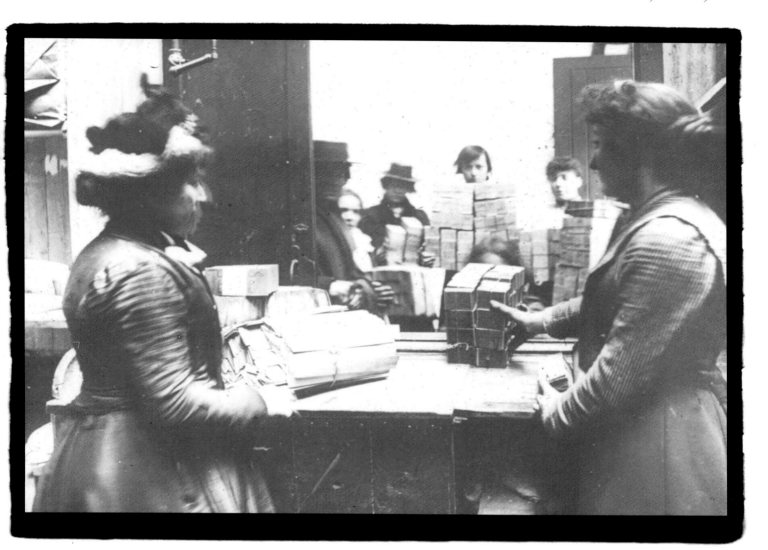

The boxes in which the matches were marketed and sold relied entirely upon a workforce outside the factory: the outworkers. These women, who will construct the boxes at home, collect the pieces of cardboard and return the assembled boxes to the depot for payment.

Collection and return of Paterson's matchboxes to the depot for payment. MASON©NLI.

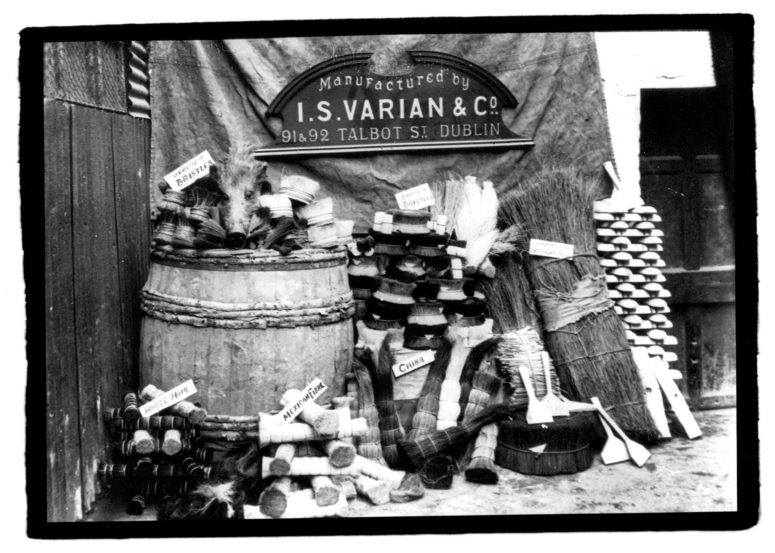

Dating from 1798, Varian's was founded in Cork by Isaac Samuel Varian. A factory and a retail outlet occupied premises at Talbot Street, Dublin, from 1856, importing raw materials from Africa, Russia, China and Mexico. Varian's remains '100 per cent Irish owned'.

Varian Brush Co. Brush factory, 91 & 92 Talbot Street, Dublin.
MASON©NLI.

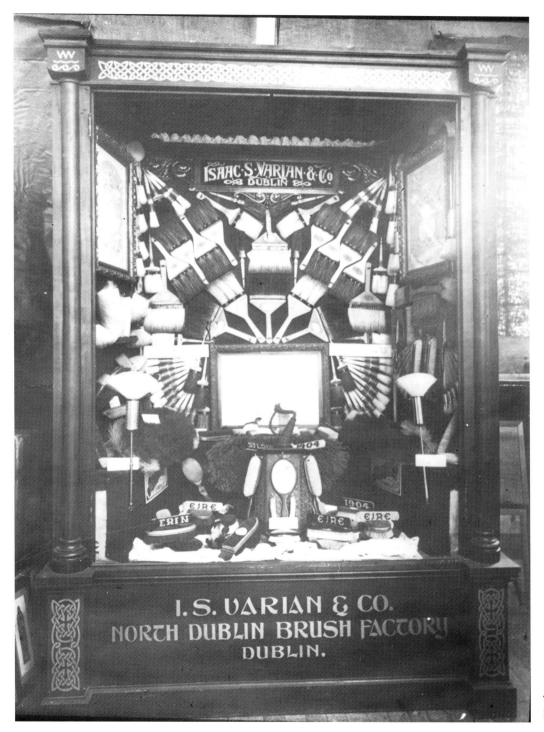

Varian's brushes display case.
MASON©NLI.

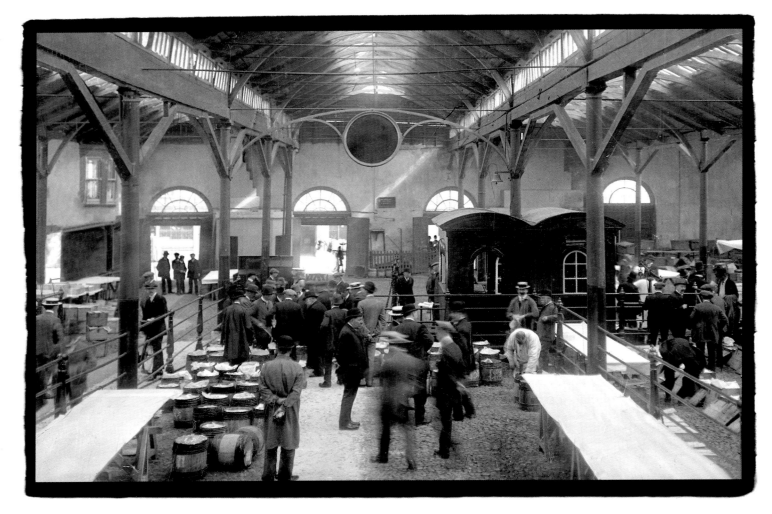

The development of dairy produce, one of Ireland's oldest industries, was significant and indicative of the constraints to development beyond local markets. The oldest dated butter in the world is Irish — preserved in a bog, it is more than 3,500 years old. Between 1770 and 1909, the Cork Butter Mart was claimed to be 'the largest export butter mart in the world', and the quality control grading system introduced there amongst the earliest to grade butter. In 1879 the mechanical separator became available — as purchased by Cleeve's Brothers at the Clonmel Show. Cleeve's thrived in the competitive global markets of Empire. The Cork Butter Mart, dealing directly with farms where separation and butter-making continued to proceed by hand, could not compete with this factory-based mechanisation of the process.

The Cork Butter Mart, 1905. ©EXAMINER.

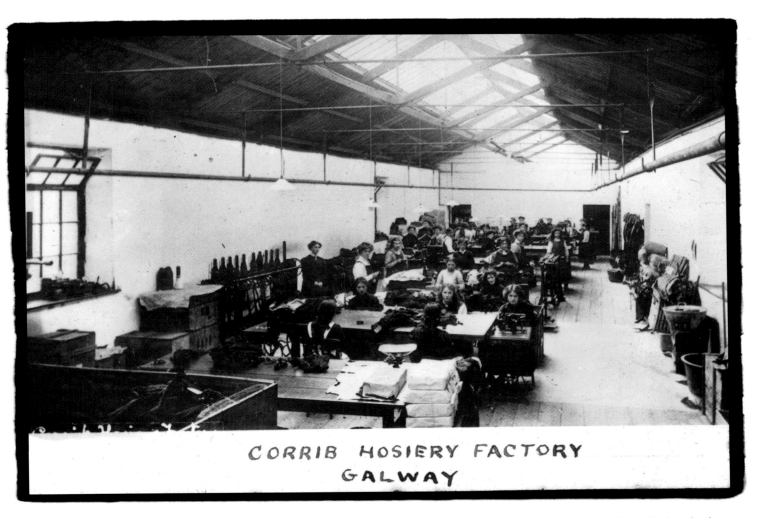

CORRIB HOSIERY FACTORY
GALWAY

Mechanisation of the process in many areas of manufacture forced other industries in Ireland, as in other parts of the Union and the Empire, into marginalised and often exploited outworking and small-scale production using quasi-redundant technology. The manufacture of hosiery and underwear competes with, and undermines the capacity of, handmade embroidery and lace to deliver such items at a competitive price. Manufacture on power looms was, however, production for a mass market, and handmade linen from handkerchiefs to sprigged petticoats would retain a social cachet in Mayfair and beyond.

Corrib Hosiery Factory, Galway. MASON©NLI.

Long term, these small-scale industries could not compete with newer technologies developed through capital investment in industry, itself reaping significant dividends within the financial markets. With the industrialised sectors of textiles and, increasingly, the manufacture of tobacco-based products and other commodities, working people were becoming aware of trade unionism.

Robbs Factory, Craigavon. Men, women and youth leaving work. MASON©NLI.

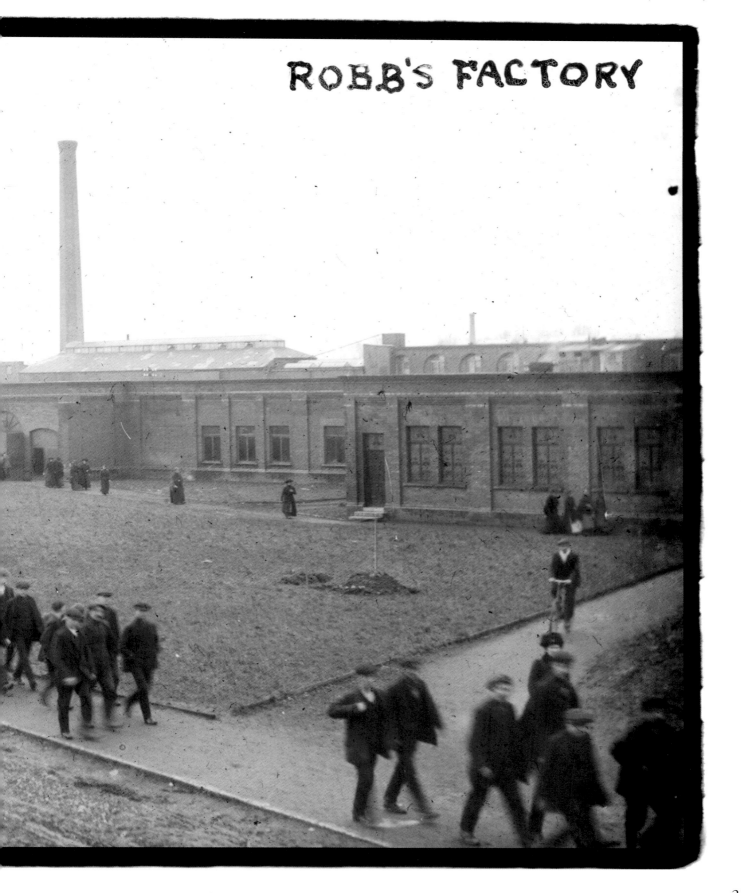

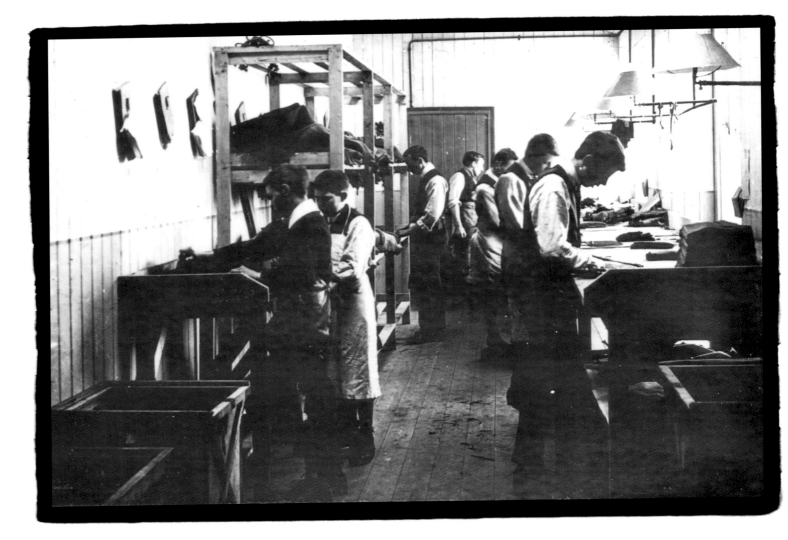

*A skill could be adapted across a range of industries —
the glove-cutter at Tipperary might become a cutter of
boots or of bags and suitcases elsewhere. Within such
industries, time served led to an increased negotiability
within a plant, or across a range of industries.*

Tipperary Gloving Factory. MASON©NLI.

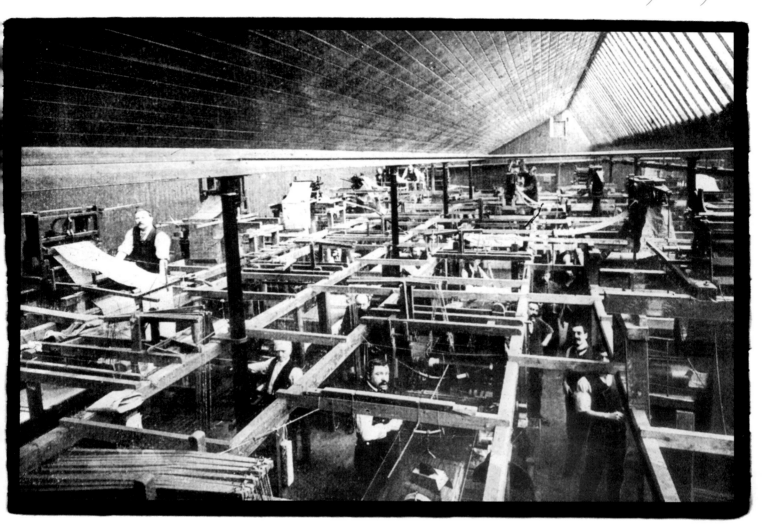

Within Irish industry, the employment of men, women and youths was widespread. In other industries, largely craft based, the male worker held a position at some remove from women and youth. Status in the industrial workplace could be defined by space, by aprons, by the tools of an apprenticed trade and by the elevation, after apprenticeship, to the authority of a skilled tradesman, or journeyman.

The Weavers. MASON©NLI.

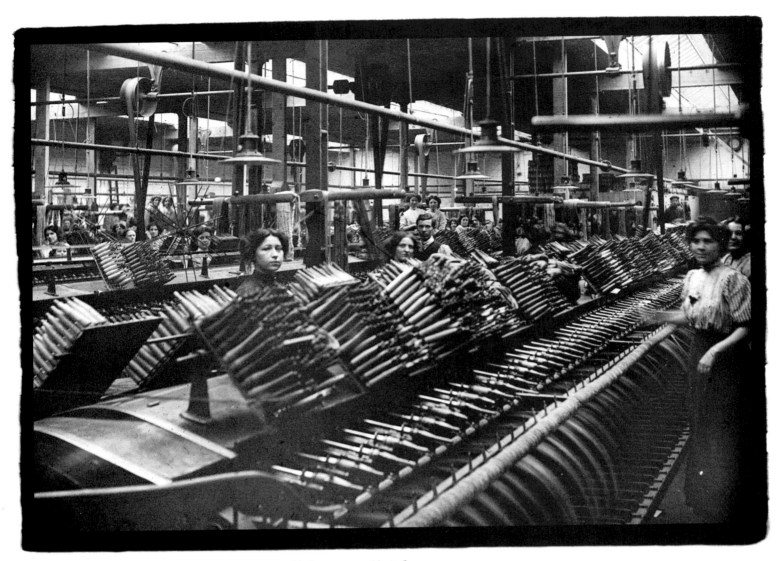

In linen manufacture the prosperity of the owners of industry was evident, from York Street to Robinson & Cleaver's warehouse in the centre of Belfast. Wages in Belfast were higher than those in the same industry elsewhere. In the north, a woman weaver earned from 7s to 16s a week, paid fortnightly, with few reaching the higher level; in the south, they were paid 6s to 15s, with a pattern of lower pay for similar work evident across all grades of work in the linen industry. (Royal Commission on Labour, 1893/4) Wages in this industry had not changed since the early 1900s, and in 1906 spinners in the York Street Mill applied for a 10 per cent increase in their wages. The dispute began with the closure of the York Street Mill and rapidly spread to other mills in Belfast. The action was won for spinners and male flax workers, but was not extended to others. Fifteen thousand workers were eventually locked out; the weavers returned to work with no increase in pay.

Weft, textile industry. MASON©NLI.

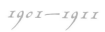

The lives of the children on the wide streets of Dublin were as mixed as the social class from which they emerged. Dating from the 1700s, Henrietta Street was home to 'five peers, a peeress, a peer's son, a judge, a member of parliament, a Bishop and two wealthy clergymen'. By the early 1900s, the street is in transition: wealth, influence and access to a motor car clearly still present, but so also are the children of working-class families, the carefully shod and the barefooted. The slow move towards tenement designation for Henrietta Street, with occupancy by multiple families where previously single occupancy held court, had begun.

Henrietta Street, Dublin, July 1909. Ephraim MacDowell Cosgrave©RSAI.

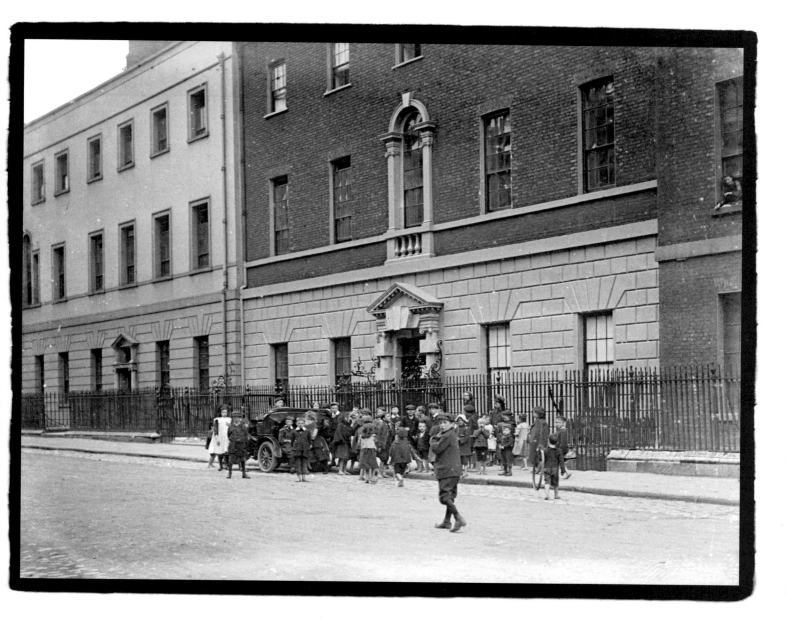

Historically, weavers had been able to secure a comfortable living and status within a community. From the late seventeenth century, Huguenot weavers had come to Ireland and worked for companies such as Atkinson's. They had introduced poplin — with a warp of silk and a weft of wool — into an Ireland mainly familiar with producing woollen goods. They had also broadened the market for Ireland and secured entry into many European centres of trade. In many areas, workshop and dwelling place were combined in one building, with workshops for weavers and others on the top floor to maximise light. The type of terraced house in Chamber Street in the Liberties of Dublin was of a form which later evolved into the 'Dutch Billy', suggesting Dutch influence and related loyalty to King William III.

Chamber Street, Dublin, 1908. Ephraim MacDowell
Cosgrave©RSAI.

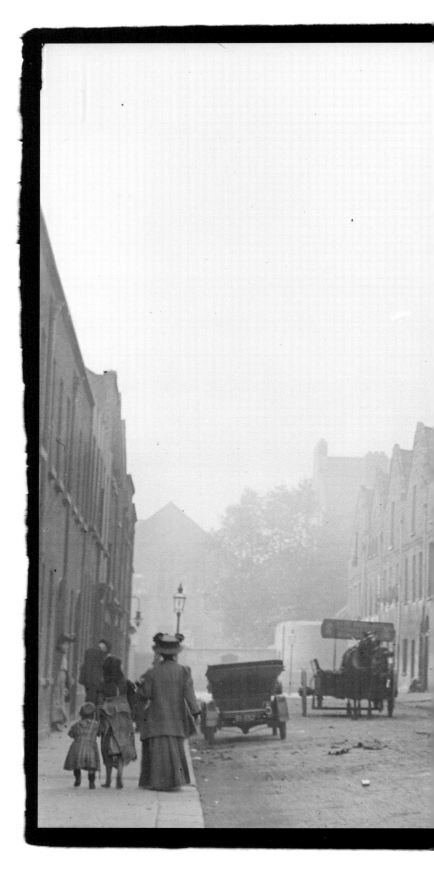

That children's lives were different across the Union is evident in the public spaces and in the absence of the very well shod from play in the streets. In shared public spaces the possibility of mutual comprehension of different cultural lives becomes accessible in multiple dimensions. The assumption that either, or all, levels of social life are of necessity more or less culturally rich, is precisely that: an assumption. The elevation of a more restrained public demeanour and dress was status bound. The economic impoverishment arising from unequal access to resources in a society, and across an empire, registered an entirely different order of concern.

School children at Dublin Zoo, 1900–1910. Ephraim MacDowell Cosgrave©RSAI.

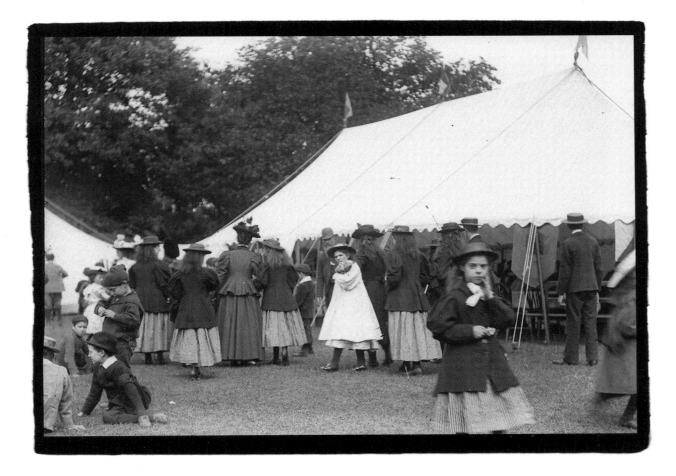

As a long-established cultural tradition in Ireland, 'A fair day brought fortune tellers, travelling show people, second hand clothes stalls and fiddlers into a town' (Daly, 2006). The garden fête is, culturally, a more restrained event. This capture of a moment is one of a series of images which include a coconut shy, a water chute, and clergy at play. At the point of cautious, and curious, entry, the trappings of cultural dominance of one form of play may serve to conceal the later emergence of the other, but the two traditions are not mutually exclusive.

The fairground. Ephraim MacDowell Cosgrave©RSAI.

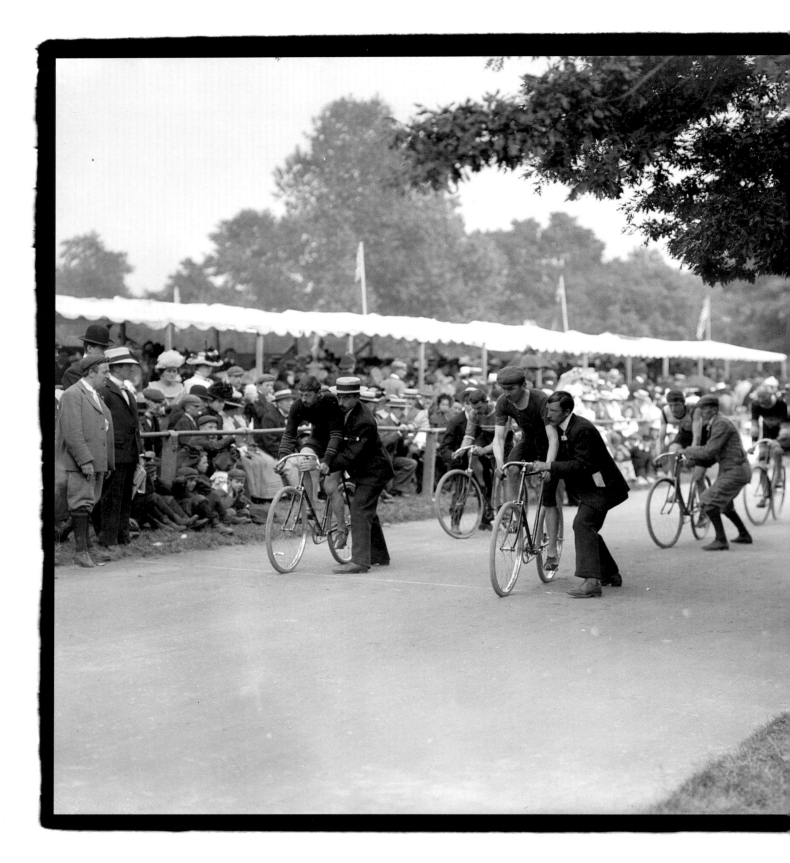

The open road had many attractions. In Waterford, riders and trainers prepare for the off.

Bicycle racers, 1910. POOLE©NLI.

By 1910, the bicycle has become ubiquitous: manufacturers included O'Neill's, building their own and marketing 'Lucania Cycles Ireland', and Pierce's of Wexford, manufacturing agricultural machinery but marketing a bicycle with a brand of their own. Pierce's established a depot for its manufactured goods in Buenos Aires, and also developed independent trade links with France. In early negotiations after its foundation in 1911, the Irish Women Workers Union members insisted that provision be made by employers for a sheltered bicycle shed to house this very public symbol of their independent earning capacity.

O'Neill's Cycles plating shop. MASON©NLI.

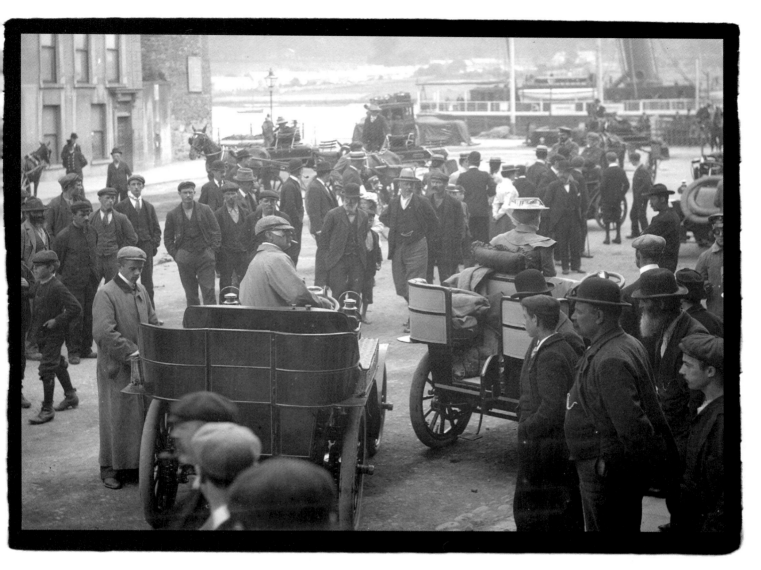

A period of transition in the economy was reflected in public life: on the road, the motor car now travelled in tandem with the horse and cart; at leisure alongside the trader with his wares. Coupled with the public curiosity at what was a vehicle for private use is the clear distance between those with disposable resources and those with few. The image is of, but not unique to, Ireland.

Motor cars on the Mall, Waterford, 1910. POOLE©NLI.

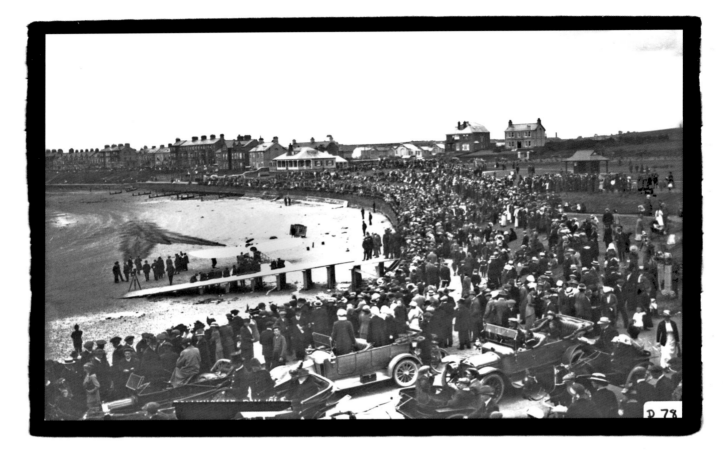

At Bangor crowds gather on the marine promenade to observe the recording in a photograph of a small plane that has landed on the sand. From the promenade, the canvas of the social hierarchies of Bangor life is exposed to public scrutiny.

Bangor, Co. Down. Crowds on the marine promenade view an aeroplane on the beach. WELCH©NMNI.

A more familiar mode of travel to, and journey around, Ireland was by sea. The Irish Field Clubs Union comprised enthusiasts and scholars, both Irish and English, whose passion for Ireland was matched by their capacity and resources to place its flora and fauna under considered scrutiny. Robert Lloyd Praeger from County Down was author of Irish Topographical Botany, *and considered a day's fieldwork as 'twelve hours spent covering 20–25 miles'. His passion for Irish botany was shared across the Field Clubs with published studies from this source including 'Butterflies of Limerick and Clare' and 'The beetles of the Limerick District'. Here, some members of the IFCU defend themselves from the elements as they travel around Horn Head, a peninsula in Donegal.*

Irish Field Clubs Union: passengers on the deck of a ship, July 1910. WELCH©NMNI.

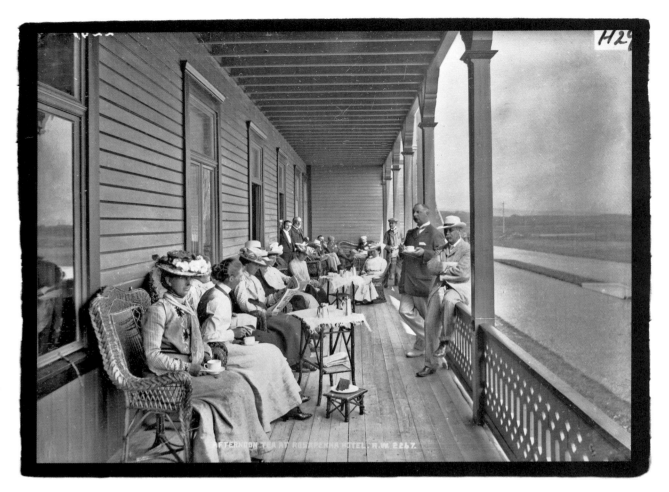

The Irish Field Clubs Union Sixth Triennial Conference and Excursion was held at Rosapenna, 8–13 July 1910. Discussion included references to 'Land and freshwater Mollusca', 'Is Hyalinia helvetica Blum found in Ireland?', 'The distribution of Bythinia leachii in Ireland' and 'Some records of Land and Freshwater Mollusca from the Counties Roscommon and Longford'. The photographer, Robert Welch, was a respected member of the IFCU.

Afternoon tea at Rosapenna Hotel, 1910. WELCH©NMNI.

In 1896 *the* Irish Daily Independent *reported on the Museum Demonstrations to be given by professors from the Royal College of Science of Ireland. These 'aimed to correct the aimless and uninstructive inspection of the interesting articles in the Museum …' (Adelman, 2005). In 1890 the curators at the Natural History Museum in Dublin had embarked upon a comprehensive review and exhibition of the zoological collection. In the same year the RCSI offered four royal scholarships, for second year students, awarding two years' free tuition at the College and an annual grant of £50. An enthusiasm for science and for collection was encouraged and facilitated.*

Man and woman collecting a tree specimen. MASON©NLI.

Part of a summer boat excursion to the Great Saltee Island, Wexford, by Mason photographers and friends on a bird-watching expedition. The day's labour generated a wide selection of glass plate images of birds nesting on the island.

Boys with instruments and photographic equipment. MASON©NLI.

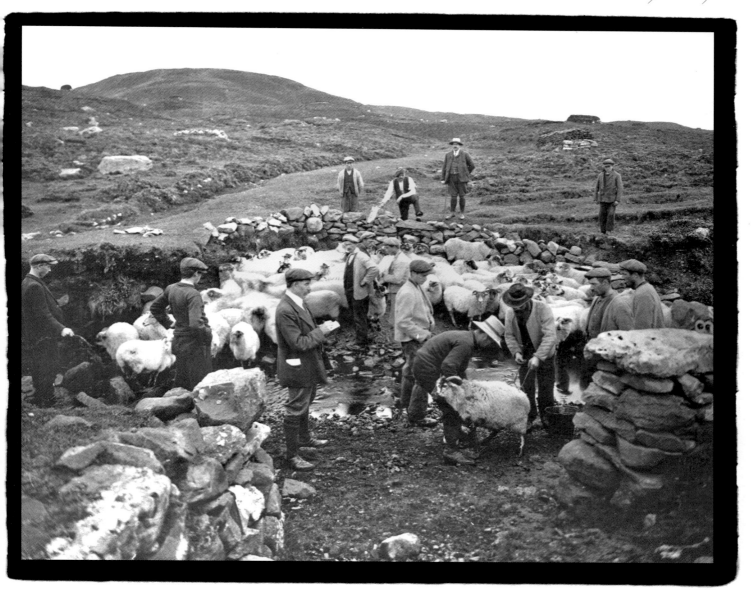

In the foreground, sheep-marking in hill country. At the centre and in the background is Robert Lloyd Praeger, the botanist who, in the space of five years, compiled 'a detailed geographical analysis of Ireland's vascular flora'. The names of the others are unknown. A gifted man, Praeger credited his country thus: 'Ireland is a delightful country for the pursuit of work in the field. Enclosed or preserved ground is but seldom met with, and the country is free and open. Few rivers but can be forded; few marshes or bogs but can be crossed; few precipices but yield their treasures to the mountaineer; few spots are so remote but they may be visited in a good day's walking from the nearest stopping-place' (Praeger, RIA).

Men marking sheep in hill country. WELCH©NMNI.

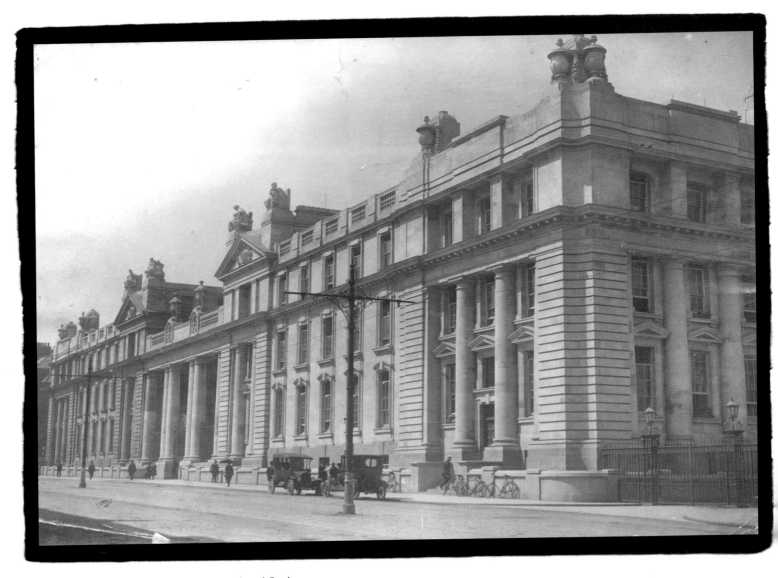

In 1899 a parliamentary committee sanctioned funds
for the construction of a building to house the Royal
College of Science of Ireland and the Department of
Agriculture and Technical Instruction for Ireland on
Upper Merrion Street. In 1911 King George V opened
the College, the last major public building investment in
Ireland by the government of the Union of Great Britain
and Ireland.

Exterior: The Royal College of Science of Ireland,
Dublin, designed by Sir Aston Webb. ©RAI.

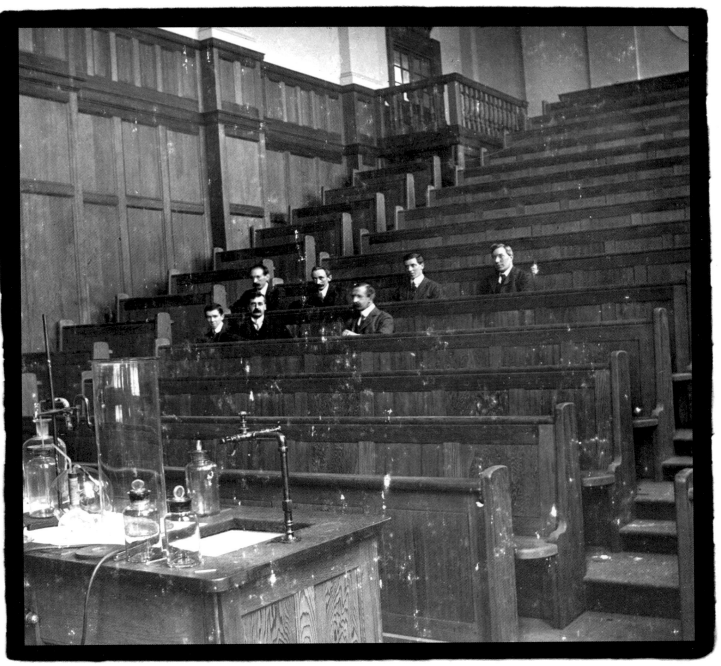

The Laboratory: The
Royal College of
Science of Ireland,
Dublin, designed by
Sir Aston Webb. ©RAI.

Across England and Ireland 1911 marked a period of industrial unrest and of significant organisation of working people within trade unions. The arrival in Waterford of Lord Aberdeen, Lord Lieutenant and representative of the Crown in Ireland, creates a scene of some tension. In 1908 Lady Aberdeen had been founder of the Women's National Health Association and was active in the Congested Districts supporting lace-making and home industries. Both were Liberals, members of the political party that supported home rule for Ireland.

In many parts of Ireland, a class of women such as Lady Aberdeen, whose public authority derived from the positions held by their husbands, had engaged in philanthropic work, often responding to the need to improve health, nutrition and childbirth. Baroness Burdett Coutts was unusual in that she had inherited vast independent wealth through her connection to Coutts bank, traditional banker to the royal houses of Europe. In 1880 she established a fund, the focus of which was the depression of herring fisheries. In 1887 she opened a piscatorial school in Baltimore, west Cork, which had 'succeeded Kinsale as the major fishing port on the Cork coast'. Plans included a purpose-built curing house and instruction in curing and net-making to be undertaken by boys aged between 9 and 15. In 1893 the line of rail was extended to Baltimore. Herring was exported from Baltimore to Russia and to the US. By 1920 the piscatorial resources of the island were subject to American tariffs.

The Industrial School, Baltimore, Co. Cork. LAWRENCE©NLI.

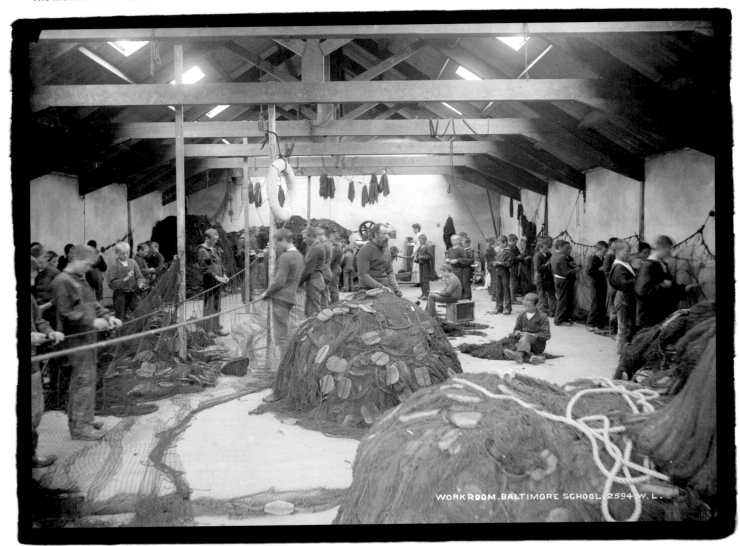

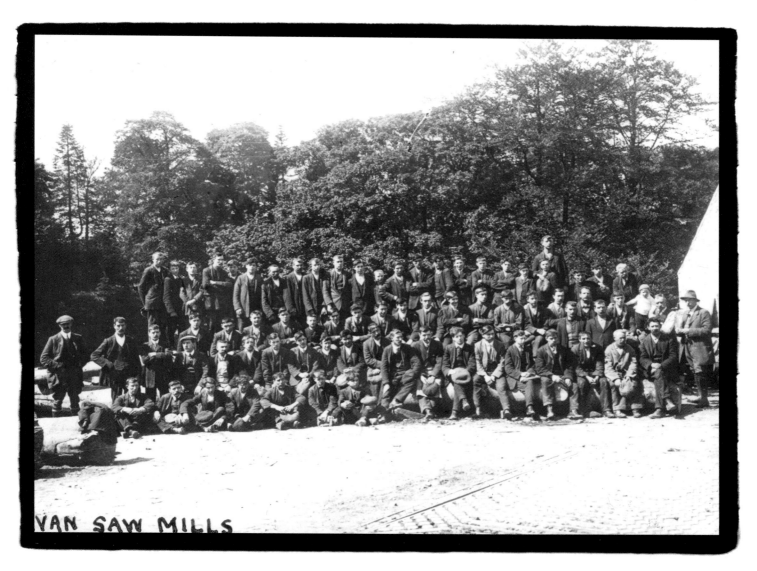

VAN SAW MILLS

Resources have, historically, been subject to other demands, transforming the topography of Ireland, 'From the Neolithic period onwards, farming, grazing and the growth of the bogs ... changed the landscape. There was ... immense and unmanaged exploitation of the remaining woods in Tudor times, but already these covered little more than two per cent of the island ... The population explosion of the 1800s stripped much of the western countryside of anything burnable outside the demesnes' (Viney, 2000). Shipbuilding, until the development of iron ships in 1860, meant that Irish timber fuelled the naval demands of Britain as a major maritime empire. In 1904 state-funded forestry began. Timber was in demand, was generating significant employment and had to be managed.

Navan Saw Mills, Co. Meath: 'Some employees'. MASON©NLI.

The Cromac Saw Mills fed the demand for construction in Belfast. In the cities, a more confident working class was asserting its status in the Orange lodges and within the trade unions. From carpenters to plumbers, shipping clerks to engineers, public investment was generating regular employment, often associated with the provision of public housing.

Crawford, Browne & Company, 1912. WELCH©NMNI.

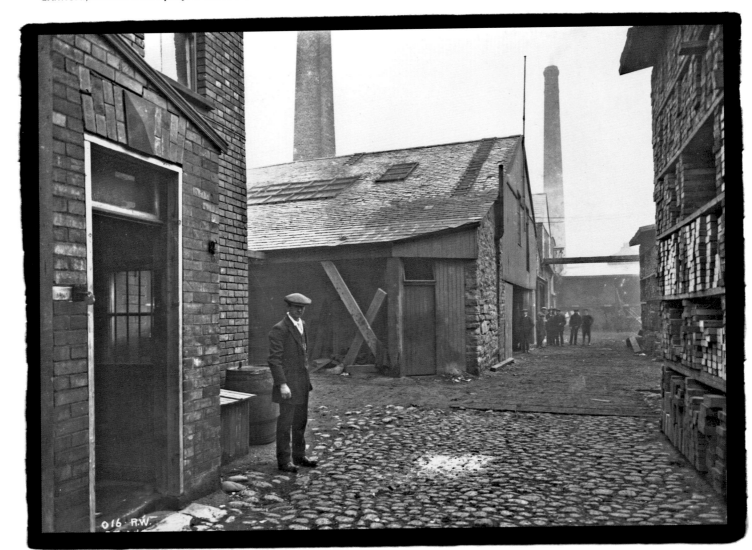

Brecht, 1929–38:

Questions from a Worker who reads:

Who built Thebes of the seven gates?
In the books you will find the names of kings.
Did the kings haul up the lumps of rock?
And Babylon, many time demolished
Who raised it up so many times? In what houses of gold-glittering Lima did the builders live?

The building of the Museum and Art Gallery: the south galleries, under construction.
WELCH©NMNI.

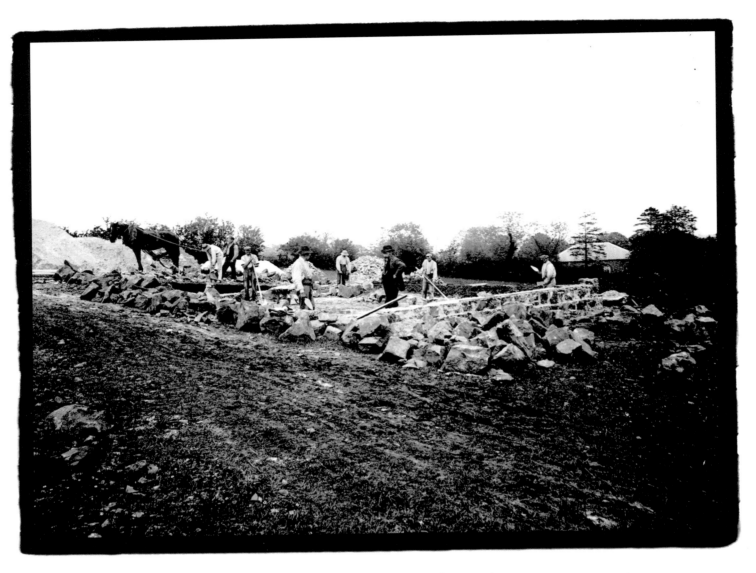

Stone and granite, quarried locally, was used extensively in the building of all forms of structure in Ireland, from dwellings and bridges to walls and massive monuments. The photographer responsible for this image worked for the Board of Public Works.

Men, with overseer, building a stone dwelling. Samuel K. Kirker©RSAI.

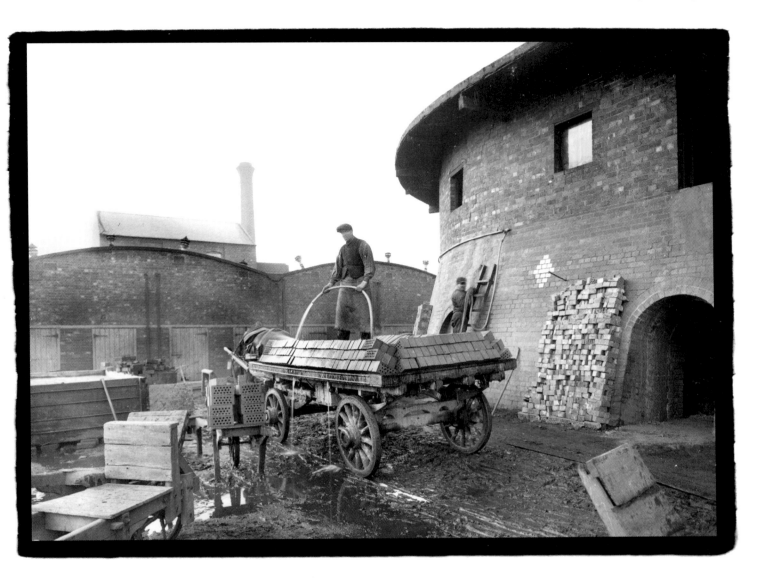

In Ireland there is no evidence of the use of brick in medieval construction, nor in any era, including the Anglo-Norman, before the sixteenth century. The later use of brick is associated with high status dwellings, often the country house. In 1706, '300,000 bricks manufactured in the Belfast area are known to have been sent to Dublin', and the importing of bricks from England, Holland, Flanders and France to Dublin and Cork in the 1770s was extensive. By the second half of the eighteenth century, clay from Sandymount was used in the building of Merrion Square, but work in brickfields was often seasonal, developed by farmers employing agricultural labourers. Fired in a clamp kiln using coal or turf, 'the clamp stokers were provided with a one-legged stool to discourage them from nodding off' (Rynne, 2006). The new kiln at Haypark, near the Ormeau Road, Belfast, as with the clamp kiln, uses bricks to build a construction to make bricks. Builders providers, including brick-makers and sawmill workers, were amongst the earliest workers to organise in trade unions.

Haypark Brickworks. Close-up view of brick kiln, with bricks being loaded onto a cart, 1910.
WELCH©NMNI.

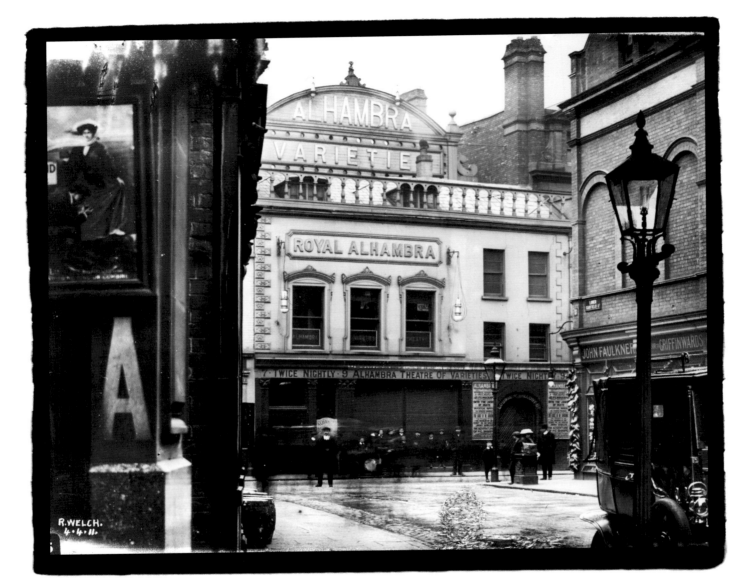

The potential of a regular wage, for a negotiated working day, offered some respite for many industrial workers and shop assistants. The Music Hall catered for cultural pursuits for a working class with disposable income and a fondness for the stage Irishman, serving as the sounding post, across class lines, for the stylishly political. Alhambra Variety Theatres were located throughout the British Empire. Irish-born 'Pat Rafferty, in 1900, sang "What Do You Think Of The Irish Now", after the Dublin Fusiliers had covered themselves in glory in the First Boer War:
"What do you think of the Irish now?
What do you think of the 'bhoys'?
You used to call us traitors / Because of agitators,
But you can't call us traitors now!'"
(Barclay, 2007)

The Royal Alhambra Variety Theatre, on North Street, Belfast: the view from Lower Garfield Street, 1911. WELCH©NMNI.

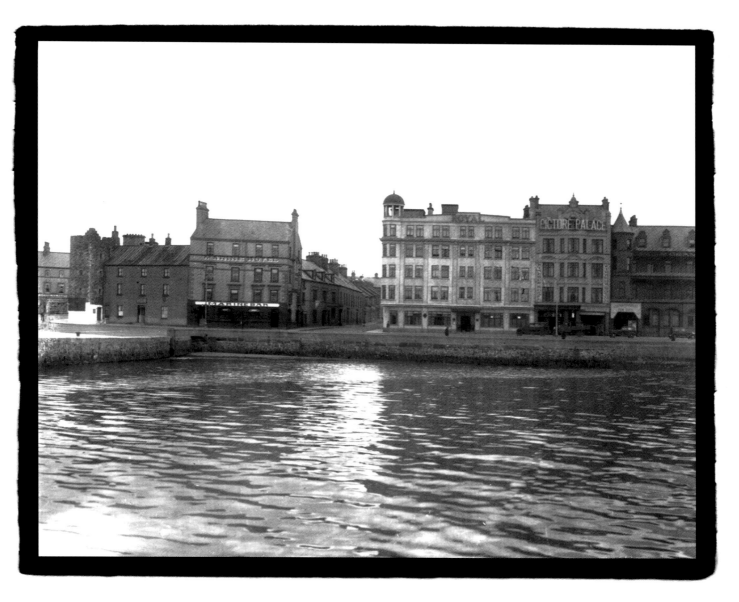

As a day return railway excursion from Belfast, Bangor had many attractions: the seaside, the Picture Palace and the café amongst others. The seaside picture palace graces a vista evoking the promise of expanding horizons and serves as the popular forerunner to moving pictures and cinema. In April 1896 the French film-maker Lumière brothers had visited Dublin and Belfast; in 1897 the first filmed Irish subjects were shown, including 'People walking in Sackville Street, Traffic on Carlisle Bridge and the 13th Hussars Marching through the City'. In 1898 Robert A. Mitchell, the first Irishman to shoot a film within Ireland, shot authentic footage of a yacht race on location.

Hotels and entertainment houses, seen from the sea, Bangor, Co. Down. WELCH©NMNI.

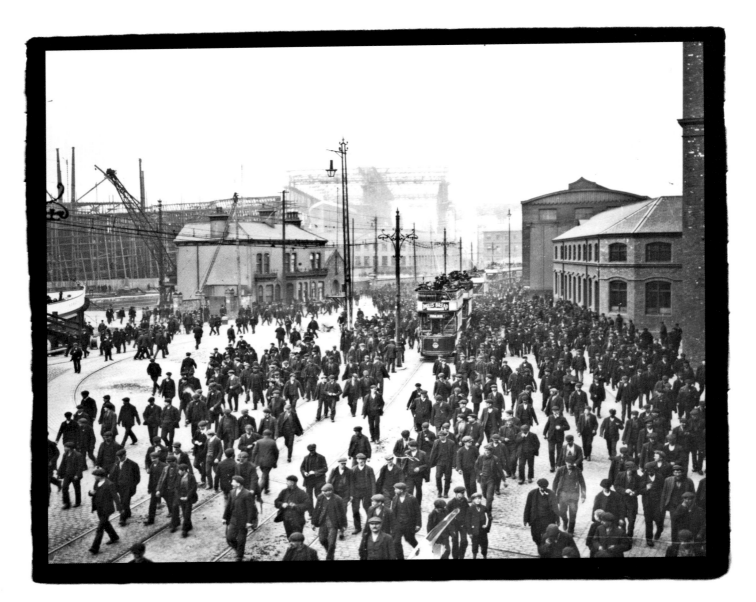

In 1907 the Belfast Dock strike, following the strike of the mill workers in 1906, was indicative of the appetite of working people to advance the quality of their lives within and beyond the workplace. With the Belfast Dock strike, Protestant and Catholic workers had briefly united to pursue common interests, but sectarianism was endemic. In 1911 James Connolly, Ulster District Organiser of the Irish Transport and General Workers Union, returned to Belfast to begin the organisation of dockers and of mill workers. He denounced the twin sectarianism of Orange and of Green. The shipyards had generated skilled and regular employment, an industrialised working class with some rights inherited through legislation and by negotiation of the British labour movement. Within the overwhelmingly Protestant workforce, maverick elements '… had emerged to challenge the easy equation of Protestant worker, Unionist supporter and quiescent employee' (Bartlett, 2010).

Harland & Wolff Ltd, Belfast: view of Queen's Road at the end of a shift. WELCH©NMNI.

1912—1920

1912 The Wyndham Land Purchase Act, 1903, followed by a Second Land Purchase Act in 1909, has resulted in a major transfer of land ownership in Ireland, with some 46 per cent of farmers now defined as owner-occupiers. All tenanted land in Ulster is in the process of passing into the hands of the tenants, leaving an enriched class of landlords, even when debt clearance is taken account of. Many landowners remain opposed to compulsory purchase.

As the 'largest ship in the world', the *Titanic*, is launched from Belfast's shipyards, the Liberals under Asquith introduce the Home Rule Bill (1912). Carson takes a leading part in the formation of the Ulster Volunteers, who — in common cause with the Orange lodges — drill openly to show that they are prepared to resort to arms 'and to become responsible for the government of the Protestant province of Ulster' (MacNeill, in de Paor, 1970). At Easter, Bonar Law, leader of the Conservative Party, comes to Belfast.

Irish Nationalist MPs, now under the leadership of John Redmond, hold the balance of power at Westminster. Redmond, opposed to physical force, is a constitutional nationalist. He is seeking limited self-government within the Union and within Empire. In April, the Liberal government introduces a Bill to grant Ireland self-government, and a third Home Rule Bill is laid before the House of Commons. There is significant dissent. A compromise is suggested — that four counties, all with a Unionist majority, will remain within the Union and outside Home Rule. The government rejects this, and presses ahead with the full measure. On Ulster Day, over half a million people in Belfast sign the Ulster Covenant in support of the Union and against Home Rule. Others are no less supportive of Union, but rule that parity begins at home: suffragettes want the vote, and many will go on hunger strike to get it.

1913 The Home Rule Bill, to provide 'an Irish parliament under the English crown', is supported by Redmond — who opposes extending the franchise to women — and the Irish Party, but the Irish Republican Brotherhood and Sinn Féin regard 'the bill as at best an instalment'. On Home Rule Day, Redmond reiterates his opposition to female suffrage, and the Ancient Order of Hibernians attack a poster parade of suffragists.

The Ulster Volunteer Force, a civilian force, rises from the framework of the Orange lodges with the sole aim of blocking Ulster subjugation to a Dublin parliament. In November, Patrick Pearse, IRB, writes in the IRB paper, *Irish Freedom*: '… I think the Orange man with a rifle a much less ridiculous figure than the Nationalist without a rifle …' (de Paor, 1970). In the Gaelic League paper, *An Claidheamh Soluis*, Professor Eoin MacNeill, founder member with Douglas Hyde of the Gaelic League, is in accord. The Irish Volunteers form in Dublin with MacNeill as leader. Both it and the UVF are extra-legislatory, will bear arms and now inflame and militarise an incendiary situation.

In Dublin, long simmering discontent focuses on appalling conditions and rampant disease in the tenements. James Connolly, James Larkin and the ranks of organised working men and women throw down the gauntlet and withdraw their labour. William Martin Murphy, owner of the *Irish Independent*, a major player in city transport and commerce with a vested interest in maintaining the status quo, forms an Employers' Federation and is supported by government and by the Dublin middle class.

Power is exercised as the doors of industry simply close: the Dublin Lock-out of workers will last for six long months, with hardship — and soup kitchens — the order of the day.

In the light of evidence of RIC brutality, the Irish Citizen Army is formed by James Connolly. Strikes, outrages and disorder flare across Ireland and Britain.

Dublin is recorded as having the worst slums in Europe. Thirty-five suffragettes are in prison and 12 are on hunger strike. In Belfast, almost 20,000 workers are employed in the shipyard. In Dublin, Guinness, the major earner of exports in Ireland, employs 2,000 workers in secure employment and with significant benefits accruing to themselves and their families. In Belfast, the industrialised skill base will ensure that workers adapt and military orders multiply as the drums of war herald the onslaught of change across the Union and across the globe. No such industrialised skill base has been developed in the industries and small foundries of the rest of the island.

World War I is on the horizon. With steady purpose, the linen trade of Belfast turns its attention to making uniforms; others re-frame and re-engineer for the production of armaments and to accrue the profits of war.

1914 75,000 men enrol in the Irish National Volunteers. Cumann na mBan is formed to oversee fundraising and to serve as nurses and messengers. Home Rule is to remain the priority, but war is looming.

The UVF land German rifles at Larne, Bangor and Donaghadee. The Irish Volunteers, on board the *Asgard*, land German guns at Howth. Carson calls on members of the UVF to join the British Army. At the Curragh Army Camp there is mutiny: 58 officers signal their intent to refuse to disarm the UVF.

Across Europe, the wheels of industry are moving in the direction of war. A heady mix of patriotism, profit and pragmatism transforms a landscape of industrial unrest into orderly battalions of young men,

recruited overwhelmingly from the working class. Officers are drawn from the existing officer class, many of whom are Irish; other than those joining the Irish Guards, however, most officers from Ireland tend to join English and other regiments. Of Irish peers and their male relations, just over 100 are recorded in *Burke's Peerage* and *Thom's Directory* as members of 22 regiments, the War Office and 'others'. (Martin, 2002)

The call for recruitment addresses thousands of young men — those for and against the Union; veterans of the Boer Wars; workers skilled and unskilled, from every province of Ireland. From 2 August 1914 to 8 January 1916, 86,277 recruits are raised from across the island. A Report on Recruiting in Ireland notes that 'The general disinclination of the farming class … to join the Colours is not specifically characteristic of one province more than another' (British Army, 1916).

In 1914 the Irish Agriculture Organisation Society records an annual turnover of £3.7 million.

The promise, the expectation, of Home Rule is coupled across Ireland with measured and varying degrees of patriotism and of pragmatism, sealed for many by the promise of security for families who had none. The Registrar General for Ireland, in his 55th Annual Report in 1919, recorded the response from Irish men and their wives: 'On the outbreak of hostilities, when an appeal was made for volunteers for the new Army, it was arranged that monetary assistance should be provided for the wives and families of those coming forward to risk their lives in the struggle for freedom.'

In August 1914 war is declared. In September, the Home Rule Bill becomes law. Implementation of the Act is shelved, in deference to the outbreak of World War I: in Ireland, the war is 'a popular cause'; in Britain, 'War fever was widespread.' The

production of agricultural produce and the need to feed an army leads to an increase in agricultural prices; unemployment falls as war production becomes intense. In Britain, the entire motor industry is transformed into the production of tanks and armoured vehicles for the war effort.

1915 The Irish Volunteers split, with the Irish Republican Brotherhood in control. IRB members of the Gaelic League change the constitution of the League and call for the declaration of an Irish Republic.

1916 The Irish Volunteers, under the leadership of MacNeill, and in common with much of the IRB leadership, would become reluctant participants in what followed. Significant members of the Irish Republican Brotherhood, and of the Irish Citizen Army, defy the logic of a failed strategy, and together rise against the British authority in Ireland. For some, this will be interpreted as a 'military putsch'; for others, an heroic defiance; and for many bystanders, a surprise attack.

The Provisional Government of the Irish Republic is declared. Many plans have failed to materialise and tactics have been poorly judged, but the long-term strategy holds. Pearse is elected President of the Provisional Government. On Easter Sunday, the Proclamation of the Irish Republic is published and distributed: its purpose, 'to rouse the nation and make it free and independent'. On a faulty printing press, 2,500 copies are prepared and given next day to Helena Moloney, a member of the Irish Citizen Army and General Secretary of the Irish Women Workers Union. After distributing the copies, she took arms and joined forces for the attack on Dublin Castle on Easter Monday. (de Paor, 1997)

The political, social and economic ramifications of an armed uprising and a prolonged siege of the centre of Dublin are significant: commercial interests and a distressed public look on as Clery's is burnt out, and the GPO and much of Sackville Street and Henry Street are reduced to ruins.

Fifteen of the leaders of the Easter Rising in Dublin are executed by the British authorities.

This summary execution — of poets, teachers, trade union leaders, socialists and revolutionaries — transforms an ambivalent, previously often unsympathetic, Irish public into a formidable, cross-class nationalist resistance to British Rule. For many, the Proclamation has served to identify the cause: national sovereignty. Thousands of 'sympathisers' are arrested. Martial Law is imposed.

Lloyd George outlines a proposed settlement for Ireland: Home Rule, with the six north-east counties excluded. The UUC accept the plan, as does a convention of nationalists from these counties. Redmond and the IPP disagree, but the stage is set for the emergence of two jurisdictions dividing the island of Ireland.

1917 America joins the war effort. Ships of the US Navy cross the Atlantic to report for orders at the US Main Base, European Waters, at Queenstown, Co. Cork. Within weeks, 8,000 American and British personnel are based in this most strategic of ports. The population of the town doubles virtually overnight. The Command reports skirmishes with insurgents in Cork. The US Navy is confined to quarters.

Éamon de Valera, American-born son of an Irish emigrant mother, a former professor of mathematics, member of the Irish Volunteers and the IRB and Commandant in the Easter Rising, imprisoned in England since the Rising, is released in a general amnesty in June 1917. He becomes President of Sinn Féin, with Arthur Griffith, a man for self-reliance, as vice-president. In April, Sinn Féin

has 166 branches and 11,000 members; by October it has 1,200 branches and 150,000 members. Éamon de Valera is elected MP for East Clare in a by-election, defeating the IPP candidate.

On the initiative of Lloyd George, a major Irish Convention is held in Dublin to discuss settlement proposals. Sinn Féin and the Ulster Unionist leadership do not attend. Southern Unionists, members of the Irish Parliamentary Party and Independents do so. Fears are aired, but 'there was an unavoidable air of irrelevance about the entire proceedings' (Bartlett, 2010).

1918 On the USS *Dixie*, in Queenstown Harbour, influenza is diagnosed as the crew and others on ships and bases along the coastline fall prey to the influenza pandemic which will kill more globally than the numbers who have died in the trenches in WWI. The Influenza pandemic reaches Belfast and Dublin: over 20,000 men, women and children across the island die by the end of spring 1919; thousands more fall sick; schools and factories are forced to close.

In May, de Valera is rearrested and jailed for leading the public outcry against Britain's decision to introduce conscription in Ireland. An Anti-Conscription pledge is signed by thousands. The Home Rule Party withdraws from the House of Commons. Irish nationalist opinion is united. Martial Law is declared in the south and west. Sinn Féin, the Volunteers and other nationalist organisations are proscribed.

The Armistice is declared to mark the end of World War I. In Dublin, shots are fired, but the Union flag is carried through the streets. The Representation of the People Act, 1918 reforms the electoral system in the United Kingdom. The franchise will include men over 21 years and all women over 30 years. John Redmond dies and John Dillon becomes Home Rule leader.

Sinn Féin contests the 1918 elections but will not take their seats at Westminster. The General Election is uncontested by the Irish Labour Party. Sinn Féin win 73 seats; the Unionist Party win 29; and the Irish Parliamentary Party win 6.

1919 Sinn Féin, in defiance of the British Government, establishes the First Dáil, and at a meeting in the Mansion House makes a Declaration of Independence.

De Valera escapes from Lincoln Jail and is unanimously elected as President of the first Dáil Éireann, which adopts the Democratic Programme, managing, before being proscribed by the Crown, to sound a considered note of defiance with an indicative socialist thrust. A system of Dáil Courts to rival Crown Courts is established. There is a subsequent mushrooming of Parish Courts, with election of judges from the ranks of the ordinary — from Catholic curates to trade unionists. Members elected to the Dáil include de Valera, Griffith, Michael Collins, W.T. Cosgrave and Countess Constance Markiewicz.

The First Dáil is proscribed by the government of the Union of Great Britain and Ireland.

Two RIC constables are shot in Tipperary: the first shots to be fired in the War of Independence. Violence spreads across Ireland.

1920 Native Irish Industry week begins in Dublin as veterans of the British Army march to protest the lack of jobs. At the stock exchange, shares in Marconi and Dunlop's fall. Food prices are rising and the Irish Labour Party and Trade Union Executive place an embargo on the export of foodstuffs. De Valera returns from a journey to America with a $5 million 'war' chest.

The *Freeman's Journal* records the opposition

in the House of Commons to the plan of Partition. The headlines of 20 February reveal a network of competing claims:

The North must pay for partition
Carson says we belong to England
Ireland says Ulster belongs to us

Newspapers report that figures indicate 'considerable financial disturbances may result from the offensive political partition of the territory in which the banks operate'. The prospect is causing 'serious misgivings in Belfast business circles, but the commercial interests are overawed by the sectarians'. In Cork, commercial interests charge Carson with the death of unionism. Commercial unionists in the South send a '… message of Unionist Cork: its bankers, its brewers, its distillers, its merchants … The men who made Unionism in Ireland a respectable and creditable creed have but one word for Mr George today. That word is self-determination. They still believe in the Empire and would cling to it … their loyalty has been replaced by desertion … out of the attempt to partition Ireland there is being born a new union of Irishmen themselves. Ourselves' (*Freeman's Journal*, 5 August 1920).

Under the Defence of the Realm regulations, Martial Law is imposed in Dublin.

1920 In autumn a force of British Auxiliary Police arrives in Cork. The force enters a situation where official retaliation for attacks on the military and police has resulted in the destruction of property in nationalist strongholds. In December 1920 there is a massive onslaught on business in Cork.

The official Military report on the state of Cork City from 10 p.m. on Saturday, 11 December 1920, to 5.30 a.m. on Sunday, 12 December 1920, during which period the city was in complete control of the military, details fires at a number of sites, the withdrawal of troops and a series of explosions that could not be located.

The Chief Secretary denies the claim in a number of newspapers that the fires and the destruction of property had been the work of Crown Forces. The fire service claims that attempts to contain the fires had been hindered by the same forces. An inquiry is established and the Strickland Report is much anticipated. A claim is made that the Auxiliaries had been responsible, using the destruction as an act of reprisal following an IRA attack.

In his report to the Lord Mayor, Captain Huston, Superintendent of the Cork city fire brigade, records his view that the fires 'were incendiary fires and that a considerable amount of petrol or some such inflammable spirit was used in one and all of them'.

1921 On 22 January 1921, the much anticipated Strickland Report is suppressed. The *Freeman's Journal* reports: '… vain is the expectation that the Irish people can be got to rally to the side of a government whose latest act has been to suppress General Strickland's own condemnation of the policy of outrage, thus suggesting that the policy of outrage is the policy of His Majesty's Ministers themselves'.

In December, the signing of the Anglo-Irish Treaty marks the end of British rule in three of the four provinces of Ireland. The Terms of the Treaty leave 26 counties of Ireland 'both administratively and economically, an artificial creation'. At the time of the Partition of Ireland, the six counties of 'Northern Ireland compared favourably with Britain, Belgium and Germany in terms of industrial orientation' (Kennedy, 1989).

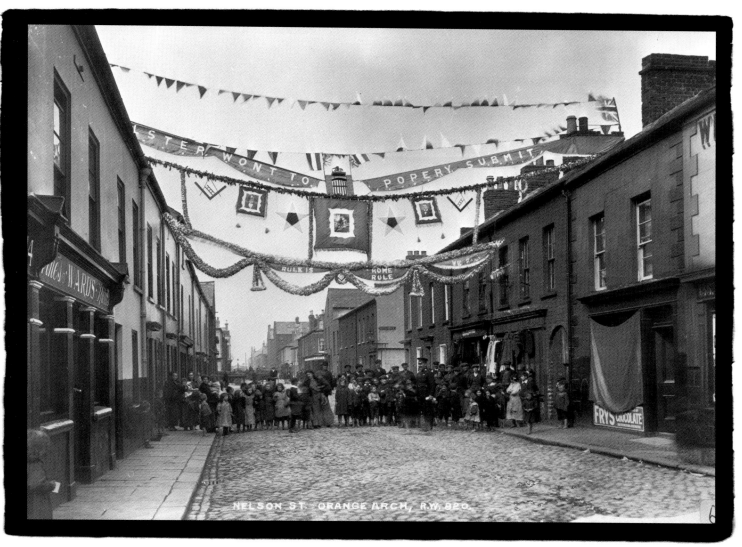

Loyalty to a liege may erode; change must, peacefully or otherwise, come to pass. The Act of Union of 1801, for a complexity of reasons and in the face of resistance, not least from Ulster, had sought to consolidate conquest, plantation and domination into a Union of 'Sister Nations'. Living within that Union, however, had fomented rebellion in some, resistance in others and, to a greater or lesser degree, fostered the practice of sectarianism to underpin privilege, to maintain inequalities, and to conserve the status quo. For many, the prospect of Home Rule lent authority to a festering fear of Rome Rule. For others, Home Rule was a distraction from a national ideal that 'Ireland stands forth before the world a nation free and independent.'

Nelson Street, Belfast, view of the upper end of the street, July 1912. WELCH©NMNI.

Unionist cultural identity had been formed within the British Empire, the power and prestige of which underpinned the increasing prosperity of Ulster. Over time, the potential for a confident sense of a Gaelic Irish identity had declined, but the aspiration to resist the Anglicisation of Irish culture had fostered allegiance to the Gaelic League. The sense of common cause with the aspirations of Empire that had been evident across Ireland during the first Boer War in 1880 had, by the second in 1899, been eroded within the nationalist communities, and amplified within the unionist. Irish cultural identity, conflated with nationalism, increasingly sought authentic definition by deference to the power and authority of the Catholic Church. In the north-east of the island, in Dublin, Cork, Waterford, Wexford and elsewhere, Scots Presbyterians, English Quakers, Anglicans, Huguenots and Dissenters nurtured an identity as Unionist and Protestent; for some, Irish and, for many, English. In 1912 a Home Rule Bill for Ireland was introduced: for a very significant minority on the island, it marked the end of the line.

Queen's Quay terminus, 1912. WELCH©NMNI.

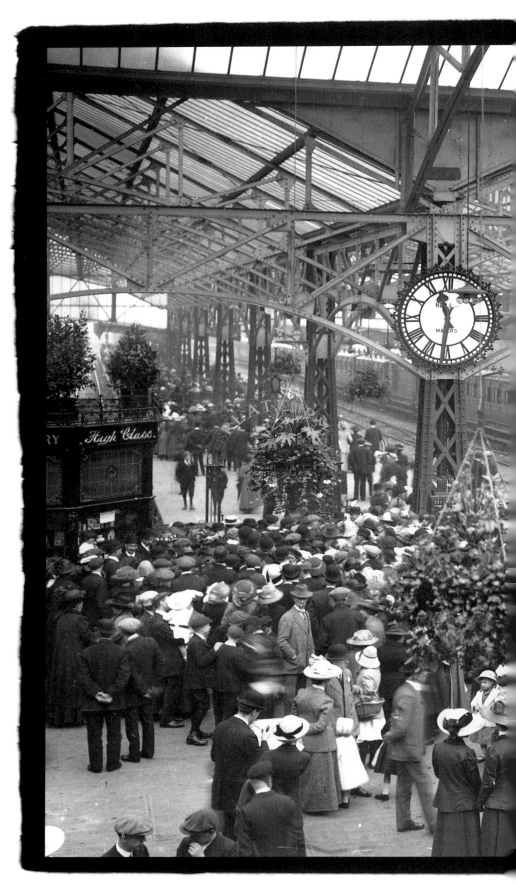

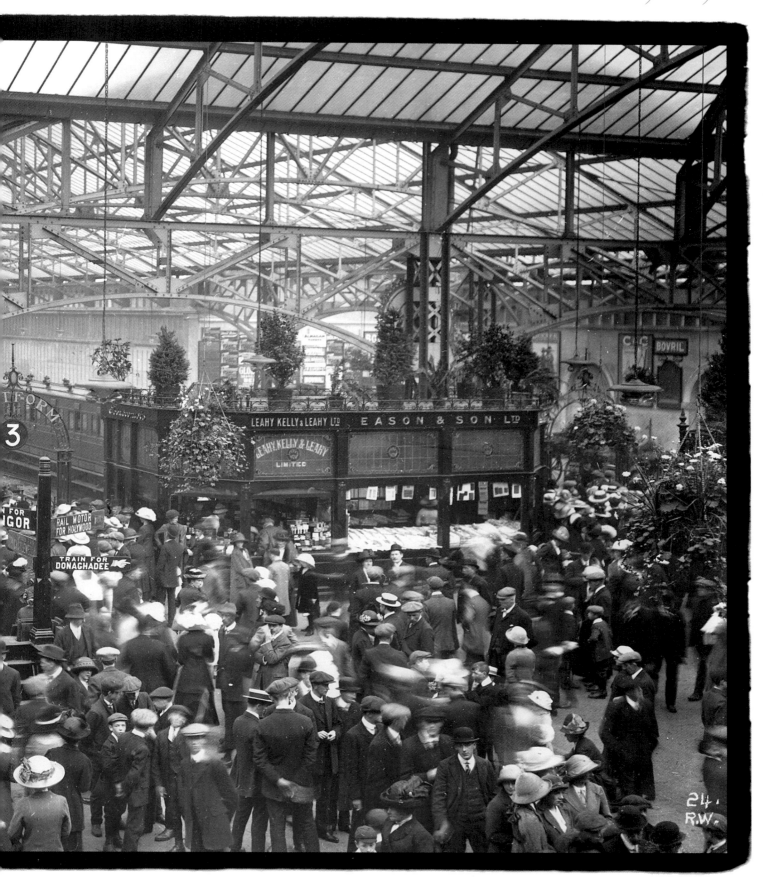

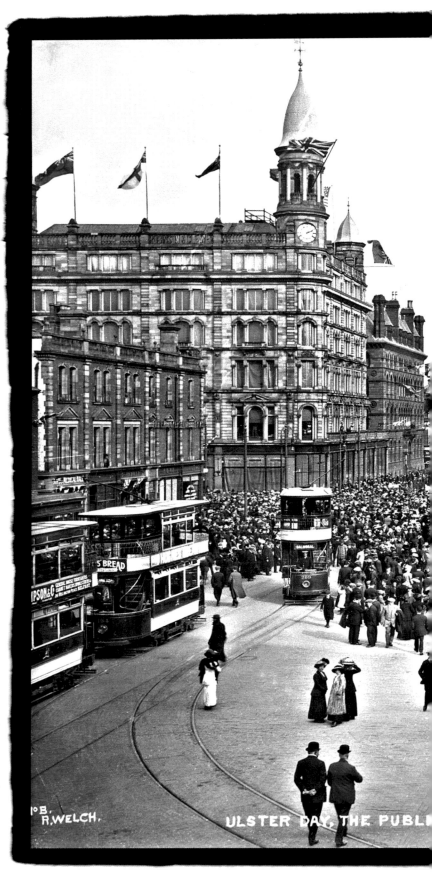

In the face of public dissent, a Liberal backbench MP suggested a compromise. Four counties of Ulster, all electors registering a Unionist majority, would remain within the Union and outside the terms of Home Rule. This was rejected by the government. On Ulster Day, 1912, almost half a million people in Belfast signed the Ulster Covenant at City Hall in a public gesture of support for the Union. In January 1913, although the Home Rule Bill had failed to pass, Orange lodges began to mobilise to practise drilling and to begin the process of establishing an Ulster Volunteer Force, a movement evoking 'a settler folk history of self reliance and self defence' (Bartlett, 2010).

Ulster Day, the public passing in to sign the Covenant, City Hall, Belfast. WELCH©NMNI.

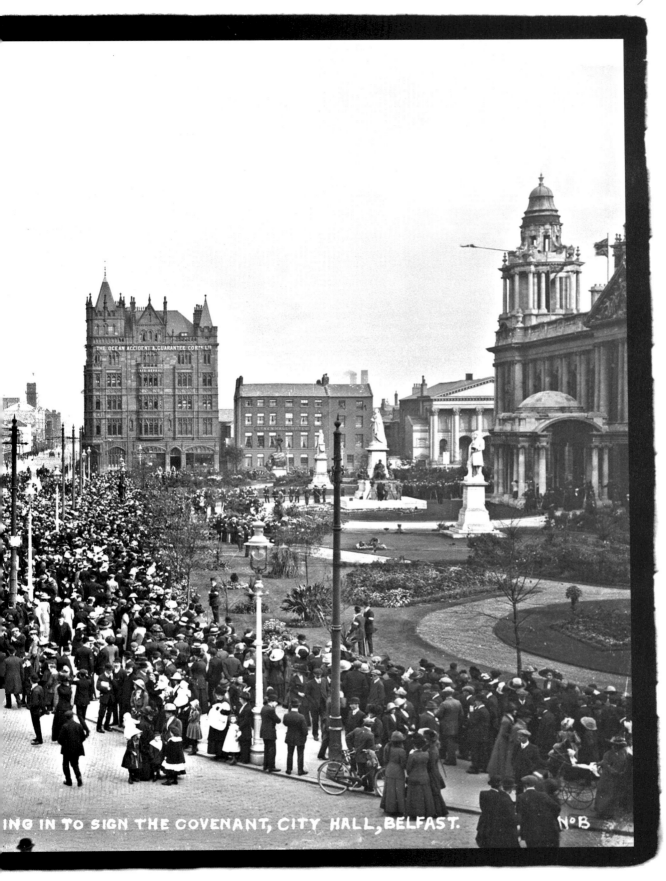

ING IN TO SIGN THE COVENANT, CITY HALL, BELFAST. N°B

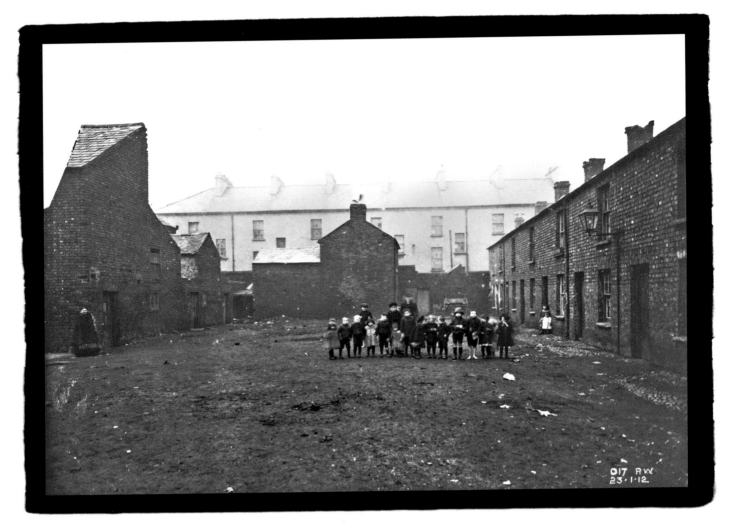

For many, the Union of Great Britain and Ireland had fostered a sense of patriotism, of purpose and of prosperity. The UVF had moved to defend all that fellow unionists believed it should stand for. For many others, the Union had come to represent alienation from their sense of authenticity as a people and, for too many, a life of entrenched poverty. By 1911 the population of Belfast stood at 387,000, many employed — men and women — in mills, factories and the shipyards. Catholics represented less than 25 per cent of Belfast's population, largely residing among the unskilled and the poor.

The view from the centre of Riley's Court, Belfast, 1912. WELCH©NMNI.

In Dublin the monument to Daniel O'Connell presides over the mixed fortunes of Catholic emancipation within the capital of the Ascendancy. Dublin has a population of 398,000. It is a capital city, with 27,000 civil servants working in 29 government departments, the bulk of which are based in Dublin. There is an efficient system of public transport and considerable prosperity: 'By the early twentieth century … the middle classes of the Dublin suburbs had developed a clear articulation of their class position and social values. Their suburban homes were … fully developed … surrounded by mature gardens and parks … ordered streets and an unrivalled public transport system' (Rains, 2010).

Magic lantern, Sackville Street, Dublin. Ephraim MacDowell Cosgrave©RSAI.

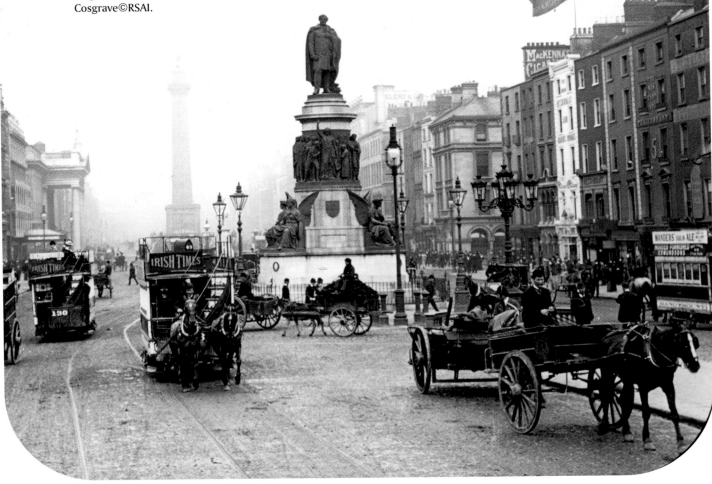

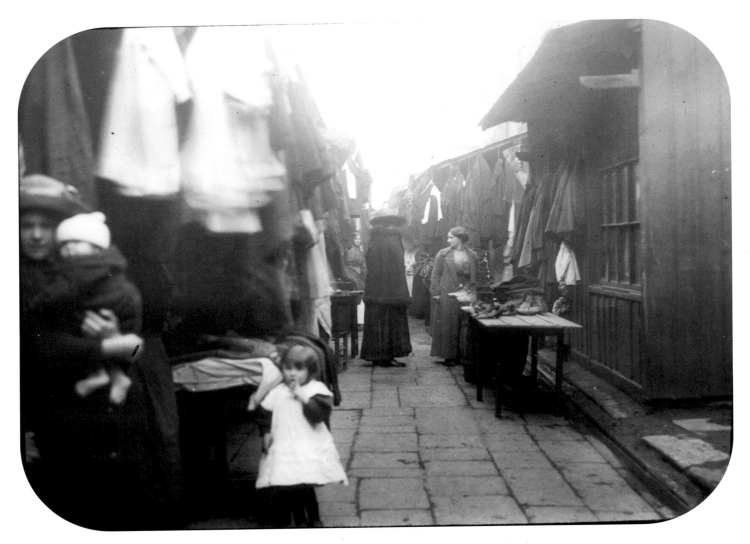

In the warren of streets behind Sackville Street and Rutland Square, in the Liberties and in the tenements at the centre of the city, a less vibrant economy sat uneasily between the village market and the modern department store, with business conducted under the formidable authority of street traders. Overall, the 1911 Census recorded 430,000 women or 38 per cent of the adult female population of Dublin in paid work. Unskilled work for men was often casual rather than regular; unemployment was endemic. In 1913 thousands of working people were locked out from their places of employment for refusing to relinquish the right to organise to improve their collective lot. The Lock-Out lasted seven months. Soup kitchens and organised discontent became the order of the day.

Darkest Dublin, 1914. ©RSAI.

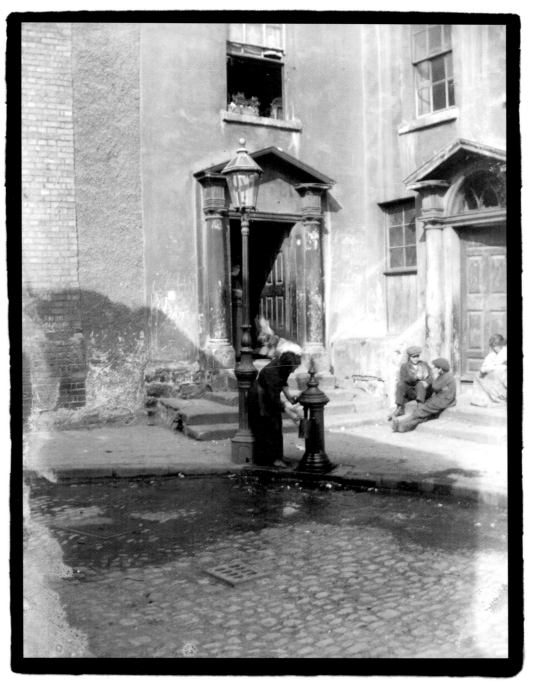

Slum housing was extensive, and in September 1913 two tenement houses in Church Street collapsed, killing seven people. A Committee of Inquiry was established and reported that '87,305 people — more than one in five of the population — live in tenement houses' in the city of Dublin. Owners of tenements included 'five aldermen and eleven city councillors'. Disease was rampant, including typhus, measles, whooping cough and tuberculosis. (Corcoran, 2005) Female beggars outnumbered males by three to one; there were more girls than boys in orphanages, more women than men in workhouses or charitable institutions. The subsistence level in Dublin was set at £2 a week, a goal few achieved. The density of population at the beginning of the century was 70 persons per acre.

Chancery Lane, Dublin. Ephraim MacDowell Cosgrave©RSAI.

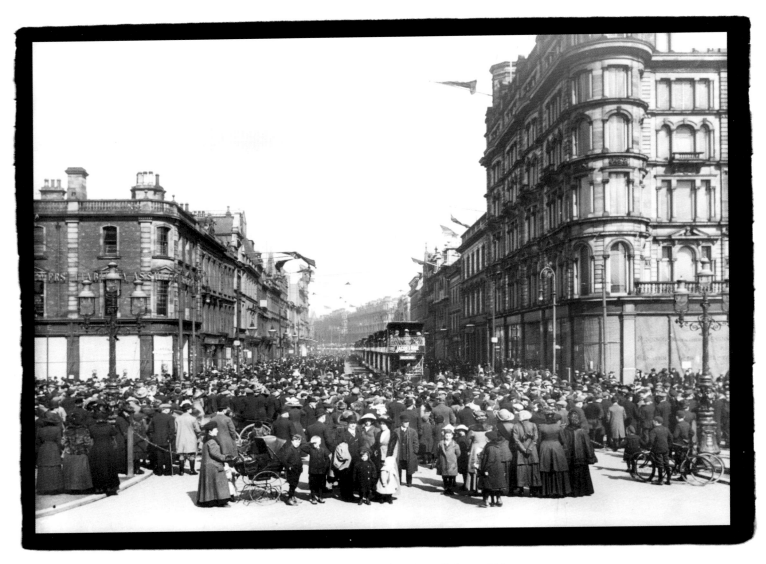

The Ulster Covenant opened with a conviction '… in our consciences that Home Rule would be disastrous to the material well-being of Ulster as well as the whole of Ireland, subversive of our civil and religious freedom, destructive of our citizenship, and perilous to the unity of Empire'. The statement was unequivocal, but with the reassembling of Parliament in 1913 a Home Rule Bill had been forced through. A gauntlet, in effect, had been thrown down in the direction of Ulster. The Ulster Unionist Council authorised the formation of the various units of the Ulster Volunteer Force to travel under a 'single centrally commanded military organisation'.

1912 Unionist clubs march to Balmoral. WELCH©NMNI.

In Dublin, the Irish Republican Brotherhood paper, Irish Freedom, *published an opinion from Patrick Pearse, a member of the Brotherhood: 'It is symptomatic of the attitude of the Irish Nationalist when he ridicules the Orangeman … not for his numerous foolish beliefs, but for his readiness to fight in defence of those beliefs'. Further, he argued that a readiness by the Orangeman to fight in 'defence of what he believes … is his clear duty'. Pearse himself would favour emulation, not ridicule. The trend towards militarisation came from other quarters also — from James Connolly and Jim Larkin, in the wake of what was seen to be the use of excessive force from the Royal Irish Constabulary in the course of the Lock-Out, and from Professor Eoin MacNeill, a founder member of the Gaelic League. By late 1913, the model established by the Ulster Volunteer Force had been followed by the establishment of the Irish Citizen Army and, under the leadership of MacNeill, of the Irish Volunteers. By 1914 all would be committed to serving as extra parliamentary, militarised forces, increasingly under arms.*

Irish Volunteers march in Killlarney, Co. Kerry, 1 July 1914. ©EXAMINER.

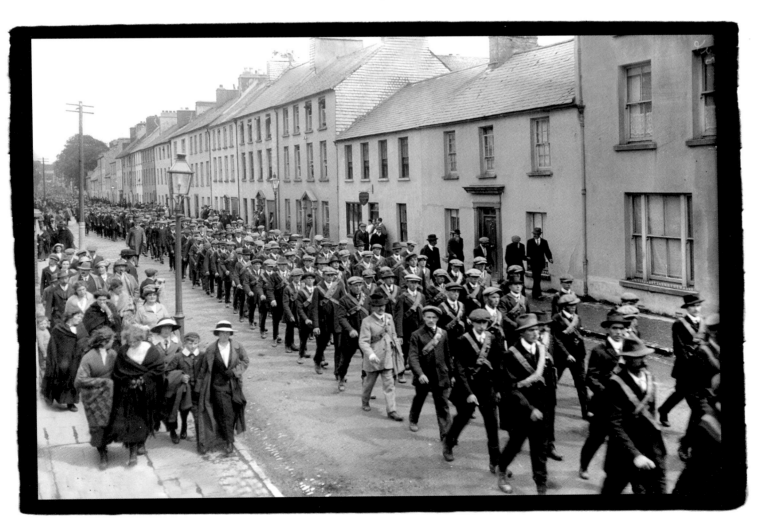

One month prior to the march of the Irish Volunteers in Killarney, Archduke Ferdinand had been assassinated in Sarajevo, an act which precipitated the mobilisation of legal military forces across Europe. One month after the march of the Irish Volunteers in Killarney, a Home Rule Act had been passed by the House of Commons. Britain and France were at war with Germany. Conceding to the imperative of the larger cause, an amendment to the Home Rule Act suspended its passage into law, and included 'a separate commitment that "Ulster", not yet defined, would not be encompassed within its reach' (Bartlett, 2010). Across Ireland the question of partition was shelved, a threat suspended as thousands of men and women of all persuasions responded to the war effort.

The Fusiliers, Cork, 1914. ©EXAMINER.

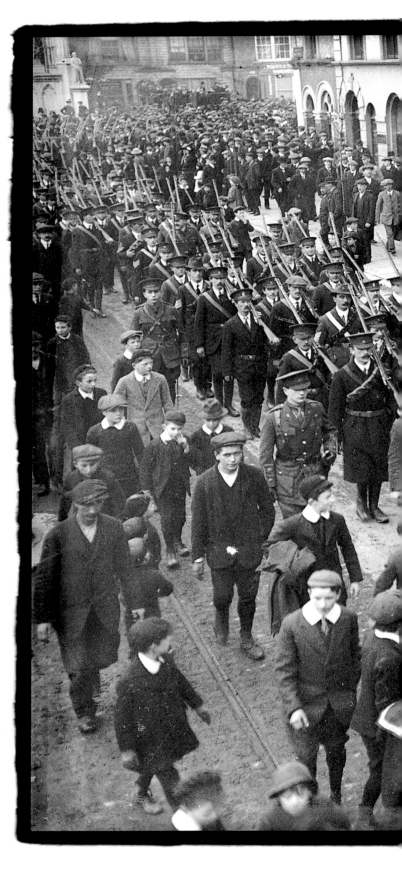

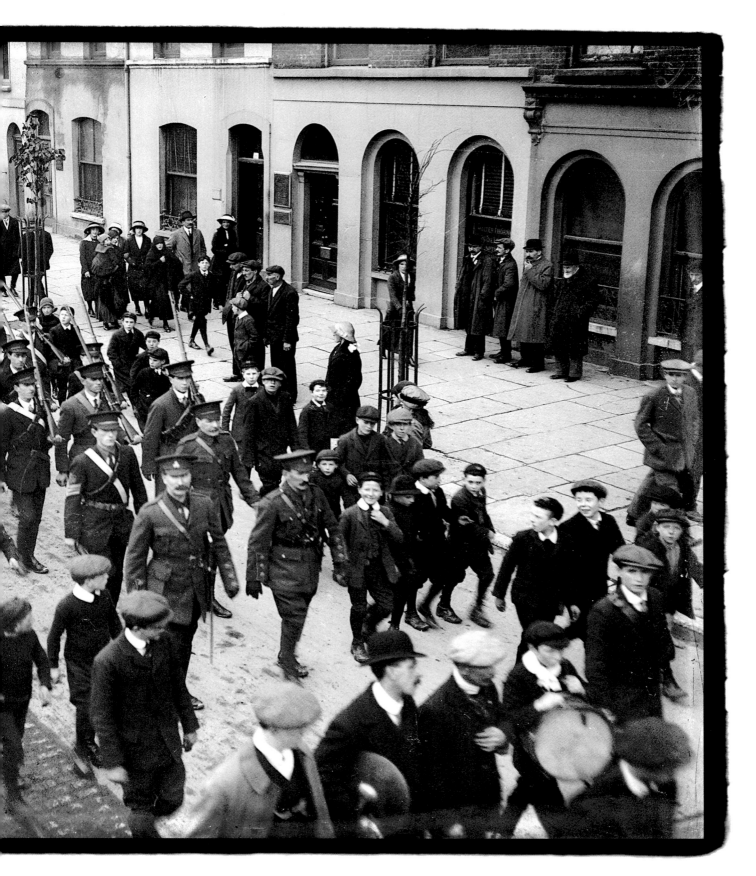

Queenstown, Co. Cork, was a major port for shipping traffic across the Atlantic — including the Belfast-built Titanic, en route to America, and for massive nineteenth-century emigration. For the local population of 11,604 in the 1911 Census, there was employment, some prosperity and the vitality of commerce. The population recorded in the 1911 Census absorbed members of the British Army stationed in Queenstown, and of the British Navy based at Haulbowline Island. Queenstown became a military and naval base of major strategic importance in the course of World War I.

Queenstown, Co. Cork, 1914, with Haulbowline Naval Base offshore. ©EXAMINER.

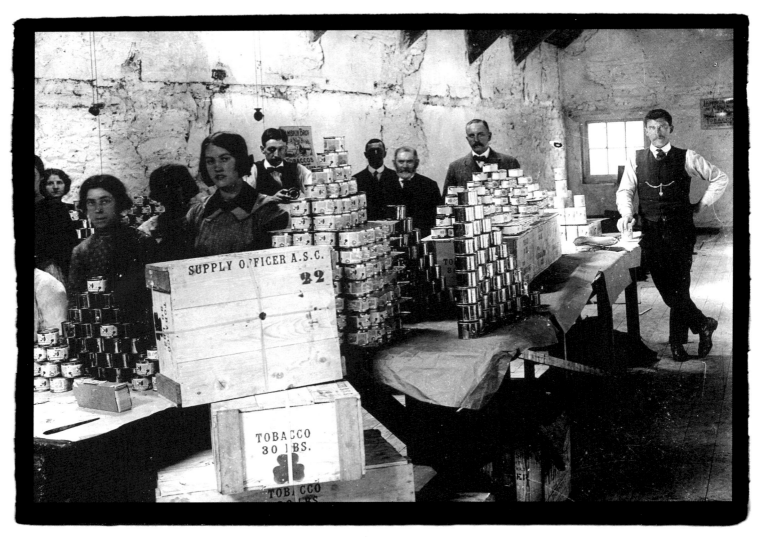

Lambkin's tobacco factory was a significant Cork employer and, as with many other establishments, through the provision of pre-packaged supplies for the British Army at the front, played a part in the war economy. Although the government was criticised for failing to place military orders with industries beyond Ulster, World War I demonstrated that the industrial base in the north of the textile industry, already engaged in the supply of uniforms and parachutes, extended, logically and technically, into general engineering, including shipbuilding and aircraft manufacture. This was a major boost to the development of the industrialised economy of Belfast and of the north-east; outside Ulster, a high explosive plant in Arklow employed 2,000 people (Ferriter, 2004) and several munitions factories produced 18 pounder shells in the Claddagh in Galway; factories in Dublin and at Pierce's and Thompson Bros of Wexford were directly related to war production. There was, however, a claim from government that no major engineering industry in Ireland, outside Ulster, had the experience of a skilled workforce capable of large-scale and immediate deployment into an economy by now overwhelmingly geared to production for warfare.

Lambkin Brothers, tobacco factory, Cork, 1914. ©EXAMINER.

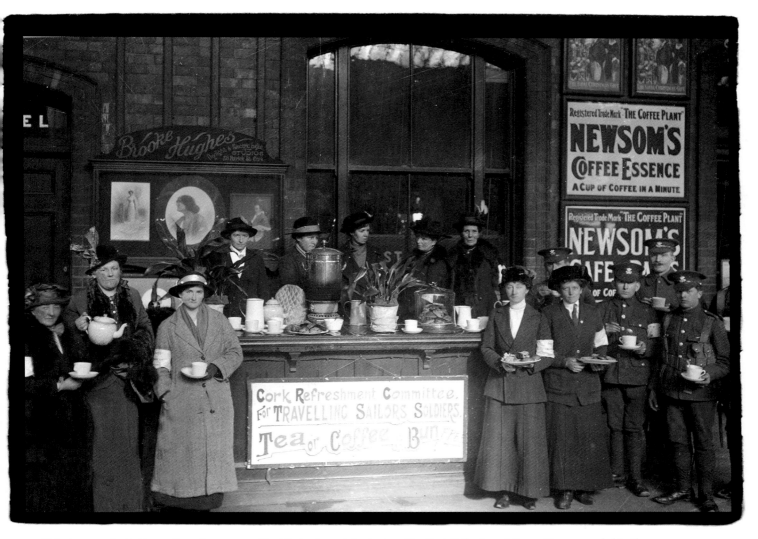

Voluntary service in times of war became a critical factor in social cohesion. The Cork Refreshment Committee responded to the war effort by providing for 'Travelling Sailors & Soldiers', many en route from Queenstown, from Youghal and from within the vast network of barracks across Ireland that were now mobilised for action. Voluntary work extended to collecting money for ambulances for the Front, and to the deployment of urban women to rural Ireland to bring in the harvest, key to the significant increase of food exports to Britain. At Leinster House, Dublin, Lady Aberdeen recorded that at a gathering 'of those interested in establishing Red Cross Work in Ireland … the hall was packed from roof to floor …' The meeting included a cross-section from a politically deeply divided land: 'the Women's National Health Association, the United Irishwomen, the Irish Volunteers Aid Association, the Dublin branch of the Ulster Volunteers and Cumann na mBan' (Aberdeen, 1925). Many were Protestant and often of independent means; Redmondite Irish Nationalists supported the war effort but, more surprisingly, 'a robust and ambitious Catholic middle class, conscious of the tantalising immediacy of Home Rule … responded positively to the summons to arms' (Reilly, 2002).

The Cork Refreshment Committee, 1914. ©EXAMINER.

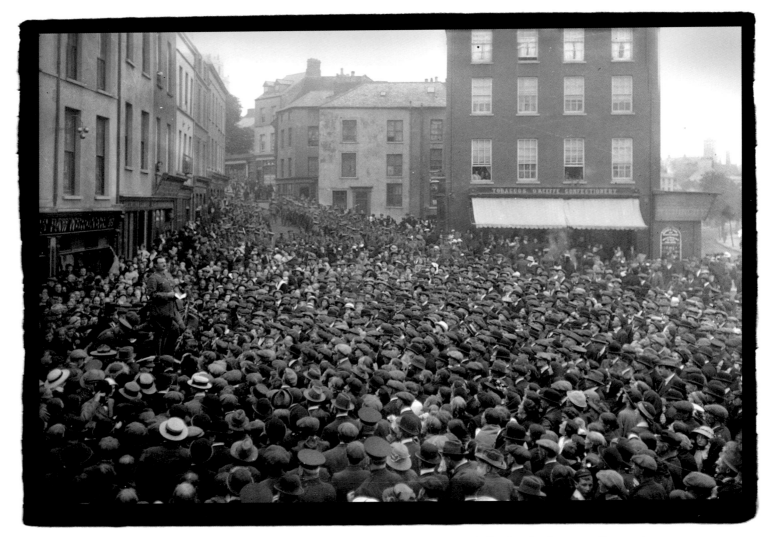

Active political hostility towards the government and the mooted policy of partition was indicative of a dangerous discontent on the ground, with no mapped legislative route in evidence. The outbreak of WWI proceeded in tandem with street and rural road skirmishes, but also with significant broad support for Home Rule within the Union. Southern and many northern unionists — bankers, brewers and businessmen — gave notice of their intention to resist partition. The war effort was widely supported across Ireland. Recruitment meetings drew large crowds, with the Irish representation in the British Army disproportionate to the numbers of young men in the population of the island. From 2 August 1914 to 8 January 1916, 86,277 recruits were raised within all the counties of Ireland. Of these an estimated 13 per cent of men were killed in action. (Kennedy, 1996) The rate of attrition in those defined as being from the Irish 'noble' class, those of diverse origin who maintained an Irish residence, was significant: the fathers and sons who enlisted from such houses numbered 109; of these, 29 were killed in action. (Martin, 2002)

British Army First World War recruiting meeting at Shandon Street, Cork, 1 November 1915. ©EXAMINER.

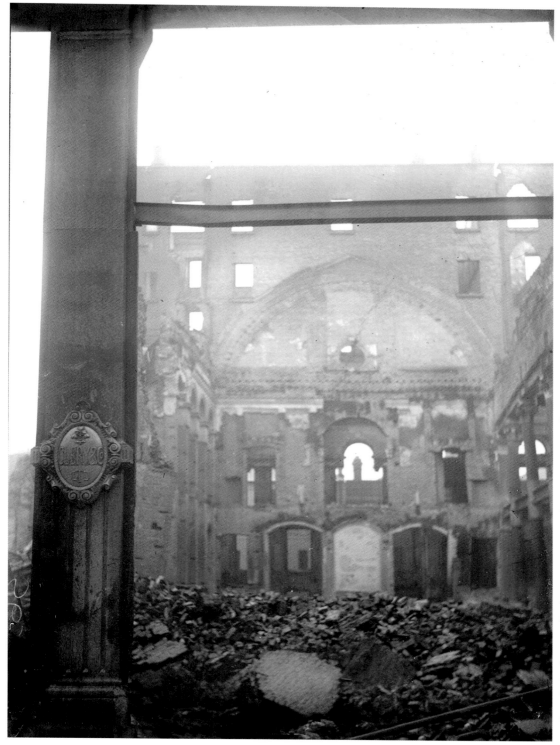

For many, a common experience of appalling conditions in the trenches, and a common enemy beyond, may have tempered differences of politics and of religion. For some, the phrase, 'A War to Unite us All', had meaning which diluted the jingoism of Empire and the legacy of the Boer War. But in Dublin, at Easter in 1916, the theatre of another war burst onto the streets of a city where an Ascendancy was in decline and from which the British parliament had signalled an intent of strategic withdrawal; where squalid living conditions festered behind the façade of exotic emporia; and where the dynamic with the potential to fuel a profoundly different vision for Ireland moved, explosively, centre stage. The brief exploits of men transformed players into heroes, and executioners into enemies. Home Rule moved towards a staged death, and a cross-class, pan-nationalist movement took its lead from the 1916 Proclamation: 'We declare the right of the people of Ireland to the ownership of Ireland, and to the unfettered control of Irish destinies ...'

The burning of Clery & Co., Dublin, 1916. ©EXAMINER.

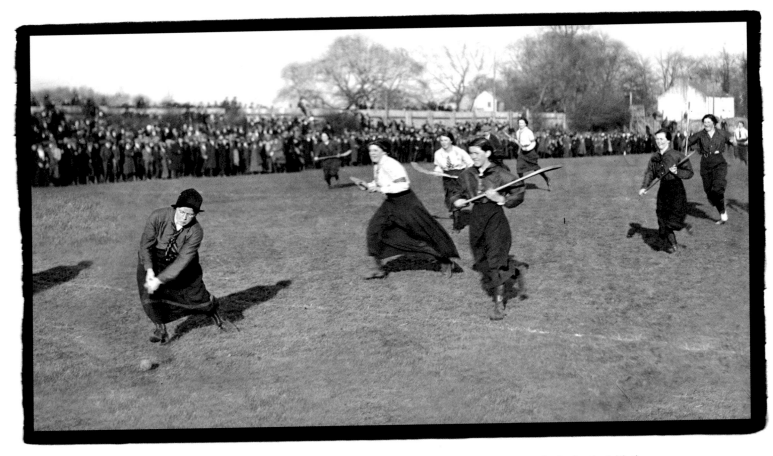

The implication that there would be multiple, rather than singular, destinies for Ireland would prove prophetic. On the initiative of the British Prime Minister, a major Irish Convention is convened, to be held in Dublin to discuss settlement proposals. Sinn Féin and the Ulster Unionist leadership do not attend. Southern Unionists, members of the Irish Parliamentary Party and Independents do. Fears are aired, but 'there was an unavoidable air of irrelevance about the entire proceedings' (Bartlett, 2010). The Proclamation was an address 'To the people of Ireland'. It had called to 'Irishmen and Irishwomen': the intent was 'ecumenical', as was its relevance to the women's suffrage movement. Throughout Ireland, the Gaelic game has returned to the field of play.

Camogie intervarsity competition, UCC v UCD. ©EXAMINER.

When America joined the war effort, ships of the US Navy crossed the Atlantic to report for orders at the US Main Base, European waters at Queenstown, Co. Cork. On the morning of 4 May 1917, the United States Navy came into anchor in the lee of Haulbowline Island. Within weeks 8,000 American and British personnel were based in this most strategic port. The population of the town doubled virtually overnight. Sinn Féin were active throughout the county and the city, and considerable tension and hostilities between two groups in Cork led to the banning of travel from Queenstown to Cork by American Navy and British Navy and Army personnel. On the USS Dixie, in Queenstown Harbour, influenza is diagnosed as the crew, and others on ships and bases along the coastline, fell prey to the influenza pandemic that would kill more globally than the men from all armies who would die in the trenches of WWI.

Queenstown Harbour, Co. Cork, 1918. LAWRENCE©NLI.

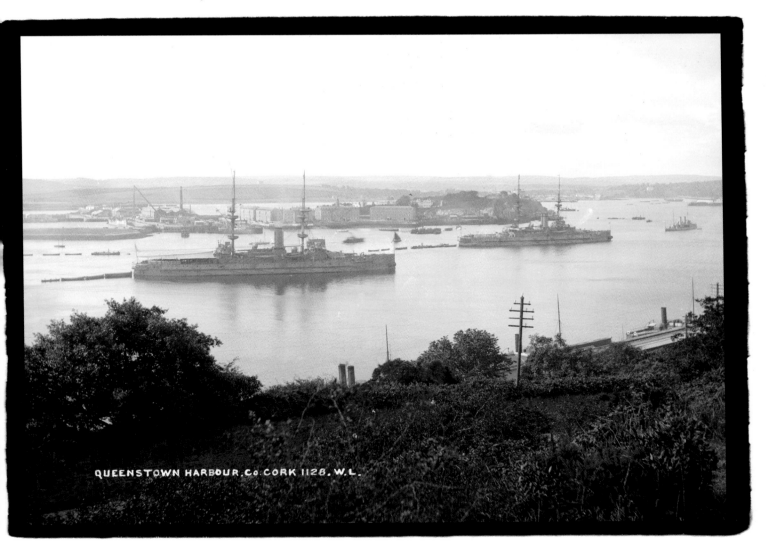

QUEENSTOWN HARBOUR, Co. CORK 1128. W.L.

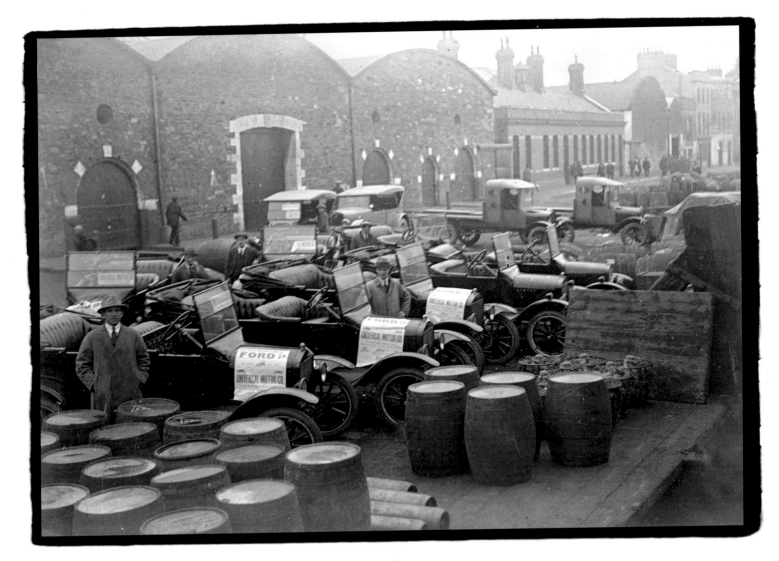

Disillusion with British government attitudes to, and reluctance to invest in, Irish industry deepened when 'the sweeping powers of the Ministry of Munitions were not used to assign a significant amount of production to the south of Ireland. The proffered justification — that suitably qualified labour for efficient industrial operations was not available there — did not tally with the wartime decision of that emblematically modern US manufacturer, Henry Ford, to locate a large plant in Cork' (Murray, 2001). When Henry Ford & Son Ltd first established a plant in Cork in 1917, its agreed brief was to manufacture 'motor tractors' or 'capital goods', part of a deal with the British government that sales of tractors to the government would be on a non-profit basis and that Ford would make no charge for use of his patents. Ireland would neither manufacture the Ford motor car for sale in Ireland, nor compete with the industrial plants in Britain that did so.

Universal Motor Company automobiles display of Fords at St Patrick's Quay, Cork, 1918. ©EXAMINER.

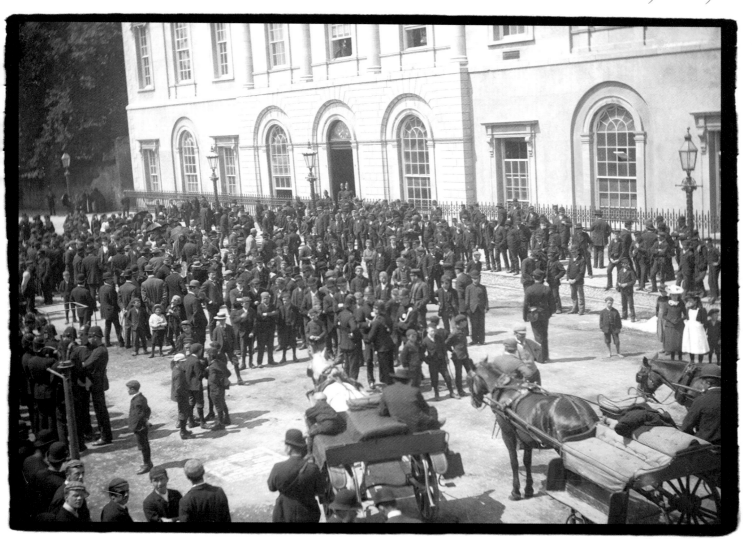

In May 1918, in the wake of major losses at Flanders, the government called for the conscription of men in Ireland. A public outcry followed and an Anti-Conscription pledge was signed by thousands of Irish men and women. The Home Rule Party withdrew from the House of Commons in protest at the call, and Irish nationalist opinion was united against any suggestion that Ireland had not, consistently, already heeded the call to enlist. Martial Law was declared in the south and in the west. Sinn Féin, the Volunteers and other nationalist organisations were proscribed. The Representation of the People Act, 1918, reformed the electoral system across the United Kingdom of Great Britain and Ireland: the franchise would extend to include all men over 21 years and all women over 30 years. A general election was called for December 1918.

The 1918 Election, Waterford. POOLE©NLI.

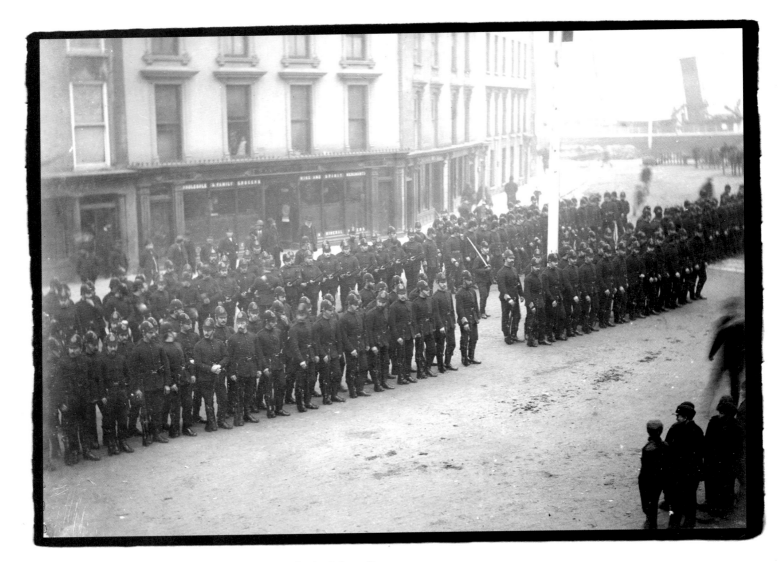

Across the country, the election was heavily policed. The Labour Party decided not to contest: James Connolly was dead, executed in the wake of the Rising, and with him much of the intellectual impulse to pursue a radically different, socialist route for Ireland retreated. Sinn Féin pursued a different strategy — to contest, but to pledge to refuse to take their seats at Westminster. The Great War had prompted a prohibition on travel from Ireland to America for a number of years, and many young Irish people who might have anticipated a future elsewhere had remained in Ireland, with the notable presence of young men in public spaces indicative of an appetite, and now the opportunity, for change. Sinn Féin won 73 seats, the Unionist Party won 29, and the Irish Parliamentary Party won 6. Sinn Féin, in defiance of the British government, called for its elected members to attend the First Dáil Éireann, to be convened in the Mansion House, Dublin. First on the order of business: a Declaration of Independence. Many young men, from all sides in a global and most bloody conflict, had died: at the Armistice Day celebrations on 11 November, the Union Jack was hoisted in Belfast and in Dublin. But in Dublin, shots also rang out, in defiance of assumptions that few would now venture to stand over.

Members of the Royal Irish Constabulary, Waterford, 1918. POOLE©NLI.

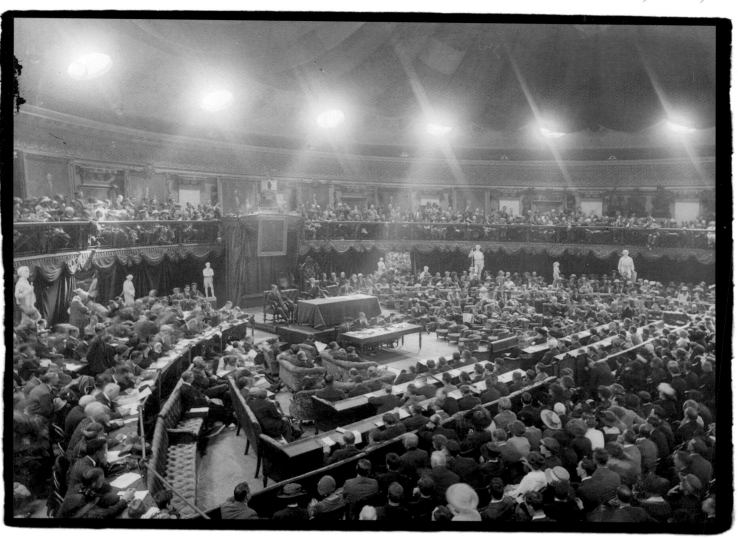

Having escaped from jail in England, de Valera is unanimously elected as President of Dáil Éireann, the Parliament of Ireland. At the first meeting of this constituent assembly, on 21 January 1919 in the Mansion House in Dublin, the independence of Ireland is declared and the Democratic Programme for government adopted. It will include a system of Dáil Courts, with 'arbitrators ... to be elected by the people of each parish', in effect, 'a lay magistracy with qualified lawyers as court officials'; a system 'of a character' to rival the Crown Courts is to be established. As the Royal Irish Constabulary had 'withdrawn to barracks', 'the people turned increasingly towards this kind of local jurisdiction and thus strengthened the authority of its innovators' (Kotsonouris, 2004).

The First Dáil Éireann, Mansion House, Dublin, 1919. KEOGH©NLI.

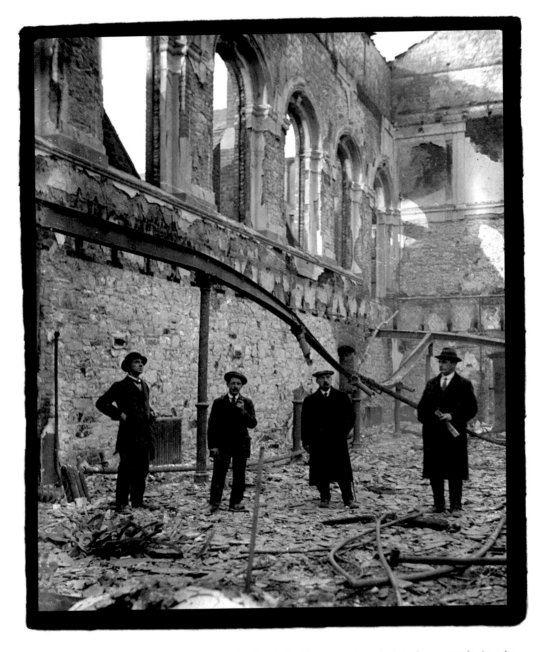

In September 1919, the First Dáil is proscribed and the Government, with de Valera away in America seeking funds, goes underground. Two members of the Royal Irish Constabulary are shot in Tipperary: the first shots to be fired in the War of Independence. Violence flares, and guerrilla warfare convulses Ireland. Food prices are rising and the Irish Labour Party and Trade Union Executive place an embargo on the export of foodstuffs from Ireland. The Freeman's Journal is suppressed; the Evening Telegraph headlines the reasons why, and the London Daily News gives two columns to the Freeman's Journal for the duration. On 12 February 1920, 10,000 people at a meeting in London demand freedom for Ireland. Martial Law is imposed in Dublin. In Belfast, merchants are uneasy and War Loans are tumbling. By June, newspapers are reporting on 'Fermoy's Ruined Shops'. In Dublin, the Freeman's Journal goes on trial at the Royal Barracks, Dublin, for 'producing false reports and reports calculated to cause disaffection'. In December, fires break out across Cork.

Cork businessmen survey the damage in Patrick Street, Cork, December 1920. ©EXAMINER.

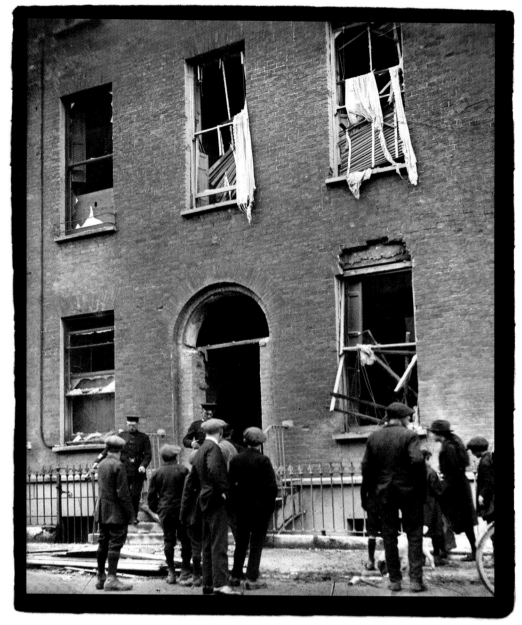

The official Military report on the state of Cork City from 10 p.m. on Saturday, 11 December 1920, to 5.30 a.m. on Sunday, 12 December 1920, during which period the city was in complete control of the military, details fires at a number of sites, the withdrawal of troops and a series of explosions that could not be located. The Chief Secretary denies the claim in a number of newspapers that the fires and the destruction of property had been the work of Crown Forces. A further claim is made that the British Auxiliary Police, recently arrived in Cork, had hindered attempts to control the burning. As part of a calculated attack on the RIC, an explosion later destroyed the Cork barracks.

The destruction of the Royal Irish Constabulary Cork Barracks at MacCurtain Street, Cork, following an explosion in 1920. ©EXAMINER.

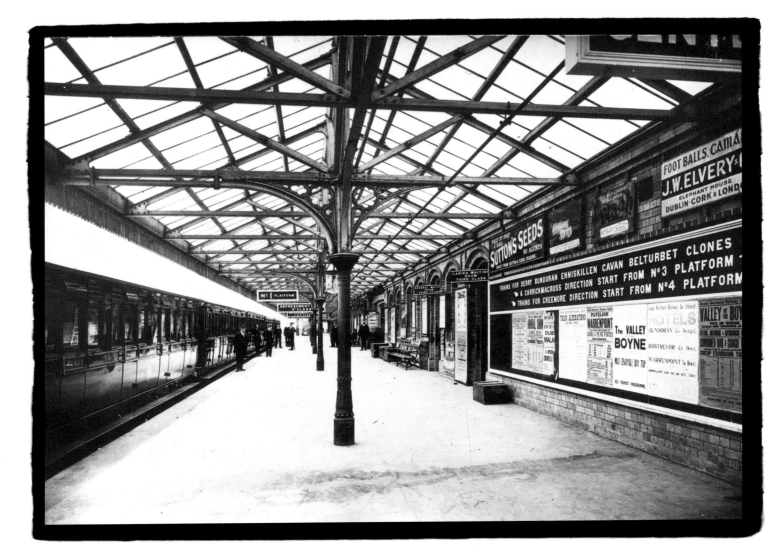

In December 1921 the signing of the Anglo-Irish Treaty marked the division of Ireland into two political jurisdictions. The island of Ireland, as with all land mass, is subject to continuous and unforeseeable change; it remains by choice, and courtesy of the peoples of the Union of Great Britain and Ireland, 1801–1921, linked by the line of rail.

The Great Northern Station, Dundalk, Co. Louth. MASON©NLI.

Select Bibliography
Select Bibliography

Primary Sources

1893 Royal Commission on Labour
The Agricultural Labourer, HM Stationery Office, 1893.
The Employment of Women: The Conditions of Women's Work in Ireland, HM Stationery Office, 1893.

Police Barracks (Ireland)
Return to an Order of the Honourable the House of Commons, 2 April 1868. Ordered by the House of Commons to be printed, 20 May 1868.
Return of the number of Police Barracks in each county in Ireland which are considered to be in a Satisfactory Condition, both as to the Security and Health of the Constabulary; of the Number in each County the Defective Condition of which representation has been made to the Government; of the Number in each county which the Landlords have agreed to Fortify on the Government Plan; and of the Average Cost of Defences of each Barrack completed. 'It has not been proposed to extend these works to Ulster'. Letter, Constabulary Office, Dublin Castle, 9 May 1868.

Reformatory and Industrial Schools (Ireland)
Copy of a circular issued in July 1871 by the Inspector of Reformatory and Industrial Schools, Ireland, to the Managers of Roman Catholic Industrial Schools in Ireland. Ordered by the House of Commons to be printed, 16 April 1872.

Extract from Report from the Inspector of Industrial Schools, March 1872.

A Bill further to facilitate the building, enlargement, and maintenance of Industrial Schools in Ireland. Ordered by the House of Commons to be printed, 13 March 1885.

Lunatic Asylums (Ireland)
The Nineteenth Report on the District, Criminal, and Private Lunatic Asylums in Ireland. Dublin. Printed by Alexander Thom for HM Stationery Office, 1870.

Return of the Lunatic Asylums and Workhouses in the Counties of Cork and Limerick, in which Turkish Baths have been erected; stating to what extent such Baths are now in use. Ordered by the House of Commons to be printed, 21 July 1870.

Factories and Workshops
Annual Report for 1907, Appendix IV, Truck and Gombeening in Donegal (by Miss Martindale).

Official Statistics
Ireland
Farming since the Famine: Irish Farm Statistics 1847–1996, The Stationery Office, Dublin, Central Statistics Office, 1997.
Population of Ireland 1831–1926

England and Wales
Population of England & Wales 1811–1931

Scotland
Population of Scotland 1811–1931

Secondary Sources
Publications

Bartlett, Thomas, *Ireland: A History*, Cambridge University Press, 2010.
Corcoran, Michael, *Our Good Health: A history of Dublin's water and drainage*, Dublin City Council, 2005.
Cullen, Louis, *Life in Ireland*, B.T. Batsford Ltd/G.P. Putnam's Sons, 1968.
Daly, Mary E., 'Two Centuries of Irish Social Life' in *A Time and a Place: Two Centuries of Irish Social Life*, National Gallery of Ireland, 2006.
De Paor, Liam, *Divided Ulster*, Penguin Books, 1970.
De Paor, Liam, *On the Easter Proclamation And Other Declarations*, Four Courts Press, 1997.
Ferriter, Diarmaid, *The Transformation of Ireland 1900–2000*, Profile Books Ltd, 2004.

Select Bibliography

Select Bibliography

Foster, Roy, *Modern Ireland 1600–1972*, Allen Lane The Penguin Press, 1988.

Gregory, Adrian and Senia Paseta (eds), *Ireland and the Great War: A War To Unite Us All?* Manchester University Press, 2002.

Joyce, P.W., *A Smaller Social History of Ancient Ireland*, M.H. Gill & Son, Ltd, 1908.

Kelly, Fergus, *A Guide to Early Irish Law*, Dublin Institute for Advanced Studies, 1991.

Kotsonouris, Mary, *The Winding up of the Dáil Courts 1922–1925*, Four Courts Press in association with the Irish Legal History Society, 2004.

Martin, Peter, chapter 2, 'Dulce et Decorum: Irish nobles and the Great War, 1914–1919' in Gregory and Paseta (eds), *Ireland and the Great War*, Manchester University Press, 2002.

Purdue, Olwen, *The Big House in the North of Ireland: Land, Power and Social Elites, 1878–1960*, University College Dublin Press, 2009.

Rains, Stephanie, *Commodity Culture and Social Class in Dublin 1850–1916*, Irish Academic Press, 2010.

Reilly, Eileen, chapter 3, 'Women and voluntary war work' in Gregory and Paseta (eds), *Ireland the Great War*, Manchester University Press, 2002.

Rynne, Colin, *Industrial Ireland, 1750–1930: An Archaeology*, The Collins Press, 2006.

Smyth, William J., *Map-making, Landscapes and Memory: A Geography of Colonial and Early Modern Ireland c.1530–1750*, Cork University Press, 2006.

An Ulsterman (George Sigerson), *Modern Ireland: Its Vital Questions, Secret Societies and Government*, Longmans, Green, Reader and Dyer, London, 1868.

Wills, Clair, *Dublin 1916: The Siege of the GPO*, Profile Books, 2009.

Journals

Cullen, Fintan, 'Marketing National Sentiment: Lantern Slides of Evictions in Late Nineteenth-century Ireland', Hist. Workshop J (Autumn) 54(1): 162–179, doi:10.1093/hwj/54.1.162.

Gibbons, Luke, 'Topographies of Terror: Killarney and the Politics of the Sublime', South Atlantic Quarterly, 95:1, Winter 1996.

Montmorency, Morris, E.A., 'Canals and Waterways of Western Europe'. Read to the Statistical and Social Inquiry Society of Ireland, 15 December 1905, JSSISI, Vol. X, 138.

Neill, Desmond G., 'Occasional Papers in Irish Quaker History', No. 1, Historical Committee of the Society of Friends of Ireland, 1992.

Weir, Anthony, 'Sweathouses and Simple Stone Structures in County Louth and Elsewhere in Ireland', Journal of the County Louth Archaeological Society © 1979.

Electronic Sources

Murray, Alice Effie, Corpus of Electronic Texts Edition: E900040.

A History of the Commercial and Financial Relations between England and Ireland from the Period of the Restoration. Second edition 1907 [9 + 486 pp. 1–43 text; 439–44 appendices; 445–67 bibliography; 469–86 index.] P.S. King, London, 1907. (First published 1903; reprinted New York: Burt Franklin 1970. *Studies in economics and political science*, No. 13.

On line Historical Population Reports 1870–1920. http://www.histpop.org

EPPI enhanced British Parliamentary Papers on Ireland 1801–1920. http://www.bopcris.ac.uk/eppi

Fitzpatrick, David, History In A Hurry, Book Review, Dublin Review of Books, March 2011. http://www.drb.ie

McCorristine, Shane, Science and Nation, Dublin Review of Books, November 2009. http://www.drb.ie

Photo Acknowledgments

Photo Acknowledgments

Photo Acknowledgments

NLI The National Library of Ireland
 Mason/Lawrence (L)/Poole (P) Collections
NMNI National Museums Northern Ireland 2011
 Collection Ulster Museum
RSAI Royal Society of Antiquaries of Ireland

Page 5 NLI, MASON_M1_S9; **page 6 [top]** © NMNI, BELUM.Y.W.10.46.1; **page 6 [bottom]** NLI, L_ROY_05856; **page 7 [top]** The UCD Archives; **page 7 [bottom]** © NMNI, BELUM.Y.W.09.51.2; **page 8 [top]** NLI, MASON_M5_S5; **page 8 [bottom]** NLI, MASON_M5_S8; **page 9** NLI, MASON_M4_S18; **page 10** NLI, MASON_M4_S15; **page 11** NLI, MASON_M4_S17; **page 12** NLI, MASON_M2_S17; **page 13** © NMNI, BELUM.Y.W.10.21.272; **pages 14–15** NLI, L_ROY_00369; **page 16** NLI, L_CAB_04056; **page 17** © NMNI, BELUM.Y.W.01.70.12; **page 18** NLI, MASON_M10_S9; **page 19** © NMNI, BELUM.Y.W.01.88.7; **pages 20–21** NLI, MASON_M1_S20; **page 22** NLI, L_CAB_03059; **page 23** NLI, MASON_M11_S16; **page 24** NLI, MASON_M11_S20; **page 25** NLI, MASON_M2_S4; **page 26** NLI, L_ROY_02161; **page 27** NLI, MASON_M7_S28; **pages 28–9** NLI, MASON_M5_S26; **pages 30–31** NLI, MASON_M11_S11; **pages 32–3** NLI, MASON_M11_S15; **page 34** NLI, MASON_M13_S17; **page 35** NLI, P_WP_0784; **pages 36–7** NLI, MASON_BOX_4_R32; **page 38** NLI, MASON_BOX_6_R27; **page 39** NLI, MASON_M12_S21; **pages 40–41** NLI, MASON_M25_S32; **pages 42–3** © NMNI, BELUM.Y.W.10.21.258; **page 44** NLI, P_WP_0651; **page 45** NLI, MASON_M1_S19; **pages 46–7** NLI, MASON_M2_S11; **pages 48–9** NLI, MASON M2_S7; **page 50** NLI, MASON_M13_S18; **page 51** NLI, MASON_M2_S2; **pages 52–3** NLI, L_CAB_03108; **page 54** NLI, L_CAB_03106; **page 55** NLI, L_CAB_02525; **pages 56–7** NLI, L_CAB_02480; **page 58** NLI, P_WP_0329a; **page 59** RSAI ©; **page 60** RSAI ©; **page 61** NLI, L_ROY_01086; **page 62** NLI, L_CAB_02946; **page 63** NLI, P_WP_0131a; **page 64** NLI, MASON_M21_BOX_42; **page 65** RSAI ©; **page 66** NLI, MASON_M7_S31; **page 73** NLI, MASON_M10_S2; **pages 74–5** NLI, MASON_M3_S13; **page 76** NLI, MASON_M1_S24; **page 77** NLI, MASON_M3_S5; **page 78** NLI, L_ROY_00621; **page 79** NLI, MASON_M10_S3; **page 80** NLI, L_CAB_03144; **page 81** © NMNI, BELUM.Y.W.05.86.1; **page 82** NLI, L_ROY_02051; **page 83** NLI, L_ROY_02052; **pages 84–5** © NMNI, BELUM.Y.W.04.69.15; **pages 86–7** NLI, L_ROY_01408; **page 88** NLI, L_ROY_01409; **page 89** NLI, L_ROY_01410; **pages 90– 91** NLI, L_CAB_04132; **page 92** RSAI ©; **page 93** RSAI ©; **pages 94–5** RSAI ©; **pages**

96–7 NLI, L_CAB_04140; **page 98** NLI, L_ROY_01918; **page 99** NLI, MASON_M20_BOX_29_S8; **page 100** RSAI ©; **page 101** RSAI ©; **page 102** NLI, L_ROY_01083; **page 103** NLI, L_ROY_01777; **page 104** NLI, L_ROY_02155; **page 105** © NMNI, BELUM.Y.W.10.69.8; **pages 106–7** NLI, L_ROY_00703; **page 108** © NMNI, BELUM.Y.W.10.21.43; **page 109** © NMNI, BELUM.Y.W.10.21.42; **page 110** © NMNI, BELUM.Y.W.10.21.117; **page 111** © NMNI, BELUM.Y.W.10.21.54; **page 112** NLI, L_ROY_02573; **page 113** RSAI ©; **page 114** RSAI ©; **page 115** © NMNI, BELUM.Y.W.04.45.5; **pages 116–17** © NMNI, BELUM.Y.W.04.45.7; **pages 118–19** NLI, L_CAB_02887; **page 124** © NMNI, BELUM.Y.W.14.05.85; **page 125** © NMNI, BELUM.Y.W.04.99.6; **page 126** © NMNI, BELUM.Y.W.04.01.2; **page 127** NLI, MASON_M8_S20; **page 128** NLI, MASON_M7_S18; **page 129** RSAI ©; **pages 130–31** RSAI ©; **page 132** NLI, MASON_M1_S1; **page 133** NLI, MASON_M5_S25; **page 134** NLI, MASON_M6_S23; **page 135** RSAI ©; **page 136** NLI, L_ROY_00479; **page 137** NLI, L_ROY_00088; **pages 138–9** NLI, L_CAB_00924; **page 139** NLI, L_CAB_00926; **pages 140–41** NLI, L_CAB_00925; **page 142** RSAI ©; **page 143** RSAI ©; **pages 144–5** © NMNI, BELUM.Y.W.14.01.1; **page 146** RSAI ©; **page 147** NLI, P_WP_0141; **pages 148–9** NLI, P_WP_0520; **page 150** NLI, P_WP_0111; **page 151** NLI, MASON_M4_S7; **pages 152–3** NLI, MASON_M7_S22; **page 154** NLI, P_WP_0265; **page 155** NLI, P_WP_0257; **page 156** NLI, P_WP_0259; **page 157** NLI, P_WP_0399; **page 158** © NMNI, BELUM.Y.W.10.21.3; **page 159** © NMNI, BELUM.Y.W.10.21.24; **page 160** RSAI ©; **page 161** RSAI ©; **page 162** NLI, MASON_M6_S7; **page 163** RSAI ©; **page 164** RSAI ©; **page 165** NLI, P_WP_0757; **page 166** NLI, P_WP_0761; **page 167** © NMNI, BELUM.Y.W.04.01.1; **pages 168–9** © NMNI, BELUM.Y.W.01.56.48; **pages 170–71** © NMNI, BELUM.Y.W.99.3; **page 172** NLI, MASON_M4_S10; **page 173** NLI, MASON_M9_S10; **page 174** NLI, MASON_M9_S17; **page 175** © NMNI, BELUM.Y.W.48.01.3; **pages 176–7** © NMNI, BELUM.Y.W.10.21.12; **page 178** Irish Examiner; **page 179** NLI, MASON_M3_S17; **pages 180–81** NLI, MASON_M3_S18; **page 182** NLI, MASON_M3_S21; **pages 186–7** Irish Examiner; **pages 188–9** Irish Examiner; **page 190** NLI, MASON_M20_BOX_35; **page 191** NLI, MASON_M21_BOX_41; **pages 192–3** NLI, P_WP_0836a; **pages 194–5** NLI, P_WP_0331; **pages 196–7** NLI, P_WP_0334; **page 198 [top]** NLI, MASON_M25_S1; **page 198 [bottom]** NLI, MASON_M25_S15; **page 199 [top]** NLI, MASON_M25_S16; **page 199 [bottom]** NLI, MASON_M25_S17; **page 200** NLI, MASON_M12_S8;

Photo Acknowledgments

Photo Acknowledgments

page 201 NLI, MASON_M12_S13; **pages 202–3** NLI, MASON_M12_S14; **page 204** NLI, MASON_M13_S4; **page 205** NLI, MASON_M12_S15; **page 206** NLI, MASON_M13_S10; **page 207** NLI, MASON_M13_S11; **page 208** NLI, MASON_M25_S24; **page 209** NLI, MASON_M25_S26; **page 210** Irish Examiner; **page 211** NLI, MASON_M7_S17; **pages 212–13** NLI, MASON_M7_S11; **page 214** NLI, MASON_M6_S11; **page 215** NLI, MASON_M7_S23; **page 216** NLI, MASON_WEFT001; **page 217** RSAI ©; **pages 218–19** RSAI ©; **page 220** RSAI ©; **page 221** RSAI ©; **pages 222–3** NLI, P_WP_0345; **page 224** NLI, MASON_M5_S15; **page 225** NLI, P_WP_0342; **page 226** © NMNI, BELUM.Y.W.05.15.57; **page 227** © NMNI, BELUM.Y.W.04.30.6; **page 228** © NMNI, BELUM.Y.W.04.69.29; **page 229** NLI, MASON_M17_BOX_J; **page 230** NLI, MASON_M20_BOX_29_S1; **page 231** © NMNI, BELUM.Y.W.99.23; **page 232** Irish Architectural Archive; **page 233** Irish Architectural Archive; **pages 234–5** NLI, P_WP_0405; **page 236** NLI, L_ROY_02594; **page 237** NLI, MASON_M25_S19; **page 238** © NMNI, BELUM.Y.W.10.29.48; **page 239** © NMNI, BELUM.Y.W.10.79.65; **page 240** RSAI ©; **page 241** © NMNI, BELUM.Y.W.10.62.3; **page 242** © NMNI, BELUM.Y.W.10.21.207; **page 243** © NMNI, BELUM.Y.W.05.15.10; **page 244** © NMNI, BELUM.Y.W.10.46.44; **page 251** © NMNI, BELUM.Y.W.10.21.205; **pages 252–3** © NMNI, BELUM.Y.W.10.46.13; **pages 254–5** © NMNI, BELUM.Y.W.10.21.124; **page 256** © NMNI, BELUM.Y.W.10.29.45; **page 257** RSAI ©; **page 258** RSAI ©; **page 259** RSAI ©; **page 260** © NMNI, BELUM.Y.W.10.21.50; **page 261** Irish Examiner; **pages 262–3** Irish Examiner; **pages 264–5** Irish Examiner; **page 266** Irish Examiner; **page 267** Irish Examiner; **page 268** Irish Examiner; **page 269** Irish Examiner; **page 270** Irish Examiner; **page 271** NLI, L_CAB_01128; **page 272** Irish Examiner; **page 273** NLI, P_WP_0648; **page 274** NLI, P_WP_0646a; **page 275** NLI, KE_219; **page 276** Irish Examiner; **page 277** Irish Examiner; **page 278** NLI, MASON_M10_S4

Index
Index

Index

Index
Index

Index

Index

Index